HOT, COLD, HEAVY, LIGHT,

100 Art Writings, 1988–2018

PETER SCHJELDAHL

Edited with an Introduction by Jarrett Earnest

Abrams Press, New York

Library of Congress Control Number: 2018936300

ISBN: 978-1-4197-3438-0
eISBN: 978-1-68335-529-8

Printed and bound in the United States
10 9 8 7 6 5 4 3 2 1

Abrams books are available at special discounts when purchased in quantity for
premiums and promotions as well as fundraising or educational use. Special
editions can also be created to specification. For details, contact specialsales@
abramsbooks.com or the address below.

Abrams Press® is a registered trademark of Harry N. Abrams, Inc.

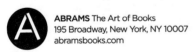

ABRAMS The Art of Books
195 Broadway, New York, NY 10007
abramsbooks.com

Contents

COLD

PART II: HEAVY & LIGHT

HEAVY

LIGHT

INTRODUCTION: SEEING AS A CONTACT SPORT

JARRETT EARNEST

Most of us have never known an art world without Peter Schjeldahl in it. We count on him being part of New York like Central Park, a living monument to the pleasures of city life in a democracy. Like that grassy haven, Schjeldahl's writing pulls off being both accessible and complex—elegant, iconic, fun. He has published regularly since the 1960s, often on a weekly or monthly basis. Familiarity may inure us to how unusual his writerly gifts are and distract us from their spectacular sweep—he chronicles a half-century of timely, always nuanced human feeling. The mode is called "art criticism," but, taken in quantity, Schjeldahl's performance of it reads more like experimental first-person literature, without pretension, and revelatory aesthetic philosophy, without pedantry.

Today Schjeldahl is best known as the authoritative art critic of the *New Yorker,* a post he's held for two decades. Many readers consider his previous work for the *Village Voice* to be criticism at its most electric; those columns have languished undigitized in library basements since the nineties. The writing collected here opens new vistas onto Schjeldahl's achievement, with texts of the last thirty years from the *Voice* (1990–1998), its short-lived sister *7 Days* (1988–1990), exhibition catalogues, and the *New Yorker.* Nothing repeats from his earlier volumes *The Hydrogen Jukebox* (1991) or *Let's See* (2008), though some pieces included here appeared in paperback originals published by The Figures, the small press headed by the poet Geoffrey Young: *The 7 Days Art Columns* (1990) and *Columns & Catalogues* (1994).

I first met Peter Schjeldahl in 2015, when I interviewed him for my book *What It Means to Write About Art: Interviews with Art Critics.* As a critic myself, I undertook the project to understand the thinking of our best writers on art and to gain insights into how to do it. During

our conversation, I said off-handedly that if *I* edited a collection of his criticism it would focus on love as the driving force. This observation came from reading the whole of his work together, which, beyond the topicality of any given argument, revealed the emotional, aesthetic, and philosophical underpinnings of a worldview. Soon after, he suggested I do just that. As a result, I'm to blame for the idiosyncratic organization of this collection in four sections: "Hot," "Cold," "Heavy," and "Light," expanding beyond affection to accommodate the full spectrum of tone and attitude. I've scrambled the hundred items chronologically, as befits a critic who defines "contemporary art" as "every work of art that exists at the present moment—five-thousand years or five minutes old." The groupings are based on affinities among the topics addressed or the tenors of response that they elicit. For instance, the catalogue essay "Concrete and Scott Burton" belongs in the "Heavy" section because it's about gravity. It is flanked by pieces on Richard Serra and Picasso, generating a dialogue on sculptural form. But it could as easily be deemed "Hot," written as a valentine to Burton shortly before his tragic death and featuring the most lyrical description of concrete ever. Further, it might be deemed "Cold," in tune with the cool rigor of Burton's artistry. All of which is to say that these categories are meant to be playful, evocative, and not taken too seriously.

The book begins hot, for sure, with the rapturous lament, "There aren't enough Flowers"—opening a review of Andy Warhol's retrospective at the Museum of Modern Art in 1989. It tells the story of Schjeldahl's first decisive encounter with contemporary art: seeing Warhol's "Flowers" while an aimless poet in Paris in 1965. The piece develops an analysis of what makes Warhol so important to American art, a discussion of the exhibition at hand, and above all, an account of the rush of experiencing great art. It's a marvelous essay, demonstrating how works of art, which are always both embedded in and slightly apart from the broad culture that we share, become meaningful in our personal lives.

Schjeldahl's primary mode is that of a lover, and you can read many pieces as impassioned love letters, often involving his favorite art: painting. His deep devotion to the medium continued throughout

the decades painting was supposed to be dead. Every painter I know would give a couple of fingers off their nonpainting hand for a good long review by Peter Schjeldahl—not only for the recognition, but because he unfailingly brings something new into the discourse, getting to the very heart of the medium that he succinctly describes as "engaging our strongest sense, eyesight, and our finest physical aptitude, that of the hand—it's about the hand and the eye in concert."

Schjeldahl attends closely to the often contradictory ideas, emotions, and associations that arise when we look at art, thereby clearing away any pre-existing opinions, and stays responsive to the specificity of each encounter. He reminds us near the end of his review "Anselm Kiefer at MoMA": "It's only art. Remember that. I know people who take vocal pride in remaining unmoved by Kiefer's work, as if this evinced integrity. The fact is that communion with Kiefer comes only with willingness to be as respectful of his sincerity as he is of yours. Otherwise the work is just brown decor." A major champion of the German painter throughout the eighties, his writing ten years later, in 1998, "Anselm Kiefer at Gagosian," exhibits a shift in tone. After an account of a Fellini-esque dinner party Kiefer hosted in 1993, Schjeldahl observes that the painter "has rung no major changes in a decade" and concludes, "For all I know, his genius, once subject to torments that no one suspected, has succumbed to late-blooming health and happiness. But I know from experience not to understand him too confidently." Even as he senses that the world has shifted away from Kiefer, or Kiefer from it, Schjeldahl doesn't issue a definitive judgment, but rather a report on what the artist's situation is like *right now*, leaving future possibilities open.

Public art emerges as a particularly charged subject, as in his writing around the removal of Richard Serra's *Tilted Arc* from Federal Plaza in New York in 1989. Schjeldahl's had been a lone serious art-world voice supporting those who wanted the work gone, believing that the public should have some say in how public spaces are arranged. "I never stopped hating the placement of *Tilted Arc*. That it was a good sculpture in Serra's obstreperous manner made it all the worse for an already cheerless setting," he wrote. "Did *Tilted Arc*, which walled off a rare

open space in the area, make people feel every kind of oppressed? Some mandarins thought that was fine. 'It'll do them good,' a famous artist said to me of the thirteen-hundred office workers who had petitioned for the work's removal. 'They'll quit and get new jobs. It will change their lives.'" Schjeldahl is ever vigilant against such snobbery, because of his own commitment to American democracy. He believes that people have more complex senses of their own needs and desires than is presumed by those who make decisions for them.

By contrast, consider his writing about Augustus Saint-Gaudens's gilded bronze of General William Tecumseh Sherman on horseback, sited at the corner of Central Park at Fifth Avenue and 59th Street. "For generations now, we have lacked the mental means for taking it seriously, even when we notice it. But this work moves me," he wrote. "Sherman's ravaged, ornery visage convinces utterly, crowning Saint-Gaudens's signature feat of investing idealist art with realist grit," and the angel conducting him is "a wonderment of alacrity." He cites Henry James's distaste for the celebration of a ruthless warrior but concludes, "The sculpture's metaphorical conflation of grisly war and blooming hope is precisely what enthralls me. It addressed a contemporaneous national yearning, most vivid in the cult of Abraham Lincoln, to wring a heart's comfort from the awfulness of the Civil War. The work is at once vulgar and sublime, in ways that invoke a common term: American." In two seemingly effortless paragraphs he changes the way you'll see this sculpture forever.

The Sherman monument recurs in a profile of Rachel Harrison, when Schjeldahl took the protean sculptor there to discuss it: "I had promised to alert the skeptical Harrison to the work's virtues, but we found that it is now hidden in a huge beige box, for a restoration of the site. She was thrilled. The box and the picturesquely jumbled rubble and machinery around it looked like an outsized version of one of her own works-in-progress. Later, noting that repairs to the statue will entail entering it through a trapdoor concealed behind the horse's saddle, she mused that 'every sculpture should have a trapdoor.'" The piece on Harrison, whose work he describes as "both the zestiest and

4

the least digestible in contemporary art," is one of two profiles in this book. The other grapples with the mercurial, hugely influential painter Laura Owens.

Schjeldahl has enriched the sensibilities of several generations by narrating his own process of looking, thinking, and feeling—making it seem like something that anyone with a pair of eyes and an open heart can do. He captures the excitement of art, as when he says that Matisse "stimulates the mind to analysis, then slaps it silly with audacities," or recounts having been "beaten to a pulp of joy" by a de Kooning show. For Schjeldahl, seeing is a contact sport that demands a precision of language. You never forget his background as a poet—every word hits its mark, one after the other, in a small miracle of a sentence. Sheer writerly virtuosity sets him apart.

Peter Schjeldahl writes detective stories about feelings. "Looking at art is like, 'Here are the answers. What were the questions?'" he once told me. "I think of it like espionage, 'walking the cat back'—why did *that* happen, and *that?*—until eventually you come to a point of irreducible mystery." Often personal anecdote or memoir frames an analysis, providing a way into a subject, a path through it, and an exit from it. This book teems with marvelous stories, finding the twenty-three-year-old Schjeldahl riding through Tuscany on the back of a Vespa in quest of Piero della Francescas, recounting a slapstick robbery of Edvard Munch's *The Scream*, or conveying an up-close encounter with the backside of Jan van Eyck's *Ghent Altarpiece* as it was being restored. Writing on a still life by Francisco de Zurbarán, he describes a frequent effect of looking at art in a private collection: "It helps when the specter of a particular person, who particularly loved particular things, stands at your shoulder, urging attention, inviting argument, and marveling at the shared good luck at being so entertained." It's easy to read this as a description of Schjeldahl's own critical endeavor, showing us how to love art works, urging our attention, and inviting our arguments. The effect of reading him in depth, over time, is like that of great literature. You come away not only with new insights and ideas, but with a feeling of having been granted an extra life.

PART I

—

HOT & COLD

HOT

—

ANDY WARHOL

There aren't enough Flowers.

How's that for hard-hitting criticism of the Andy Warhol retrospective at the Museum of Modern Art? It will have to do. On an occasion so gaga that it begs for curmudgeonly demurral, I'm just another happy face in the crowd. I love the show. I love Warhol, with a fan's abandon. The feeling isn't so much a warm place in my heart, an organ not notably engaged by this artist, as a flat spot among the folds of my brain, from where they got run over in the sixties.

Warhol had a steamrollering effect on the whole mental apparatus of Western culture. The weight that did the trick wasn't his but history's: gigantic American power, pride, affluence, idealism, social mobility, technology, mass entertainment, and associated troubles. But nothing foreordained the appearance of an artist who would clarify the age, while it was happening, in icons of uncanny fidelity and amazing pleasure. Warhol gave shocks of self-recognition to lives that were changing anyway. He thus imbued many of us with the unreasoning devotion that is typical in the wake of conversion experiences. Mine came in Paris in 1965. It was a show of "Flowers."

Having only paused in New York after fleeing the Midwest, I was living out a dreary year of unrequited romance with France. It was a gray day. I entered a gallery packed with Warhol's silkscreens—big ones like billboards, little ones like ranked trivets—of hibiscus blossoms reduced to single flat colors amid grainy black-and-white blades of grass: photography degraded to the verge of abstraction. The pitch-perfect synthetic hues were never dreamed of in nature or previous art. My head sprouted a thought balloon: "Wrong city!"

Weeks later I was a naturalized New Yorker. I lived on Avenue B, used drugs, was often miserable but too excited to notice, saw Warhol's films (saw *all* films, but Warhol's stand out as the most revelatory of the decade), walked into galleries and was wowed, walked the streets and was wowed, gave or attended innumerable poetry readings, felt on the brink of possessing important knowledge, didn't sleep much, anticipated a political Revolution (didn't like the idea but didn't argue), went with a flow like a whirlpool with riptides, and liked things.

Warhol said that Pop Art was "about liking things." The effect was a sort of Zen keyed to supermarkets and movie magazines. (It had only glancingly to do with camp, Susan Sontag to the contrary, because active rather than reactive—a proposition of normality, even, with only whispers of rebellion and no defensiveness at all.) My compulsion to be analytical proved a nuisance, which I beat down with drugs and flirtations with the occult. (But the *I Ching* lost me to boredom by proving always right.) Aesthetic sensation inhered in every particle of a world like an explosion, things flying and tumbling.

I had a couple of conversations with Warhol, who was so omnipresent, you thought there must be several of him. I talked in rushes and jumbles. He replied, as near as I can recall, "Oh," patiently. He was nice when not many were. (He referred in his diaries to "Peter Schjeldahl who I know hates me," which, with remorse, I attribute to my way of dissembling nervousness. What looked like hostility was terrified respect.) He was shot in 1968. Everybody valuable seemed to be getting shot or else hit on the head by police or shattered by the drugs. People fled one another and crashed. It was over. What "it" was, I forgot.

At MoMA, I remember. I had expected the show to be beautiful and fun, which it is, and perhaps nostalgic, which it isn't. The three hundred or so objects, most from the early and middle sixties, remain too potent to be mooned over. Their radiance is still like a lighthouse seen at night from a sinking ship. They reawaken a state of mind bashed around by impersonal forces, staggering for balance, and, now and then, making a dance of the stagger.

There are only two middling Flowers. The reason may be lingering sensitivity about one of MoMA's old pieties—the sanctity of modernist abstraction—which Warhol wrecked. He strip-mined the pleasures of Clement-Greenbergian Color Field painting, which was touted then at the museum, and expunged its preciousness. Is this still a sore point on West Fifty-Third Street?

I didn't know that in his miracle year of 1962 Warhol did a painting of Natalie Wood: several dozen repetitions of her preternaturally pretty face in black and white in that fast and lucky, there's-no-such-thing-as-an-accident silk-screening. He also made one I hadn't known about of Roger Maris hitting a home run: the big, grunting swing in rows of mighty whacks. Each work feels definitive, freezing for all time a fleeting euphoria.

I didn't know how great were the Marilyns, Elvises, Lizzes, Marlons, Jackies, electric chairs, car crashes, and "wanted" posters—and the Flowers, where are the Flowers?—which is odd, because I thought they were as great as anything gets. Not that thinking has much to do with a sensation of, chiefly, rapture. Rapture merges the top, bottom, and all sides of yourself, such that you don't know where you leave off and anything else begins. It's like D. H. Lawrence's speculation about the sensory awareness of fish in water: "one touch."

The sixties were about blurring boundaries. Warhol triumphed because the frontiers—between high and low and art and commerce—never existed for him. Look at every other important artist then, especially every Pop artist, and you will detect some or another skittish irony. Warhol wasn't ironic. He was neither naïve nor cynical. He was innocent and greedy. Middle-classniks tied themselves in knots trying to fathom the complexities of a mind whose secret was simplicity, as efficient a life-form as a shark, a cat, or an honest businessman. He gave himself with no strings attached, only price tags.

Warhol had a barbarian's unblinking detachment, as a son of lower-class Slovak immigrants and (it turns out, which almost no one knew) a lifelong observant Eastern Orthodox Catholic. He became the artist laureate of capitalism, in which everything is priced, because it

seemed to him only natural. Having grown up on the system's under-side, with no privilege and thus no ambivalence, he didn't fret about its morality, though he was moral within it.

He ran into creative trouble in the seventies, it's true. MoMA's representation of the later paintings is mercifully brief. (I do enjoy the society portraits, however—a genre achievement that no one has prop-erly characterized yet, though some of us have tried.) I think the culture became so permeated with Warhol's influence that his responses to it picked up feedback, to deleterious effect. He still did well with death (skulls, guns), totalitarian and shamanistic sublimities (Mao, Joseph Beuys), and himself (the never-fail self-portraits).

Warhol had announced that the show I saw in Paris in 1965 was his last one of painting. His next major outing, at Castelli in 1966, was a walk-in beautiful climax of the careening decade, with drifting silvery-plastic balloons that mirrored our delirium and cow wallpaper that mimed our stupefaction. He planned to abandon the art world for Hollywood—a campaign that was defeated by the movie industry's real-life ways. (Liking things cut no mustard with bottom-line executives.) That he had to come limping back to New York, and to paint again, is still a little sad.

But leave downbeat notes to the curmudgeons. What they will miss, as usual, is that Warhol remains ahead of us all, as contemporary civilization's comprehensive seer. He delivered the glamour-industrial goods with full knowledge of the bads inherent in them. The petrifica-tion of life played by rules of celebrity was a fair bargain for him, and a serviceable business plan, but he never disguised its coldness. Pleasure and alienation aren't two sides of a coin in his work; they are the same side, a sleek, transparent surface with nothing—black-hole-in-space nothing—behind it. His art superimposes our gawking reflections on bottomless want.

7 Days, February 22, 1989

WILLEM DE KOONING

Like the bus in the thriller *Speed*, this masterpieces-only retrospective never slows down and thus is hard to board. How I did it was to stroll nonstop through the show, finally pausing in the last room with the eerily deliberate paintings of de Kooning's dotage that lay out rudiments of his genius like silk ties on a bedspread. I studied those works that have no historical precedent that I can think of. Then I left the show and nonchalantly walked back in at the beginning, going straight to *Pink Lady* (1944) and giving it my full attention. The effect was like a plane taking off, when the acceleration presses you against the seat. The painting's violent intelligence detonated pleasure after pleasure. When I turned around, everything in the show was singing its lungs out. Half an hour later I was beaten to a pulp of joy. I'll rest and go back for more.

If something similar doesn't happen for you at the Met, either you are distracted by personal woes or the art of painting is wasted on you. The art of painting does not get more exciting than Willem de Kooning on a good day, and this show amounts to months of his Sundays. *Times* critic Holland Cotter has argued well, in his review, that the Greatest Hits approach is a poor way to represent this artist, whose feints and jabs set up his knockouts. But we must do our best with what we are given. The show will make a doomsday division between those who are attuned to painting and those who aren't.

De Kooning is ninety and under nursing care. He has not worked in several years. Except for some rumored late-late paintings, we have his whole career in sight. Only Picasso, Matisse, and maybe Mondrian, among the century's painters, had more substantial careers over comparably long hauls, though you wouldn't guess de Kooning's stature from art criticism of the last three decades.

De Kooning did some of his strongest work after the early sixties, while excluded from the conversation of contemporary art. He seemed left behind. He was waiting ahead. At last catching up, we have no

major critical assessments of him fresher than musty old myths of his existentialist heroism (Harold Rosenberg) and "Luciferian" ambition (Clement Greenberg), unless an allegedly lousy attitude toward women counts. It makes sense to start from scratch. I suggest a focus on de Kooning's mental powers.

He was an intellectual giant among painters, with an analytical grasp that registers in every move with pencil or brush. A mark by de Kooning always has more than one thing on its mind: direction, contour, composition, velocity. The mark lies on the surface and digs into pictorial space. It makes a shape of itself and describes shapes next to it. Such doubleness derives from Cubism, which gave de Kooning his initial orientation. With crucial guidance from Arshile Gorky, who showed him ways around Picasso's intimidatingly authoritative permutations, de Kooning blew open the Cubist grid, changing its mode from structural to fluid. De Kooning is to classical Cubism as flying is to walking.

His art is not abstract, just relentlessly abstracting. Memories of depiction cling to every stroke. They contribute to a fabulous complexity that, as you look, can supercharge your capacity to maintain disparate thoughts simultaneously. This is never more the case than in the Women, where sublimely abstracted marks bend to the vulgarity of a derisive, yakking image. It is as if an angel choir chanted a dirty limerick. Savagely comic, the work unites exalted and degraded feelings in Möbius-strip continuity.

De Kooning had the skills with line, paint, and color of an Old Master, the last in a parade from the Renaissance. After Jackson Pollock, dripping, broke physical contact with canvas, ideas commenced to eclipse craft in significant art. The craft secrets lodged in de Kooning's wrist—still active in his late work, without help or hindrance from a brain gutted by senility—have not been inherited by anyone, nor will they be. They posed an odd problem for de Kooning himself, who in midcareer seemed to realize that his mastery overqualified him in a changing culture.

No one since 1950, including de Kooning, has painted a picture as consummately grand, as much an emblem of Western civilization in its glory, as *Excavation*, here paying a visit to the city of its creation from the Chicago Art Institute. Conservative critics still deplore the artist's abandonment of his late-forties heights. But he saw that nothing important was left there. His ravening Women and then his blowsy abstract landscapes, of the late fifties, react to a time when everything old was winking out. For a while—as in a 1955 painting whose deadpan title, *Composition*, is made hilarious by a stumbling and dancing, falling-forward manner dis-composed to the nth degree—the very ruin of the world seemed to drive his brush.

It couldn't last. As beautiful as they often are, the abstract landscapes strike me as manically overoptimistic in their rhetoric, presuming a level of poetic communication with viewers that lured him off-balance—and incidentally jinxed a generation of young painters, influenced by him, who tried to start from there. It took years of wood-shedding in *The Springs*, painting friendly nudes and engaging in one of history's most profound excursions into mysteries of drawing, for de Kooning to recover his own wavelength. By 1967, with *Two Figures in a Landscape*, he had it. The rest, allowing for runs of so-so work now and then, is as much happiness as eyes can bear.

De Kooning's keynote is a self-engulfment in painting that demands every resource of wit and skill not to become a mess. He regularly raises the ante of the game with clangorous colors, bizarre textures, and ripped and shredded compositions, seemingly at ease only on the lip of chaos. It makes the paintings inexhaustible. They keep happening as you look. They are eternally in the middle of something, not that you know what.

Being all middle, a de Kooning is the opposite of the typical artwork of the present day. Our young artists tend to give us things with pat premises and rote finishes, distinguished from mass-cultural commodities by piquant subject matter and aren't-we-smart ironies. No one is to blame for the diminishment that such work represents. The decline of high culture that de Kooning accepted after *Excavation* was

not about to stop with him. But what do we make of the fact that until just recently the old Dutchman was getting out of bed every morning and making miracles? He was our contemporary, breathing our air. Where were we? What were we thinking of?

Village Voice, November 1, 1994

"WOMEN" BY WILLEM DE KOONING AND JEAN DUBUFFET

When a boy wants to feel like a bad boy—most boys want to feel they are bad sometimes, others want to feel they are bad most times, and some are bad (beware these)—a reliable way is to draw a dirty picture of a woman, or Woman. Bad-boy drawings may be caricatures of, say, a despised teacher, if done well enough that anyone can tell, but normally they take the most economical linear route to the double message "female" and "stupid." The transgression relieves the boy's woe at being short, in all ways, on power. If the boy is a good boy, the drawing also makes him ashamed. The pleasure of being bad for a good boy isn't worth the discomfort it costs, and he stops doing dirty drawings. Or he becomes an artist.

A grown-up straight male artist is perhaps a good boy who has made a vocation of maximizing the pleasure of being bad while minimizing its downside. He may dream of Pablo Picasso: full-time bad boy, shameless, who got all the girls and made the badness in good boys weep with envy. But he is not Picasso, and he is never going to be Picasso. He must face that. He makes art, or Art, in which furtive badness mysteriously informs goodness, or "quality." In his heart, pleasure and shame dance the old dance. Usually that's his story, in which nothing dramatic happens.

A show at the Pace Gallery spotlights a moment, around 1950, when the stories of two men who were hardly immature or powerless, in their respective milieus, took similar, very dramatic turns. Each man was deemed by many, including himself, the best painter on his scene. Independently, in New York and Paris, Willem de Kooning and Jean Dubuffet made series of pictures of Woman more vehement than anything comparable in big-time art before or since. I am interested in why that happened and, too, in a historical consequence of it: lasting damage to traditions of Romantic sincerity in painting.

De Kooning's "Women" and Dubuffet's "Corps de dames" were deliberately destructive, involving in the first case what de Kooning called "the female painted through all the ages, all those idols" and in the second what Dubuffet denounced as the association of the female body "with a very specious notion of beauty." "Surely I aim for a beauty, but not that one," he said. So notes of liberation were sounded, but from what? The beauty of Dubuffet's Woman pictures—splayed, big-genitaled, tiny-headed, graffiti-flat totems in materials as thick as dirt—is alluvial. The beauty of de Kooning's—figures with blindly staring eyes, one or more sets of ferocious teeth, and torsos hard to parse from welters of paint—is virtuosic.

De Kooning's and Dubuffet's travesties of a revered central theme of Western painting since the Renaissance still unsettle, partly because they seem so self-lacerating. A paradox of bad-boy drawings of Woman is germane: trying to reduce the female to a derisory cipher invests it with devouring force and confesses the boy's puniness. De Kooning's subject grows more fearsome the more he attacks her. His brushwork in these pictures is often called "slashing," but the Woman is made of the swipes he takes at her. The effect of a Pygmalion despite himself is self-mocking.

I remember bad boys, the older ones on the playground who used obscene language and gestures to intimidate us younger ones with their sexual knowledge (never mind that they were surely bluffing). I remember humiliations that I wanted to hide but couldn't. Responses of inferiority in other boys are the bad boy's satisfaction. He doesn't care if he is tipping the hand of his own abjection, if he can demoralize. Do I think that de Kooning and Dubuffet enacted bitter playground machismo? I do. It adds up when you know their career situations at the time.

They were relative elders on competitive scenes where public attention was just beginning and pecking orders were being worked out. De Kooning, forty-six years old in 1950, and Dubuffet, forty-nine, were verging on fame after years of frustration. Imagine that you are the more disaffected of the two, Dubuffet, until recently a wine merchant

whose first stab at recognition, two decades earlier, was dismissed by art-world coteries. Now it's your turn. Young artists in your war-groggy capital are trying to revive high-taste School of Paris aesthetics, and you think: pathetic. You will take the lads into the pissoirs and show them what their precious painting is about.

Now consider that you are de Kooning, with a firmly established downtown reputation as a painter's painter. Among other things, you draw like an angel. But as you start to win the game, the rules change. With Clement Greenberg theorizing it, field abstraction becomes the living end. It is tailored perfectly for Jackson Pollock, Barnett Newman, and others who are klutzes at drawing. You are threatened with becoming prematurely old-hat. You throw an expedient tantrum.

Why were the cockfights in question conducted over the body of Woman? The model of Picasso, whose priapism raged on, had to be a factor, as did Surrealism's then-recent poisoned-sugar obsession with the feminine. Sexual content was being suppressed in the time's newly high-toned art worlds. The working-class de Kooning and the petit-bourgeois Dubuffet likely figured that they stood less advantage in a debate of formal issues, despite their mastery, than in a bar brawl. The fiercest such fights are over women, with whom they may have only incidentally to do.

Whatever the reasons, de Kooning and Dubuffet went and did it, hell-bent to shock. They conflated creation and desecration in the way that every bad boy knows the desolate pleasure of, and the power of what they did is permanent. Like violence, their Woman pictures induce a state where you can't believe that something is happening, but it is, and you wish it would stop, but it hasn't yet.

Village Voice, January 8, 1992

ARSHILE GORKY

The safest and loneliest place in the world, for a devotee of modern art, is within arm's length of any first-rate painting by Arshile Gorky, the subject of a galvanically moving retrospective at the Philadelphia Museum of Art. In that zone, where the artist's decisions register kinesthetically, awakening your sense of touch as well as engaging your eye, it is hard to doubt the value of the modernist adventure: a bet on the adequacy of sheer form, in the right hands, to compensate for a lost faith in established orders of civilization. No other artist has invested more ardor in naked technique: how to activate an edge, how to rhyme a color. Gorky was an academic painter in a modern academy of one. Take *Scent of Apricots on the Fields* (1944). A pileup of loosely outlined, thinly painted fragmentary shapes, like plant or body parts, embedded in passages of golden yellow, hovers above a green suggestion of a table and below a skylike expanse of brushy rose red. Dabs of raw turpentine cause runny dissolutions, as if some forms were melting into their white ground. The downward drips yield a paradoxical sensation of buoyancy. The picture's visceral shapes seem to ascend like putti in a Renaissance firmament. The dynamics are at once obvious and inspired, stroke by stroke and hue by hue, and deliriously affecting—when viewed near at hand.

From a distance, the work flummoxes evaluation. Its style fits only too comfortably into a period vogue of surrealistic abstraction—that of minor figures like André Masson and Roberto Matta, backed by the giants Picasso, Kandinsky, and Miró. Its content—romanticizing supposed memories of a boyhood that Gorky regularly lied about—is "poetic" in ways that turn treacly and banal when you try to appreciate them. Art history and biography are blind alleys in Gorky's case. His art feels contemporary, because no discursive account of the past can contain it. That also makes it a lonely enthusiasm, difficult to espouse. Still, he is the twentieth-century painter dearest to my heart.

Of what use is biography in assessing someone who made himself up? Gorky told people, including his wife, that he was Russian, a cousin

of the writer Maxim Gorky (evidently unaware that "Maxim Gorky" was a pen name), born in the Caucasus in 1905 and educated in France. Actually, he was an Ottoman Armenian, Vosdanig Adoian, born circa 1902, in a village near Van. He couldn't speak Russian and never saw France. His father emigrated to America in 1908. His mother died in Yerevan, perhaps of starvation, in 1919, four years after the remaining family had fled the Turkish massacres. In 1920, Adoian and a sister joined relatives in Watertown, Massachusetts. The first evidence of his new identity appears as the signature "Gorky, Arshele," on *Park Street Church, Boston,* a skillful pastiche of Neo-Impressionism that he painted in 1924 while teaching at an art school in Boston. He admired the work of John Singer Sargent before latching on to Cézanne as a god of art second only, later, to Picasso. Early imitations of Cézanne, in the show, are astonishingly acute. Cézanne is the foremost of painters who unfold their majesty to close-up inspection. (Gorky stumbled in his tyro emulations of Matisse and de Chirico, artists more reliant on overall design.) With Gorky, influence is no incidental issue. I think he never ceased to regard his own creations vicariously, through the conjured eyes of heroes—he cited Uccello, Grünewald, Ingres, Seurat. He spoke with scorn of "originality" as a criterion of artistic value. His friend and self-declared disciple Willem de Kooning reported Gorky's remarking to him, "Aha, so you have ideas of your own." De Kooning recalled, "Somehow, that didn't seem so good."

The tall, preposterously handsome Gorky, who moved to New York in 1924 and took a studio on Union Square in 1930, was revered for his gifts, enjoyed for his clowning, and resented for his bossiness in the poverty-ravaged downtown art scene. Many women adored him. I incline to a partly cynical view of his famous images of himself as a painfully shy lad with his haunted-looking mother, based on a 1912 photograph. Gorky's suffering was surely real, but the pathos of the pictures strikes me as calculated to seduce. He wanted mothering. In politics, he was a loose cannon among radicals, an admirer of Stalin who pronounced social realism "poor art for poor people." In 1936, he produced WPA murals, later mostly destroyed, for Newark Airport.

(Photographs show him explaining the work to a visibly unimpressed Fiorello La Guardia.) Remnants of the murals, in the Philadelphia show, deploy a dashing, generic modern-artiness like that of his friend Stuart Davis. But Gorky's ambition centered on an intimate and desperate grappling with Picasso, whom he didn't so much emulate as channel, in a spirit nicely characterized by the critic Robert Storr in the show's catalogue: that of "a gifted pianist who habitually forgets in the middle of performing a canonical sonata that he has not composed it himself."

Gorky's Picassoesque works of the thirties are commonly scanted in favor of the pictures with which, from about 1940 until his suicide in 1948, he anticipated the triumphs of Abstract Expressionism. (His end was terrible, in a madness brought on by a studio fire that destroyed much of his recent work, an operation for rectal cancer, his beloved wife's affair with his best friend, and a crippling car crash.) But the drama of, say, *Enigmatic Combat* (1936–37), a sprightly patchwork of amoeboid and spiky shapes, rivets me. Its thickly layered surface bespeaks long, onerous toil for a kind of effect that Picasso brought off with ease. The task seems absurd. Gorky's self-abnegating success with it has the equivocal glory of a saint's welcomed martyrdom.

The Philadelphia show, curated by Michael R. Taylor, is probably overcrowded and definitely underlit (a consequence of interspersing paintings with drawings, which, in standard museum practice, require dim illumination). And it's wacky, in the big section representing the early forties, when Gorky abandoned his downtown friends for the relatively glittering society of refugees—including Léger and Duchamp—who embraced him. Walls painted with a wraparound, jagged band of gray, evoking exhibition styles that were à la mode at that time, emphasize a revisionist thesis that Taylor spells out in a catalogue essay—assigning Gorky's breakthrough works to European Surrealism rather than American abstraction. I'm sorry, but that's wrong. Gorky is ours. The exiles inspired him; André Breton celebrated him as "the only painter in America"; Matta taught him a crucial trick of divorcing crisp line from atmospheric washes of color. But the younger surrealists, like Matta, were mediocrities on the downslope of a movement.

De Kooning, Pollock, Rothko, and other locals grasped and developed the revolutionary implications of what Gorky did, which was, roughly, to scale every inch of a painting to the impact of the whole. American eyes saw through the lingering surrealist clichés in his work—often sketchily abstracted sex organs—to a new, expansive, burstingly songful type of pictorial unity.

Textures of intensely sensitive touch, making forms quiver and squirm, are the most eloquent element in late Gorky. Color comes second, yet it, too, is extraordinary, evoking bodily wounds and inflammations and ungraspable subtleties of nature. Drawing, though busily abundant, feels incidental, like fleeting thoughts of a mind in the grip of an extreme emotion. I am convinced that, had Gorky lived, he would have suppressed line, perhaps in a way that, absent him, fell to Rothko. He would also undoubtedly have undertaken bigger canvases, in the budding New York School manner. *Untitled* (1943–1948), a medium-sized and not quite resolved painting, of scrappy shapes jittering in a surface of hot orange scumbled over a muted yellow, feels pregnant with promises of engulfing wonderment. The closing chords of Gorky's unfinished symphony remain incipient.

New Yorker, November 11, 2009

TWO BY REMBRANDT

Dutch and Flemish Paintings from the Hermitage, a loan show from the U.S.S.R., is distracting and dissatisfying in the way of all masterpiece samplers. It is piety on parade, a lineup of usual suspects, party appetizers: some of this, some of that, you're welcome, go home. Curatorial packaging (decorator-color walls, sleeping-pill labels, murmuring Acoustiguides) and diplomatic blather (glasnostalgia) all but smother it. People will mob it who never look at works by the same artists, as good or better, in the Met's permanent galleries. None of this poses a problem for the Old-Master maven, who knows that visiting such shows is a guerrilla operation that skirts many targets to take others by stealth. He or she knows, in crowded rooms, what elbows are for.

Rembrandt's *The Sacrifice of Isaac* (1635), a large canvas with a gruesomely age-deadened paint skin, is odd, as a kind of Baroque machine that Rembrandt rarely went in for, but so infernally clever as to be a lesson in greatness. As always—and I mean *always*—even with uncongenial projects, the Dutchman found ways to keep himself interested. This one tells a familiar story with a cunning twist. The key is a knife in midair. At first it appears that an angel grasps Abraham's back-stretched arm to prevent him from stabbing Isaac. His knife drops. But look again. The weapon is round-pointed, not a stabber but a slicer. Abraham has shoved Isaac's head back to expose his throat (also perhaps to spare himself the sight of his son's face). He was about to slit the throat. His arm is behind him because the angel, a mild girl with a light grip, has yanked it there. She is supernaturally strong. The look that the patriarch gives her expresses shock at something he has never felt before: overpowered, physically feeble. The knife doesn't fall. Flung loose as his arm is retracted, it flies out of the picture. Duck!

Flora (1634), a portrait of Rembrandt's first wife, Saskia, as the goddess of spring, is the best painting in the show, if not the world. He has dressed her in ravishing pale green and gold satin, silks, and brocade, and made her a fabulous bonnet of fresh flowers. He shows how beautiful every stitch and petal is. But chiefly he shows *her*: plain and simple,

round-faced Saskia, oblivious to the finery and pleasantly distracted. She watches something. Her gaze is directed out to mid-body level. She sees hands that hold a palette and brushes. She may think her husband is the best painter in town.

When *Flora* was bought by Catherine the Great, someone titled it *Portrait of a Lady Dressed as a Shepherdess*—absurdly, for a young woman who is both so little ladylike and so expensively decked out. But it's a sexy picture, and shepherdesses were an eighteenth-century idea of sexy. Then, in the eighteen-twenties, the work shows up on Hermitage inventories as *The Young Jewess*—again on no visible evidence but reflecting Romantic-era mix-ups of the erotic with the exotic. Feudal Russians couldn't recognize a new thing—a seventeenth-century Dutch innovation—in the social history of the heart: bourgeois, domestic, private, matrimonial love. The Eros of *Flora* is a closed circuit between two people, alone with each other: the glad wife, the uxurious husband. It allows a viewer no point of entry. We can look, but we're not there.

7 Days, April 13, 1988

ZURBARÁN'S CITRONS

We know what a great painting looks like while we are looking at one. Turning away, we don't exactly forget, but our recall of the experience—how we felt, looking—starts to edit what we saw. Some details and qualities are magnified; others evanesce. With time, the picture becomes ever more ours and less the painter's. My several visits to the best painting in the world, Velázquez's *Las Meninas* (1656), at the Prado, instruct me in this regard. My first reaction is always disappointment at the coarse, almost drab handmadeness of the big (but smaller than I recalled) canvas, the absence of a glamour that I have cherished in memory and have refreshed by contemplating reproductions. (Reproductions are pandering ghosts; they confirm what we like to believe.) Then I find myself under Velázquez's spell again, as if I had never been before—pitying the fool that I must have been when I last viewed the work. This time I get it! But the moment I am back out on the streets of Madrid, my memory will have begun complicating, with my heart's partialities, the simplicity of naked brushy paint that describes a little girl, at the center of a courtly society on a certain day, being offered a red glass of something.

Encountering one of the five canvases in *Masterpieces of European Painting from the Norton Simon Museum*, a loan show at the Frick Collection, has shocked me with really embarrassing proof of my memory's fecklessness. The painting is a supreme work by Velázquez's contemporary, friend, and sometime peer Francisco de Zurbarán. (Both were from Seville. Velázquez landed the nation's plum job of court painter; Zurbarán subsisted on religious commissions.) *Still Life with Lemons, Oranges and a Rose* (1633), the artist's only signed and dated still life, amounts to three pictures, side by side, in one: a silver plate holding four citrons (baggy and nubbly kin of lemons); several oranges with stems, leaves, and blossoms, heaped in a basket; and a two-handled gray ceramic cup, apparently filled with water, on another silver plate, with a pale-pink rose facing it from the plate's lip.

The objects rest on an oxblood-brown table against a pitch-black ground. Sunlight rakes them from the left. Scholars speculate that they allegorize virtues of the Virgin Mary (citrons for faithfulness, water for purity—but allegory bores me). Certainly, there is a sense of conceptual rigor in the work's rebuslike presentation, which invests ordinary comestibles on a piece of domestic furniture with the gravitas of a sacrificial altar. I was overwhelmed when I saw the citrons in the picture, many years ago, at the Simon, in Pasadena, California (inch for inch, the finest collection of European paintings west of the Mississippi). Ever since, they have served me as a touchstone of painterly potency. I was pleased to discover, at the Frick, that my mental image of them had been close to photographic. No nuance of the dusky russet shadows and tiny green inflections, in the fruit's soprano yellow, surprised me. But the other objects registered with a jolt: I didn't remember any oranges, basket, cup, or rose at all. My recollection had amputated two-thirds of a tour de force.

Well, yellow is my favorite color. And the painting's other, more muted hues were likely dim prior to a recent cleaning. But current brain science affords me a less abject excuse. Research has confirmed what experience posits: strongly emotional events linger in vivid but narrowly focused memory, etching certain facts—a gun pointed at you, say, as once happened to me—while occluding pretty much everything incidental to them—such as the color of the gunman's hair, or whether he had any. In fact, the work still affects me as principally about those citrons, never mind their impeccable companions. The fruit's combined fierce materiality and celestial beauty channel the artist's genius. The distinctly Iberian black background is part of it. (Any painter who uses black as a color should pay a royalty to Spain.) Likewise telling, about the style, is a distilled spirit of the Counter-Reformation. Zurbarán was one of that feverish pietism's chief visual propagandists after El Greco.

Zurbarán's brand of rhapsodic austerity faded in mid-seventeenth-century Spain. Also in the Frick show is a sumptuous painting by the sweet-tempered Bartolomé Esteban Murillo, who ousted him, late in his career, from clerical favor. *The Birth of St. John the Baptist* (circa 1660)

teases softly glowing figures, including a rumpus of putti, from ambient blackness, with baby John, at the center, managing to be realistically infantile while conveying, by look and gesture, that he can't wait to get started prophesying. Like many people I know, I've been repelled at times by Murillo's winsomeness—I could do without the onlooking fuzzy puppy in this picture—but, if decadence in art is ever forgivable (it is), he commands admiration. The three other Simon treasures on show are *The Flight Into Egypt* (circa 1544–45), by Jacopo Bassano, a rushing action scene in top-drawer Venetian color and decorative and narrative technique; *The Holy Women at the Sepulchre* (circa 1611–14), an unusually restrained Rubens in which women confronted by two beefy angels look unimpressed, except for one, who leans out, simpering, and seems to wave "Hi!"; and Guercino's *Aldrovandi Dog* (circa 1625), a low-angled, monumental portrait of a brindle-and-white mastiff posed on a balustrade against a twilight sky and a verdant landscape with palatial towers. The animal sports a heraldic collar and valorous scars. All five works abound in what auctioneers term "wall power."

The business tycoon Norton Simon, who collected art from 1954 until his death in 1993, frankly followed the prodigious model of Henry Clay Frick. (Frick, a half century earlier, patronized the prince of dealers, Lord Joseph Duveen; in 1964, Simon bought an option on the entire remaining inventory of Duveen Brothers.) But the two men differed in temperament. Simon's evident relishing of drama, eroticism, and strong color, often in figure compositions, challenges Frick's penchant for relative quietude, propriety, and subtlety, tilting toward portraiture and landscape. Four of the Simons here are Baroque, a period downplayed at the Frick, and the fifth, the Bassano, is slam-bang Mannerist. Their incursion slightly suggests a street gang crashing a tea party—the rowdies, accustomed to preeminence on their home turf, a bit daunted by the cool of the host company but irrepressibly cocky. They are not made altogether welcome. I fancied an irritable shudder in the Frick's sensitively indefinite Chardin, *Still Life with Plums* (circa 1730), at the blazing Zurbarán's sudden proximity. (This came with a revived savor of Chardin's tenderness.) The abrasive match of two formidably refined

tastes affirms the superiority, for aesthetic enjoyment, of intact private collections over the committee-screened hit parades of standard museums, where even, or especially, the greatest works feel more endorsed than valued. After all, amateur enthusiasm is our one trusty route to communion with the Old Masters, whose original social and spiritual functions have long since gone obscure, if not obsolete (though nothing can be wholly lost that lives in art). It helps when the specter of a particular person, who particularly loved particular things, stands at your shoulder, urging attention, inviting argument, and marveling at the shared good luck of being so entertained.

New Yorker, April 6, 2009

VELÁZQUEZ

Diego Velázquez (1599–1660) was as good at oil painting as anyone has been at anything. When Edouard Manet, discovering him at the Prado in Madrid in 1865, said that he wondered why others, including himself, bothered, he expressed an enduring thought: painting has been done, and Velázquez did it. That was a watershed historical moment. Modern art was born when Manet saw Velázquez and despaired.

The feeling of Velázquez is light and swift. He is never "intense." Unprolific, he reworked his pictures at length, as attested by pentimenti. But you don't see him sweat. He is profound but in ways that seem to say, "Isn't everybody?" His truth seems self-evident, as if you always knew it. You don't learn about the court of Philip IV, say. You suddenly just know or, because this is painting, just see.

If Velázquez were a rock singer, he would be Roy Orbison. He respects all possible sentiments but isn't sentimental, and he is alert to all manner of charm without being charmed himself. He is somehow detached in the very act of being engaged, staying out of the way of what he fixes on. Compared with him, all other painters "seem completely like fakers," as Manet said, too.

The hardest thing about getting Velázquez is believing your eyes, accepting that such superhuman lucidity is really happening. That's why it's good to view many Velázquez paintings, so the gliding truth can break down your suspicion that, when you look at art, you're bound to miss something. The only way to miss Velázquez is to be blind.

Those of us who know the Prado have an unfair edge at this show, because we can refer to what's lacking: *Las Meninas*, chiefly. Other of the artist's absent greatest works include London's *Rokeby Venus* and Rome's portrait of Pope Innocent X. Top-drawer are about a half dozen of the thirty-eight pictures in this brief compendium. ("When did they start putting the gift shop in the middle of a show?" an unprepared friend said as she reached the end.) The rest are early and/or odd and/or in bad shape and/or grand while gloomed by the constricting nature of their commissions (not that Velázquez couldn't handle it, but you sense

his ennui). I'm ready to believe Met director Philippe de Montebello when he crows in the catalogue that this show fulfills "an unrealizable dream." But when I have unrealizable dreams, they tend to be, you know, fabulous.

The idea of reviewing Velázquez is silly. What follows are notes toward an opinionated user's manual.

Remember in the first room that you are seeing a very young show-off from Seville who is out to make it at court in Madrid. The coups of verisimilitude in *Old Woman Cooking Eggs* and *The Water Seller* are staggering but at a cost of torturing space in the pictures. Already there is philosophical and poetic brilliance. If you want to tell yourself an intricate story about the meaning of the old-woman picture, do. You'll be on fertile ground.

There is something painful, in the second room, about the big Philip IV portraits and even the terrific *Forge of Vulcan*, because Velázquez was laboring to prove himself as a reliable propagandist, in the first case, and up to speed with Italian Baroque fashion, in the second. High status seems to have motivated him. He all but quit painting in his later, best years for the more prestigious jobs of court decorator, art adviser, and household manager.

The show's first clean hit is *Prince Baltasar Carlos with a Dwarf*: the sixteen-month-old royal posed in elaborate military garb (poor kid) while a little person shuffles past with a rattle and an apple (parody of scepter and orb). Taking sides in an art historians' debate, I believe that this is a picture within a picture. The dwarf is painted in front of a painting of the regal tot. The textures are an express elevator to heaven.

Moving along, zero in on the small, snapshot-modern *Riding School*, which narrates the dynastic hopes, power relations (centering on the unsavory Count-Duke Olivares), manners, and mores of Philip IV's reign as they pertained one crisp, cool morning. This is more than an artwork. It's a world. And note also the easily missed small, unfinished *Needlewoman*, a poem about work: she is caught in skilled action so fast that that the position of her fingers had to be intuited rather than seen.

The two perfect works in the show are the Met's own *Juan de Pareja* and the portrait of the dwarf Francisco Lezcano. The slackly arrogant Lezcano is often described as "witless," but ask yourself: what if he's intelligent? If the answer is affirmative, he is the most dangerous little bugger you ever saw.

In the last room, with things from the period of *Las Meninas*, there is supreme artistry—brushwork in dizzying interplay with color—but no supreme art. The Met's poster child *Infanta Margarita* is gorgeous (salmon-pink dress, blue-green drapes) but feels like a rush job. In *Las Meninas*, the same little girl tosses out a gaze that knocks two eye-shaped holes in your heart.

Velázquez's theatricality includes you in its dynamic. The space is essentially cylindrical, swooping around behind figures and out into your space. Time lives in it, as everything *turns*. Often, when the eyes of a subject meet yours, they will just have done so: *click*. A half dozen sets of eyes do this in *Las Meninas*, which, when I first saw it after a sleepless night flight from New York, caused me to hallucinate that the characters were alive in the room with me.

As with hallucinations, you know that what you see in a great Velázquez isn't real, because it is *too* real, steadier in appearance than anything is in life. He knew how to keep his distance, did the courtly Velázquez, and the keeping of distance is strict in his official portraits. But when it was OK to home in, the door to any soul would spring open at his touch.

Little is known of his personal life. He did well in court for his family, nepotistically. He fathered an illegitimate child in Rome while living there, in middle age, for nearly three years on an art-collecting mission, fending off the king's demands that he come home. He performed in women's clothes in a court burlesque. Besides the knee-bucklingly sensual *Rokeby Venus*, done for a patron who was a notorious libertine, he painted at least three other female nudes, now lost.

He got away with the feat, rare in Spain, of doing very little religious art—unlike his exact contemporary and fellow Sevillian, Zurbarán.

(Imagine being as great as Zurbarán and knowing you'll always be the second-best painter in the country.) Why do the masteries in the huge *Saint Anthony Abbott and Saint Paul the Hermit* (1635) add up to less than the sum of their parts? I think Velázquez did the picture sullenly, not because he was irreligious but because he was bound to begrudge realities that insisted on being invisible.

Nearly naked, crestfallen *Mars* is a glorious hoot. It pictures the god as a shamed adulterer, having been caught in flagrante with Venus by Vulcan. Be alert in all Velazquez's art for a strain of down and dirty, slightly cruel, also strangely redemptive comedy, in a line that stretches through him from Cervantes to Goya. Velázquez as archetypal Spaniard: you can count on his humanity, but if you presume on his sympathy, you are asking for anguish.

We can use Velázquez for remembering how to love life: directly, with an attentiveness and a responsiveness that drive thoughts of "love" and "life" out of our heads and consume us like a clear flame. How to make inanimate matter, such as paint, dance attendance—as if the flame painted the pictures—is a secret probably lost forever, but we won't be wrong in taking it as a compliment. One of us did that.

7 Days, October 18, 1989

COURBET

The Courbet show at the Brooklyn Museum is right on time for us, but when wouldn't it be? We are always in the mood, whether we know it or not, for a brash, authentic arriver who is wild for our approval and, cheerfully absorbing abuse, keeps on coming. Gustave Courbet was like that in mid-nineteenth-century Paris, a swaggering fanatic importuning the public with paintings that Edgar Degas said made him feel he was being nuzzled by the wet nose of a calf. Courbet is the same today in Brooklyn, which is a good place for him. He is to great art what a "dese, dem, and dose" accent once was to American speech. In Brooklyn, as in all else, he is off-center in a way that makes the center feel feeble.

The show is a neatly crafted container for Courbet's big, sloppy talent, unfortunately lacking the Musee d'Orsay's *A Burial at Ornans* and *The Painter's Studio*—two stupefying masterpieces that, by failing to terminate art history, proved that no one work can do that. The show is racy, giving pride of place to Courbet's erotic or, well, pornographic—or, not to put too fine a point on it, *filthy*—pictures *The Origin of the World* and *The Sleepers*.

Courbet was one of those blustering self-revealers who maintain a childlike immunity to self-consciousness. It seems a shame that he never met his exact contemporary Walt Whitman (they were born eleven days apart, in 1819), who was like that, too, with an ego as roomy as a continent. The half dozen most robust people of today, standing on one another's shoulders, wouldn't reach the kneecaps of those two.

Courbet billed himself a "realist," promulgating the first and still most elusive of the "isms" that have jazzed and befuddled modern culture. I went to the show with questions about what that meant and might still mean. I got that it was, and is, an anti-artistic reflex, asserting the superior claims on us of actual life. Courbet painted in ways that inculcate a restless disgust with the merely aesthetic. You want to run out and start a riot, milk a cow, have sex, eat an apple, die—anything but stand around abrading your nerves with the angel-grit of "fine" art.

Technically and formally, Courbet trashed conventional ideals of finish and finesse. Some of his pet stylistic tricks, such as making fast smudges with a palette knife to render highlights and shadings of "sea" and "rock," predict nothing so much as the stuff of stores that advertise "1,001 Original Oil Paintings, Half Price." At other times, Courbet's tropes are so bizarre that you have no idea what you're supposed to be experiencing even as they swarm you.

Maybe because some of their colors have gone bitumen-dark with age, nearly all of Courbet's landscapes—about two-thirds of his total production—dishearten. To succeed, his paintings have to be like reminders of something you knew already, such as what makes people interesting. Most of his portraits are fantastic, in exactly the way other people are when you're infatuated with them. And his sexy stuff—the early, fully clothed *Young Ladies on the Banks of the Seine* somehow quite as much as the later, lascivious nudes—might make your knees buckle, recalling your desires.

Courbet made few drawings, going straight to work with paint. This was his sharpest break with a drawing-based norm of painting that Ingres had taken as far as it could go. It wasn't a clean break. Nothing about Courbet was clean. (He wasn't the kind of man who takes a lot of baths, for one thing.) He could fake up a reasonable facsimile of figure-study modeling right off the palette. But there's no delectation in that. He treated tradition like a powdered aristocrat on the day after a revolution, handing it a shovel and telling it to start digging a grave.

Courbet's intractable matter-of-factness excites. We can use that now. Our culture today is suffocating under heaped technologies of fiction. To speak of truth is to arch people's eyebrows. Courbet suggests that the trick to being true is no trick. Just do it.

Charles Baudelaire, who is my hero, evidently disliked the portrait Courbet painted of him, and I think I see why. It's like a caricature of genius. The poet is perched uncomfortably on the edge of a seat, supporting himself with a clawlike hand as he reads a book with an intensity that could burn holes in it. I love the picture, and I believe it. It doesn't even try to empathize with Baudelaire, whose loneliness must

have throbbed painfully when he saw it. It just revels in this man's eerie energy, as you might in a thunderstorm or a sunset.

Sex is the key to Courbet. Like Whitman, who celebrated what he called "adhesiveness" in all things, Courbet kept the business of life simple: possess what possesses you. When he painted *The Origin of the World*, for which the up-to-date term is the name of a clever animal that builds dams in forest streams, he made a philosopher's stone to transmute the lead of lust into the gold of awe—and vice versa, in a continual flicker. It is indefensible as art. Somebody should have punched him in the face for it, as the only conceivably apt response.

Courbet's public triumphs may have made him creatively lazy, but they hardly mellowed him. He became an actual revolutionary in 1871, as arts commissioner of the Commune. He was associated with the toppling of the Napoleon Column in the Place Vendome. The restored government, faced with the problem of how to punish a genius of France, opted to bill him for putting it back up. Escaping the debt in Switzerland, he seems to have drunk himself to death. It was a Falstaffian end that befitted him. Now he's in Brooklyn, inviting the public. He has things there that he knows you are going to like.

7 Days, December 21, 1988

JACKSON POLLOCK

The Museum of Modern Art is showing nearly all of what it owns by Jackson Pollock—some sixty works, most of them rarely seen prints and drawings, that date from 1934 to 1954—in its second-floor graphics galleries. Why? That is, besides: Why not? It's a boon. Pollock's lifelong intensity and, at his peak, sublimity do not pale. The trajectory of his too-brief career retains a drama, as evergreen as a folktale, of volcanic ambition and personal torment attaining a liftoff, with the drip technique, that knitted a man's chaotic personality and revolutionized not only painting but the general course of art ever after. (It can be argued, and has been, that the matter-of-factness of Pollock's flung paint germinated minimalism.) There's even, for anyone susceptible to it, a nationalist sweetness: Pollock's peak period as the V-E Day of American art.

MoMA may be dangling bait to philanthropic collectors, in the form of the lacunae in its holdings. True, no other museum has more Pollocks. And none other boasts perhaps his single most satisfying work, the songful *One: Number 31, 1950*, more than seventeen feet wide: interwoven high-speed skeins in black, white, dove-gray, teal, and fawn-brown oil and enamel bang on the surface while evoking cosmic distances. (The Metropolitan's *Autumn Rhythm* and, at the National Gallery, in Washington, *Lavender Mist*, both also from 1950, are its chief rivals.) MoMA also has the transitional touchstone *The She-Wolf* (1943)—a picture ferociously conflicted between Jungian voodoo and exasperated originality—and a rough gem from the artist's blocked, sad last years, *White Light* (1954). But the museum's only other big drip painting is the audacious but awkward early *Number 1A, 1948* (the one with handprints across the top). MoMA has lasting cause to rue the slowness with which, at the opportune time, it picked up on Pollock and other Abstract Expressionists.

Pollock was eighteen when he arrived in New York from California, in 1930, and began to imbibe the influences of Thomas Hart Benton, who was his teacher at the Art Students League, and the Mexican muralists. The early works in the show are a thrill ride of quick studies,

as Pollock devours those models and then suggestions from Picasso, Miró, and André Masson—paying off in lyrically inventive engravings, from the early forties, that are a revelation here. Pollock was always Pollock, though he was long in agonizing doubt, notably about his ability to draw. Dripping brought a rush of relief, as he found a steadying and dispassionate, heaven-sent collaborator: gravity. Drawing in the air above the canvas freed him from, among other things, himself. *Number 31* is the feat of a fantastic talent no longer striving for expression but put to work and monitored. He watched what it did. We join him in watching. Pollock redefined painting to make it accept the gifts that he had been desperate to give.

New Yorker online, December 21/28, 2015

JEAN-MICHEL BASQUIAT

"What else could he have done?" So quipped someone to a friend of mine apropos Jean-Michel Basquiat's death, on August 12, of a heroin overdose, at the age of twenty-seven. The repulsive suggestion that Basquiat died as a career move belongs to the genre of cynical wise-cracks that are passed around after any public tragedy to prove that we're shockproof. As well as slimy in the way of such pleasantries, the remark is exceptionally cruel as a parting shot at an artist who was often scorned, among the stuffy or envious or otherwise mean-spirited, as an upstart beneficiary of hype. It pleases such people to believe that Basquiat, who rocketed to fame in the Neo-Expressionist early eighties, had worn out his vogue. His style was passé. With the death last year of his mentor Andy Warhol, he was adrift.

In point of fact, Basquiat could have done what he was doing. Though not his best work, his recent pictures maintain crackling edgi-ness and authenticity. Across expanses of bare or colored ground, they deploy his familiar but always fresh stick figures, funny-savage mask faces, and block-lettered prose poetry. The work is kinesthetic, as engag-ing to our sense of bodily motion as good dance.

Basquiat may be a martyr to nothing except the Russian roulette of a dope habit. But there's no denying that his reputation, which will ultimately rest (securely, I believe) on the quality and significance of his art, underwent weird inflations and deflations. The art world enabled his rise. For a while, he helped define it. Then much of it turned on him.

I met Basquiat in March 1981 at the opening of a strenuously hip P.S. 1 show of scene-making artists and photographers: *New York/New Wave*. His work was the hit of the occasion. At that stage, it was still a fairly direct transfer onto portable surfaces of the gnomic markings that he had strewn downtown as the leader of a two-man graffiti team, Samo. The spiky cartoons and stuttering nonsense writing were elec-tric. At first glance, they seemed to clinch a myth of demotic, up-from-the-streets energy on the burgeoning (now defunct) Lower East Side scene, to which Basquiat never really belonged.

The notion that this dreadlocked Haitian-American was an untu-tored wild child didn't square for me with an elegantly elliptical man-ner distinct from the *horror vacui* of the subway graffitists. His stuff looked highly sophisticated. I mentioned Dubuffet to him. "Who?" he said, coolly. (I got that we weren't going to be friends.) He was an upper-middle-class kid from Brooklyn who knew a lot about art from his schooling and from museum-going with his cultured mother. But he played along with a mythologizing bent of the moment, when people were eager to see a whole truth in the half-truth of a democratizing trend in art. (That seems a long time ago, now.)

There followed Basquiat's legendary months of working in the basement of the Annina Nosei Gallery; social shepherding and career advice by Henry Geldzahler; entrance into a ravenous European mar-ket through the Swiss dealer Bruno Bischofberger; erratic behavior that included a reported readiness, graying the hair of his dealers, to swap work from his studio for whatever cash or drugs he wanted on a given day; a tempestuous stint with the Mary Boone Gallery; and the temporarily sustaining father-son, or at least uncle-nephew, relationship with Warhol.

The eclipse of Neo-Expressionism by geometric modes around 1986 deprived Basquiat's warm, jazzy manner of chic but hardly invali-dated it. He was a leader, not an epigone, of Neo-Expressionism, with an aesthetic rooted in New York big-painting tradition and with imagery drawn from heartfelt anthropological and urban-pop veins. Nor was he a retailer of faddish angst. To the end, his graphic ferocity—typically with oil sticks, using brushes mainly for erasure and filling in—was tensile and plangent. He was a real artist, living to work rather than to support a lifestyle.

The lifestyle was quite something, though. In 1985, I was asked to do an article on him for *Vogue*. (The magazine anticipated a hatchet job, as I learned when my finished piece was killed for being "too positive," an editor told me.) I visited the artist in the converted carriage house that he rented from Warhol on Great Jones Street. The dimly lighted place was a sort of busy womb, with a steady traffic of assistants and

hangers-on, an attentive girlfriend, phones ringing incessantly, and a table piled with Mediterranean delicacies and bottles of costly Bordeaux.

Basquiat looked like a soft young African prince. "It was getting worse, but now it's getting better," he said of his work. He spoke nostalgically of his earliest days of making art. He seemed to worry that what he called a "messy and earthy" feeling had receded. He was plainly in for a rough time, which he might have come through had he kicked drugs. His subject had been passions and humor of insurgent youth in a chaotic metropolis. He was inevitably leaving that behind, even as its distillations adorned walls of rich, white, perhaps in every sense patronizing collectors from Düsseldorf to Tokyo. His later work emphasized African references, to the possible end of deepening his identity as a black artist.

"What else could he have done?" Plenty. But the true question bears on what he did do, which the art world took up and then let drop, both carelessly.

7 Days, September 21, 1988

ANSELM KIEFER AT MoMA

For the rest of this year, the Anselm Kiefer show will be a city within the city of New York. It will attract tourists and pilgrims to its combination theme park and necropolis, its opera houses, temples, libraries, and plazas where the living stroll with the dead. It is beautiful and clever, as a city should be. You will feel welcomed there, though your intelligence may sweat from the credit being given it.

The landmarks are not visible things but tones, ways of thinking and feeling: some tender, some disquieting. (Any proper city has dangerous neighborhoods.) The images are largely rural or fanciful. Farm country and architectural ruins, crusted with paint, straw, and nameless crud, predominate. But there are watercolors of a frozen North and dim photographs of odd objects: a coffin-shaped bathtub, a toy tank. Many pictures bear written words.

This is the last stop for the Kiefer survey, which started in Chicago last winter and has toured to Philadelphia and Los Angeles. I've seen all four installations. (I've had a six-year mini-career of writing and lecturing about him.) This one is not as theatrical as the others. It reflects an old MoMA preference for seeing artworks in contemplative isolation. The hanging obliges viewers to provide their own rhythms to the show's unfolding. But that's citylike, too. It should scotch a misconception that Kiefer is some sort of brutal Expressionist rather than, as he is, a discursive poet, ruminative scholar, and cottage craftsman. He is also a thematic daredevil who has addressed subjects that some people, especially in his homeland, would rather ignore.

Kiefer, who is forty-three years old and lives reclusively with his family in the Oden Forest south of Frankfurt, commenced in the early seventies to raid warehouses of German culture quarantined for taints of the Third Reich. He resuscitated nineteeth-century Romanticism and nationalism, Wagner, the Holocaust, Albert Speer—memories big and small—in a pageant of doom. Amid ruins, he reared the fragile symbol of a palette, an emblem of the artist as a survivor determined to forget nothing.

There is much irony and some outright humor in Kiefer's art, but you wouldn't know it from public responses that yaw between weepy reverence and indignant denunciation. The errors spring from gut reactions to his visual rhetoric: unearthly light seeping through clotted matter. People feel invited to abandon themselves to pathos, ignoring evidence that Kiefer intends to cut historical passions down to manageable human scale.

The feeling, like the look, of all Kiefer's work is chiaroscuro: light and darkness, disembodied spirit and gross material. The polarity generates streams of inspirations like an intellectual Roman candle. The placement, in the painting *Shulamite*, of a menorah in a Nazi war-hero monument could make you cry. It efficiently plumbs depths of horror, rage, and sorrow that are untouched by the death-camp photographs that lesser artists have exploitatively recycled lately.

It's only art. Remember that. I know people who take vocal pride in remaining unmoved by Kiefer's work, as if this evinced integrity. The fact is that communion with Kiefer comes only with willingness to be as respectful of his sincerity as he is of yours. Otherwise the work is just brown decor.

Kiefer's aesthetics—syntheses of Jackson Pollock, Joseph Beuys, conceptual and process art, photography, woodcut, collage and montage and assemblage—call for no special analysis. His technique is right to the point in communicating states of mind. The point may be erudite—Kiefer is bookish—but, given a little background information, it isn't impenetrable.

The drama of Kiefer's art is that of a mind struggling to know itself. The project has an old, Enlightenment cast, like the essays of Montaigne. It bespeaks a faith in humane intelligence that is exotic in these times, when few people dare to express anything without communal permission. Kiefer can disturb, as when he confronts, in personas of Hitler or Nero, the megalomania that lurks in every ambitious ego. But this guarantees his honesty.

The putative "greatness" of Kiefer is worried over by many, including myself in the past, but I now see it as a distraction. His work may

be best viewed as an antidote to delusions of grandeur, offering a home-made world where the worst terrors and giddiest exaltations wait upon attention like a book on a bedside table. Finally, it is lovely to look at, and getting lovelier. Kiefer seems bent on discovering just how virtuosic a painter he can be. I stress his art's ethical current only because it moves me so deeply. Be a little brave, he seems to say. It may not make you happy or good, but you'll breathe free.

Village Voice, November 2, 1988

OTTO DIX

To truly appreciate Otto Dix (1891–1969), the most shocking major artist, against stiff competition, of Weimar Germany, it may help to loathe him a little. That worked for me at the Neue Galerie's explosive show, the first American retrospective of Dix, of an artist who is cherished in Germany. (Late in life, he traveled freely, to accolades, in both halves of the Cold War–riven nation.) "Dix comes along like a natural disaster," a Dresden critic wrote, in 1926, of the artist, a veteran of the First World War who funneled his intimacy with horror into paintings and prints that lace Old Master technique with Dadaist nihilism. In the past, I've ducked into a psychic storm cellar when assailed by his distressingly avid images of war, *Lustmord* (sex murder), and all-around depravity. Compared with his universe of derision and disgust, *Cabaret* is a kohl-smudged *Sesame Street*. But finally letting Dix get to me pays off in aesthetic and moral fascination. I recommend an approach of cordial enmity. By disliking Dix, you may balance a sense that he dislikes you first, along with just about everybody except, maybe, himself.

Most artists who address social ills either protest them, as did Dix's contemporary George Grosz, or evince personal anguish, as did, years later, Francis Bacon. Not Dix. "Don't bother me with your idiotic politics," he told the Dresden Secession artists' group, in 1920. "I'd rather go to the whorehouse." An American-styled dandy with slicked-back hair, whose night-life sobriquet was Jimmy, Dix danced the Charleston amid cascading chaos in nineteen-twenties Düsseldorf and Berlin. The retrospective centers on the blazingly amoral *Portrait of the Dancer Anita Berber* (1925)—"without a doubt *the* icon of the Weimar Republic," according to Olaf Peters, the show's superb curator. Looking more than twice her age of twenty-six, the slinky erotic dancer, prostitute, and notorious bisexual preens in a skintight scarlet dress against a blood-red ground—a one-woman general-alarm fire. She died, of tuberculosis, three years later. The picture was reproduced on a German postage stamp in 1991.

Dix was born near Gera in 1891, to an ironworker and a seam-
stress with artistic inclinations. After apprenticing to a housepainter, he
became an independent professional by the age of sixteen. Inspired by
a painter cousin, he studied art in Dresden, where he was enthused by
reading Nietzsche (whom he portrayed in an energetic sculpture) and
by discovering Renaissance masters and avant-garde crazes of the time,
notably futurism. He enlisted in the army when the war began, writing
later, "The war was a horrible thing, though it was something powerful
all the same. I certainly didn't want to miss it." Dix headed a machine-
gun squad from 1915 until the Armistice, despite being wounded sev-
eral times, and in 1916 he fought in the unimaginable abattoir of the
Somme, which left more than a million wounded or dead. He appalled
a friend, Peters writes, with a "detailed description of the pleasurable
sensation to be had when bayoneting an enemy to death."

His career was launched with visions of the carnage. A room at the
Neue Galerie is a catacomb of grotesquerie, presenting watercolors of a
man with nearly half his face gouged out and of operating-room debris
(discarded organs, including a brain) and a series of fifty etchings, *The
War* (published in 1924), which is like nothing else in art since Goya's
Disasters of War. Quick with intimations of sounds and smells, they
feature fields of shell craters, heaped corpses, a mustached skull swarm-
ing with worms, and an insanely grinning woman with a maimed,
dead baby. Unlike Goya's harrowing humor, Dix's emotional stance is
neither detached nor compassionate. The question of whether the work
qualifies as antiwar seems debatable, given that its rage is blended with
relish, though no doubts fazed the Nazi regime when it drove Dix into
internal exile, in 1933, after finding that his pictures were "likely to
detract from the will of the German people to defend itself." Ambitious
to stun the world, Dix had at hand a wealth of witnessed atrocity, and
he flung it like a bomb.

In photographs and self-portraits, the young Dix has a quality of
oddly superfluous conventional handsomeness, like that of the pre-
Sergio Leone Clint Eastwood. He had no use for beauty; he called a

house on Lake Constance, in the Alps—now a museum—where he lived after 1936, "so beautiful that you have to vomit." His colors run to stimulating awfulness. He liked fattening or emaciating even subjects who had commissioned their portraits. (It took guts to sit for Dix.) Most of the women in his work are either victims or monsters, though they are perhaps granted winks of complicity in the resilient glee with which he beheld them. Hard to take, though, are Dix's lyrical imaginings of women ripped open by psychopaths. In a big, lost painting of 1920, he pictured himself, blood-spattered in a natty suit, gaily strewing female body parts around his studio. *Lustmord* was a theme rife in popular culture then (as it is today, come to think of it), exploited by artists (Grosz, Kurt Schwitters, Hans Bellmer) and writers (Alfred Döblin, Robert Musil) to outrage a bourgeoisie whose predilections Dix termed "puke—kitsch—noise—shit."

But was he a misogynist? Oh, yeah. He refused to emigrate to America because he was wary of "the revolution of daughters" that, in his view, pertained here. In 1921, he lured away Martha Koch, the wife of a doctor who was a portrait subject and a friend; they married in 1923 and had three children. (The doctor then wedded Martha's sister and remained lifelong friends with Dix.) A self-portrait *en famille*, *Artist's Family*, from 1927, finds Dix displaying bad teeth in a ferocious rictus, as he contemplates a distinctly unappealing baby son on Martha's lap. A winsome little girl appears, too. That's Nelly, whose likeness recurred, when she was eighteen, in a painting by her father on the theme of Death and the Maiden.

Dix claimed to have invented the definitive Weimar art movement, Neue Sachlichkeit (the term, coined by a *Kunsthalle* director, in 1923, is usually translated as New Objectivity but has connotations of sobriety and banality). It rejected the sincerity of Expressionism for a harsh focus on external realities; it didn't eschew emotion, but it trashed empathy. Certainly, Dix tops the Neue Sachlichkeit field, which includes the antic Grosz and the icily obscene Christian Schad. Dix gained his edge with a fluent mastery of varied styles, from steely realism to poetic (though hardly dreamy) fantasy. His great 1926 portrait of Dr. Mayer-Hermann,

with an archaic method of oil glaze over tempera on wood, is Neue Sachlichkeit for the ages. Dix had a thing for doctors, such as Heinrich Stadelmann, the fashionable psychiatrist who stares from a canvas of 1920 with demented eyes worthy of a midnight-movie maniac.

Dix could be formally inventive: witness *Memory of the Halls of Mirrors in Brussels*, a startlingly gorgeous, Cubism-inflected painting, from 1920, of a jolly, red-faced officer disporting with a prostitute, in which parts of the image are reflected in mirrors. With primitivist touches, it suggests a dirty-minded Chagall. But Dix would readily uglify any image rather than let it escape his pugnacious temperament into merely aesthetic avenues. A general exception sets in, sadly, with sugary landscapes from the nineteen-thirties. Dix painted them in order to scratch out a living while he was denied a public career under the Nazis, who paraded his work in the scurrilous "Degenerate Art" exhibition of 1937. Peters detects esoteric protest in certain paintings of Christian allegory, including a kitschy *Saint Christopher IV* (1939): the brawny saint labors across a mountain river with a tyrannically posturing baby Jesus on his shoulder.

Dix lay low through the Second World War. Dragooned into the last-ditch Volkssturm militia, in 1945, he surrendered to French troops and spent nearly a year in a prison camp, where he painted portraits of his captors. His reputation dimmed during the postwar vogue of abstract painting, but it resurged in the sixties, when young Germans began to identify with art that Nazism had sought to obliterate—a recuperation that helped to fuel the German preeminence in painting of the past forty years.

<div align="right">

New Yorker, March 22, 2010

</div>

PICASSO AND THE WEEPING WOMEN

Did Pablo Picasso exist? It gets harder to believe. Think of him wielding pencil and pecker, astride a century. He rewired the world's optic nerves and imagination. He clambered through life on a jungle-gym of female flesh. "I'm God! I'm God!" he crowed occasionally to his umpteenth girlfriend Dora Maar in the late thirties. He was then still four decades short of receiving the universe's riposte. It must have killed him to die.

We no longer know what to do with Picasso now that ultravirility has become a nonvalue. The schoolyard envy of ordinary men for the priapic Spaniard used to be constant in writings about him. It isn't entirely gone, persisting, as it does, in vocational sheet-sniffing. MoMA's William S. Rubin, in effect our Master of Mistressology, has triumphantly opined that a famous 1923 painting, *Woman in White*, depicts not first wife Olga Koklova, as was supposed, but American glamour-puss socialite Sara Murphy, a previously undetected Pablo playmate. Another William S., the Met's Lieberman, stubbornly deems it an Olga. Having carefully weighed the evidence, I don't care.

Pabloid revelations keep coming, but their tone shifts from awed to forensic. "Picasso scholarship is still essentially in its infancy," this show's curator, Judi Freeman, says ominously in the catalogue. Build a new wing on the library already groaning with Picasso tomes. Build a new library. Curtain off an Adults Only section. Freeman tells us that, in 1928, Picasso "initiated" his teenage love-toy Marie-Therese Walter "into his preferred sadomasochistic sexual practices." That's all. No details. But you can bet that someone is indexing the behaviors as we breathe.

At the Metropolitan Museum, *Picasso and the Weeping Women: The Years of Marie-Therese Walter and Dora Maar*—images from the late thirties of women going to oddly shaped pieces with grief and terror—is great. It covers a period of grueling brilliance, when Picasso kept junking and reassembling the female physiognomy like God the Creator with a hiccup. The upbeat is formal invention; the downbeat is moral awfulness. As usual with Picasso, the emotion of the work

matters little—far less than it should—compared to the mere fact that it motivated him.

Picasso was simple in the ways that counted. People make the mistake of supposing that genius is complicated. It is the opposite. We regular folk are complicated—tied in knots of ambivalence and befogged with uncertainties. Genius has the economy of a machine with a minimum of moving parts. Everything about Picasso came to bear when he drew a line. He was a line-drawing critter.

While commanding fantastic technique and formal acumen, he would make these silly little decisions, such as that an eye could be a chimney-thing in a tiny boat spilling tears, and then put them over with the full force of his talent. Observing his decisions image-to-image at the Met, and within each image, I experienced my familiar mode of Picasso-response: gasping like a beached fish. It's sort of horrifying how good he was, as well as how horrible.

Judi Freeman approaches the Weeping Women on two fronts. She relates the work in one way to the artist's rambunctious love life, juggling Walter and Maar as Koklova fumed, and in another to political events of the day, which makes sense given that Picasso's labors on *Guernica*, in May and June of 1937, kicked off the main Weeping Women series. But both connections are incidental to how I experience the pictures.

Sure, Picasso was roiled by his women and enraged by the rape of Spain. But to say that he "expressed" those feelings is too much. He never expressed anything except ironically or sentimentally. He was too self-centered. He sometimes put coded clues to his feelings in his work, which explains his appeal to the detective instincts of scholars. But the emotional impact of the hints—faces of seemingly erectile tissue indicating Walter, ravaged horses for Spain—is just about nil. Picasso was no more expressive than your average cartoonist.

He was repressive, really. Painting, he said in what has passed for a political manifesto, is "an offensive and defensive weapon against the enemy." But I believe that, for Picasso, "the enemy" was only the not-Picasso: everyone and everything in the world that presumed to be

taken seriously on its own terms. His art maneuvers against that threat. What he couldn't ignore—or needn't, if it could be fucked, eaten, or otherwise delectated—he Picassoized. He served the political left by letting them think that his heart was with them. In truth, his heart was a stone.

But look at what he could do with a line and some color, as in the supreme *Weeping Woman*, of 1937, from the Tate Gallery. It is a splayed jigsaw of cubistic planes and surrealistic curves in bright primaries plus green, purple, and a deathly white. It describes a woman covering her lower face with a handkerchief and simultaneously crumpling and biting on it, her mouth full of grinding teeth showing through. She wears a jaunty hat, as if ambushed by tragedy at a party. Each detail, such as a racy blue flower on the hat, delivers a singular emphasis. Scanning the details is like being knocked down and getting back up to be knocked down again.

I believe that Picasso was fundamentally anti-modern. His art is one long combat of a primitive ego against the impersonal powers and teeming othernesses of modernity. He seized on the very quiddity of the new—alienating, uncanny—to subdue it. While inventing and mastering no end of wonderments, he refused to yield prerogative—a right to exist, even, except with his permission—to anything or anyone. Was he heroic? Ask Dora Maar, an intelligent woman who had to witness her own nervous breakdown mirrored in a sequence of vicious Picassos.

To come to terms with him is not possible.

Village Voice, July 20, 1994

HENRI DE TOULOUSE-LAUTREC

At a dinner party recently, a nice young political consultant rhapsodized to me about the portent of the millennium, in which he foresaw the dawn of, yes, a New Age. I wasn't having it. I remarked that scholars now date the birth of Jesus to about 6 B.C., so the millennium passed already. Round numbers mean nothing, anyway, except when, as just happened to me, your Detroit clunker's odometer rotates majestically from 99999.9 to all zeroes: prophecy of mounting repair bills.

I might have added that the mark of any era's promise is the previous one's farewell party. A tangy show of all of the Met's Henri de Toulouse-Lautrec holdings, mainly rarely seen prints and drawings, makes me think of this. The eighteen-nineties in Paris were a wingding compared to which our nineties are a month at your grandmother's. Given our non-head of steam, what might we expect from the two-thousands besides a culture of agoraphobes with modems?

I left the show with smells of makeup, sweat, and alcohol in my mind's nostrils and a conviction that Toulouse-Lautrec is now the most living of fin de siècle Frenchmen. (Édouard Manet is still more vital, but he died in 1883.) Set aside Monet, Cézanne, and even Degas: museum stuffing, auction goods. The little dipso aristocrat embedded art in an imperishable present tense like no one else until Andy Warhol. (A later avatar is Nan Goldin.)

The show's contemporary edge, if only in emphasizing fun and folly that we lack, may affect you strangely, if its impact on Hilton Kramer signifies. The reliably grumpy critic was moved to a breakthrough for conservative rectitude, sharing in a recent *Observer* that Toulouse-Lautrec's pictures traffic in "the seamier side of life," "illicit pleasures," and "dispiriting grotesques sporting the scars of experience." You might think that being very long dead would cut those folks some slack, but for a dedicated moralist it may never be too late to disapprove of somebody.

It's true enough that the Toulouse-Lautrecs in the show stir moral imagination. They intoxicate. How you respond depends on your

temperament when drunk. No other artist is less detached. Toulouse-Lautrec's feelings swarm his subjects. Except in the great posters, where professionalism dictated elegance, perhaps only the emergency brakes of fear and loathing save his psychic balance. His intermittent bitterness gives a satirical cast to his work, but never—not even once—at the total expense of affection. Toulouse-Lautrec's mockery couldn't bite as it does if not touched by love. This is especially so in his work about women. Kramer adduces "pitiless misogyny." (So a good man pities women?) That's wrong.

Toulouse-Lautrec vivifies a society that viewed women in public as properties to which men of wealth had rights. The artist hardly regretted his own privilege in this regard, while exercising it with attentive and funny gallantry and despising sexual presumption. (Perhaps his only really savage images skewer a lecherous Englishman chatting up the bar girls.) But Toulouse-Lautrec's emotional investment in women follows a pattern of other heterosexual male artists sometimes simplistically termed misogynous: Ingres, Manet supremely, Degas, Duchamp. I mean vertiginous intimacy betraying a wish to *be* a woman, perhaps complicated by reactions against the wish.

When Toulouse-Lautrec's images of women are negative, it is with anything but masculine disdain. The feeling is more like the competitive malice that one woman may feel toward another or the harsh criticism that a woman may direct at herself. (I am counseled on these points by women in my life.) The evidence at the Met includes a stunning suite of sixteen lithographs from Toulouse-Lautrec's more than fifty pictures of the café diva Yvette Guilbert: tiny acrid eyes, bayonet nose, wire-thin smile, and startlingly long limbs, all usually raked from below by footlights.

Guilbert hated what Toulouse-Lautrec made of her aside from more famous, which moved her to forbearance. A photograph at the Met shows why. Her improbable features harmonized rather prettily. Toulouse-Lautrec scuttled the harmony. Have you ever desperately focused on unattractive qualities of someone you feared falling in love with? The Guilbert images are like that, from a smitten man.

Toulouse-Lautrec's imposition of sacred monstrousness on the singer generates a poetry of both yearning and vengeance, immersed masochistically and sadistically in utter Guilbertness.

Toulouse-Lautrec's exposure of the full light-to-dark spectrum of his feelings is a magic carpet to the thick and very noise of his milieu, drenching the mind with immediacy. The milieu is theatrical—vain and false, though preening on intelligible principles and sincerely insincere. Quiet moments bring temporary balm. How happy—potent and tender, dignified as a man—Toulouse-Lautrec must have felt on the occasion of the wonderful poster of his pal Jane Avril, dressed to the nines, inspecting a printed sheet in his favorite lithography workshop. Life had to seem good that day.

Toulouse-Lautrec is a classic type of the alcoholic artist. Drunks (also addicts) don't grow and change much, because they lack traction in everyday reality. Their creative level is a luck of the draw: the character and work habits that their upbringing and education dealt them. Toulouse-Lautrec is all there in his juvenile works: avidity, humor, love of craft, and a passion for showing off. He played himself out in a rush, with help from his friends, and crashed well before his death, at age thirty-six, in 1901.

Toulouse-Lautrec had superb codependents, we might say: a brilliant, cruel subculture. Did people behave badly? Oh, my. But they behaved in concert. The demimonde really was a *monde*, with customs and protocols. Any peculiarity of a participant might count for something. Toulouse-Lautrec's high birth gave him cachet in the dives, and his wit and physical oddity won him a jester's license. He didn't so much render the Belle Époque as become the finest instrument with which it immortalized itself. That was fortunate, because to his own self he was disastrous.

Village Voice, August 27, 1996

JANE DICKSON / KAREN FINLEY

Early one morning in Washington, D.C., last week, I couldn't sleep and so went walking. Traversing the Mall in stagnant air that presaged a stifling day, I considered visiting Abe Lincoln's statue, but there looked to be about a hundred more steps to it than I remembered. I slouched into the Vietnam Memorial. Already another light sleeper, a woman, was taking a grease-pencil rubbing of a name. The memorial did not move me, for once. It felt inoperative, as if unplugged. I reflected that public art looks futile without its power source: a crowd. The better, more sensitive the work, the more embarrassed it seems when deserted. You're not supposed to be alone with it.

Everyone needs love. So does each thing that is made for other than expedient reasons. Each such thing implies the thought, "They're gonna love this!" When nobody does, it's mortifying. I had a moment of seeing as unloved even the profound Vietnam Memorial, where the touching sight of the grease-pencil woman palled as she industriously piled up one rubbing after another. There may be a market in them.

Lack of love is a present plague. It rages in the art world. This past season of shows was like an orphanage of the emotionally starved, some noisily acting out while most suffered quietly in corners. Many shows were likable—a grave condition. Merely to like an artwork is to acquire an awkward affection, as for a cute, not very bright cousin who is new in town and needs a place to stay. Likable art is more trouble than it is worth. I may have thought of all this in Washington because, the day before, I had seen a show at Times Square.

On Forty-Second Street between Seventh and Eighth Avenues there are installations by over two dozen artists, sponsored by the 42nd Street Development Corporation and Creative Time, Inc. The artists are crows to urban carrion. Like leaking roofs, art in otherwise idle buildings means that the buildings are doomed. The present deathwatch ensemble is a long way from a federal monument dedicated to remembrance. But in New York it may make sense to have

our commemorations, like everything else, on the fly. The works are mostly lame, as shocking as this judgment may be to all you lovers of recent public art out there. But a couple of installations, by Jane Dickson and Karen Finley, really do address things that are both specific to the place and universally meaningful: dreams of whores and keenings of the ravaged.

"They're gonna love this" is not a thought associable with that perhaps over-famous block, whose edge on the world's innumerable similar strips may be just its presence in a city chronically full of writer-flaneurs. "This'll open their wallets" is more like it. Itch and compulsion—a sin zone's flywheels—are considerations a lot more practical than love. They require no creativity, only powers of observation and a heart of stone. The romance, for those susceptible, is precisely a travesty of natural emotion. Ignored, yearnings desperate and tender hover like the foggy glow around neon signs. Half a snoot of alcohol enhances the mood, which can easily get you mugged.

I was immediately enchanted by Dickson's installation, which dragoons a former porn parlor into service as a showcase for bridal fantasies. I initially abhorred Finley's, which transforms the defunct Papaya World at the corner of Seventh Avenue with a passion-purple paint job and a mural of inept drawings and poems reeking of adolescent sentimentality. Dickson's work has stayed with me. Finley's has come to haunt me, as I grasp its wavelength with the living and dying street. No names of individual subjects appear in the two pieces because Times Square keeps no files on its casualties. But communal loss throbs in the temporary monuments to temporary lives.

Dickson is a veteran realist painter of demotic subjects. She has long lived near Times Square. The density of her experience gives weight to her installation. She has filled the windows of Adult Video World with backlit oval paintings on vellum of contented brides. Through the locked front door we can peer into a cavernous space with booths and counters visible in subdued lighting. Stairs lead to a mezzanine. There a spotlighted, resplendent effigy of a bridal gown made of transparent

plastic rotates, shedding gleams of color like the rainbow hues of gasoline on water.

Dickson's piece could be saying either that marriage is the opposite of prostitution or that marriage and prostitution are the same thing. I think she's impartial. Recreated in a museum, the work would be arch, but it hits home on stinking Forty-Second Street. Its double essences of peep and matrimony, cynicism and sorrow, are irony-free and pure in themselves while mutually lacerating.

Dickson speaks in a public way to solitary woe. Finley whines and jabbers out of aloneness with no notion of where it ends and anything else begins. She is a remarkable figure in our culture. In performance, she combines astonishing charm with grating plaints of victimization. She is a doyenne of damaged lives, an avatar of every skeleton in every family closet, society's chickens home to roost. To call her authentic is to say the best and worst about her. I fled her Papaya World piece, but it caught up with me.

The clumsy figures in Finley's mural are idealized nudes of a man, a woman, and a child. They are accompanied by manic prose poetry of self-infatuation: "I am a polka dotted pony. Lollipops of cherry and grape adorn me. . . . I am a bouquet for all mankind." The tone goes beyond gush. It seems mad. The impression is hardly allayed when you register that the "lollipops," speckling the figures, are Karposi's sarcoma lesions.

The AIDS element of *Positive Attitude*, not spelled out on site, allows for a general resonance. The work's desperate upbeatness evokes a corresponding negativity, the inky shadow of persons as blighted as the mural is frisky. Aesthetic distance collapses. The installation becomes a sheer phenomenon, really happening in a real place habituated by terrifyingly harmed people whom Finley reaches toward without condescension. A viewer is knocked sideways into awareness of a common humanity in need of uncommon—indeed, practically incomprehensible—compassion.

The best that public art may offer now is a meditation in an emergency, exposing our lack of shared symbols either public, to which we

gladly pledge allegiance, or private, inviting soulful identification. Both kinds require that we welcome impulses of selfless participation, the spending of surplus love. Whose heart today sufficiently overflows? Maybe ask Abe Lincoln, if you can stand the climb. Ask yourself. Keep asking.

Village Voice, August 3, 1993

KEITH HARING, 1958–1990

The sweet world-enhancer is gone.

Haring's last years—the last years of one who died at thirty-one—were variously dimmed. The ebullience of the New York night-world of the early eighties, of which he was the artist prince, was fading into history already. Partly, it succumbed to its own success at defining youthful authenticity in an age of youth marketing.

As an artist, Haring briefly occupied a previously uninhabited (even by Andy Warhol) stratum between street-low and museum-high, impeccable in both. Because civilization is pleasant complication, he was a tremendous civilizer. He delivered a vision of democratic soulfulness whose impression lingers while it dissipates and will not be reinforced, as darkness increases.

Haring's rock-and-roll-Dubuffet designs declared a trickle-up-down-and-sideways economy of hip potlatch, a Walt Whitman Memorial punkdom. He meant it, as he proved by devoting his upbeat penchant to serious ends. His wonderful *Crack Is Wack* mural by the FDR Drive in Harlem, still unmarred the last I saw, is credible in ways not to be expected in any art star, let alone a bouncy gay white kid from Kutztown, PA. Still, it's hard not to feel that social as well medical emergencies sidetracked his talents.

Keith Haring's forte was knowing and imparting happiness. He beamed joy from some common human source to which he had miraculously unimpeded access, in an outward wave that irradiated everything. We will reap advantage from Haring's legacy when the day comes that we are disposed to be happy again.

7 Days, March 21, 1990

REE MORTON

Ree Morton was a pure product of America circa 1970. When I met her around then at an art school in Philadelphia, she was an ex-Navy housewife in her mid-thirties with three children. She seemed a nice person bedraggled with care and possessed, it quickly emerged, of intense artistic ambition all the fiercer for blooming late. She showed me works, fishing some of them out of her pockets: scraps of wood with patterned markings. They had something, fetishy but formal. Morton struck me as an unlikely type to become a consequential artist. I didn't get that she was a new type.

Morton died in a car crash in 1977 in Chicago, where she was teaching at the Art Institute. I was in Chicago lecturing that day. I had not seen her in a long time. Judging from her ever more confident work, such as colorful swags and banners celebrating "feminine" sentiments with funny panache, she had changed a lot. She was expected at a party after my lecture. Then someone came in and said she was dead. The shock persists for me. I still await having a distinct feeling about the event—unless, as I now suspect, traumatized anticipation is it.

"She was Emily Dickinson in love with Raymond Roussel," said the late sculptor and critic Scott Burton, who was great at pegging people. That is, she was abstract passion in love with methodical eccentricity, enigmatic emotion doting on enigmatic thought. How do you understand someone in flight from understanding? You attend the person's doings and worldly context. Morton's belonged to an extended-family-like art scene friendly to idiosyncratic creative personalities. She did not live to transcend that stage, but, like few others, she distilled it into poetry.

The little retrospective of Morton drawings, constructions, and installations at Brooke Alexander, covering the first half of a six-year career, is a time machine to the early seventies. During that recessionary era, the serious American art world was an archipelago of schools and alternative spaces with abundant public funding and scant public interest. The private-moneyed, big-audience eighties were far distant.

Artists proved themselves, if at all, to their peers. Obscure, funky, ephemeral expression was valued by a milieu drilled in minimalist form and hankering for heartfelt content. Installations (called "environments" then) were favored. Women were a growing presence.

All those period characteristics figure in the Morton show. Her main medium was found wood: bits of used lumber or logs, which she altered and arranged in quietly theatrical, allusive ways. Mysteriousness is the work's strength and weakness. Vested in maps of unknown places and diagrams of unknowable ideas, Morton's hunger for meaning was its own object. She did not create so much as conjure art, ritualizing a desire to create it. At the show, I was amazed by the force of motives so frail. I was drawn anew into Morton's rigorous self-contemplation, her intelligently dreaming soul.

The earliest work in the show, a suite of manipulated wood scraps like those I remember, is solid. It is a display of pure aesthetic aptitude recalling Jasper Johns's famous prescription for art-making: "Take an object. Do something with it. Do something else with it." The combination of funk and formalism rivets because each extreme is so credible. Morton really was enamored both of humble stuff and of art for art's sake. These pieces delicately suggest heavy-lifting spirit work: putting together the high and the low registers of a self, minus anything middling. They bracket an invisible wholeness.

Every beginning artist reinvents the wheel, producing art that is neither good nor bad but imaginary: art-in-general. Morton's is the extraordinary case of an artist whose art-in-general phase, occurring well into a life already rich in experience, overlapped her maturity. The wood sketches are not tentative. They harvest ripened feelings. The feelings inevitably thinned out as she groped for agreement with her place and time. But there are compensations.

Morton's most successful environment is *Sister Perpetua's Lie*, directly inspired by Raymond Roussel's plotless novel *Impressions of Africa* (1910), which details bizarre rites and amateur theatricals among the shipwrecked French guests of an African king. (A cult classic, this book periodically pounces out of oblivion to change somebody's life.)

Morton's three-part construction of drawings and wooden elements, connected by a black framing strip that meanders across walls and floor, is indescribable not because it is so complex but because each of the artist's decisions is at once so precise and so opaque. Thousands of words would be needed to detail it justly, and no number could explain it.

Morton was indeed a vicarious soul mate of Roussel, whose artistry is vivid in a passage that her piece quotes: "To the question, 'Is this where the fugitives are hiding?,' the nun, posted before her convent, persistently replied, 'No,' shaking her head right to left after each deep peck of the winged creature." Aside from citing Morton's Catholic upbringing, not even her most devoted critics have made much of the beleaguered Sister Perpetua (who is, by the way, a mechanized statue in Roussel's telling). I think Morton enjoyed the refusal to yield information.

I had a distant crush on Morton. Many people did. While being as toughly independent as a woman artist had to be, not to be patronized, she radiated qualities of both the maternal and the childlike. If she had any flaw, it was more enthusiasm for joining the art world than the art world deserved. The young-artist scene back then was a sort of collective holding pattern for refugees from sensible career choices. We may be into another era craving intimate heroes who will shift a sense of encroaching meaninglessness from negative to positive. Such heroes must want to be artists in the Ree Morton manner: desperately, and homing in on joy.

Village Voice, May 25, 1993

HÉLIO OITICICA

I'm getting braver at saying the name of a sorely under-known Brazil-ian artist whose retrospective at the Whitney Museum, *Hélio Oiticica: To Organize Delirium*, comes as an overdue revelation. Oiticica died in 1980, of a stroke, at the age of forty-two, after early success in Rio de Janeiro, a brush with fame in London, obscurity during seven years in New York, and a return to Rio that, at one opening, occasioned a riot. Along the way, he turned from superb abstract painting to innova-tive work in sculpture, film, writing, political action, and participatory installation, much of which remains as fresh as this morning. The sand, huts, potted plants, caged parrots, and inscribed poetry of his sprawling *Tropicália* (1968) await your barefoot delectation, should you choose to park your shoes in the rack provided. So do the multifarious love nests (mattresses, straw, chopped-up foam rubber, water) of a more austere faux beach, *Eden* (1969). Works that he made in New York and, at the time, showed only privately exalt sex, drugs, and rock and roll—delirium aplenty, yet managed with acute aesthetic intelligence. But back to the name. My pronunciation can still come out a little different every time, along a scale from the "Oy-ti-seek-a" recommended in the *Times* to the "Whoa-ta-cee-kah" that a self-confident Midwestern friend of mine swears by. I mention this because a tin ear for Portuguese makes me typical in an art world that, with exceptions, has long been inattentive to Latin America.

Oiticica was born in Rio in 1937 to an upper-middle-class and deeply cultured family. His father was a polymath engineer, mathema-tician, scientist, and experimental photographer whose own father, a philologist, published an anarchist newspaper. Oiticica spent two years in Washington, D.C., starting in 1947, while his father worked at the National Museum of Natural History. He devoured modern philoso-phy, favoring Nietzsche. Back in Rio, he wrote plays, studied painting, and, in 1955, joined a group of artists who were strongly influenced by European geometric abstraction. (This put them on a course alien to artists in the United States, where Abstract Expressionism—soon

to be followed by Pop Art and minimalism—sought to eclipse European modernism. The split proved enduring.) In hundreds of small paintings—too few, in the show, to sate my appetite for them—the young Oiticica rang startling changes, mixing homage and rivalry, on the styles of Mondrian, Malevich, and Klee.

By 1960, with like-minded compatriots including Lygia Pape (her own grand retrospective currently at the Met Breuer signals a corrective attention to Latin American art), Oiticica had developed sculptural expansions of painting, with standing and suspended panels. Those led to his "Penetrables"—booths that could be entered—and "Bólides," finely built wooden boxes with drawers or flaps that viewers could open to find various raw materials, mostly earthen. He took to frequenting Rio's favelas, the direly impoverished hillside shantytowns that overlook the prosperous city. The improvisatory folk culture there inspired his "Parangolés": garments for festive wear, mainly capes, that he stitched together from swaths and scraps of colorful fabric. With concerted study, he became an expert samba dancer. When, in 1965, Rio's Museum of Modern Art barred entry to parangolé-clad folk brought by Oiticica to dance at the opening of a show that he was in, the group disported outside in what became a legendary ad-hoc pageant. A military coup in Brazil in 1964 had ushered in a period of governmental oppression, which initially spared artistic activities. Needling of the junta by Oiticica and other artists—*Be an outlaw, be a hero,* he printed in black on a red banner with the image of a fallen youth—ended, in 1968, with a crackdown that drove many, including him, into exile. Like other aspects of his quicksilver character, his politics were ambiguous: leftist in general but what might be termed pop-aristocratic in effect. Jimi Hendrix became a guiding light to Oiticica at least as consequential as Marcel Duchamp.

"Creleisure," Oiticica termed the principle of his sensual installation *Eden* at London's Whitechapel Gallery, in 1969. The idea of Dionysian pleasure-seeking as a creative and, somehow, politically meaningful pursuit was much in the air then. (An observer at the Whitechapel show, perhaps in the mood for an orgy, deplored the no-fun restraint of British viewers.) But Oiticica was too tough-minded to

indulge in hippieish peace and love. *Sex and Violence, That's What I Like*, he had lettered on one Parangolé. His gayness became a driving personal cause and may have figured in his move, in 1970, with funds from a Guggenheim grant, to post-Stonewall New York, where he took an apartment on Second Avenue in the East Village. He relished the round-the-clock bacchanal of the West Side piers, photographed hustlers, and filmed the drag star Mario Montez. But he disdained the commercially oriented scene at Andy Warhol's Factory for, he said, "raising marginal activity to a bourgeois level." Insuring his own marginality, he took to dealing cocaine, a drug that became something like the love of his life. He gave varieties of it poetic names: Snows of Kilimanjaro, for one, and Carol Channing's Diamonds, for another. In an undated, lovely still-life photograph, a little heap of the intoxicant rests on a box of Bold laundry detergent.

I never met Oiticica, as far as I can recall, though he lived three short blocks from me and knew artists whom I knew—notably the dazzling Gordon Matta-Clark—in a scrappy SoHo milieu that was minuscule by today's standards. I get to sample at the Whitney what (perhaps luckily for me in the long run) I missed out on in the hermetic scene that Oiticica hosted. *CC5 Hendrix-War* (1973) is a room equipped with six comfortable hammocks. Projected on the walls and ceilings are overlapping slides of the cover of *War Heroes*, a posthumous Hendrix album, from 1972, as its thrilling songs play from multiple speakers. On the cover, decorating Hendrix's face like war paint, are lines of cocaine. Cradled in a hammock the other day, I couldn't imagine anywhere in the world I would rather be, tracking subtle variations in the changing slides: for example, a matchbook first closed, then open, then burning, then, finally, burned. The work's form anticipates subsequent generations of installation artists, none of whom can beat it for immersive and bracing cogency. Of course, Oiticica's blitzed afflatus was insane, as any former addict will tell you. After 1975, references to cocaine dwindled in his work.

Oiticica was a great one for planning. His buoyant writings in English, displayed in vitrines and seductively recited through earphones,

hatch intricate utopian schemes, often architectural in character. In 1971, he proposed one that involved labyrinthine spaces, for construction in Central Park, called *Subterranean Tropicália Projects*. Judging by the maquette in the show, I endorse reviving the idea. Oiticica's feel for spatial arrangement and proportion, developed in his early painting and sculpture, is just about preternatural. Had he lived longer, we would likely be blessed with a number of landmark achievements in public art.

In 1978, weary of New York and of being harassed, for want of a green card, by U.S. immigration authorities, Oiticica returned to Rio. His last major work, *PN27 Penetrable, Rijanviera* (the title was taken from a coinage referring to Rio de Janeiro in *Finnegans Wake*), ends the Whitney show in a spirit of chastening ritual. Entering a pavilion that is made of translucent, subtly hued plastic panels, you wade through running water and emerge on soft sand, amid a rock garden. The work's solemnity didn't deter rowdies in 1979 who attended the show in Copacabana where it was introduced, incautiously augmented with blasting Hendrix music. When the installation's water pump broke, flooding the gallery, a number of the viewers went wild, wrecking a nearby piece by Lygia Pape and forcing Oiticica to physically defend his own (he is said to have hit one vandal in the face with a rock). But the contretemps seems not to have marred his happiness at being back in Brazil—"free free free," he wrote to a friend. When he died, he had a profusion of projects in development, and a future ahead of him that invites our imagining.

New Yorker, July 31, 2017

ELIZABETH MURRAY

If you have ever wanted anything as much as Elizabeth Murray wants to paint, you have it by now. Sensuous, lyrical, and given to domestic affections, she convinces us that, as a painter of buoyant semi-abstract images, she just wants to have fun—but also that having the fun, in times that are hostile to painting for painting's sake, is a serious affair. With skewed and fractured formats to keep things fresh and surprising, she squeezes dollops of joy from masses of toil. Imagine someone wanting to dance who must build a city from scratch so that a ballroom can open to oblige her. Murray's strange mix of hedonism and willpower packs a punch at the Whitney. Stand close when you look at the paintings. The experience is like a full-body massage from a beautiful Swede on the verge of forgetting his or her professional detachment.

7 Days, May 11, 1988

ELIZABETH PEYTON

Elizabeth Peyton polarizes people. Some deplore her small, swiftly and tenderly brushed or drawn portraits of celebrities and friends, based mostly on photographs, as trivially sentimental. Others thrill to the self-abandon of her enraptured regard. What else in contemporary art is so wholehearted? A big show of little pictures, now at Gavin Brown's Enterprise, resets the debate. The chief apple of Peyton's eye here is the sensational German tenor Jonas Kaufmann, whose recent performances in Wagner operas at the Met astonished. Seen close-up or onstage, Kaufmann projects sensitive absorption and a peculiar loneliness; he appears more appealing than he knows what to do with. Like some of Peyton's other fascinations—Leonardo DiCaprio, Yvonne Rainer, members of the Danish band Iceage—he registers as a capital-A Artist, blessed and afflicted with charisma. Hung far apart on vast walls, Peyton's works look a mite lonesome themselves, in their stubborn beauty. They are points of ardor in the cold world.

New Yorker, April 20, 2013

BRONZINO

There's a new old art star in New York this winter: Agnolo Bronzino, the sixteenth-century Florentine painter, all of whose sixty known drawings are on exhibit to rousing effect at the Metropolitan Museum. His arrival heralds a new old movement: Mannerism, the most commonly despised period in Western art history and, I think, the one that best befits creative culture today. Art about art, and style for style's sake, Mannerism held sway from the end of the High Renaissance, circa 1520, until the Baroque kicked in, seven decades later. Even the strongest Mannerists—Pontormo and Bronzino in Florence, Parmigianino in Rome, Tintoretto in Venice, and El Greco in Italy and Spain—squirmed under the crushing standards of Leonardo and Raphael. They did so in ways both ingeniously elegant and gamily perverse.

Think of Parmigianino's elongated body parts, then of El Greco's elongated everything. Recall Bronzino's *The Allegory of Venus and Cupid*, at the National Gallery in London: a confounding tour de force of over-the-top sensuality and cryptic symbolism, painted for France's racy, bookish Francis I. A teenage Cupid lewdly embraces his naked mother while Father Time presides, a butterball putto rejoices, a cute-faced and snake-tailed grotesque proffers a honeycomb, and a dove departs on foot like a stricken guest from a party that has gotten out of hand.

As the Mannerists toiled in the twilight of the Renaissance, so do we in relation to the modern age—the word *modern* having been torn from its roots, by the bizarre coinage *postmodern*, to signify things behind us. The cinquecento artists would be intrigued by our popular musical oddity, the mash-up—new songs cobbled from old songs— which shares an arch intricacy with their favorite form, the madrigal. The movie *Avatar* strikes me as Mannerist through and through, generating sensations of originality from a hodgepodge of worn-thin narrative and pictorial tropes. Ours is a culture of mix and match. We are primed for Bronzino.

He was born Agnolo di Cosimo Mariano di Tori, a butcher's boy, near Florence in 1503. He may owe his nickname (the Bronze One) to

the fact that he had a ruddy complexion. Sometime between the ages of twelve and fifteen, he became a student and protégé of Pontormo, the introspective pioneer of Mannerism, who had known Leonardo and studied with Andrea del Sarto. Pontormo and Bronzino are presumed to have been lovers; they remained close until Pontormo's death, in 1557, when Bronzino was robbed of his mentor's estate in a court case brought by a weaver who claimed, falsely, to be a blood relation. Bronzino's early work can be hard to distinguish from Pontormo's supple and energetic hand—seen at the Met in a furiously blowsy sketch of a Madonna and Child—but by the late fifteen-twenties he had come into his own, with polished splendor.

As the chief court painter of Florence's ruler, Cosimo I de' Medici, Bronzino executed some of the greatest of all portraits. Two are among the few treasures of Mannerism in American museums. Both exude aristocratic hauteur and erotic glamour: the Frick's *Lodovico Capponi*—with that lad's unforgettably protruding, glad-to-see-you codpiece—and the Met's own superbly arrogant *Young Man*. They depict individuals. Bronzino's women tend to be generic masks of beauty—devastatingly so in the *Head of a Smiling Young Woman* (circa 1542–43), a study for his elaborate frescoes in the chapel of Cosimo's Spanish wife, Eleonora di Toledo, in the Palazzo Vecchio. One glance at this girl—if she isn't an idealized synthesis of girls—might land you, as it did me, goofily in love.

Bronzino was also a skilled poet—witty, erudite, and, when not penning courtly lyrics and paeans, raunchy. A leading intellectual of the time testified that the painter had memorized all of Dante and much of Petrarch. Bronzino spoofed the bards in burlesques celebrating rough trade in the night streets of Florence. Prose translations document a knack for double-entendre, as on *pennello*, which can mean "paintbrush" or "penis":

Who is the person who does not take pleasure in the things that this thing does . . . I would not know how to recount one of the thousand different actions and extravagant ways; you know that

everyone likes variety. It is enough that in order to make it from behind, in front, across, foreshortened, or in perspective one uses the [*pennello*] for them all.

I have two thoughts about this. First, it's fun; and, second, it's not that remote from American humor today. A similarly burlesque spirit permeates *The Daily Show* and *The Onion*: taking glee in the absurdities of inescapable conditions. Folding ribaldry into nightmarish politics, for instance, doesn't change anything, but it cheers us up. The trick is to force despairing cynicism to a pitch of revelry.

The pictures in the show, most of them black-chalk studies of heads and bodies, are working drawings. A telltale feature is the thin, continuous line that contours his figures, divorcing them from the negative space of the paper: they were limned to be integrated elsewhere. Within the lines, fabulously deft anatomical details, in hatched and smeared shadings, capture musculature and voluptuous flesh. Bronzino makes this look so easy, you should remind yourself to appreciate it.

The most gorgeous of the drawings are male nudes, including a tall, narrow study, for the Eleonora chapel, of a young man seen from behind, twisting in a serpentine posture while holding a pillow, or a bizarre hat, on his head with one hand. The artificiality of the pose coexists perfectly with lip-smacking relish. That's Mannerism: the most contrived fantasy, the most candid appetite. It bespeaks the urbanity of someone conducting himself impeccably in any company while pursuing personal pleasures without compunction.

Bronzino's long residence in the doghouse of art history began during his lifetime, with his displacement, as Cosimo's favorite, by Giorgio Vasari, whose treatment of Bronzino in his biographical magnum opus, *Lives of the Artists*, drips condescension. (It seems that the duke was swayed by the relative speed with which Vasari's workshop fulfilled commissions.) Later, Bronzino, suffering through centuries of contempt for Mannerism in general, as an addled interregnum between the Renaissance and the Baroque, was often singled out for abuse on moral grounds. A leading American art historian, Frank Jewett Mather,

restated the case in 1923: "He was a vicious person, a cold aesthete, with few of the generous virtues that nourish the soul." In 1903, Bernard Berenson cheerfully contemplated the prospect of "Bronzino sinking into obscurity." The connoisseur's connoisseur of Italian painting detected "feebleness of touch" in Bronzino's light-fingered drawings.

It's unsettling to read that expert's judgment on art that looks so good at present—as it does to a lively cohort of art historians who include the show's excellent curators, Carmen C. Bambach, Janet Cox-Rearick, and George R. Goldner. The old verdicts suggest a proactive condemnation of our own era, which, for all we know, future generations may endorse. Meanwhile, we are doing the best we can in the twenty-first century, things being as they are; and anyone who wants our friendship had better be civil to Bronzino.

New Yorker, February 2, 2010

A VAN GOGH PORTRAIT

From a distance, the face is closed, hieratic, and a bit intimidating. Up close, the eyes seem frightened. They stare without focusing. The other features spread, threatening to lose track of one another. It is a deracinated face in a conflicted picture that is unified by genius invested in the craft of painting. Decide when you make your welcoming visit to *Portrait of Joseph Roulin* (1889) by Vincent van Gogh, a new acquisition of the Museum of Modern Art.

It's wonderful, the effect of a work not yet encrusted with familiarity as it joins the museum's permanent collection. Other paintings in the vicinity, including van Gogh's own standby *Starry Night*, feel jarred awake, made alert and voluble by the newcomer. So it seemed to me the other day. It's a big relief, by the way, to see that the work joins MoMA's few exceptions to the former, terrible house rule of standard-issue strip frames that was imposed by the ex-director of painting and sculpture William Rubin. A beat-up old brown frame, with chipped gilt, is perfect for *Roulin*.

Van Gogh is the proverbial exhibit A in a case for "genius" as a near kin of "madness"—a comfortable formulation, balancing envy with pity, that is out of fashion. You don't have to be a critical theorist to feel that "genius" and "madness" are evasive generalizations. But now how do we describe van Gogh, whom the ideas fit like a glove? (I mean it. I'm curious.) Are we pleased or displeased to observe that van Gogh gave over more of himself to painting than is wise for people to give themselves over to anything?

"Oh, lighten up, Vincent," I've felt at times. "It's only art." There's a taxing relentlessness to his intensity, like that of a friend with a personality stuck in high gear. But we always hang in with van Gogh if we love painting and want to know the extreme form of the love, which will persist for as long as our eyes are wired to our feelings.

Joseph Roulin was a postman in Arles. The artist painted several portraits of him and his family, attracted to the proud civil servant who was vociferously leftist in his politics. Van Gogh's fascination is the

true subject of the painting, as it is with most of his portraits. Ardent and shy, he tends to split differences between his sitters and himself, producing reversible masks.

Painted in van Gogh's Japanese-inspired mode, Roulin is boldly contoured against a floral-patterned background. The composition is rife with spiral motifs (rousing the empathy of the nearby spiral-happy *Starry Night*) and is keyed to a clash of fresh blue in the uniform and moody green in the background. Variously spiced browns in Roulin's beard, forthright yellow-gold in the buttons, and rust reds and pinks in the flower shapes keep your eye jumping. The overall composition is as hyperactive as relative symmetry can be. Roulin's flesh is rendered in medieval-ish green and red hatchings.

Maybe from simple suggestibility, triggered by the work's Japanese flavor, Roulin seems, from a distance, almost a caricature of an Oriental potentate. From ten feet away, you may see a cruel mandarin. Approach, and the face turns European, young, and vulnerable. Something uncanny about the eyes is explained when you realize that their "whites" are the green of the background: windows not of a soul but of the painting itself, which for van Gogh may amount to the same thing.

The near-far contrast, like the blue-green clash, generates aesthetic and psychological heat. Formally, there's a mighty push-pull. The modeling of the face seems to carve back into shallow space while the background presses forward. (If you try, you can imagine the blue uniform as a deep pool or cavern.) But you'd have to be pretty phlegmatic to savor the picture as a formal exercise.

When van Gogh looks at Roulin, what does he see? Pride, which he endorses. (Roulin is his friend.) His brush celebrates the dignity of the slightly rumpled uniform (*POSTES* lettered on the cap with the pomp of Roman insignia) and the preening masculinity of the well-tended double cascade of the forked beard. But, as often with van Gogh, the emotion gets a little out of hand.

With the painting's floral symbolism and its light—a sharp illumination coming from both sides, and redolent of summer heat—van Gogh associates Roulin with nature. The virile postman is plainly a

baby-maker. His sexuality lends tenderness to the close-up, boyish aspect of his face and a touch of the terrifying to its distant look. At one point I had a sudden thought: "It's the Devil!" Then, doing a double-take, I couldn't see it that way again, as if the picture were a kaleido-scope that had been jostled.

Van Gogh will give you as much subjective adventure as you can take. His art is inexhaustible—or so I believe. (Dear MoMA, Please lend me a van Gogh for a year or two, so that I can test this at home. Thanks in advance, Peter.) They are most communicative on your first encounters with them, before they acquire the postcard aura to which their design qualities make them prey. Make your initial visit to *Roulin* count. Then observe the effect on its peers. Gauguin, Seurat, Munch, Redon, and Rousseau flock like teammates of a slugger who, having homered, returns to their midst with high fives all around.

7 Days, September 6, 1989

KERRY JAMES MARSHALL

Mastry, an exhilarating Kerry James Marshall retrospective at the Met Breuer, is a big deal for three reasons: it marks the museum's blessing of Marshall and, in turn, Marshall's benediction of the museum, and it affirms a revival of grandly scaled, thematic figurative painting. Marshall, now sixty-one and based in Chicago, has achieved prominence as an artist of universal appeal—he won a MacArthur "genius" grant in 1997—with a particular focus. He has strictly depicted African American life and experience since 1980, when he made *A Portrait of the Artist as a Shadow of His Former Self*. Executed in the antique medium of egg tempera, the painting is in blacks and grays, save for the whites of the eyes, a shirt collar, and a gap-toothed grin. Small in size but jolting in impact, the portrait bears hints of ghastly blackface caricature but turns them around into astute ironies of a self-aware, unconquerable character—not an "identity," a term that is as reductive in art as it is in politics, and which Marshall bursts beyond. He doesn't argue. He tells.

Most of Marshall's imagery is celebratory, and often at mural scale. His keynote is a commitment to blackness both represented and literal, modeling flesh in pigments of acrylic carbon, ivory, and Mars Black. *School of Beauty, School of Culture* (2012) convenes eight women, two men, two toddlers, and the artist, who is seen in a mirror, his face obscured by a camera flash. The adults sport smart styles of dress, hair, and posture, in luscious colors pegged to a dominant coral and blue-green. Background details done in gold glitter pop forward from the wonderfully handled deep space. Floating free, and noticed only by the children, is a distorted image of Walt Disney's blond Sleeping Beauty: an ideal that is implicitly, and decisively, shrugged off by the kids' glamorous mothers and aunts.

Other of Marshall's subjects include lovers in intimate interiors or lyrical landscapes; artists at work on paint-by-numbers self-portraits; people relishing, or enduring, life in public housing and inhabiting utopian suburbs; and upper-middle-class matrons in living rooms filled with civil-rights-era memorabilia. There are also enlarged panels from

Marshall's raucously Expressionist comic strip about a black superhero, *Rythm Mastr*. A rare Caucasian figure in a show of some eighty works is that of a head severed by an axe-wielding Nat Turner, in a history painting redolent of baroque gore (all those postmortems of David and Goliath) and ambiguously pitched between menace and dread. But the show's cumulative, epic effect is neither political protest nor an appeal for progress in race relations. It's a ratification of advances already made.

Marshall's compliment to the Met is expressed by a show within the show, of works from the museum's collection that he particularly values. He selected paintings by four modern African American artists— Horace Pippin, Jacob Lawrence, Romare Bearden, and Charles Wilbert White (a WPA muralist who was an inspirational teacher of Marshall's in college)—and three African sculptures: a Dan mask, a Senufo oracle figure, and a Bamana Boli (a featureless animal encrusted with "sacrificial" matter, including blood). But most of the works are by dead white men, from Veronese and Holbein through Ingres and Seurat to Balthus and de Kooning, with surprising nods to George Tooker, Paul Cadmus, and Andrew Wyeth. In each case, an intellectual spark leaps to some aspect of Marshall's art: eloquent figurative distortion, from Ingres and de Kooning; dark tonality, from Seurat and Ad Reinhardt; and theatrical violence, from nineteenth-century Japanese prints. Only one choice baffled me: a blushy Bonnard nude, which feels antithetical to Marshall's manner. (Is that the ironic point of its inclusion?)

Kerry James Marshall Selects, as the sub-show is titled, amounts to a visual manifesto with which Marshall pays homage to a personal pantheon of forebears even as he shoulders in among them. The gesture confirms him as the chief aesthetic conservative in the company of such other contemporary black artists as David Hammons, Kara Walker, and Fred Wilson, who are given to conceptual and pointedly social-critical strategies. Marshall's untroubled embrace of painting's age-old narrative and decorative functions projects a degree of confidence that is backed both by his passion for the medium and by the authenticity of his lived experience.

Marshall has said, "You can't be born in Birmingham, Alabama, in 1955 and grow up in South Central near the Black Panthers headquarters, and not feel like you've got some kind of social responsibility. You can't move to Watts in 1963 and not speak about it." (The artist's father, a postal worker, took Marshall and his mother and his two siblings to Watts for a year before settling in South Central.) Marshall's childhood was marred by violence—friends and neighbors were stabbed or shot with awful frequency—and enriched by a budding enthusiasm for art. His first visit to the Los Angeles County Museum of Art, in 1965, stunned him. "I went from floor to floor looking at everything, in the same way that in the library I went down the stacks and looked at every art book, without discrimination," he later wrote.

In 1968, when he was thirteen, a teacher's nomination won him placement in a summer drawing course at the Otis Art Institute, a school dedicated to relatively traditional training. He set his heart on attending that college upon graduation, but it took him four more years to qualify for admission, two of them spent working odd jobs to save enough money to enter Los Angeles City College, and two acquiring sufficient academic credits there. His already active bent for African American subjects was confirmed and amplified at Otis, where he took a course in collage with the prominent artist Betye Saar, and was galvanized by reading Ralph Ellison's *Invisible Man*, which directly inspired his *Portrait of the Artist*. The painting, he has said, is, like Ellison's novel, about "the simultaneity of presence and absence"—about being real but unseen.

A residency at the Studio Museum in Harlem brought Marshall to New York, in 1985. There he encountered the influence of painting-averse post-minimalist and conceptual artists. In 2000, he recalled his renegade response, and what it led to, this way: "I gave up on the idea of making Art a long time ago, because I wanted to know how to make *paintings*; but once I came to know that, reconsidering the question of what Art is returned as a critical issue." The reconsideration landed in an improbable place: lessons from the Old Masters applied

to modern American experience. At first, Marshall availed himself of stylistic ideas that had marked the rise of Neo-Expressionist painting in the early eighties, with coarse figurative images and paint built up in rough marks and patterns that recall the muscular temerity of Julian Schnabel, among others. From Leon Golub, a too-little-regarded master of violent themes, Marshall adopted the format of unstretched canvas fastened flat to a wall.

His growing ease with rendering space came to fruition in the mid-nineties, with vast paintings of housing projects, such as Nickerson Gardens, in Watts, which had been his family's home for a time and which he recalls fondly. My favorite work in the show is the Fragonard-esque *Untitled (Vignette)* (2012), in which a loving couple lounges in parkland made piquant by a pink ground, a dangling car-tire swing, and an undulating musical staff in silver glitter, with hearts for notes. Marshall's formal command lets him get away with any extreme of sweetness or direness, exercising a painterly voice that spans octaves, from soprano trills to guttural roars.

There have been other significant African American painters in recent years, including Robert Colescott, whose somewhat similar engagement with art history ran to fantasias of interracial romance, and Jean-Michel Basquiat, whose linear panache qualified him as the greatest of American Neo-Expressionists. But Marshall's *Mastry* has a breakthrough feel: the suggestion of a new normal, in art and in the national consciousness.

New Yorker, November 7, 2016

HENRI MATISSE I

The Matisse show at the Museum of Modern Art is a controlled orgy. It will let you know how much pleasure you can stand. I mean visual pleasure, of course—arousal of eyesight—but more, as well. Matisse cross-wires sight with other senses, sparking phantom thrills of taste and smell. He stimulates the mind to analysis, then slaps it silly with audacities. He activates the occult handshake of aesthetics and sex. He does it all with practically monkish discipline, giving grown-up permission to our immersion in polymorphous joys. He makes a science of pleasing, as pleasurable in what he leaves out as in what he provides. He omits any messy appeal to the heart. He is monstrously cold.

I went to MoMA with a lot of accumulated ambivalence about the yeoman of the armchair. I wanted to be hard on him—I still dislike him—but it's not easy to be critical while swooning. John Elderfield, the show's curator, is no help. I can't recall another exhibition installed with so successful an aim to addle intelligence with delight. The Matisse on view is a better artist than Matisse has been before or will be again.

The show starts slowly, like damp kindling smoldering into fitful flames. Fauvism arrives as a steady and merry though modest blaze. (It's striking how small those famous pictures are: parlor decor, often in overly ornate frames bespeaking the insecure taste of their early collectors.) Then, in 1907, with *Blue Nude*, a body erupting with distortions that both energize and monumentalize the picture, all hell breaks loose. Only Picasso had a run of pictorial invention like Matisse's in the subsequent seven or so years, and we are along for every whoop of the ride.

Matisse's aesthetic raises decoration to a level of panic: representations slammed up to the surface with linear rhythms and color combinations registering as willfully arbitrary pattern, each detail a surprise and the ensemble a riot. The freedom is staggering. It is as if the least desire, the merest whim to see a certain motif in a certain way, were granted the power of a thunderbolt-wielding Zeus to fulfill itself. No Matisse imitator has come close to that quality of the big effect delivered with seeming nonchalance.

Some pictures aren't very good, such as the 1909 *Spanish Woman with Tambourine*, which feels less easeful than just complacent, and the wonky 1910 *Girl with Tulips*. Most of his portraits and all his landscapes of the time flop, sabotaged by his exasperation with fellow humans and unorganized nature. In this greatest of his periods, Matisse burns with resentment for subjects that resist being schematized. Only inspired tantrums (for instance, the cancellation-like black arc in *Portrait of Olga Merson*) rescue some works. But the failures prove that he took real risks. (Come to think of it, Matisse's most endearing trait may be how generously he can fail.) He would not believe beforehand that anything was impossible, and when he brought off a major picture like *Dance (II)* (do you suppose the Hermitage will mind if we send them back *Dance (I)* and keep this one?), *The Conversation*, *The Piano Lesson*, or *Bathers by a River*, he entered upon a chartless realm of wonderment forever.

In the late tens, he comes bumping down from those heights with morbidly obsessed pictures of the model Lorette, his dark lady of the sonnets. He painted her nearly fifty times, and nobody seems to know even her last name. (This biographical lacuna is typical of Matisse scholarship, still weirdly constrained by a sort of gentlemen's-club loyalty to the straying husband's privacy.) Then he decamped to Nice, where in the twenties he churned out the self-exploiting style, the sensualist chic, that put modern painting over the top with haut hoi polloi. Some people insist on deeming the Nice period underrated. It isn't for me, though Elderfield improves it with grouped hangings that camouflage individual pictures' weaknesses by rhyming their strengths. He even sneaks a potted plant into a room of these bourgeois baubles.

Matisse in Nice is drugged on rapture. The artist in claustrophobic hotel rooms compulsively repeats his primal scenario of staring at nude or spicily costumed models. He hardly glanced at naked women, I think. He saw models, clothed in nudity. He taught his sexual arousal not to fixate but to dilate across a pictorial field, such that details of decor are as eroticized as breasts and legs. His art is fueled by sex, and it burns clean. Conservative types revere him for this. The efficiency of Matisse's sublimation is a triumph of decorum under pressure. Of

course he would have to have the young woman—and you just know what a sensitive lovemaker he must have been—but the painting, there on the easel, wouldn't breathe a word of it.

After the twenties, Matisse is essentially a graphic artist, making design-y pictures dead flat and flashy. He rarely fails to arrive at something satisfying, though his reach is not heroic. The late cutouts are overrated—more winsome than wonderful, on the whole. But Elderfield serves them with an installation that, like the shoot-the-works finale of an action movie, sends a viewer out the door reeling. There has never been a better paced, more exhilarating, more refreshing museum show. Go soon. Have a friend with you so as not to appear crazy when making involuntary noises.

Village Voice, September 29, 1992

HENRI MATISSE II

Matisse: Radical Invention, 1913–1917, a power-packed show at the Museum of Modern Art, which surveys the most adventurous phase of one of the two greatest modern painters—still tied with Picasso, in overtime—offers me a chance to ruminate on why I habitually say that one particular painting, MoMA's own *The Piano Lesson* (1916), is my favorite work of twentieth-century art. The brushy, big canvas (eight feet high by nearly seven wide) represents Matisse's son Pierre at an oddly pink-topped piano, his sketchy face inset with a shard of black shadow, in a schematized room: cornerless gray wall; the pale blue frame of a French window opening onto triangular swatches of green and gray; a salmon rectangle of curtain; and a black window grille that echoes the curlicues in a music rack bearing the instrument's brand name, Pleyel, spelled out in reverse. There is a lighted candle (indicating that the time of day is dusk), a metronome (indicating time itself), and two earlier Matisses: a small sculpture of a sensual odalisque and a large image from a painting of a stern-seeming woman seated on a high stool, floating free on the gray wall. The philosophical conceit of the quoted works—id and superego, conjoining in music—is pleasant, though a bit arch. Like any successful art, *The Piano Lesson* generates tensions of antithetical qualities—lyrical and harsh, mysterious and blatant, intimate and grand—and resolves them. It's terrific, but the past century affords many paintings (and not all of them by Matisse and Picasso) that are as good or better. My preference for it is not a considered judgment. It's a reflex, like the one that twitches when I'm asked my favorite movie, and I automatically, helplessly, say *Psycho.*

Matisse's bourgeois idyll and Hitchcock's cheapo shocker have in common, for me, an acute insight into what is meant by the words *painting* and *moviemaking*. On themes hardly apt for great art, both works exalt their mediums by sabotaging normal orders of response. Through strictly painterly and cinematic means, they jar our settled expectations of paintings and movies—and make us relish the disturbance, surrendering ourselves into the peremptory hands of their

creators. Think of the moment in *Psycho* when Norman Bates abruptly tosses the newspaper, which conceals the stolen money, into the trunk of the bog-bound car. We cared about that money, suckers that we are. Now what we thought was the story isn't the story. *The Piano Lesson* renders a sweet little domestic scene huge and dead flat, with violently summarizing forms and colors—the green triangle usurping what, in a preliminary drawing for the work, was an abundance of plants—that we seem to see before we can start looking at them. The cascading effects, so incongruous to the narrative velleity of music on a summer day (during the Battle of the Somme, which is perhaps encoded in the somber gray), both fascinate and estrange. For me, it's like falling in love at warp speed, zooming through the happy part straight into the subsequent remorse. Like *Psycho*, *The Piano Lesson* unfolds the secret of its coherence by seemingly precipitous but precisely calibrated jumps and starts.

The MoMA show—curated by John Elderfield and Stephanie D'Alessandro, of the Art Institute of Chicago, where it first appeared—is largely a forensic exercise, attended by scholarly minutiae and the lavish use of X-rays, infrared reflectograms, laser scanning, and other current gadgets of the field. The premise is that Matisse's pell-mell development during the period in question was so complex that the sequence of finished works misses certain stages, which show up in layered alterations of the initial designs and in the evidence of scraping, wiping, hatching, resist (liquid paint beading up atop dense paint), and other improvisatory methods. The phase began in 1913, when Matisse returned from a sojourn in Morocco and confronted, in Paris, a raging, almost dictatorial vogue for Cubism, backed by the undeniable achievements of Picasso, Braque, Gris, and others. Matisse had been supreme in the avant-garde of Fauvism—reorienting painting to the dynamics of bold color—and famous for his smashingly decorative distortions of the figure, in pictures like the big-hipped *Blue Nude (Memory of Biskra)*, from 1907, which so disconcerted Picasso. ("If he wants to make a woman, let him make a woman. If he wants to make a design, let him make a design," the Spaniard grumped, loath to admit that

Matisse had done both at a go.) Now Matisse was driven to rethink his enterprise in the light of the steely Cubist aesthetic: pictorial space redefined with geometric elements that tilt in and out of an artificial, shallow depth. He took a sweeping view of the challenge, speaking of a shift from composition to "construction" as the painter's essential task. Shunning the intricate systems that confine early Cubism to small scale and tonal color, he adapted its rationality to expansive, decorative formats—frontally arraying emphatic objects in the combined still life and landscape *The Blue Window* (1913) and balancing a jaggedly busy scene on two little slivers of orange in *Interior with Goldfish* (1914).

Matisse's march of audacities, including flirtations with futurism and the occasional ghastly overreach (such as a virtual parody of Cubism in *Head, White and Rose*, from 1914, perhaps finished in 1915), became hermetic as the onset of war suspended public critical discussion, throwing noncombatant artists back on their own resources. (Matisse, aged forty-four in 1914, was too old to enlist.) His innovations almost certainly spurred his competitive friend Picasso to advance the bigger, flatter vocabulary of what is called Synthetic Cubism. Those innovations ended in 1917, with Matisse's move to Nice and the long, relaxing sigh of a revived naturalism, in high keys, characterized by pretty young women lolling in lovely rooms. (Draconian modernists used to disparage that work as retardataire. So did I, but now I succumb to its ostensibly effortless glories—the artist was surely entitled to coast on the artistic dividends of his investments in the radically new.)

The show pays exhaustive attention to one painting, the friezelike *Bathers by a River*, which was begun in 1909 and was continually revised until its completion, probably in 1917. Four hieratic, cubistically shaded, faceless female figures stand out on a ground of green, black, white, and pale blue vertical bands. Spiky black lines suggest foliage. A silhouetted snake intrudes. The picture is magnificent and historically crucial, as a bridge from certain representational traditions, mainly that of Cézanne, toward full-bore abstraction (which Matisse, like Picasso, disdained). For me, however, it consumes at least as much aesthetic energy as it imparts, lacking the surplus joys of *The Piano Lesson*. Its many X-rayable

layers excite the curators with a wealth of telltale changes. But their finicky documentation, besides being murky and confusing, puts me in mind of meteorologists taking barometric readings outdoors in a hurricane. Their findings are unexceptionable but well short of compelling, in terms of the tumultuous experience.

My amateur pleasure directs me to the whipsaws of *View of Notre Dame* (1914), an image so perfunctory that its most immediately striking feature is that the artist declared it finished by signing it; the yet more rudimentary, and prophetic, *French Window at Collioure* (1914), its central black swath as stark and as electrically charged as the dominant form in a top-notch Barnett Newman or Mark Rothko; and the black-contoured, zero-gravity, incredibly sumptuous ciphers of fruit in *Bowl of Apples on a Table* (1916). Even close to a century after the fact, an ancestral voice in my head shrills, "You can't do that in a painting!" (But, guess what?) I remain less persuaded by the vast, collagelike tableau of *The Moroccans* (1916). Ravishing in detail, the picture's bobbing disks and domes and its scrawls of architecture add up, to my eye, to a goofy, overqualified cartoon. I'm also only mildly a fan of Matisse's sculpture, including, in the show, three versions of *Back* (1908–16), which set the curators' laser scanners and modeling software frantically abuzz.

As Matisse made clear—with the loyalty to genre subjects that persisted throughout his career—he had no argument with the conventional uses and meanings of painting. (He ignored the insurrections of Dada and Surrealism.) Indeed, his conservatism grounds the tigerish pounces with which he exploits the formal and rhetorical capacities of the medium in unprecedented ways, stirring in the viewer a vicarious elation. We enjoy what Matisse does to the point of almost feeling that we did it ourselves, as if our mere appetite had conjured the means of its gratification. By the way, I don't necessarily propose that *The Piano Lesson* and *Psycho* comfortably inhabit the same stratum of cultural value, as that value has been adjudicated by qualified assessors of taste and significance. I'm just in a mood—enhanced, now, by the thought of the inexplicable, inchoately thrilling arc of black paint that slashes Matisse's *Portrait of Olga Merson* (1911) from chin to left thigh—to insist

on a hierarchy of sensations that favor the experience of being tripped cleanly out of ourselves and into wondering glee. I learned at the show that Pierre Matisse was sixteen years old when his father painted him at the piano. He looks about eight. That's perfect. *The Piano Lesson* makes me feel like a kid, too.

New Yorker, July 26, 2010

COLD

ANDY WARHOL'S GRAVE

The Andy Warhol Museum has instituted a twenty-four/seven Webcam feed of the artist's grave, near his hometown of Pittsburgh. The idea occurred a year ago to the museum's director, Eric Shiner, in conversation with the CEO of EarthCam, Brian Cury. Cury cites his encounters with Warhol during the artist's last year, 1987, as an inspiration for his business, founded in 1996, of maintaining sleepless camera eyes around the world. Shiner consulted Warhol's surviving relatives and the St. John Chrysostom Byzantine Catholic Church, which owns the cemetery. No one objected.

Online the other day, in soft sunshine, a wind rustled flowers and bobbled Mylar helium balloons around the small gravestone, upon which eight cans of Campbell's soup sat. The Web site allows you to order further offerings; you would be given a time of day to observe their delivery. Twenty-four other stones were visible. Little American flags waved at two. Legible names included Jaczesko and Mascenik. A large marker just behind Andy's, that of his mother and father, bore his birth name, Warhola.

He was from immigrant-Slovak, working-class stock. His alien mien is simply explained. Once having revealed his talent, at Carnegie Tech in the late nineteen-forties, he rocketed from being marginal, at the bottom of society, to being marginal, at the top. He spent no time among the majority of us, in the middle. His vision of things as a rich artist was identical to the one he had had as a poor boy, only beamed from the opposite direction.

I have angled for reasons to snoot the Webcam stunt. I can't think of any. It is Warholian to the, well, life: watching the present habitation

of a man who liked to watch. Warhol pioneered movies of motionless subjects; and we have him to thank, or not, for prophesying reality television. His beholding bent became, as it remains, a default setting of artistic and popular culture everywhere.

Moreover, death suits him. His early images sing of it: fatal car crashes, suicide leaps, the electric chair, JFK's funeral, a plane crash, the atom bomb, victims of accidental botulism poisoning, and, of course, fame's sacrificial lamb, Marilyn Monroe. Warhol conferred on defunct subjects the immortality of art, understood as permanent publicity. Beyond iconic, the pictures are icons in the Byzantine mode—direct links to eternity—which came to Warhol naturally from his upbringing and his never discontinued observance as an Eastern Orthodox Catholic.

Warholian celebrity was always a kind of accelerated embalming. Its subjects are all the same, fixed in a frozen gaze. Their fame proceeds without them. It discards them, really.

By general agreement, Warhol would have liked the grave cam, though it violates a written wish of his: "I always thought I'd like my own tombstone to be blank. No epitaph and no name. Well, actually, I'd like it to say 'figment.'"

There's an artistic precedent for the project: Bruce Nauman's *Audio-Video Underground Chamber* (1974–75). A coffinlike concrete box, buried outside an art space, contains a light, a video camera, and a microphone. On a monitor, you see and hear in real time what's going on in there, which is what you would expect. Then there's Marcel Duchamp's parting shot of an epitaph, on his gravestone in Rouen: "*D'ailleurs, c'est toujours les autres qui meurent*" ("By the way, it's always the others who die"). Think too long about that, and a wisp of doubt arises about who is and isn't dead.

In words prefacing his "figment" quote, Warhol wondered why, upon dying, "you didn't just vanish, and everything could just keep going on the way it was—only you wouldn't be there." That's the self-assessment of a pure spectator. By that reckoning, his demise merely removed one set of eyes and ears from among the world's billions.

The best joke of 1975 involved Generalissimo Francisco Franco, whose protracted dying had made for monotonous headlines. Every Saturday night for weeks afterward, Chevy Chase would report some variation of a news flash: "Francisco Franco is still dead." Partly, the laugh was on the unctuous solemnity of TV anchors. But it tickled, too, by riffing lightly on a fine point: the dead are always up-to-date.

It stands to reason that no one can be better than anyone else at being dead. But it's hard to remember that when checking in on Warhol's grave. (There are two more soup cans today.) It memorializes a man who brought deadness to life, and vice versa. Say what you want about him. He's there for us.

New Yorker online, August 9, 2013

BALTIC VIEWS

Last week on a bus to Leningrad, as a bottle was passed around, I got angry for Finland. The Finns aboard found this very funny. For three hours we jolted on atrocious roads through Karelia, former Finnish heartland gobbled by Stalin in the Winter War of 1939, then regained and lost again during the Second World War. Amid forests of birch and pine, I glimpsed a long disaster. This was my first time in the USSR (my fourth in Finland). I was unprepared for the brokenness of every human thing, the old Finnish farmhouses and lakeside villas collapsing or collapsed, the travesties of farming apart from neat kitchen gardens. The once famously cosmopolitan Baltic port of Vyborg (Viipuri in Finnish), which could be the prettiest small city in the world, felt post-nuclear, its citizens (non-Finns, with whose forebears Stalin replaced the native population) listlessly wandering. Some gaped as our fancy tour bus wallowed by. The single purposeful activity I saw in Karelia was that of a man painting an ornamental fence around a roadside ammunition bunker. The contrast to Finland's grace and bustle was unbearable.

"Vyborg," I said to the Helsinki art critic Markku Valkonen, who has Karelian roots. "You want it back."

"Sure, I would like it back," he said softly, "but I do not want to spoil my life with bitterness."

"Then I'll get it back for you!" A military truck passed. "Bastards!"

That the American proposed to fight for Finland made the rounds, hilariously. Finns have the absurdist humor of a people fewer than five million strong who, Markku told me, "are very warlike and have lost thirty-six consecutive wars," with much larger Sweden and very much larger Russia. They tend to be outwardly diffident, inwardly stubborn, and soulful. "We are Scandinavian in politics, economics, and everyday culture," another Finn said to me, "but underneath is . . ." She hummed "Volga Boatmen" with super vibrato. Finns have a dramatic and sad musicality. I love to hear Finnish spoken. With its doubled letters, that language of obscure origin is devoid of cognates (except in Hungarian

and Estonian), and its rollicking locutions sound less like speech than water over rocks or wind through trees.

Of course I did a proper sauna, leaping parboiled and starkly into a Baltic Sea whose fantastic coldness registered intellectually while regarded with indifference by my body chockful of coziness. A sensation of invincibility is the payoff of the sauna, I decided. This fades rather quickly, so I splashed to shore and hurried to recook. Then in the translucent blue midsummer dusk that deepens toward midnight I wahooed off the pier again.

I like Finland, and it seems Finland likes me, if only for comic relief. The Foreign Ministry hosted me for the reopening of the country's national gallery, the Ateneum. Six years under renovation, the Beaux-Arts building housing classic and contemporary Finnish art is a blend of meticulous restoration and understated high tech. Happy thousands of Finns swarmed it on opening day. I turned out to be the Western Hemisphere's only representative in a press contingent that included an Estonian, a Lithuanian, and two Latvians. Do you think the USSR isn't over? The nationalist tempered steel in those careworn but fearless Baltic art people would make Gorbachev cry. No one having hinted to me of a quid pro quo, this quid is gratuitous. To salve my independence, I will now nip the hand that flew me Finnair Executive Class.

Helsinki is horribly expensive. A present recession, due to collapsing trade with the destitute Soviets, has yet to weaken a currency so mighty that, what with social-democratic taxes, everything costs twice what it does in New York—unless you want a drink, in which case take out a bank loan. Finns do drink, with an almost sacramental self-consciousness that you must adore, even as you move around gingerly the next morning. More disturbingly, the country has a xenophobic streak. A recent presence of Somali refugees has occasioned overt racism. And I was astounded by an omnipresent Finnish licorice ad featuring a Sambo-like cartoon of a black African. Finns said defensively that the logo goes way back in time. I told them that so does cholera. I believe I won that argument, watching Finnish pride beat one of its practiced orderly retreats, this time in face of a politically correct

American. It seemed fair compensation for the sense of being spiritu-ally flimsy and superficial that, as an American, I experience in the dark gravity of Finland.

One of the best public performance works I ever saw took place in front of the Ateneum on opening day. It involved African drumming, gamely approximated by Finnish musicians. Choreographer Reijo Kela arrayed twenty-eight teenagers from the city's theater high school on oil barrels. Dressed in black and white and wielding pine branches, they danced free-form for seven hours. That's right, seven hours. Full of themselves above the passing crowds in Railway Square—against a great installation of rippling green-and-white-striped flags by Daniel Buren and the sublime National Romantic–style train station of Eliel Saarinen—the kids were over the top but so gorgeous and committed they made me crazy. I felt, "Stop, stop; no, don't stop!" They and the drummers went flat out for the last hour, and you could see bystand-ers going to pieces. It was like an angelic cavalry charge. I sensed a subterranean connection to the peak of Finnish art, a century ago, in the Ateneum's gloriously neurotic National Romantic paintings. That was a time of surging nationalisms and apocalyptic intimations. A bit like the present.

I thought of it again in Leningrad, where apocalypse is now. The city is huge and grand beyond anything I expected. Its nineteenth-century buildings by C. L. Engel, who also worked in Finland, gave me a first impression of an imperial Helsinki, with aspects of Paris and Amsterdam thrown in. But the beauty is a patch that unravels within a block of the Winter Palace, exposing uniform squalor. The tour went to the Hermitage. There I was overwhelmed by the Rembrandts and by a room of Matisses that nearly forced me to my knees. Like other lovely things in Leningrad, the staggering holdings end abruptly in 1914. Meanwhile, in a separate building of the Hermitage, there was a show of—get ready—Peter Max. I wish I could find that amusing. But the evidence of near-term Soviet vulnerability to Western hustlers is too awful. With its stupid Revolution finished, the USSR may be in for a flood of imported stupidities.

I can't prove it, but I think the solutions, good and ill, for that part of the world will entail old ethnic and national mysteries. I thought this during yet another Ateneum performance, at opening ceremonies attended by Finland's President Mauno Koivisto. Charismatically mournful-looking Koivisto (I love saying that name), his hangdog features over excellent bone structure evoking a thousand forest nights, sat in the front row with his vivacious wife, Tellervo. The evening ended with two bearded Danish veterans of Fluxus, sculptor Bjørn Nørgaard and composer Henning Christiansen, onstage wearing huge hooked plaster cones as hats and as codpieces and feathered chicken wings all over. Lurching around the stage and sometimes climbing a ladder, they made caveman noises, baby noises, animal noises, bird noises, and somehow mineral noises, a racket from a primeval Baltic of the mind. Imagine George Bush thus regaled, not that we have qualified shamans. From where I sat, Koivisto looked exceptionally mournful. But Christiansen told me afterward that Tellervo had laughed throughout. I like to think that she comforted her husband later.

<div style="text-align: right">Village Voice, June 11, 1991</div>

CASPAR DAVID FRIEDRICH

In Berlin a year ago last December, as the Wall came down, I was startled by having a happy feeling about repaired but still visible bomb damage to the Charlottenburg Palace, where I saw a wonderful collection of paintings by Caspar David Friedrich. The feeling was unconsciously called forth (I have decided) by my own and everybody else's euphoria at the liberation of the East. Old misgivings about a unified Germany surfaced as macabre pleasure in residual rough alteration by B-17s. I didn't have to brood on past events about which my nation had expressed itself satisfactorily when it counted.

Once again, now, I have been looking at paintings by Caspar David Friedrich, in a small but absorbing show of works from Soviet collections at the Metropolitan Museum, with an adrenaline level raised by the day's news. U.S. bombs are involved again, this time dropped less in righteous anger than with smug pragmatism. As it happens, I have thought of Friedrich occasionally these past months when seeing the regular recourse of news photography and television to the artist's signature motif of a lone figure, back turned, confronting a barren expanse at sunset or dawn. Now it's a GI and the expanse is sand, not a poetical fellow facing Baltic waters. But the pictorial structure is the same, as is the evoked feeling of heroic melancholy. The contemporary additive is patriotic goo: soldier pining for yellow-beribboned hometown. And just to make a connoisseuring approach to Friedrich truly tough, there is another historical matter.

Like Richard Wagner, Friedrich (1774–1840) has long had something to answer for in some estimations, as Hitler's favorite Old Master. He is associated with the Nazi participation mystique, a pathos that, considered as uniquely Aryan, encouraged Germans to do as they liked with other racial denominations. A foreboding is there to be seen in Friedrich, whose heroes wander their bleak landscapes defiantly sporting German medieval garb that was officially banned under the Metternichian new world order of that time. Spiritual abandonment to nature mixes with resentful nationalism, as if they entailed each other. The

retroactively sinister presumption has made me want to turn his moony guys around and slap them.

Nor is there a lot to be said for the artist's ideals of human relations. A big painting at the Met, *Moonrise by the Sea* (1821), in which two men stand out on a rock beholding the moon over the sea while their women watch them adoringly from farther ashore, becomes hilarious when you notice its allegorical equation of the men with two sailboats and the women with a pair of anchors. Likewise wacky is *Sisters on the Harbor-View Terrace* (circa 1820), a picture of two women looking across a nocturnal harbor at a forest of phallic masts and spires. One of the women touches the other's shoulder as if to say, "Steady, girl."

And yet Friedrich is great. Even the paintings just mentioned can sneak up on you with the artist's slow-acting disembodied color. The buzz of a Friedrich occurs when what have seemed mere tints in a tonal composition combust as distinctly scented hues—citron lights, plum darks—and you don't so much look at a picture as breathe it. He is an artist of pale fire, of twilight that scorches. His Romantic innovations, notably in emptying landscape of form to fill it with emotion, retain the edge of their radical novelty, still fresh after nearly two centuries. As for his frequent awkwardness, that is characteristic of any flat-out symbolizing art. Edvard Munch is often awkward, as is Edward Hopper. Really ambitious symbolism always drives art's communicative capacity to the breaking point, at frontiers of the inexpressible.

Born to a small-industrialist family in Pomerania and living most of his fairly sheltered life in Dresden, Friedrich was one of "the surplus of over-educated, highly ambitious, under-employed, and deeply frustrated middle-class young men" who fueled the explosion of Romanticism around 1800. (The quote is from a recent book, *Caspar David Friedrich and the Subject of Landscape*, by Joseph Leo Koerner.) Goethe was an early champion of his, though the scientific-minded great man eventually got fed up with Friedrich's doomy, free-floating religiosity. ("One ought to break Friedrich's pictures over the edge of a table; such things must be prevented," Goethe remarked with the moderation that we so admire in Germans.) Friedrich was touchy and shy. "In order not

to hate people, I must avoid their company," is one of his few recorded sayings. He was convinced of being a genius of the new Romantic law-unto-oneself type, and a lot of youths were quick to agree in Germany and other Northern countries, including Russia.

Friedrich despised France, which returned the sentiment. (The Louvre recently acquired its first painting by him.) After fashion ran against him in Germany, turning to naturalism and genre well before his death, he fell into near-oblivion unrelieved until the early twentieth century in Europe and little slackened in the United States until the 1972 publication of *The Northern Tradition: From Friedrich to Rothko*, by Robert Rosenblum, invigorated study of German Romanticism as a liberal movement whose shadowy aspects, under later peculiar circumstances, abetted a criminal regime.

No end of dark ironies may coalesce in the spell of Friedrich—ideally in Germany, which has nearly all his best works as well as the right associations. Friedrich's fondness for ruins, seen at the Met in wonderful sepia drawings, can seem to anticipate a century notable for producing ruins. (Tune in to CNN for the latest models.) We are not apt to think that about other painters of ruins.

It is Friedrich's fate, as in many ways it was his aim, to represent the most convulsive potentials of Romantic consciousness. He did it with pictures that are to the ultimate degree hushed and static—as charged with unseen power as those shots of soldiers in vacant deserts. Thinking of Friedrich, I feel close to an essence of sick excitement, of pleasure in immolation, that is war's spiritual lubricant.

Village Voice, February 19, 1991

JOSEPH BEUYS

Going again to see Joseph Beuys's immense 1970–72 photo-installation piece *Arena* before Dia shuts down for the summer, I reflected that I have never written anything exclusively about the late German, though like most other critics I have referred often to his spooky and benevolent eminence in art of the last quarter-century. I think I've waited to develop a clear take on him ever since he burst upon New York's consciousness in a 1980 retrospective at the Guggenheim. But unclarity may be of the essence, with Beuys, and I might as well make a subject of my confusion.

Recent world events goad me. Beuys was a prophet of ineradicable powers of irrationality in a postwar German culture that was hysterically certain of having buried them. Each sickening headline from Middle Europe, seeming to herald a new barbarism, increases the urgency of taking seriously the power of myths to make things happen. In Beuys's smoky aura, useful thoughts may form.

I was in rooms with Beuys a few times and shook his hand once, but I never spoke to him. Charismatic types make me nervous, and Beuys, who died in 1987 at age sixty-six, was the most charismatic man I've ever seen up close. He isn't done justice even by all the seductive photographs of him with his beat-up fedora, fishing vest, and hound-dog glamour. With courtly, shambling humility, he seemed, albeit unconvincingly, to put himself below others. Charisma may be the ability to convince people that they have potential they never suspected. Andy Warhol had it, too, though what his gaze conferred—celebrity—was superficial. Beuys seemed to detect untapped depths.

Ah, Germany. (Or is that Uh-oh, Germany?) Beuys, the shameless shaman, functioned as a living symbol of national rebirth, wandering into the nineteen-sixties out of the inferno of the forties, as if by a shock-dimmed and circuitous route from the wreck of the dive bomber in which, a Luftwaffe pilot, he had been shot down in Crimea. The Soviet gunner could not know that his bullets were initiating a legend that,

as Rosalind Krauss once noted, smacks of St. Paul's conversion on the road to Damascus.

Some people doubt Beuys's tale of being saved from the snow by Tartar tribesmen who wrapped his shattered body in felt and animal fat. Nonplussed by probing questions, he began to downplay his wartime experience, to the point of denying that his constant use of felt and fat in his art were related. The facts do and do not matter.

The ragged tracks of suffering in Beuys's countenance seemed real enough, and his conviction of having a vaguely apostolic mission was palpable. If he lied about his past, that just adds a cautionary note to a persona that functioned symbolically in a way peculiarly German. In Germany, persons are forever being swallowed into social roles, and the roles into abstract principles. In conversation there, I've caught myself wondering not *who* but *what* I was talking to.

Beuys was a one-man masquerade ball of self-displacements, embodying one abstraction after another in acts theatrically calculated to rivet and bewilder. His message was Utopia Now if only everyone would talk the talk and walk the walk that he demonstrated. His political program as an activist for unorthodox education and the nascent Green Party—liberty, democracy, ecological virtue—was unremarkably liberal in its ends, though arrived at by means including a theory of money that somehow (I don't get it) requires that every person be regarded as an artist.

Arena, with a mock-Nietzschean subtitle, "where I would have got if I had been intelligent," is a gravely beautiful collection of some four hundred black-and-white photographs arrayed in ninety-seven steel-framed gray panels. Three panels of intense monochrome, one yellow and two blue, interrupt the sequence. The snapshot-like photographs of objects, installations, and performances are grainy or blurry and often drawn or painted on. None of the subjects is identified, and their chronology is scrambled. Only deep-backgrounded Beuys fans will know what they are looking at. It's rather like the spectacle out the window of Dorothy's tornado-lofted Kansas farmhouse: memories swirling by.

All of Beuys's works are in a sense souvenirs of his activity, making *Arena* a souvenir of souvenirs—a dried garden of dried flowers. It succeeds, if you play along, in conjoining a physical here-and-now with a mental there-and-then and, at a stretch, a mystical above-and-beyond. I confess to cooperating only gingerly. My resistance seems to me typically American, an effect of pragmatism with shallow spiritual roots.

I can't imagine sharing Beuys's wild faith in the coherence of existence on a plane of abstract ideas. Still, I am grateful for the insight he affords into the totalizing compulsions always stirring in the depths of Germany, and not only Germany. I believe that he was a positive force, as a holy-foolish dispenser of antidotes to old toxins of fanaticism. But when I reflect on the persistence of the toxins, with Beuys's aid and the spur of the evening news, I tremble.

Village Voice, June 23, 1992

ANSELM KIEFER AT GAGOSIAN

There has been almost no art-world conversation about Anselm Kiefer since 1993, when a bizarre show at the Marian Goodman Gallery left a traumatized silence that has not dissipated. That occasion incidentally ended my friendship with the German artist, whose work I had often celebrated. I still think he's great. His recent things on view at Gagosian may be retreads of familiar motifs, but they're beautiful in the Kiefer way: brutal and exquisite, operatic and hushed. New vast paintings and massive handmade books, based on Kiefer's photographs of brickyards in India and inscribed with phrases of poetry, move me almost as of old when I am looking at them, though they lack his classic art's staying power in my mind.

In the seventies and early eighties, Kiefer changed the world as much as any artist can. Artistically, he dissolved contradictions between photography-based, intellectually dry Conceptualism and handmade, emotionally agitated Abstract Expressionism. He did so in service to a recklessly brave critical mission: unpacking mythic pathos and historical ironies of the Third Reich. For many, including me, his work melted a frozen curse on Germany. Kiefer made his fellow Germans nervous. He was received with thrilled gratitude nearly everywhere else, notably including Israel. His career is an absorbing, complicated story, now in the blind spot of art talk.

A major revival of interest in Kiefer seems likely at some point, but it will be difficult. He is a difficult man, as his revelations of 1993 made plain. Shortly before that, he left his wife, Julia, children, and longtime home in a forest town near Frankfurt and moved to his present estate in the south of France. He did something wild with his huge inventory of his own artworks, worth millions even in that moment of market recession. Rather than truck them to France, he made a ceiling-high stack of them, impaled on a steel rod and strewn with dirt and dried vegetation. He titled the never-to-be-disassembled heap *20 Years of Solitude*.

The reference to isolation was no mere literary gesture, it turned out. Hundreds of white-painted ledgers and handmade books complemented that skewered pile in the 1993 show. The pages were stained with the artist's semen. If you believed him—I never knew him to lie—his sex life during his last score of years in Germany consisted largely of masturbation onto paper, giving "bibliophilia" a new spin. Kiefer asked me to write a text for a catalogue of the books. I tried. Between shock and giggles, I failed. Other critics simply tiptoed away. Ever since, it has been as if the show never happened.

On the fresh May night of the 1993 opening, Kiefer and his companion Renate Graf threw an immense dinner party in a candlelit West Village loft hung with white muslin, carpeted with white sand, and staffed by mimes in whiteface. An elite throng of the New York art world was served a many-course meal of mostly white, generally ghastly food, including bull testicles, pancreas, and other arcane organ meats. (Seated across from me, the artist Sherrie Levine remarked, "You know, it's funny. I always thought I could eat anything.") Authored by a figure of legendarily hermitlike reticence, this event pitched somewhere between Federico Fellini and Caligula still bemuses. What did Kiefer expect? People couldn't forget the opulent ordeal fast enough.

Since then, Kiefer and Graf have divided their time between rural domesticity and world travels. Outside factories in India, he discovered bricks stacked by the thousands in arrays as monumental and evocative as they were accidental. At the time, he was reading poems by the Austrian Ingeborg Bachmann, who died in a fire in Rome, at age forty-seven, in 1973. Bachmann's abstract elegies on love and time are up Kiefer's metaphorical alley, and her identity suggests a valentine to Graf, who is Austrian, too.

The Gagosian show's centerpiece, an eighteen-foot-long painting of a pyramid, bears in German the charcoaled Bachmann line, "Your age and mine and the age of the world." The suggested algebra of littleness and bigness is Kieferian. He operates at simultaneous extremes of epic and lyric, grand and humble, transcendent image and crude

material, high-holy-day incantation and rough craft. A subtle humor inheres. Kiefer rarely gets credit for being funny. He seems to me dead serious only in intimate dynamics of touch and tone, stuff and color. Viewed from inches away, it can take your breath away.

Starting each of his new paintings and book spreads with an image in photographic emulsion, Kiefer applies acrylics, shellac, clay, and sand to build textures of incredible variety and sensitivity, ranging from grossness like that of volcanic debris to the delicacy of lichen. Notice, in a blizzard of sand colors, faint infusions of pink, rose, or rust like Proustian aromas. I was transfixed by a zone at the right-hand edge of the twenty-four-foot-long *The Square*, where apparently Kiefer used a blowtorch to char and crackle a bit of the surface. The effect is like a song tucked into a symphony.

Kiefer's command of the big and the little—macrocosmic scale, microscopic beauty—remains unbeatable, but he has rung no major changes in a decade. Nor has he found any compelling new theme for his work, since some plangent explorations of Christian and Jewish mysticism. The new work smacks of travelogue. For all I know, his genius, once subject to torments that no one suspected, has succumbed to late-blooming health and happiness. But I know from experience not to understand him too confidently.

Village Voice, February 17, 1998

SIGMAR POLKE

I feel in good hands with Sigmar Polke, which is peculiar, because the man is a nut. Actually, there's no paradox but instead a lurking truism: artistic genius tends to be a shifty, shady, half-crazy phenomenon in our civilization. Hold that thought while enjoying this show, at Mary Boone, of fourteen strange and beautiful two-sided paintings. Flat-out innovative and insouciantly masterful, the works make me high on hope for art.

Polke is forty-eight. From East Germany, like so many of the best German artists, he sat down in Düsseldorf in 1963 with fellow painters Gerhard Richter and Konrad Fischer (who would become a major dealer) and concocted a seminal response to American Pop Art. They called it "Capitalist Realism." As hip to anti-capitalist critiques by Walter Benjamin as to capitalist icons by Andy Warhol—and jet-fueled by trashy romances with science fiction, hallucinogens, and hippie-type mysticism—Polke commenced to play at painting rather like Jerry Lee Lewis plays the piano: none too exactingly and incredibly well. Ever since, he has gotten exciting music from an instrument he often seems bent on smashing to bits.

I've met Polke once, at the opening of the West German pavilion, with colossal mineral-flaked resin paintings, at the 1986 Venice Biennale. In a naked bid for public sensation, the opening was delayed until the last officially allowed moment. Masses of people, including swarms of paparazzi, attended. A chubby elf in a frantic Hawaiian shirt and green satin trousers, Polke bounced around, giggling, with a huge shoulder-mounted movie camera that he whirred at anyone trying to photograph him. (That must have made a nifty film—if the camera was loaded.) Perhaps miffed at such grandstanding, the Biennale prize committee split their "best artist" award between Polke, whose show was astronomically superior, and the English painter Frank Auerbach.

I had just published an essay on Polke in which I wrote of "primordial fear" in the way his art seemed to flirt with psychic disintegration. Introduced to me amid the Venetian clamor, he thanked me warmly for

my praise—then seemed exasperated, perhaps by a sense of sucking up to a critic. "Do you really find me *fright-ening?!*" he suddenly roared at me, making like a bug-eyed maniac. With that, he moved off, working his big camera, leaving me delighted. Later that day I encountered him wandering like a dazed tourist, with a woman, in a narrow street. He looked deflated inside his preposterous duds, lost-little-boyish. He smiled weakly and nodded. I wanted badly to talk to him, but the best I could manage was to smile back encouragingly.

Polke's theatrics reminded me that in Germany artists are often vested with shamanistic prestige, emanating some ratio of the prophet, the jester, and the sacred monster. Joseph Beuys was the champ at this, of course, but even before Beuys's death Polke was starting to run him a close second. Anselm Kiefer, an artist avowedly influenced by both Beuys and Polke, is the flip side of the type, reclusively abjuring any public presence at all. My glimpse of Polke's vulnerability brought the exhausting toll of the game home to me.

Polke's new works continue the influential coups by which he has energized painting with heterodox supports (every sort of non-canvas fabric), materials (witches'-brew chemicals in place of paint), technique (for example, overlay drawing), and imagery (for example, sleazy cartoon jokes). The most irreverent painter since Francis Picabia, he seems fascinated by how the medium's aesthetic unities survive no matter how much stress. The new paintings—on both sides of semi-transparent silk, clamped in stretchers—have, in effect, two fronts and no back. Much but not all of the marking on one side will show through on the other. I can think of no true precedent in art history.

As always, Polke employs a disjunctive sequence of procedures that add up without really blending. You can see exactly how he slathered orangish artificial resin, doodled drawings in black marker (faces, expressionistic stick figures, a rococo entablature, a Dufyesque landscape, a Mayan idol), suspended pigment in wet resin (drying in cloud-crystal patterns like *Scientific American* illustrations for an article on chaos), and painted mock-ups of the Ben-Day Dots screens often

featured in his earlier work. Viewed from either side, the accumulations of seemingly slapdash operations almost always feel achingly perfect.

The effect of the drum-tight silk darkened and made more transparent by the resin, like greased paper, is no cinch to describe. In my notebook I scribbled "tender glow, suavity, parchment, unhealthy skin, old bruises, dirty stained glass, hard candy, amber." It is, in any case, an erogenous membrane that draws a viewer into reverie. Lest you forget whom you're dealing with, an occasional stupid joke jumps out and bites you. A turdlike shape turns out to represent Mount Rushmore, which Mary Boone told me was Polke's idea of a greeting to America.

Seemingly a resilient type of the carefully deranged sixties leftist—erecting barricades amid his own brain cells—Polke at times has seemed out to test the bourgeois stratagem that Herbert Marcuse termed "repressive tolerance." Not that he is at all given to ideology. He seems a cheerful enough compromiser, despite a legendary fecklessness in administrative and business matters. Simply, he is a temperamental violator of any sort of purity. As a leading light, now, of Western art, he is like a parasitic growth that thrills its afflicted host.

Is it bourgeois of me to be reassured by Polke's continuing success? No doubt. (Painting is still *the* bourgeois medium, which is why leftists since Walter Benjamin have kept trying to scuttle it.) But the reassurance is hardly sentimental, laced as it is with tones of decadence and, yes, *fright-ening* deracination. Polke's triumph remains radically provisional, as moment-to-moment as life feels today, like walking in a haunted house where the next step could drop you straight through the floor with a burst of mad laughter fading away.

7 Days, April 26, 1989

MARTIN KIPPENBERGER

I first met the late German bad-boy artist extraordinare Martin Kippen-berger at the opening of a show of his in Madrid in the early eighties. Raffishly handsome and reeling drunk, in a tailored suit, he struck me as a blithely obnoxious Teutonic yuppie. The second and last time I met him, it was years later in Los Angeles at another of his openings. He was negligently dressed, bloated, and glum. In what I meant to be amiable banter, I recalled to him the earlier occasion. He gave me a tired look and walked away. It wasn't much of a relationship.

I disliked him, and he fascinated me. He was a significant actor on the art-world stage of his era—leading light in the fourth gener-ation of a German art juggernaut that had descended from Joseph Beuys through Sigmar Polke, Gerhard Richter, and Georg Baselitz to Anselm Kiefer, Jorg Immendorff, et al.—and he knew it. He was much sharper than other globe-trotting stars in his cohort, such as Gunter Forg and Rosemarie Trockel, whose art runs to precious I'm-an-artist longueurs. With Kippenberger, it was I'm-an-artist-and-you-know-where-to-put-it.

Did I dislike him in a way that he planned? That would make me a Kippenbergian. But no, it was a wrong way: a national thing. Having converged in the early eighties, German and American art cultures were veering apart again. Kippenberger's stance as a one-man Rat Pack (along with a gifted crony, the abstract painter Albert Oehlen) had an untranslatable spin. It expressed the mood of a prosperous but strangely sour time in West Germany.

Was Kippenberger cynical? You bet. He was a cynic's cynic and a dedicated self-destructor. Early death seemed foreordained. (Liver disease did the honors, in March of this year.) He was a scalding talker and writer. It was said of him that he would rather lose a close friend than suppress a snappy remark. He once wrote, "Sometimes I have the feeling that during the Nazi time they made a mistake with me, throw-ing away the birth and bringing up the afterbirth." He may have cribbed

the line from somewhere, seeing as how he wasn't born until 1953. You could rely on him to be unreliable.

A current show at the Barbara Gladstone Gallery of videos by Trockel features a sequence of Kippenberger's young daughter dancing as, off camera, he sings Sinatra's "My Way" in a voice that makes Sid Vicious sound like Mel Torme.

Kippenberger was staggeringly prolific, in many mediums. He was a virtuosic draftsman and a deft painter in the insolently trashy while densely skilled mode of eighties Neo-Expressionism in Cologne. He scattered anti-art gestures like loose change. The show I attended in Los Angeles consisted of large and gorgeous color photographs of big paintings by him that, after being photographed, had been destroyed, their remnants stuffed into Plexiglas bins.

Kippenberger luxuriated in self-loathing. His very success seemed steeped in disgrace for him. He sculpted several variations of a life-size figure enacting the title *Martin, Stand in the Corner and Be Ashamed of Yourself*. His sculptures of bent lampposts, sometimes dangling glass teardrops, are like monuments to alcoholism. As a citizen of self-help America, I find it hard to get with a culture in which being fucked up earns you points.

To deal with most of Kippenberger's work is to come away feeling soiled. He may be easiest to dislike precisely when most brilliant, as in his habitual tour de force of drawings on hotel stationery: strong fantasy images in a kaleidoscope of compelling styles, suggesting midnight illuminations of booze and perhaps other chemicals, plus jet lag, sex, and demoniacal anguish and glee. The drawings kill a soul into art. He didn't have much use for himself. Art had a use, and yet, in a scary way, he didn't care a lot about art, either. His game suggests the situation in chess called *zugzwang*. Any move that you can make loses.

The show centers on a huge sheet-aluminum sculpture of an uprooted subway entrance, part of a project that involved placing other faux entrances in Greece and Canada. The idea of a subway uniting the world has a feel-good aura unusual for Kippenberger. More typical was

his response when told, shortly before his death, that the nearly thirty-foot-long work would not fit through the doors of Metro Pictures. Crush it, he said. Heavy machinery punched and crumpled the thing until it could squeeze into place. The resulting rococo ruin looks good.

Kippenberger's nihilism blew through the world like a yakking ill wind. Had he liked himself a little, he might be a cult hero. As it is, whiffs of bile forbid identification with him. But he remains an unflinching representative of a time and place that, gaga about art for shallow reasons, could seem to make serious artistry a fool's errand. Someday there will be a proper Kippenberger retrospective, likely both dazzling and disheartening while lacking the master touch of an artist who, one of his dealers told me, would show up before an opening and, if finding any elegance in the installation, would do something on the spot to wreck it.

Village Voice, October 14, 1997

URS FISCHER

"Why must the show go on?" Noël Coward wondered. The question recurs apropos a desperately ingratiating Urs Fischer exhibition at the New Museum. Trivial japes by the mildly talented Swiss-born sculptor—the international art world's chief gadfly wit since Maurizio Cattelan faded in the role—are jacked up to epic, flauntingly expensive scale. There are huge aluminum casts of tiny clay lumps (you can tell by the giant thumbprints), walls and a ceiling papered with photographs of themselves, and big mirrored blocks that bear images of common objects. When a hole in a wall is approached, a realistic tongue sticks out of it. A faux cake is suspended in the air by hidden magnets. It's all nicely diverting—but from what? If you spend more than twenty minutes with the three-floor extravaganza, you're loitering. The New Museum could just as well not have done the show while saying it did. The effect would be roughly the same: expressing a practically reptilian institutional craving for a new star.

New Yorker, December 14, 2009

SHEPARD FAIREY

It was only about a year ago, though it feels like half a lifetime, that Shepard Fairey created the most efficacious American political illustration since "Uncle Sam Wants You": the Obama "Hope" poster. In innumerable variants, the craning, intent, elegant mien of the candidate engulfed the planet. I won't forget coming across it, last summer, stenciled on a sidewalk of a hamlet in the upper Catskills, where cell phones don't work and most people, if they vote at all, vote Republican. Underfoot, the small, tidy image organized its rustic environs as a frame for itself, like Wallace Stevens's jar in Tennessee. I was delighted, as an Obama supporter. But I was a trifle disturbed, too, by the intrusion on a tranquil—and, it suddenly proved, defenseless—reality of weathered houses amid humpbacked mountains. The result was strident and mystical, yanking my mind into a placeless jet stream of abstract associations. It exploited a familiar graphic device—exalted and refined by Andy Warhol—of polarizing photographs into solid darks and blank lights, thus rendering volumetric forms dead flat. Mentally restoring the splotches to rounded substance makes us feel clever, on the important condition that the subject excites us enough to elicit the effort. The reward with Fairey's picture was a thrill of concerted purpose, guarded against fatuity by coolly candid deliberation. The effect is that of epic poetry in an everyday tongue.

A "Hope" poster hangs alongside about two hundred and fifty slick and, for the most part, resistible works in a Fairey retrospective, his first, at the Institute of Contemporary Art, in Boston. The thirty-nine-year-old Fairey, a Los Angeles-based street artist, graphic designer, and entrepreneur, was born and raised in Charleston, South Carolina, where his father is a doctor. At fourteen, Fairey, a budding rascal, started decorating skateboards and T-shirts. He graduated from the technically rigorous Rhode Island School of Design with a bachelor's degree in illustration in 1992. While a student in Providence, he took to applying gnomic stickers and posters, without permission, to buildings and signs. The signature image of his street work is the cartooned face of the

wrestler Andre the Giant (André René Roussimoff, who died in 1993, and is remembered fondly for his role in the 1987 film *The Princess Bride*), accompanied at first by the wacky caption "Andre the Giant Has a Posse" and later by "Obey Giant" or, simply, "Obey." Lyrically paranoid, the motif was inspired by the artist's reading of George Orwell's *Animal Farm* and *1984*—a connection that looped back to the source last year when Penguin U.K. reissued those books with new cover designs, by Fairey. Fairey's street work popularized a going fashion for academic deconstruction, with pretensions to exposing the malign operations of mass culture. Hip rather than populist, the Andre campaign projects an audience dumb enough to fall for media manipulation while smart enough to absorb a critique of it. And, of course, it's vandalism—in the vein of urban graffiti—invading environments whose inhabitants, for all any artist knows, might like them just as they are. Boston's I.C.A. has condoned a citywide smattering of street art by Fairey, as an extension of the show. That makes sense. So does the decision of the Boston police to arrest him for it, on his way to the show's opening.

Fairey has run into a similarly predictable legal snarl with the "Hope" poster, having lifted the image from an Associated Press photograph. The original shows Obama seated at a dais (next to George Clooney) at the National Press Club, in 2006, and attending to a speaker who stands outside the frame, to his left. Knowing this deflates the mystery of an expression that has suggested, to some, a visionary surveying the future. Obama listens, merely, with a grimly amused concentration explained by the identity of the speaker, the arch-conservative Senator Sam Brownback, of Kansas. Anyhow, with the A.P. seeking compensation for copyright infringement, the artist has sued for a judicial ruling of fair use. This counterattack aside, the general issue is an old story of our litigious republic. Appropriative artists, including David Salle, Jeff Koons, and Richard Prince, have been sued at intervals since a photographer went after Andy Warhol for basing his *Flowers* series (1964) on one of her images.

As an art maven, I'm for granting artists blanket liberty to play with any existing image. I also realize that it is not going to happen, and

I'm bored by the kerfuffle's rote recurrence, with its all but scripted lines for plaintiff and defendant alike. It is of a piece with Fairey's energetic but unoriginal enterprise, with a repertoire of well-worn provocations—imitations of Soviet agitprop on shopping bags designed for Saks, to cite one example. Warhol sublimely commodified images of Mao and the hammer and sickle four decades ago, in keeping with an ambition—to infuse subjects and tones of common culture with powers of high art—that has not grown old. Warhol's revelatory games with the cognitive dissonance between art and commerce have galvanized artists in every generation since. But you can stretch a frisson just so many times before it snaps. Like the Japanese artist Takashi Murakami, who included a Louis Vuitton boutique in his Los Angeles retrospective, Fairey reverses a revolution achieved by Warhol. He embraces a trend in what the critic Dave Hickey has called "pop masquerading as art, as opposed to art masquerading as pop."

The aesthetics of Fairey's Boston show are formulaic, but they exercise immediate force. He is a terrific designer. His screenprints on paper, canvas, plastic, and metal, from found photographs and illustrations—publicity portraits, vintage advertising and propaganda, historical icons (Patty Hearst with a gun), satirically altered currency and stock certificates—deploy a standard palette of acrid red, yellowish white, and black. (The red, white, and blue of "Hope" were an ad-hoc departure.) Often, the images are overlaid on printed or collaged grounds of wallpaper-like pattern or fragments of newspaper pages, which impart a palimpsestic texture and a flavor of antiquity. Fairey's stylistic borrowings from Russian Revolutionary, Soviet, and WPA propaganda are often remarked upon, but borrowedness itself—studied anachronism—is his mode of seduction. But the old-timey charm is not inexhaustible. That leaves the inherent interest of his subjects and of the ready-made images chosen to represent them. These include, besides mainstream heroes like Martin Luther King Jr., and Muhammad Ali, Che, Fidel, Lenin, Stalin, Mao, Malcolm X, Angela Davis, generic freedom fighters, and "revolutionary women." Punks abound: Johnny

Rotten and Sid Vicious, Debbie Harry, Iggy Pop. Let George W. Bush pictured as a vampire exemplify the caliber of Fairey's satirical japes.

Fairey has said that the real message behind his work is "Question everything." I question the I.C.A. director Jill Medvedow's claim, in the show's catalogue, that Fairey pursues a "quest to challenge the status quo and disrupt our sense of complacency through his art." What isn't status quo about political rage? And have you met anyone not heavily medicated who strikes you as complacent lately? The retrospective is dated on arrival. Oddly, Fairey's tour de force for Obama anticipated a national mood, of serious-minded pragmatism, which makes ideological extremes seem quaint. I found myself regarding the show as strangely wholesome, like a vaccine that defeats the virus it imitates. It's as if Fairey meant to ridicule rebellion. I'm not sure he knows what he meant, beyond wanting to get a rise out of people. But if he did know— that is, if he were a better artist—he probably could not have helped change the world with one magically ambiguous picture.

New Yorker, February 23, 2009

FREDERIC REMINGTON

Where did I get the idea that Frederic Remington is some kind of cruelly underrated artist? The error is buried by this show, which proves that Remington, the turn-of-the-century maker of mythic images of the then recently housebroken Wild West, is rated just about right: terrific illustrator, erratic painter, lively but cornball sculptor, and beacon of macho-conservative nationalism. I have a column's worth of thoughts about him, but first I must sift through the wreckage of my overestimation.

It happened in a bar. The bar was called Remington's, in basement rooms on Waverly Place now occupied by a bar called Nowhere. Twenty years ago, Remington's was a hangout of choice for down-at-the-heels young art people put off by the expense and uptown tourists at Max's Kansas City. One spent beery evenings with shabbily attired loft dwellers in an ambience of saloon browns. The only reliable aesthetic objects were reproductions of Remington paintings.

With a mind stimulated by conversation and standards made magnanimous by alcohol, I would look upon those images, my heart filling with a sense of something fine and lost. It was complicated nostalgia, probably drawing on my prairie upbringing—largely in Northfield, Minnesota, fabled site of Jesse James's disastrous last bank raid—and my old love of Western movies, a genre then mired in the exciting but terminal decadence of Sergio Leone and Sam Peckinpah. I think it was also a yen for brushy narrative painting, which was taboo in art then.

I am relieved to confirm that the picture that most transfixed my tired and emotional regard at Remington's really is good: *Fight for the Water Hole*, which still seems to me better than anything else by the artist except his one and only bulletproof masterpiece, *The Scout: Friends or Enemies?* The latter is a moonlit snow scene in which your gaze, from behind, at an Indian scout is relayed into empty, blue-white depth, toward the tiny fires of a far-distant encampment. An early work, done when Remington was only twenty-nine or so, though already famous as a magazine illustrator, *The Scout* may be his only painting with a

satisfying internal dynamic, neither ponderously arty like his later Impressionist pastiches nor, in the common way of his illustrational style, simply shoving something wild and woolly in your face. Smoothly adapting a motif of European Romanticism—Caspar David Friedrich goes to Montana—it works on all levels. Even Remington's pedantic detailing of the Indian's costume and horse is poetic, for once, because the picture is about a desperate straining *to see*.

Fight for the Water Hole—five cowboys defending a nearly dried-up desert pool against circling Indians—is absorbing as a neither-fish-nor-fowl stalemate between painting and illustration. Its even tones of lavender-gray, butter yellow, and powder blue seduce the eye into a vast and indifferent landscape in which a deadly action is slowly unfolding. The illustrational quality is given mainly by an implausible point of view, that of someone standing (suicidally, under the circumstances) outside the lip of the contested hole. In this regard, *Fight* relies on a literary rather than a painterly convention of narrative.

Actually, there's another word for that convention of a disembodied, omniscient narrative eye: cinematographic, the artistry of avidly intrusive camera angles. Remington's bravura compositions are more than halfway from their sources in nineteenth-century painting to the movies of, say, John Ford. The distinctively angled cavalry column in *The Quest* could be a gussied-up still from *She Wore a Yellow Ribbon*. Considered as a cultural-industrial engineer—a technician of the higher cliché—Remington was major. As a painter, he was pretty hopeless. His stabs at Impressionism show the problem: formulaic figures dabbled with, rather than made of, feathery strokes.

As a man, Remington was a pig. And I don't mean just that he was carrying nearly three hundred pounds on his five-nine frame when he died after an appendix operation at the age of forty-eight, in 1909. I mean this sort of thing, from a letter to a fellow oinker by the name of Poultney Bigelow: "I've got some Winchesters, and when the massacring begins which you speak of, I can get my share of 'ern and what's more I will. Jews—injuns—Chinamen—Italians—Huns, the rubbish

of the earth I hate." A New York native who did most of his work in New Rochelle, he lied about his practically nonexistent exploits in the West, which he never visited for more than a month or two at a time. Teddy Roosevelt's reputation gains no luster from the fact that Remington was a pal of his.

(The above information, from a splendid catalogue essay by David McCullough, does honor to a show that tempers its excessive claims for Remington with candid scholarship. In a related vein, an entertaining section of bronze sculptures cheerfully acknowledges that several "Remingtons" in the Met's collection, for half a century, have turned out to be unauthorized casts at best.)

Remington's career sheds historical light on the phenomenon, symbolized by Teddy R., of the United States's turn to full-bore imperialism after the last recalcitrant Indians were crushed. As an artist-correspondent in Cuba in 1897, he was the supposed recipient of William Randolph Hearst's legendary cable: "Please remain. You furnish the pictures and I'll furnish the war." He did wonders for Hearst's jingoing with a sensationally successful propaganda sketch based on a false report about a lady strip-searched by Spanish soldiers. It is one of his few images of women. "I don't understand them," he explained.

Remington's thoroughly cinematic painting of the *Charge of the Rough Riders at San Juan Hill*—Teddy on a horse, the attentive leader of running and whooping men, one of them being inconvenienced by a bullet in the chest—makes the affair "look more like a football game," as McCullough remarks, than like war, but there is a sickening truthfulness about it. Precisely that rah-rah spirit sent America galloping into this century with a whole new style of geopolitical mischief, from San Juan Hill to the Tet Offensive. (Teddy, meet Ho Chi Minh.)

Still and all, it makes sense in the present twilight of American global sway (Teddy, meet Toyota) to look afresh at the culture of its dawn, in which Remington was a morning star. The reexamination ought to cure nostalgia while perhaps intensifying fascination—in the way of the startlingly good recent TV miniseries of Larry McMurtry's *Lonesome Dove*. Little else that might happen in the nineties would make me, for

one, happier than a big revival of the Western, a consummation made thinkable by the McMurtryesque principle of looking each messy fact of the epoch and its heritage in the eye. Dead as a motive force (knock on wood), the romance of the Wild West seems newly retrievable as a smoky forge of American destinies.

7 Days, March 15, 1989

CHRISTOPHER WOOL

Like it or not, Christopher Wool, now fifty-eight, is probably the most important American painter of his generation. You might fondly wish, as I do, for a champion whose art is richer in beauty and charm: Wool's work consists primarily of dour, black-and-white stencilled words, in enamel, usually on aluminum panels; banal patterns made with incised rollers; and variously piquant abstract messes, involving spray paint and silkscreens. Let's get over it. A dramatic retrospective at the Guggenheim Museum confirms, besides a downbeat air, the force and the intelligence of a career that, according to legend, caught fire in 1987, after Wool saw the words *sex* and *luv* spray-painted in black on a white delivery truck. His stencilled repetition of those words, on paper, is among the earliest works in this show.

A cutely vandalized truck would seem a pretty humble epiphany, as epiphanies go, but it inspired a way of painting that quietly gained authority while more ingratiating styles rose and fell in art-world esteem. If you are put off by the harshness of Wool's rigor, as I was, it means that you aren't ready to confess that our time admits, and merits, nothing cozier in an art form that is besieged by the aesthetic as well as technical advances in photographic and digital mediums. Once you stop resisting its gloominess, Wool's work feels authentic, bracing, and even, on occasion, blissful.

Wool was born in Boston, to a molecular-biologist father and a psychiatrist mother, and grew up in Chicago, enthralled by art. In 1972, he entered Sarah Lawrence College, where he won permission to take two exacting studio courses, in painting and photography, on the promise that he would buckle down to required courses the next year. Instead, he dropped out, moved to Manhattan, and enrolled in the New York Studio School, the diehard academy of Abstract Expressionist technique and style. That training served him well. In a fine catalogue essay, Katherine Brinson, the curator of the Guggenheim show, notes a standard emphasis of Studio School instruction: the rendering of forms in charcoal by partial erasure. (Wool's later paintings do wonders

with passages that are thinned, rubbed, overpainted, or wiped away.) Meanwhile, he plunged into the emerging East Village scene of punk rock, underground film, gallery graffiti, performance art, and up-all-night dissipation, as immortalized in the photographs of Nan Goldin. His friends and sometime collaborators included the painter James Nares, the writer Glenn O'Brien, and the poet-rocker Richard Hell. Wool briefly studied filmmaking at New York University, but by 1981 he had settled into painting, at first producing gawky abstract shapes that were influenced by the sculptor Joel Shapiro, who employed him as an assistant.

The efflorescence in downtown art was racked with schisms. Hot Neo-Expressionist painters like Julian Schnabel and Jean-Michel Basquiat went one way, feeding a vogue that became a market frenzy; and cool "Pictures" conceptualists, including Cindy Sherman and Richard Prince, went another. Money that favored the former eventually got around to the latter. It can't have been clear at the time that Wool's middle way, of earnest painterly invention, which was anything but seductive, would triumph. Several other painters—among them Peter Halley, David Reed, and Jonathan Lasker—gained success with conceptually alert abstract styles. Those artists now seem dated. Wool doesn't. His works ace the crude test that passes for critical judgment in the art market: they look impeccable on walls today and are likely to look impeccable on walls tomorrow. Lately fetching millions at auction, Wool's art leaves critics to sift through the hows and the whys of a convergence of price and value. Would that the expensive were always so good.

Renunciation benefitted Wool. He did not use color, or expressive gesture; their meanings could not be controlled. Nor did he indulge, as his friends Robert Gober, Richard Prince, and Jeff Koons did, in the ironies of adopting themes and images from mass culture. (Koons wrote the press release for Wool's solo show, in 1986, at the short-lived Cable Gallery, keenly observing that "Wool's work contains continual internal/ external debate within itself.") Wool liked the éclat of Pop-influenced art but not its subject matter. Around the time of his delivery-truck eureka, he hit on a witty means of grounding high art in the everyday:

the incised paint rollers once commonly used by slumlords to make tenement halls and stairwells look wallpapered. The paintings that resulted—floral or grille-like patterns, with skips and smears suggesting haste—have just about everything you could want of an all-over abstraction, plus the humor of their absurd efficiency. Can painting be so simple? It can for an artist who has despaired of every alternative. The expedient of the rollers, like that of the words that Wool proceeded to paint, suggests the ledges to which a rock climber clings by his fingernails.

Word painting has a history, from the snatches of newspaper text collaged by the Cubists to Ed Ruscha's portraits of words that pique the mind's incapacity to look and read in the same instant. Barbara Kruger and Jenny Holzer have worked primarily with language; Lawrence Weiner does so exclusively. But Wool made it new. He merged the anonymous aggression of graffiti with the stateliness of formal abstract painting. Selecting words and phrases that appealed to him, he leached them of personality, by using stencils, and of quick readability, by eliminating standard spacing, punctuation, and, in one case, vowels ("TRBL"). The effort required to make out the messages may be rewarded, or punished, with a sting of nihilism: "CATS IN BAGS BAGS IN RIVER" or "SELL THE HOUSE SELL THE CAR SELL THE KIDS." (The latter is from a deranged officer's letter home in *Apocalypse Now*.) Once read, the words don't stay read. When you leave off making sense of three stacked blocks, "HYP/OCR/ITE" or "ANA/RCH/IST," they snap back into being nonsensical graphic design. We're not talking about a major difficulty here, but just enough to induce a hiccup in comprehension, letting the physical facts of the painting preside. The effect calls to mind Jasper Johns's Flag paintings, with their double-bind readings of paint-as-image (it's a flag) and image-as-paint (it's a red-white-and-blue painting).

Traces of past American masters—Rauschenberg's sprawling montage, Twombly's sensitive scribble, Warhol's off-register silkscreens, Guston's clunky animation, and even some dynamics recalling the god of the Studio School, de Kooning—abound as the show unreels up the

Guggenheim's ramp. Wool increasingly mixes and matches mechanical and freehand methods in layered compositions. Thus, rolled patterns interact with splotches, transferred by silkscreen from earlier paintings, and with interweaving skeins of spray paint. Wool no longer eschews gesture; sprayed lines curl and buckle in taut relation to the scale of the pictures. (That's de Kooning-esque.) Colors—yellow, brownish maroon—begin to make eloquently sputtering appearances. With no hint of pastiche, and still less of nostalgia, he is reinventing certain charismatic tropes of mid-century New York painting—or recovering them, as if they had been wandering around loose all this time.

I question the choice to mount many of the big paintings on cantilevered struts, so that they appear to float, in some of the museum's curved, top-lighted bays. It's like a magic trick that delights once. Deprived of flat walls, the pictures look lost. In a more apt tour de force, hundreds of black-and-white photographs are arrayed at intervals. Wool took them on nocturnal rambles between his studio, in the East Village, and his loft, in Chinatown. They are dismal with a vengeance, an encyclopedia of wrack, ruin, and squalor, wanly bleached by flash illumination. To make the world appear uniformly horrible requires discipline. Wool's grim shutterbugging suggests a peculiar creative psychology. When he feels bad, it would seem, he perks up. And when he feels worse, he's golden.

New Yorker, November 4, 2013

WEEGEE

I would like a chemical analysis of the taste that Weegee had in his mouth when he worked: cigar juice and microbial cultures spiked with adrenaline by-products. I'm glad to have missed his smell, that of a slum bachelor who slept in his clothes. He worked at night with a plate camera in situations that might give him just one stab at a salable picture, delivered to a newspaper before sunup. I think that the taste helped him. Eyesight may merely have chaired the committee of his senses, including a dog's ear for giveaway noises and an intellectual itch in his skin. If, for one instant, you could experience your body as Weegee did his all the time, your sanity would totter.

The immortal power of Weegee's photojournalism, circa 1935–1947, seen in a vast and entertaining show at the International Center of Photography, owes much to its tacit registration of the non-optical senses, which clamor mutely to be credited. Weegee's eye swam in a stew of sensations. His Naked City rarely bathed. His original flash glossies, their shrieking contrast calculated to survive degradation on newsprint, are almost less visual than tactile. They paw at what's there, with a formal character like bas-relief: sheets of glare pounded down around shapes that bulge from nothing. The pictorial space is shallow. Like Cubism. No wonder the Museum of Modern Art started buying and showing Weegees in 1943. Here is medium-specific stylization raised to a screaming pitch.

The photographs are instant icons, investing tatterdemalion drama with weird, cold glamour. No matter how circumstantial, the scenes feel timeless, as if they—and, by implication, everything else in existence—were scripted in advance. Weegee pulled triggers of mass response. You cannot have a personal relation to his pictures.

Weegee wasn't above faking a shot. To get his famous one of a street woman sneering at bejeweled socialites, he plied the woman with liquor and shoved her into the frame. You have a problem with that? If your livelihood depended on producing a drop-dead image before dawn, you might jigger the odds in your favor, too. That heroic age of

the tabloid game demanded the instincts and approximately the ethics of a sewer rat. Weegee set the standard. Even his gross self-promotion was expedient. He could get a picturesque rise out of people just by showing his face.

Cops and firemen hammed up their roles for him. You can see them doing it semiconsciously. New York, New York: where everyone, sensing an event, stars in it. The odd spontaneity gets mopped up by a passing archetype. In a shot captioned *The Human Cop*, a policeman's unremarkable concern for a stretchered victim becomes Christ's second coming. People knew what Weegee wanted. When not starkly voyeuristic, his pictures bespeak streetwise complicity.

Corpses were on their mettle for him. Another echt-New York photojournalist, James Hamilton, once told me that death is the perfect subject in this line. Besides being surefire arresting, it affords leisure to consider and even (if less scrupulous than Hamilton) to goof with the staging. I only half believe some Weegee death scenes, such as the terrific composition of a man killed by police, crumpled in the background on a broad sidewalk, with a cheap-looking revolver resting in a pool of light in the foreground. That pistol rouses suspicions of a cop-exonerating "throw-down" or, anyway, an artfully arranged still life.

Nothing human was alien to Weegee, but he was no humanitarian. Some critics try to make him out as a bighearted man of the people. He was of the people, all right, but as a breed: New York feral. His work is so exciting that you can miss how depressing its moral premises are: no dignity, no escape. His disdain for the rich might be leftist, if that cheers you up, but it seems mainly to channel popular animus at an imagined pretense to be "better than us." The ideology is tabloid democracy, which holds to be self-evident that nobody is entitled not to wallow in shit.

Weegee sped to sites where blood exited human containers to become interesting stuff in the world. The same went for the grief or glee of onlookers in the aftermath of a homicide. It went, too, for the lust of youths who felt safe at night under the boardwalk at Coney Island. They never heard of infrared film. Whatever could impress itself on a

light-sensitive emulsion was fair game. Weegee was Moses who gazed into the Promised Land that we inhabit now, where privacy is a default zone for things that interest no one at the moment.

His mountaintop was Sammy's Bowery Follies, one of the century's great social ground zeros. Sammy's was a carnival of poverty and failure catering to the unpoor and unfailed. Old, fat, sick vaudevillians strutted their rancid stuff for an uptown crowd. They were more than happy to have their obsessions with performing applauded as such. Sammy's held over a pageant of the Great Depression for indefinite encores. Weegee loved it.

He was a real artist, meanwhile—an intuitive genius somewhere between an Atget and a Douanier Rousseau. You can tell by his response to other real artists. Just two photographs, by my count, of the hundreds in this show convey reverence for persons. They are of Alfred Stieglitz and Lisette Model. A cruder fellow feeling informs Weegee's shots of Salvador Dalí, whose influence pointed the scrabbling Lower East Sider toward the cornball Surrealism of his later years.

After retiring from the gutter, Weegee became a sucker for his own stuff. He was never that before. His photojournalism gulled, and still does, everyone except himself—a Mephistophelian dandy with bad breath. You can't avoid feeling soiled by his classic work, and you can't avoid praising it unless wanting to advertise your moral superiority. If you're like that, nobody here wants to know you.

Village Voice, December 9, 1997

ADOLESCENTS

Someone said that adolescence is a mental illness cured by time. I concur. Besides evidence from parenthood and general observation, I have the example of my own teen years. It's not that I remember being crazy. (Is that even possible?) It's that my memories of the time are so strange. What come back aren't events—except by subsequent guess, like stories about someone else—but feelings in a hormonally juiced fog. It might have been a dream but for documentary evidence including photographs of the teenaged me. Not that those show a person I recognize. They reek of innocence, which is impersonal, and attempted attitudes, which are pathetic. (I never want to go through that shit again.)

Nor am I enthralled with adolescence as a subject for art photography, though it yields some riveting images in this group show at the Julie Saul Gallery. Adult takes on teenagers tend to be creepy and, well, adulterating. Teenagers sense this. Unless employing classic forms of tragedy (*Romeo and Juliet*) or comedy (*Clueless*)—or perhaps love, though that opens a loophole for ghastly Humbert Humbert—the scrutiny is exploitative: a gaze that knows what it likes delectating a creature that doesn't know yet that it knows nothing.

Commercial engineering of perceptions of adolescence, for dissemination to adolescents, is rife now. Advertisers signal to youth, "This is how you can be impressive and/or alluring," The transaction is perfectly honorable. Adolescents want illusions of power, and marketers want money. They swap. Everybody's happy—if cynicism is happiness, in what sometimes seems the only equation that is operative these days.

Things used to be different, as witness a dazzling contrast between nineteen-forties studio portraits by Disfarmer, the Arkansas Nadar, and nineties shots by Adam Bartos of well-to-do youths at a state park in Montauk. Disfarmer's war-era kids pass the awkward age in football uniforms or movie-magazine-influenced hairdos. They belong to a society that is functional, though rather grim, for adolescence. The world that Bartos captures is dysfunctional but buoyant. His subjects address

the camera with calculated aplomb learned from lifelong immersion in media.

So image-conscious is today's youth that, to find naïve specimens, a photographer must venture far afield, like a butterfly collector. Judith Joy Ross does it in Pennsylvania towns, where, achingly unaware, a boy guitarist with hair over his eyes and a homely girl in a bathing suit stir feelings pitched between amusement and worried compassion.

Ross's work is almost honest enough to stand up in the company of pictures by Diane Arbus, whose greatness keeps growing retrospectively. Arbus regarded life as a devouring element, smashing and grinding individuals. Consider her shot of an angry youth, *Teenager with a Baseball Bat, N.Y.C.* (1962). You know instantly that he harbors deep hurt and is primed to pass it on. If you don't turn away scared, you recognize his pain as an amplification of your own. (How else could you understand it?) Arbus's images aren't illustrations of suffering. Each lays bare suffering's hideous heart.

Zoologists speak of "critical distance" in the behavior of threatened animals. Within it, an animal will attack. Outside it, the animal will run away. The trick of lion-taming is evidently to keep the big cats precisely suspended between fight and flight. Arbus's people suggest such a suspension. A bit farther removed, they would become spectacle, as in classic Robert Frank. Any closer, they would become symbiotic, as in Nan Goldin. Arbus is among the bravest while also cruelest artists of the twentieth century.

This show reminds me that I hate August Sander, the Weimar typologist whose pictures here with titles *Middle Class Child* and *Blind Children* exalt social science. Try viewing any of Sander's subjects as a specific person, whom you might know. You can't. Each is a token in a game of arrogant categories. How twisted was German avant-garde culture on the eve of Hitler?

Not that present American culture is wonderful, though its signature excesses in the picturing of adolescence do not appear in this show. Sally Mann and Larry Clark are elsewhere, for a change, and so is the moral anguish that attends their different brands of exploitive

aestheticism. Mann and Clark obliterate the personhood of their subjects in a narcissistic American way. We are sucked into fretting about whether Mann is a good or a bad mother and whether Clark is a mentor or a lecher. Their art status dissembles the truth that the dynamic is only about themselves, self-congratulated on their coldness. It's art because otherwise it would be unforgivable.

In a better world than ours, adolescence would run its course in relative shadow. Sometimes the kindest adult service to youth is an averting of the eyes. The Dutch photographer Rineke Dijkstra nails the problem with surprisingly respectful pictures of teens awkwardly posed in bathing suits on beaches. With just a slight, indispensable whiff of objectification, she vivifies beings that are not what they were and not what they will be, biological and psychological blurs of change no more stable than the ocean waves behind them.

Village Voice, August 17, 1997

MARK MORRISROE

Mark Morrisroe was a scuzzy kid with good luck in friends. Or was he a Rimbaudian prodigy? The verdict hangs fire for the Bostonian hustler-poet-photographer who died from complications of AIDS, thirty years old, in 1989. How you describe him bears on present confusion about the art world's rebellious peripheries, for which we have no apt word, *avant-garde* and *bohemian* being threadbare. I sense gnawing questions, while enthralled and a trifle nauseated, in this show of Morrisroe photographs at the Pat Hearn Gallery.

Desultory black-and-white Polaroids, with emotional tones that feel translated from fin de siècle French, cast spells. Some—a fancy gravure suite printed posthumously—are only too seductive: poverty-scented luxury goods. The Morrisroe estate, reportedly large, could be a gold mine if properly promoted, as I hope it will be. We will be well served, on several counts, by having Morrisroe in our faces for a while. The promotion itself will spotlight a timely issue.

Morrisroe belonged to a movement of photographic artists, lately dubbed the Boston School, that includes Nan Goldin, Jack Pierson, David Armstrong, and Tabboo! (Stephen Tashjian). They met at art schools in the seventies and egged one another on in their common preoccupation with, as the art historian Norman Bryson has put it, "breaking the spell of impersonality that from its earliest beginnings photography has cast over our visual field." They stuffed their lives down the camera's throat.

The Bostonians reacted authentically to a situation in new art photography that was dominated, at the time, by pictorial mediating of, you know, mediated media mediations. Rather than deal in signs of signs and images of images, they sought bedrock in exposure of their first-person, sex-saturated, fantasy-realizing, determinedly reckless experience. Their faults of callowness were obvious at once. Their strengths become more striking with time.

The key is self-consciousness so intense as to go inside-out, naked to the moment. Fear of isolation drives it. Each shutter-click responds

to an emotional emergency. The picture affirms that the photographer is not crazy, or not only crazy. Looking and being looked at made whatever was happening real. The manner of the look mattered. Care was taken to make the pictures beautiful and touching, because the parties involved had to become famous.

"I was a wreck," Pierson has said of a stunning photograph Morrisroe took of him in 1982, when they were lovers, "and Mark seemed like he'd be the next Warhol if we could just get to New York." The New York that they had in mind hardly existed by then. Had it ever? Maybe it always does, with the caveat that it evaporates the moment you set physical foot here.

Morrisroe was a teenage prostitute, the son of a promiscuous mother. He insisted that his shadowy father was the Boston Strangler. Louchely cute, he limped from a bullet in his back received at age sixteen, when he called himself Mark Dirt and edited *Dirt*, an estimable fanzine whose six issues appear in the show. When he painted swastikas at Boston's School of the Museum of Fine Arts, there was a debate about expelling him. Permissiveness won.

What is it about Boston? The chronically talky, unvisual city funnily mingles Puritan starch, liberal pieties, and variegated mean streaks. Transgression can seem more dramatic there than in less high-strung American places. Morrisroe and his friends soon had a fierce and woozy scene going, centered in performances, film screenings, drag shows, and other nighttime diversions.

The photographs are theatrically intimate. Many are self-portraits in variously arty or porn poses, or cross-dressed. Some are arch "nudes" of friends, mostly female. Others have anecdotal airs: someone drunk and/or freaking out. A window view of a wintry parking lot nails a bleakness of empty time. Poetic scratches and blurs recall the photo-collages of the Starn Twins, who also arose in Boston at the time, but with nebulous content. Morrisroe's tactics are always about something.

It is hard to characterize his work without stumbling into clichés: self-invention, dandyism, gender-bending, the *maudit*. The difficulty may be the master key, an effect of having contempt for aesthetic

manipulation but giving your life over to it anyhow. With what result? Rage, neurotic symptoms, and perhaps art—a benediction that you must never explain. Let someone else figure it out.

"Mark was an outlaw on every front," begins a statement by Goldin, a great artist and the Boston School's doyenne. Morrisroe certainly broke laws, not to mention what he did to common sense. But the term feels decrepit in our era of dysfunctionality theory and gangsta rap.

The cogency of Morrisroe's story has to do with playing the hand that life deals you. If the hand—yourself—is exotically impaired, that makes the play easier to follow. You wouldn't act this way if you had a choice. Or would you? Meanings shuttle between fate and fantasy, case history and chic. Morrisroe's work is truly glamorous, which seems a fair return on his self-immolation. He died for it—of a chance disease, but something was bound to get him, if only the F. Scott Fitzgerald no-second-act blues.

The question of the hour, to which I have no answer, is how Morrisroe's punk-Faustian bargain adds up culturally. Is it negotiable in spheres of high art? If not, there's no surprise. Rock music so efficiently channels flaming youth that art, with its slow uptake, can scarcely compete. But if Morrisroe does prove inescapable, it will signify that social dislocation has come alive at depths that only art can sound. Like his, the resulting work will have blood in its veins and perhaps on its hands.

Village Voice, April 9, 1996

LOUISE LAWLER AND
INSTITUTIONAL CRITIQUE

I remember when photographs by Louise Lawler, currently the subject
of a retrospective at the Museum of Modern Art, first hurt my feel-
ings, some thirty years ago. They pictured paintings by Miró, Pollock,
Johns, and Warhol as they appeared in museums, galleries, auction
houses, storage spaces, and collectors' homes. A Miró co-starred with
its own reflection in the glossy surface of a museum bench. The floral
pattern on a Limoges soup tureen vied with a Pollock drip painting on
a wall above it. Johns's *White Flag* harmonized with a monogrammed
bedspread. An auction label next to a round gold Warhol "Marilyn"
estimated the work's value at between three hundred thousand and four
hundred thousand dollars. (That was in 1988. Today, you might not be
permitted a bid south of eight figures.)

I knew what Lawler's game was: "institutional critique," a strategy
deployed by members and associates of the Pictures Generation. That
theory-educated cohort—which included Barbara Kruger, who pro-
duced mordant feminist agitprop, and Sherrie Levine, who took dead-
pan photographs of classic modern photographs—beamed contempt
at established myths, modes, and motives of prestige in art. As a sort
of mandarin parallel to punk, the movement disdained the idealism of
previous avant-gardes. I found most of its ploys lamely obvious: bullets
whizzing past my head. But Lawler got me square in the heart.

There is a recurrent moment, for lovers of art, when we shift from
looking at a work to actively seeing it. It's like entering a waking dream,
as if we were children cued by "Once upon a time." We don't reflect on
the worldly arrangements—the interests of wealth and power—that
enable our adventures. Why should we? But, if that consciousness is
forced on us, we may be frozen mid-toggle between looking and seeing.
Lawler's strategy is seduction: her photographs delight. We are beguiled
by the bench, wowed by the tureen, amused by the bedspread, and
piqued by the wall label. She knows what we want. Marcel Duchamp

called art "a habit-forming drug." Lawler deals us poisoned fixes. The image of the Warhol appears twice in the show, under two titles: *Does Andy Warhol Make You Cry?* and *Does Marilyn Monroe Make You Cry?* Your emotional responses to the painting are thus anticipated and cauterized. The effect is rather sadistic but also perhaps masochistic. Lawler couldn't mock aesthetic sensitivity if she didn't share it. Her work suggests an antic self-awareness typical of standup comics. It feels authentic, at any rate.

Lawler was born in 1947 in Bronxville, New York. Having graduated with a bachelor of fine arts degree from Cornell University in 1969, she moved to New York City and got a job at the Leo Castelli Gallery. That's about the extent of the biographical information she has made available. She shuns interviews, and whenever she is asked for a photograph of herself she provides a picture of a parrot seen from behind while turning its head to look back at you, Betty Grable style. Lawler varied that tactic in 1990, when the magazine *Artscribe* requested a likeness for a cover: she submitted a photograph of Meryl Streep (with the actress's permission), captioned "Recognition Maybe, May Not Be Useful." Lawler's stand against celebrity deserves respect, despite the fact that it comes from an artist whose work advertises her entrée to the inner sanctums of museums and private collections—her derisive treatment of them notwithstanding—and her ability to have Meryl Streep return her calls. The road to becoming famous while remaining unknown does not run smooth.

Yet although Lawler has resisted public exposure, she has been collegial with her peers. Among the early pieces in the MoMA show are two photographs, from 1982, of works by fellow artists, including Sherrie Levine, Roy Lichtenstein, and Jenny Holzer, which Lawler had arranged in two different groups, on black backdrop paper, in one case, and tulip-red paper, in the other. Dominating each arrangement is a "Cow" poster, by Warhol, which he sent to Lawler in 1977, in return for the favor of giving him a roll of film at a party when he had run out. She has photographed more works by Warhol than by any other artist, and with what seems an unusual affection; her own art wouldn't be

conceivable without his trailblazing conflations of culture high, low, and sideways. But Warhol's happy commodifying of art couldn't sit well with her, given the ideological slants that she shares with others in her social and artistic milieu.

From 1981 to 1995, Lawler was married to Benjamin H. D. Buchloh, the formidably erudite German-American art historian and apostle of Frankfurt School critical philosophy who can winkle out malignancies of the hopefully termed "late capitalism" in just about anything. Certainly, her work has invited that sort of analysis, which some of the eight essays in the show's catalogue doggedly apply. But one essay pleasantly surprises. In it, the British art historian Julian Stallabrass wonders how it is "that Lawler's art, which is sly, slight and light, quick, jokey, agile, epigrammatic, and perhaps subversive, has elicited a literature that is slow, ponderous, grinding, and heavy." Lawler's tendentious critics lumber past the sense of a personal drama—ethics at odds with aesthetics, and rigor with yearning—that makes her by far the most arresting artist of her kind. She transcends the dreary impression, endemic to most institutional critique, of preaching to a choir.

Humor helps. Having landed herself in a war zone between creating art and objectifying it, and between belonging to the art world and chafing at it, Lawler capers in the crossfire. She charms with such ephemera as paperweights, matchbooks, napkins, and invitations—one announces a performance by New York City Ballet, tickets to be purchased at the box office—that reproduce her photographs or are imprinted with bits of teasing text. (The MoMA show takes its title from a sort of Zen koan that Lawler rendered on a matchbook, in 1981: "Why Pictures Now.") For *Birdcalls* (1972/1981), a sound piece broadcast, for the show, in MoMA's garden, she recorded herself chirping the names of twenty-eight celebrated male contemporary artists, who are listed alphabetically, on a glass wall, from Vito Acconci to Lawrence Weiner.

Her recent work lampoons the pressure on artists to produce big-scale works to satisfy a trend, in galleries and museums, toward ever pompously larger exhibition spaces. It consists of photographs, or tracings of them, that she has made of artworks installed in museums:

sculptures by Jeff Koons and Donald Judd; paintings by Lucio Fontana and Frank Stella. The pictures are enlarged and distorted, scrunched or elongated, to fit the dimensions of vast walls. (In one of them, shot from floor level in a room displaying minimalist works by Judd, Stella, and Sol LeWitt, the blur of someone's striding leg intrudes evidence of real time on putatively timeless art.) The effect of the mural-making distortions is spectacularly clumsy, cranking up a pitch of arbitrariness to something like a shriek.

Lawler's work is periodically topical, as with her occasional, somewhat frail gestures of antiwar sentiment. (Shelves of glass tumblers engraved with the words *No Drones*, from 2013, don't exactly menace the Pentagon.) But, even if she didn't intend the significance that I take away from the show—an antagonism to art's organs of commerce and authority in gridlock with a profound dependence on them—her career has a timely political importance. The retrospective comes at a moment when an onslaught of illiberal forces in the big world dwarfs intellectual wrangles in the little one of art. Who, these days, can afford the patience for mixed feelings about the protocols of cultural institutions? Artists can. Some artists must. Art often serves us by exposing conflicts among our values, not to propose solutions but to tap energies of truth, however partial, and beauty, however fugitive; and the service is greatest when our worlds feel most in crisis. Charles Baudelaire, the Moses of modernity, wrote, "I have cultivated my hysteria with terror and delight." Lawler does that, too, with disciplined wit and hopeless integrity.

New Yorker, May 8, 2017

PICTURES

The Pictures Generation, at the Metropolitan Museum, revisits a hot-house orchid of an avant-garde that sprouted in art schools in the nineteen-seventies and, by 1984 (the cutoff date for works in the show), had withered in the chill winds of the New York art world. The movement's vastly influential signature method was appropriation: the filching or the imitation of existing images, to sabotage and/or revel in their rhetorical contrivance. Born of recessionary, disenchanted times, Pictures art shared menacingly cynical attitudes toward mainstream culture with punk rock, in night-life venues, and with deconstruction-ist lucubration, in academe. It yawed between those poles: sardonic burlesque and stilted critique. If any single work in the Met show could stand for all, it would be one of a series executed with minimal labor, in 1979, by the artist Sherrie Levine: fashion ads from glossy magazines trimmed to the contours of the profiled heads of George Washington or Abraham Lincoln, and framed. Looking at them, you register the sainted presidents and the soignée models—and the forms of silhou-ette and of color photography—in stuttering alternation. Your brain can't grasp both at once. Nor can your heart. The images aren't neutral. They come loaded with political and social associations, bearing on notions of "America." With diabolical efficiency, Levine thus made good on a claim commonly advanced for Pictures art: spurring conscious-ness of how, and to what ends, representations affect us. Let it be noted that these works do nothing else. As slight and as brittle as they are pure, they demonstrate the limits of critical knowingness as an artistic strategy. The rest of *The Pictures Generation*—photographs, paintings, drawings, collages, installations, sound pieces, films, and videos, plus books, magazines, and ephemera—is comparatively slipshod, though often arresting and occasionally fun. In the unique case of the self-photographer Cindy Sherman, it is transcendent.

Mounted by the Met's associate curator of photography, Douglas Eklund, in the museum's newly spacious photography galleries, the

show is largely a story of two gangs of artists that convened in New York. It was plainly heaven, in the SoHo of the late nineteen-seventies, to have been a student at the California Institute of the Arts or the State University of New York at Buffalo. CalArts kids were mentored by the conceptualist and legendary teacher John Baldessari, who, among other assignments, instructed pairs of students to film themselves performing snippets of scripts from old movies. (A projected compilation of the results, *Script*, made between 1973 and 1977, evokes an era smitten with the freeze-dried passions of Jean-Luc Godard.) The CalArts star was David Salle, who later gained renown as a painter—a chief colleague and rival of the paladin of American Neo-Expressionism, Julian Schnabel—after breaking ranks with his mostly painting-averse peers. Early works by Salle in the Met show, including a svelte and spooky installation of unnerving photographs (a sneering galoot in a race car, bare-breasted female African dancers), sentimental music, and flashing lights, well described by Eklund as "like a church of someone else's religion," are a revelation. The Buffalo cohort had a student couple at its core: Sherman, who entertained friends by showing up at gatherings in disguise, and Robert Longo, who was given to movie-inspired icons of macho melodrama. Coming independently to the movement were the stalwarts Richard Prince (a versatile prankster who made an early hit with reproduced Marlboro cigarette ads), Barbara Kruger (with brilliantly crafted feminist agitprop), and Levine (a scandalous success with re-photographed photographs by Edward Weston and Walker Evans, which needled the mystique of authorship in art). The photographer Louise Lawler merits special mention for her cold-eyed shots of expensive artworks in overdecorated apartments—as wince-makingly pitiless as the assessment of a privileged youth, home from college, of his or her parents' taste. For highly comic relief, there are videos by the gifted performance artist Michael Smith, whose "Baby Ikki" character (1978) casts him as a diapered tyke crawling on a sidewalk and toddling out into traffic in lower Manhattan, to the amusement of passersby and the dudgeon of a police officer obliged to hustle him—none too gently—out of harm's way. Eklund writes that Ikki stood for the fix of a generation

"infantilized as part of their induction into the mainstream of American culture." Be that as it may, he's a hoot.

I missed *Pictures*, a movement-initiating, instantly legendary group show, curated by the critic Douglas Crimp, at the public-funded gallery Artists Space, in the autumn of 1977. Levine and Longo were in it; Salle, Sherman, and Prince were not. It was a tentative affair, most telling in short films by the Californian Jack Goldstein: the MGM lion incessantly aroar, a trained German shepherd barking on cue. Works by Longo foretold his later big drawings, from staged photographs of chicly clad citizens apparently being hit by fatal bullets, which became virtual logos of the New Wave in art; three of those saturnine tableaux temporarily grace the Met's lobby. But the alien sensibility that the show heralded was soon unavoidable: a precociously brainy mood in art that was fronted, rather than followed, by critical talking points.

"Postmodernism" was the password. Critics—including Crimp, Craig Owens, and Hal Foster (the editor of a 1983 anthology forthrightly titled *The Anti-Aesthetic*)—who were influenced by Rosalind Krauss, the Columbia professor and a co-editor of the academic journal *October*, vied for prestige with the artists, whom they rather gingerly promoted. The artists turned out to be as unherdable as artists, like cats, generally are. Several joined Salle on a bandwagon of painting that had been set rolling by a resuscitated art market and by fresh styles spawned in Italy (which proved transitory) and Germany (which did not). As a phenomenon of fashion, Pictures art blurred into a katzenjammer scene of graffiti, club performance, do-it-yourself film and video, and all-around youthful effrontery on the Lower East Side. I deemed the Pictures artists too strainingly smart to be durable until I was stunned by a show, in 1982, of wide-screen-format color photographs by Sherman, in which she posed as variously anxious or stupefied vulnerable women in cinematically composed and lit solitude. Here was something really new (one-frame movies, Hitchcockian in their expertly managed intensity) and at the same time old (painting-like inventions, with a nuanced imagination and a visual beauty redolent of Old Masters including Rembrandt).

Real Life, a low-budget magazine co-founded in 1979 by the painter (and now the dean of CalArts) Thomas Lawson, apostrophized the Pictures worldview. It was aggressively ironic. Nothing could so curl the lip of a self-respecting intellectual in that milieu as any assertion of "reality" independent of texts and images, which—in buzzwords of French philosophy—were understood to "construct" consciousness by way of "simulations" in "a forest of signs." ("As we know," Foster wrote, in 1982, "the real cannot be apprehended directly: we have only (mis)representations of it.") Life wasn't in particularly good odor, either. In 1979, Salle published a personal manifesto titled, with bleak satisfaction, *The Paintings Are Dead*. Not that the artists were deep thinkers. As members of a generation steeped in mass media and nurtured in graduate schools, and following the general collapse of established values in the sixties and of revolutionary idealism thereafter, they thrilled to suggestions that their automatic sophistication could see through, and dissipate, the authority of their elders. But they suffered, too, from a loss of credible traditions that had made life seem real and reality seem livable. Many works in *The Pictures Generation* exude a melancholy of clever artifice masking inexpressible emotion. Such was a conscious goal for Sherman, who stated in 1982 that she wanted "that choked-up feeling in your throat which maybe comes from despair or teary-eyed sentimentality." (Having succeeded, she would go on to explore other recognizable states and conditions of experience.) Goldstein's dutifully barking dog and Longo's stricken citizens convey double binds of excitement and constriction. Dour nudes in early paintings by Salle hint at sexual obsessions drained of sensuality—let alone love, or even liking. Ever elegantly wistful, Levine touched a nerve, familiar to artists who envy the past, with handmade, faithful copies of reproductions of modern artworks, like rubbings of an Aladdin's lamp that should, but won't, disgorge a genie in service to the heart's desire. The show catches these and other poignancies on the fly. The Pictures moment was brief, but it vibrates, still.

New Yorker, May 4, 2009

JENNY HOLZER

Jenny Holzer's LED word-crawl up the Guggenheim's corkscrew makes for an amazing scene. I visited it in Christmas week, when museums are mobbed with college kids and tourists, and I'm glad. This is a show you want to see in a crowd—the more the better—because the flashing tapeworm's effect on people is so delicious: hundreds standing around in stopped-in-their-tracks postures as they perform the unnatural act of reading in public.

They read such punk-poetical greatest hits of Holzer as the obscurely menacing "SAVOR KINDNESS BECAUSE CRUELTY IS ALWAYS POSSIBLE LATER"—a sneakily metrical sentence, front-loaded with spondaic stresses that make it slow, heavy going. Contemplating it in Frank Lloyd Wright's bobbin is like being inside the head of someone insane.

This is great public art because the public is at least half the show. Young folks sprawl in the ramp's empty, darkened bays. People who aren't reading look at those who are. There's a feeling of temporary disorder—a kind of staleness verging on dramatic change—like the last day of the closeout sale in a store that is going to be torn down.

The words glide by in various fonts of the red and green light-beads—which can combine to make a sickish yellow—with spookily silent celerity, changing course at angles of the balustrade like water spraying off rocks. At a trot (not advised), you might physically keep pace with the upward scoot of, say, "PROTECT ME FROM WHAT I WANT." Walking down-ramp and looking across, you may briefly fancy that you are not only tracking a crawl but somehow causing it to move.

Holzer is a contemporary of artists who in the late seventies produced work defiantly heralded as "Bad Painting," and I think of her stuff as Bad Writing: a use of language aggressively ugly, expressionistically jagged, and in your face. The word choice is often just a bit "off," but the syntax is so imposing that you automatically read carefully, as if seeking cues for fight or flight. Her masterpiece, from the early eighties, is a

many-line monologue of distilled malice which ends, "DO YOU WANT TO FALL NOT EVER KNOWING WHO TOOK YOU?"

Or consider "THE MOUTH IS INTERESTING BECAUSE IT'S ONE OF THOSE PLACES WHERE THE DRY OUTSIDE MOVES Toward THE SLIPPERY INSIDE." Why would anyone say something like that? Anyone wouldn't, which seems an essence of Holzer's harsh and pointlessly true statements, seeming to issue from a consciousness belonging to no one. The effect is alarmingly in key, at once insinuating and alienating, with our time's distinctive public places: malls, airports, plazas, lobbies—and museums, which in a way are all lobby.

The psychopathology of everyday life that Holzer explores is a trackless realm, in which she sometimes gets lost. Her recent aphorism-engraved marble benches, which I can't help thinking of as chatty garden furniture, are inauspicious. Worse, an LED installation that is now at Dia hints at a decline in her writing. The piece is stirringly theatrical, with vertical LEDs seeming to fire words up through the floor and down through the ceiling, but the messages sag.

"WHEN MY MIND IS RIGHT I CAN SAY WHAT NO ONE WANTS TO HEAR" is like the nervous brag of an author on a talk show, and "A CLEAR THOUGHT MUST COME TO STOP THE MEN AND MAKE THE AUDIENCE LAUGH UNTIL THEIR INSIDES BUBBLE" invites the rejoinder, "No, it mustn't." Many of Holzer's new nuggets are likewise arguable or pleading. Does art stardom make it hard for her to stay productively pissed off? But the Guggenheim installation realizes a significant ambition. By trial and error, Holzer fashioned an extraordinary role for herself, as an abrader of political and moral nerve-ends, and she is incomparable in it.

Village Voice, January 17, 1990

A THEFT IN NORWAY

A blurry surveillance tape showed two men schlepping a painting out of a second-floor window and down a ladder. One man fell off the ladder. I had mixed feelings, watching on network news. I would not have wept to see the guy break his neck—some other time. But while the painting was at risk, I wanted him to be a pulled-together cat burglar, not a gravity-challenged Bozo. I wished the jerk finesse.

The place was the National Museum of Norway in Oslo. The painting was Edvard Munch's *The Scream*, which turned a hundred years old last autumn. It is a terrifyingly delicate object, three feet high by about two and a half wide. It is made of oil paint, pastel chalk, graphite, and milk-based casein on a piece of cardboard. It is infinitely precious to me and, I think, to everybody, whether they know it or not.

Would the theft have become television news without the slapstick video? Days passed with no further word, and the networks remained mute when, at last, newspapers reported rumors that the painting was being held hostage by anti-abortion fanatics. The ransom was to be propaganda: a broadcast on Norwegian television of the anti-abortion shockumentary *The Silent Scream*. It appeared that Munch's painting had fallen victim to the coincidence of its title.

Fame made it a target, too, of course, though the paucity of news coverage confused me on that score. Didn't anyone care? Then it occurred to me that, in most people's minds, *The Scream* isn't an object but an *image*: the distended mask of existential terror. Images can't be humped out of windows. They are everywhere and nowhere. You can't steal something that exists in thousands of reproductions, cartoons, greeting cards, and, lately, inflatable toys.

Many people find the image irresistibly funny: over the top. The derision may be self-protective. A joke is the epitaph of a feeling, Nietzsche said. The feeling buried beneath amusement at *The Scream* is universally stalking aloneness and dread. Who wouldn't prefer a callous chuckle to that? But you can't patronize it when in front of the physical work. Then it's a fact.

The Scream and other Munch originals changed my life when I saw them in a retrospective at the National Gallery in Washington in 1979. The experience confirmed me as an art critic. I wanted a piece of the difficult glory that the show exposed—power that can be wielded only through being shared. Like most Americans, I had no previous idea of Munch's chops as a painter, really knowing only his prints (including uneven versions of The Scream, with which he started the debasement of his own creation). Nearly all his paintings are in Norway. I have since been three times to Oslo and the cavernous museum hall, hung with the masterpieces, that to me is holy ground.

My sudden devotion was partly narcissistic. My ancestry is Norwegian. People told me I looked like Munch. I wrote a long essay on him and for a while almost fancied I was him. I got over the infatuation but not the interest, which has given me abundant instruction in how art works.

The Scream tells very exactly a truth of the easiest thing in the world to lie about: pure subjectivity. It culminated two years of Munch's effort to convey a personal event of 1891. In his words: "Stopping, I leaned against the railing, almost dead with fatigue. Out over the blue-black fjord hung clouds like blood and tongues of fire. My friends walked away and, alone, trembling with fear, I became aware of the great, infinite scream of nature."

Early paintings about the experience show a faceless man hunched over the railing. Only the whiplashing red and yellow sunset and writhing landscape are active. Then it came to him: a figure formed of the rhythms of earth, sea, and sky, all of the nature within a person in contact with the nature, at large, of an uncaring universe. The cry isn't a reaction but an eruption. It vents a reality always implicit, boundless, without beginning or end.

Twenty-nine years old when he made the picture, Munch was a strung-out young genius: alcoholic, agoraphobic, a compulsive traveler, a tormented lover. (He crashed in 1908, salvaged himself, and worked at reduced steam until his death in 1944.) He had a rock-star-like career then, especially in Germany, which exacerbated the pressure he put

on himself to be, as he said in 1892, "the body through which today's thoughts and feelings flow." His reckless ways gave him sensational subjects that he distilled with care, applying lessons from van Gogh, Gauguin, and other contemporaries.

In person, the rawness of the work astounds. Nothing about it bespeaks finish. But nothing suggests sloppy self-expression either. There is deliberated terseness in the clash between the frontal, wavering bands of the sky, sea, and land and the railing's firm lines in fleeing perspective. Space reverses, near and far exchanging places. A killer detail is the pair of figures obliviously walking away, affirming that the scream is inaudible.

Munch penciled faintly on one of the painting's red stripes, "Only someone insane could paint this!" The work is not personal. It pivots from the naturalism and positivism of the late nineteenth century into a future of one damned thing after another. It is beautiful for its color and drawing and impressive for its discipline. It is like a flame into which the artist, mothlike, fed himself. As long as it hangs somewhere on a wall accessible to the public, people will lack one alibi for being stupid about the human toll of modernity—in a phrase of Kierkegaard's, "the dizziness of freedom."

The work was a grainy gray rectangle on the television screen, coming out the window. The sight was like a kick in the stomach. It was crazy. It got crazier with the news that the perpetrators might be right-to-life. What sort of life did they have in mind? To be preserved before birth for no end of barbarity later? But their reasons don't matter. They stole our picture and should fall from higher ladders.

[*Author's note: They were just crooks. A police sting operation recovered the painting.*]

Village Voice, March 8, 1994

JUDITH LEYSTER

A show at the National Gallery of Art, in Washington, D.C., of the seventeenth-century Dutch painter Judith Leyster (1609–60) would have been a political gesture had it been held thirty or so years ago. Now, in celebration of the artist's four-hundredth birthday, it's a dramatic pleasure. Leyster's genre pictures, from a fleetingly brief career in her native Haarlem, are among the slim pickings of important Western fine art by women prior to the nineteenth century. Feminist critics and scholars have adopted Leyster as a heroine perhaps second only to the Italian Artemisia Gentileschi (1593–1652). She is an apt candidate on biographical as well as on aesthetic grounds, illustrating the tall odds against women in art worlds of yore. Her story, like Gentileschi's, involves a legal case won to meager satisfaction. Gentileschi was raped by a painter when she was eighteen. After she was tortured to prove that she was telling the truth, he was convicted. Then he was let go. Mild in comparison, but galling nonetheless, was Leyster's complaint to the painters' guild of Haarlem (she was one of only two women granted membership in the entire seventeenth century) against her possible teacher Frans Hals, the city's lion of painting, for stealing an assistant. Hals paid a small fine but kept the assistant. That was in 1635. A year later, at the age of twenty-six, Leyster married Jan Miense Molenaer, a successful but starkly inferior artist, and plunged into childbearing and family affairs. What little she created thereafter lacks her previous originality. I knew Leyster was good, but the Washington show surprised me with its suggestions of the formation of a great artist. It left me indignant on her behalf.

She was the eighth child of a brewer and cloth-maker who took the family name from that of an eminent house he bought in Haarlem in 1601. (In Dutch, *leyster* means "lodestar.") In 1628, he went bankrupt. The family moved to the vicinity of Utrecht, where, on the evidence of her paintings, Leyster was exposed to the work of artists, notably Hendrick ter Brugghen, who emulated the revolutionary light and shadow of

Caravaggio. She was soon back in Haarlem as a tyro entrepreneur—like nearly all the artists of Holland's capitalism-pioneering Golden Age. Whether or not she studied under Hals, she speedily absorbed his innovative style—drawing with paint, essentially—while integrating lessons from the Utrecht Caravaggisti. The show begins with *Serenade* (1629), done when she was twenty. It's an astonishing portrait of a fancily dressed lute player, rendered swiftly in sonorous light. Leyster obliged the going market for scenes of tavern jollity—a specialty of Hals, who begs to be termed the master of the Golden Age's happy hour. Leyster was forgotten after her death until 1892, when it was discovered that the curious monogram on a painting of drinkers—*The Happy Couple*, from 1630—thought to be by Hals, was hers: a large *J*, a small *l*, and a star.

Leyster's adherence to a hedonistic ethos can feel forced, against the grain of her nascent temperament. The slaphappy topers in *Merry Company* (circa 1630–31) strike me as too merry by half. More persuasive is the contemporaneous *The Last Drop*, in which two carousers are attended by a ferociously gleeful skeleton that cradles a lighted candle and a skull in one hand and holds an hourglass aloft with the other. But all such voguish themes are baby fat on a sensibility in which sterner, more complex qualities were struggling to mature.

Three works riveted my attention in this small show. *Self-Portrait* (circa 1632–33) finds Leyster, dressed to the nines in a gown with sleeves of purple silk and a lace-trimmed linen collar, wielding brushes and palette at her easel. A not quite pretty but vibrant young woman, she turns toward the viewer, smiling and appearing to speak. On the canvas before her is a fiddler copied from *Merry Company*, advertising her genre specialty. The brush in her right hand points at the man's crotch—a bawdy nuance, to the taste of that time. X-rays have revealed the portrait of a girl, probably herself. The literal self-effacement tells a melancholy tale, but the painting is a joy and, retroactively, a feminist icon.

Even better is one of Leyster's last surviving works, a masterpiece, *Young Flute Player* (circa 1635). A seated boy in a red hat and a ruffcollar plays a flute while gazing, sidelong, into the source of the picture's

streaming, tender daylight. A violin and a recorder hang on the wall behind his chair. The work's finely modulated browns and grays are breathtaking. They affect like essences of the flute's sound—you practically hear them. Contemplating that work, I hankered for another dozen that would extend and develop its angelic motif. But there's just the one.

The Proposition (1631) is inexhaustibly interesting and disturbing. A ruddy, leering satyr of a man leans on a table beside a woman who is intently sewing and offers her a handful of coins. The figures are oddly shoved to the left of the canvas, leaving empty space in which indefinite, almost Edvard Munch–like shadows lurk; the picture centers on a flaring oil lamp. He wears an un-Dutch fur hat, indicating that he is a foreigner and just in from the street. She wears a dazzling white smock over a voluminous blue-green skirt and rests her feet on a warming device, in which embers glow. (It's a cold night in Haarlem.) She stolidly ignores the man, though one of his hands is draped on her right arm and the other, with the coins, is inches from her toiling fingers. Her intelligent face is painted with a crystalline precision that subtly cracks the convention of a then common genre: temptation scenes, in which women were usually seen as more than receptive. The art historian Frima Fox Hofrichter, writing in the show's brochure, notes that "to sew" was, as it remains, Dutch slang for sex, giving an unmistakable spin to an offer of money for a woman's sewing. So the woman's stony reluctance contests not only a socially superior man but the proverbial character of her situation. The painting's very style, sensuously brushed and robustly colored in a fashionable vein, seems to side with the likes of the lecher against those of his prey. The effect is like an anxiety dream from which you struggle to awaken but can't.

I can't decide whether Leyster feels contemporary or makes me feel Old Dutch. In her work, social and sexual tensions tingle with fire-alarm immediacy. Plainly, she had what it took to cope with those stresses in imagination and—bridging the bravura of Hals to the later pregnant stillness of Vermeer—to turn them to account. Dutch genius of the seventeenth century found successive balance points in a tumult of worldly change. Leyster verged on one all her own. But the life of an

independent woman, competitive with men, was unsustainable. In our last glimpse of her, she plays a dainty cittern in her husband's *The Duet* (circa 1635–36), an irritating wedding picture that virtually displays Leyster as one item in an array of his possessions, along with a sleek dog and a luxuriantly set dinner table. He, with a huge lute, radiates self-satisfaction. Her face is a mask of dull contentment. The bold young artist has disappeared.

New Yorker, June 29, 2009

LUCIAN FREUD

A lot of people need Lucian Freud to be a great artist. How else to explain the furor for the pretty good English portrait and figure painter? This is not a rhetorical question. I don't know the answer, though I am convinced it must go beyond the intrinsic charm of Freud's old-fashioned way of painting. The answer may involve exasperated nostalgia for artistic meat and potatoes rich in vitamin PPP, for Painted People Pictures, as against the dietetic cuisine of so much contemporary art. There may also be yens for the lovely old bedtime story of Genius—the demiurgic, shady master at once fantastically better and soothingly worse than you and me.

In any case, the sudden mania for Freud does not seem merely a conservative backlash, because it's too bubbly for that term of embitterment. It's more of a frontlash. Everything's coming up Freud, naturally including commerce. Retroactively conferring "greatness" on an already high-priced artist transmutes inventories of his work from silver to platinum. At least three galleries besides Robert Miller are now showing something Freudian. The competition for pieces of him is an art-business Oklahoma land rush. To which my considered first response is: phooey. But when a wave of taste breaks this strongly, one must surf or drown.

Born in Berlin in 1922 and brought to England in 1933, Freud became a cosmopolitan ornament in the post-traumatic-stress London of the forties and fifties. He flogged his pedigree in early work that marked him as a minor late entry in Weimar-era New Objectivity, spiced with generic Surrealism and sugared with Keane-eyed pathos in portrait heads. To excuse the sentimentality requires fancy special pleading, provided by Robert Hughes, John Russell, and others in a luxurious little book issued by Miller. The gist is a you-had-to-be-there evocation of postwar London's soiled, cold-water, alcoholic, ragamuffin Eros. Want to know why Romanticism will never end? It works for *anything*.

The maturing Freud stopped doing big eyes and entered into a very English romance with pigment that looks the way shepherd's pie

looks and smells. He paints really well in a realist vein, maintaining tension between the literal stuff and color of paint and the fiction of a subject's presence. Freud's color has a fine dirty smolder to it. "Raw umber is to Freud as pink was to Matisse," Robert Storr has said. Freud's gnarled surfaces seduce the eye, but resistance may set in when a particularly clotted buildup brags of how hard he worked to get a face, hand, or genital right. (I'm supposed to be impressed? I thought he was supposed to be a professional.) Freud's main cachet is an inkling that oil paint and flesh are so similar that they might as well be regarded as the same thing.

To gauge the psychological charge of Freud's art, it helps to revive a musty buzzword of his grandfather's: *neurotic.* Neurosis is a tortuous means to an end, as in going from point A to point B via point Q. Point B for Lucian Freud is, I think, domination of other people. His point Q is painting, with which he solicits the complicity—and the ravening fandom, why not?—of strangers. He wants us in on the sick excitement of playing with paint as if it were the substance, not just the image, of his willing victims.

He never uses professional models, just people he knows. He dotes on their vulnerability, which he treats with punitive indulgence or tender contempt. The mood is not sadistic, exactly. Call it sadistic, approximately. A notoriously randy straight, Freud paints almost exclusively women and gay men—the latter "because of their courage," he has bullshitted. I think the reason is a seigneurial condescension to less favored (and, by the way, not sexually competitive) folks. The only person Freud renders as an equal is himself, in ferociously agitated, incredibly unpleasant self-portraits which impress as, yes, courageous. A special case is the man-mountain performance artist Leigh Bowery, so much more interesting than the painter that he steals the show in Freud's pictures of him.

To tax Freud with misogyny seems pointless, given that he obviously despises and in some sense wants to fuck everybody, himself included. But his most telling paintings are those of naked young women, mostly blondes, in which his warts-and-all approach

encounters no warts, only pulchritude. A question sometimes raised by nude painting—why is the artist depicting this desirable creature instead of having sex with her?—becomes acute with Freud, whose every brushstroke cops a feel. "Sensuality" is no answer. The effect is febrile arousal, sex in the head—so much more trouble than it can be worth that trouble must be the point.

There is no gainsaying Freud's guts. The big problems arise with his paintings as artworks. His audacity with the brush is vitiated by academically fussy composition. The good perversity of his vision comes a cropper on the bad perversity of his great-artist airs, as in his injunction that all his paintings be framed behind glass. The late Francis Bacon enforced the same policy, sensibly in view of dead paint surfaces that are pepped up by the glass's simulation of glossy reproduction. The use of glass in Freud's case sacrifices juicy surface appeal in favor of swank. For a laureate of humiliation, Freud lacks humility.

I believe the great-ification of Freud won't work. The already great-ified artists in the museums will look him over, chuckle, and bundle him off to his place among the century's honorable mentions. But today's push for Freud will itself go down in history as at least a symptom of a nineteen-nineties ache to rehabilitate tradition. There may be something more and healthier to it, as well, if Freud's best quality—candor about how actual life actually feels—becomes a cue picked up by a new generation. That he only shakily spans a present chasm between art and lived experience does not mean that the gap is trivial. We should just wish for sturdier bridges.

Village Voice, January 4, 1994

FRANCIS BACON

Francis Bacon has long been my least favorite great painter of the twentieth century. My notes from a visit to the new Bacon retrospective, handsomely installed at the Metropolitan Museum, seethe with indignation, which I will now try to get over. It's unseemly to stay mad at an artist whose canonical stature, as graphed by the fervor of intelligent admirers, not to mention market value, has only grown since his death, in 1992, at the age of eighty-two. But first I must file away my accumulated objections to the theatrical shock tactics with which Bacon, in the nineteen-forties, aimed to create museum-worthy European painting that could stand up to that of his hero, Picasso. An old politics of style hovers. Bacon opposed American Abstract Expressionism, scorning Jackson Pollock's manner as "old lace" and Mark Rothko's as "rather dismal variations on colour." I have liked to believe that, in the mid-century contest for a radically new and befitting Western art, my countrymen played fair, and Bacon cheated. They forged integral styles that absorbed and transcended Impressionism and Cubism, engulfing rather than just addressing the eye. He vamped with an eclectic mix of Expressionist tactics and decorative longueurs. But I'm aware that the scorekeeping applies to a game not won or lost but called on account of rain—proliferating points of view that have swamped all would-be authoritative accounts of art history along with those of history, period.

In fact, it is Bacon, rather than the Abstract Expressionists, who now looks prophetic about subsequent developments in art, starting with Pop and continuing through the so-called Pictures Generation, the worthy subject of a concurrent exhibition at the Met. The key is his pioneering use of photographs and printed sources for his subject matter. To make his well-known, mordant takeoffs on Velázquez's *Portrait of Pope Innocent X* (circa 1650), beginning in the early nineteen-fifties, he worked from reproductions, passing up opportunities to view the original in Rome during an extended stay there. Bacon also exerts an influence on young artists of today, such as Peter Doig and other friskily decadent British-educated painters. So here goes a rearguard skirmish,

on behalf of Pollock and Rothko—and of Willem de Kooning, who, like Bacon, was a self-conscious inheritor of European tradition, an Oedipal scion of Picasso, and lingeringly a figurative artist, despite his achievements in abstraction.

Bacon was born in Ireland, in 1909, the son of a cutlery heiress and a military man who raised horses. As a teenager, Bacon was flamboyantly effeminate, and his behavior enraged his father, who, according to a story reported by a friend, the novelist Caroline Blackwood, had him horsewhipped by grooms. By 1926—spottily educated, having run away from boarding school—he was living in London on an allowance from his mother, supplemented by petty theft and, a bit later, by occasional largesse from enamored older men. Jobs as a valet and a telephone answerer, for a dress company, were brief. Bacon read eagerly—Nietzsche, Eliot—and knocked around London, Berlin, and Paris. He was excited by Russian Revolutionary and surrealist films. A show of works by Picasso in Paris in 1928 fired an artistic ambition that would sputter until the war years. Among the few early works he did not destroy is the first in the Met show: *Crucifixion* (1933), a vaguely Picassoesque figure, also reminiscent of work by a mentoring friend, Graham Sutherland, in ghostly white-on-black. The religious reference is not pious. All his life, in the words of his most devoted critic, the eloquent David Sylvester, Bacon was "an old-fashioned militant atheist who always seemed to be looking for pretexts to issue a reminder that God was dead and to bang a few nails into his coffin." He made a compensatory sacrament of a penchant for rugged sex, alcohol, and gambling.

In 1929, all of twenty years old, he set up as an interior designer in London. He enjoyed immediate success, recognized in an issue of a leading magazine devoted to "The 1930 Look in British Decoration," but, in a decade of abundant social and erotic doings, he stuck with nothing for long. When war came, in 1939, asthma got him excused from the military and then, tormented by dusty air during the Blitz, from a civil-service position. At a house in South Kensington, his major work commenced. Here I glide past immense quantities of biography, amounting to an alternately exalted and gutter picaresque, which, in

writings about Bacon, make him seem as much a literary character as a working artist. While his work is routinely celebrated as an authentic reaction to the horrors and the dislocations of the Second World War, it can come off, in the telling, as a pageant of hangovers and refractory lovers. He remains, in death, the raffish celebrity that he was in life; a meticulous re-creation of one of his incredibly cluttered studios, in which a book of Velázquez lies near a beefcake magazine, lures tourists to the municipal Hugh Lane Gallery, in Dublin.

In 1943, Bacon painted *Figure Getting Out of a Car*, derived from a photograph of Hitler. It centers on a naked, long-necked lump whose head is all toothy maw. This seminal picture is not at the Met, but variations of the figure, on orange grounds, dominate a triptych, *Three Studies for Figures at the Base of a Crucifixion* (circa 1944), which announces Bacon's vision of an age of monstrosity. *Painting* (1946), from the Museum of Modern Art, renders a crucified victim as sides of beef. Some screaming popes of the early fifties are striated with vertical bands suggested by Albert Speer's cathedral of searchlights for a Nazi rally. Writing in 1948, Sylvester detected in Bacon's style a redolence of the sixteenth-century painter Matthias Grünewald's "germanic temperament of epileptic delirium." In ways comparable to but ranging beyond those of his existentialist contemporary Alberto Giacometti, Bacon mobilized an emotion of energetic, strangely energizing despair. He regularly proclaimed his allegiance to primal drives as the only credible substitute for meaning in a hostile universe. (But did he have to be quite so enthusiastic about it?)

Bacon's formal innovations, in handlings of pictorial space, include swiftly limned cubical enclosures and evocations of proscenium stages, in which single figures—or paired figures interwoven in paroxysms of sex and/or death—leap to the eye. Marvelously snarling knots of brushwork in the figures are increasingly offset by flat grounds and, at times, by overlaid geometrical ciphers, such as graphic arrows. The critic Lawrence Gowing wrote, approvingly, that Bacon hatched a look "at once of pastiche and of iconoclasm." It's on this point that I rebel in favor of, particularly, de Kooning's hardly less ferocious "Women" paintings,

which observe the imperative, shared by all the Abstract Expressionists, to reconcile figure and ground. Bacon spoke of "a complete interlocking of image and paint, so that the image is the paint and vice versa," but he attained that effect only in isolated passages, surrounded by dead space. His paintings, despite their extraordinary visual drama, thus lack a de Kooningesque sense of scale, which knits visible brushstrokes to the proportions of the canvas and relates the whole to the viewer's body. Big or small, the size of a Bacon feels arbitrary. With a few exceptions— such as some van Gogh–inspired painterly thunderstorms that he made in the late nineteen-fifties and that I wish he had built on—they are illustrational: tissues of fiction, or caricature, that complete themselves in literary imagination.

Not that there's anything wrong with illustration. That's the retroactive mercy of regarding Bacon in the light of Pop Art and of later grapplings, by artists including the Pictures crew, with the tyranny of mechanical reproduction in contemporary culture. The most crucial tension of Bacon's style, between life mediated by received images and life suffered in the flesh, can be awfully heady. In one of his caustic moods, he pronounced ninety-five percent of people "fools about painting." He complained, "Hardly anyone really feels about painting: they read things into it." I disagree, except in cases, like Bacon's, where reading things in can seem pretty much the modus operandi. With a Pollock or a Rothko, you either feel about painting or have nothing to engage you. But I find myself persuaded that Bacon did identify with the visceral sorcery of paint—though he wouldn't maintain it across any whole canvas—and that he wanted us to perceive that fact, even as he perversely threw melodramatic scenarios in the way.

A sense of dilemma leads me to reconsider a feature of his art that I have regarded as finicky and precious: his insistence that all his paintings be displayed behind glass, in gold frames. The only reason I could surmise for this was that Bacon used glass as a prosthetic gloss to unify his lurchingly fragmented surfaces. But having witnessed, at the Met, the gleaming parade of his career, I begin to understand the policy as a poignant gesture that weds decorative chic to fierce aspiration.

Reflecting in more ways than one, the framing registers the viewer's physical presence and, abstractly, the hermetic fate of Western painting, fallen from the Renaissance into a state of besiegement by cameras and printing presses. Bacon's paintings objectify the subjective ordeal of perishing bodies that harbor immortal longings. In this, the paintings are indeed great, standing for a historical condition even of people who can't abide them.

New Yorker, June 6, 2009

EDGAR DEGAS

Among many little-known things in the Degas retrospective at the Metropolitan Museum, one shocks. It is evidence of an act of physical violence that I can't believe I never knew about. Hold the art review until we get to the bottom of this. Why isn't the act in question a legend up there with van Gogh's ear-ectomy, with which it shares the ad hoc use of a razor?

I refer to a double portrait that Degas, thirty-four years old, did of and for his older friend Edouard Manet and Manet's wife, Suzanne, the former lounging and the latter playing a piano. More than a quarter of the painting, containing Suzanne's face, is missing, because Manet slashed it off. Degas got back what was left in the ensuing frostiness and repaired the gap with blank canvas. He may have meant to repaint it but never did.

What the hell was that about? It seems that no one knows. This needn't surprise. The bourgeois gentlemen of the Impressionist generation were fanatically discreet, and all of the giant Degas catalogue's lowdown on personal foibles of any sort wouldn't fill a column for Liz Smith. But I have a hunch.

Suzanne was older than Manet and likely a maternal figure for him, anyway a comfortable presence. She is always a bit blurry in his pictures of her. I think that indignation at the way Degas looked at her—perhaps snarkily, as a matron of a certain class—made Manet grab the vandalizing razor. The painting so offended Manet that he castrated it, incidentally violating his own reverence for art.

I believe that Manet, modern art's founding father, had a flash in which he saw Degas as a little monster. It was a glimpse of the future, because Degas was, and still is, a prime type of the modern artist: willful and absorbed in style. Manet was that himself, but not at the expense of humane emotions. He was a mensch, you can tell—helpless to paint anyone for whom he lacked empathy and probably naïve about the people he liked. I bet that his reaction to Degas's Suzanne was fright.

Why isn't this small atrocity famous? That the painting has been in Japan since 1923 is no excuse. The reason may be protectiveness

of cherished myths. The Impressionists are feel-good guarantors of modernity, giving all of us our first intimations of aesthetic splendor and beaming comfort and joy into even dull hearts. Let Post-Impressionists like van Gogh, Gauguin, and Cezanne be flaky, but don't tell us weird stuff about our daddies.

"Every 'original' genius has something a bit shady about him," W. H. Auden wrote. I presume that, at some point, most of us have had epiphanies of realizing that Degas's ballet dancers are not the spun sugar that middlebrow taste supposes. Rather, they are relentless looks at women torturing themselves to be on display. Degas loves to watch them fight balky muscles and gravity, and he doesn't give a rat's ass about them otherwise.

I presume, too, that we've all heard Degas called a misogynist and an anti-Semite. The charges seem true enough but are beside the point of his art, which is where a rarer scariness comes in. His mother died when he was thirteen. He may have felt unconsciously that his puberty killed her. This would help explain his eternal-bachelorish inhibitions with women, whom he pictured in the nude almost exclusively from behind. (You can all but hear him snapping at the models, "Don't look at me!") His siding with the army in the Dreyfus affair may have reflected insecure pride in his aristocratic roots, through a half-Italian father whom he never rebelled against.

It makes sense to seek answers in Degas's childhood, because his maturity as an artist, seen in early works that are a revelation of the show, came so quickly. He seems to have been born wearing a cravat. He is all there in a self-portrait at age twenty, gazing sullenly from a head plainly programmed with every requisite aptitude. The academic work he did in Rome is stunning. Want a John the Baptist? Bam.

His Salon paintings are every bit as good in their way—meaning his way, nimble and icy—as his middle periods of realist portraiture, naturalist genre, and Impressionist dancers and racing scenes, and his last mode of virtual Expressionism with pastels. He was a medium-is-the-message stylist who had nothing to say except one thing, in varying accents: behold perfection. If he roughed up the job with unfinished

looks and off-kilter compositions, it was to make the poise of the results more amazing.

Through it all there is the chill of the thin, intoxicating air at the snowy peak of the capital *A* in Art. If you've ever breathed it, you'll do your share of gasping at the show, exalted by the finesse and the incredible intelligence that mingle so strangely with the man's crotchets.

Degas had a last phase typical of demonic male stylists who outlive their virility. Like Ingres, Renoir, and Picasso, he went out in an explosion of female flesh: mother, sister, goddess, whore. This is Degas, so you get a voyeur's Monument Valley of turned butts, with breasts peeping out from under armpits, and it's done not in carnal oils but in pastels, colored dust.

The colors go hot, hotter, hottest. The models are killing themselves, holding those poses. He's an old man. How much more does he have in him? He is a meteor trailing fire, beginning to wink out. Nearly blind, he molds wax sculptures of dancers and horses from memory. Then that stops, too.

"It's amazing how indifferent you get in old age," he told a friend— a Jew whom he had shunned for years on account of Dreyfus—at an auction where one of his paintings went for a large sum. His American friend Mary Cassatt, who had long endured his misogyny, soon described him as "a mere wreck." He lasted another four years. "I found him seated in an armchair, draped in a generous bathrobe, with that air of the dreamer we have always known," one of his last visitors wrote sentimentally. "Does he think of something?"

I doubt it. He would have been making something if he did. Art was dead in him, and there was never anything else about him worth mentioning. Even that could be dicey, as Manet had occasion to realize. But Degas was as good as anyone gets at anything in the modern age, at a price reckoned on the standard rate of exchange: one soul in return for never being forgotten.

7 Days, October 19, 1988

LUC TUYMANS

The Belgian Luc Tuymans is the most challenging painter in the recent history of the art, if recent painting can still be said to have a history and not just a roll call. A retrospective of the fifty-one-year-old artist at the Wexner Center for the Arts, in Columbus, Ohio, invites a verdict. Mine is thumbs-up. Tuymans's thinly brushed, drab-looking, but sneakily lovely canvases, usually based on banal photographic images with wispy political associations, do two big things at once. First, they dramatize the fallen state of painting since the nineteen-sixties, when Andy Warhol merged it with mechanical reproduction and minimalism petrified it with a basilisk stare. Not for Tuymans the tragic pathos of the previously preeminent Gerhard Richter, whose several styles, alternately realist and abstract, have acknowledged the collapse of any coherent tradition in painting but have done so with defiant bravura, nostalgic for the old, grand manners. Tuymans's grayish daubs announce that the war against mass media and minimalist skepticism is truly over, because truly lost. Second, Tuymans discovers in the very humiliation of the medium a vitality as surprising as a rosebush on the moon. He does it with nothing-to-lose audacity. If painting has nothing significant left to say, he seems to reason, it might as well say nothing about significant things. Themes of his series include the Holocaust, disease, Flemish nationalism, Belgian colonialism, post-9/11 America, and the mystique of Walt Disney. It's hard to tell his attitude toward his subjects, but he is plainly fascinated by the power of images to roil minds and hearts.

One of Tuymans's first definitive works, from 1986, is a small painting of the gas chamber at Dachau (which was never used for its purpose), copied from a watercolor he made at the site. Its perfunctory splotches and smears, on a yellowish ground, indicate the wide door, the fake showerheads, and the floor drain. Whatever feelings and thoughts you have about it are only your own. Tuymans leaves you alone with them, and with the innate sensuousness and sensitivity—the physical appeal to the imagination—of paint on canvas. The first-person touch

of his brush is the work's sole, and frail, emotional anchor. I have often wondered, in front of paintings by Tuymans, why I was looking at anything apparently so desultory. Minutes later, I'm still wondering, unable to tear myself away from a delicate engagement that mysteriously feels as necessary as a raft in a flood. The flood is the noise of the world. The work is silent.

Tuymans is Flemish, a native and lifelong resident of Antwerp, in the region that speaks a dialect of Dutch and is congenitally at odds with the Francophone south of Belgium. He studied art there and in Brussels. He identifies with the historical bounty of Flemish painting. (Tuymans opined in a recent interview that since, nearly six centuries ago, Jan van Eyck promulgated the use of oil paints and the aesthetics of methodical realism, all painters, himself included, have been "dilettantes." That sounded crazy but has made me look at van Eyck harder and with growing awe.) After struggling with an early style of crude portraiture, Tuymans quit painting for several years in the early nineteen-eighties to pursue filmmaking, with a Super 8 camera and a spirit so obsessively experimental that only one completed though hardly finished—it is wearyingly frenetic—work resulted.

He resumed painting in 1985, with cinematic lessons learned. His ways of framing images within his series—long shots, establishing shots, close-ups—evoke the movies, although with a softly blurry look suggestive less of film stills than of videotape paused on a primitive VCR. In that year, he sent out a thousand invitations to his first solo show, at a derelict luxury hotel in the seaside resort of Ostend (James Ensor's hometown). Not one person showed up, he says. The impressive failure points up Tuymans's independence of the Belgian and, for that matter, the international art world of the time, when swaggering Neo-Expressionism set the pace for new painting.

Hunger for notice may have motivated Tuymans's Holocaust-related works, including a sketchy painting of a modernistic structure and the hand-lettered words *our new quarters*. (It is from a postcard issued to inmates of the Theresienstadt concentration camp, a fraudulent showplace that was, in truth, a way station to Auschwitz.) His far

less sensational works since then prove that he would rather whisper than shout, while always strumming raw nerves. Two series bearing on Belgian politics—*The Flag*, mocking a recurrence of separatist agitation in Flanders, and *Mwana Kitoko: Beautiful White Man*, alluding to the dénouement of colonialism in the Congo—are exotic to my mind. But then, Tuymans makes me feel exotic to myself, as an American, with *Proper* (2005), a suite responding to this country in the era of George W. Bush.

Clouds of dust (*Demolition*) and a naggingly familiar face (*The Nose*) evoke, without quite representing, the towers' fall and Osama bin Laden. Ballroom dancers in the rotunda of the Texas State Capitol are viewed from above. A dinner table is set with genteel precision. Condoleezza Rice squints from a gorgeously painted close-up, *The Secretary of State*. I've looked long and searchingly at this last painting, testing one interpretation after another; each seems plausible at first, then not right. Does Tuymans like Rice or not? Does her appearance "stand for" something? Many things? Nothing? The painting both demands and rejects answers. It is beautiful, with no conceivable right to be so. I suspect that it's a masterpiece but cede the judgment to a less politically distracted posterity.

A tireless exegete of his own work, Tuymans articulates a modern tradition that gives equal weight to the dazed German Romanticism of Caspar David Friedrich and to the wide-awake Parisian modernity of Manet—bridging a gap that still divides Western taste. He is Manet-like in his smart synopsis of borrowed images. His smoldering colors are Friedrichian: pale blue-greens, wan oranges, dusty lavender, violet, muddy vermilion. There are no true grays, because he eschews black for a blackish mix of reddish brown and emerald green. He claims to make each of his works, albeit after lengthy rumination, in a single day— sometimes a very long day—painting wet-in-wet with dark-over-light colors, forming the image as he goes. He insists that this is so even in the case of *Turtle* (2007), a picture about twelve feet high by seventeen long, from a photograph of a Disneyland parade float. He compares his method to the self-developing of Polaroids.

Tuymans has told Artnet that in his initial hours of work, "until I get to the middle of the process—it's horrific. It's like I don't know what I'm doing but I know how to do it, and it's very strange." That— uncertain ends, confident means—is about as good a general definition of creativity as I know. It illuminates and justifies Tuymans's eccentric work rule, with its distant redolence of Jackson Pollock's decision to paint in the air above a canvas. The unities of form and feeling in Tuymans's work may be shallow—as, under time pressure, he seizes upon whatever resolution of a picture first beckons. But the effect is thrillingly open-ended, as if the work were still in the act of coming to its point.

Tuymans is vastly influential among younger painters, but none have gone much beyond imitating his look of laconic dash and sangfroid. The next painter who greatly matters may or may not recall him in style but will—must—have a particular attitude toward him. Such a painter might not appear. Tuymans's feat may prove hybrid, unable to propagate. Meanwhile, he is not apt to become popular. There is an air of penitent mortification about his work, which frustrates even as it arouses our childish craving to be told stories. He conveys a dim view of the world and scant trust in our capacity to cope with it. But, if you like painting enough, you will gamely endure the bitterness of this artist's intoxicating brew.

New Yorker, October 12, 2009

PETER DOIG

Frank O'Hara pegged the going look of urbane sex appeal, in 1962, as "a little 'down,' a little effortless and helpless." He could have been forecasting the dominant fashion in painting almost fifty years later, exemplified in the resonant languors of Luc Tuymans and Elizabeth Peyton and positively exalted, to peaks of forthright nonchalance, by Peter Doig. Concurrent shows, at Michael Werner and Gavin Brown, of the Scots-born, Canadian-raised, English-educated Doig, who lives in Trinidad, answer the question, "Why paint now?" with eloquent shrugs. His brushy landscapes and dreamlike or, better, half-awake visions of odd personages (see *Man Dressed as Bat*, in two versions, at Werner) variously recollect Munch, Klimt, Nolde, Matisse, Rothko, and other past masters, in a spirit less of homage than of smart despair. Doig's is an art up to its nostrils in historical quicksand. His raffish drawing and quite wonderfully seductive color promote being stuck in post-everythingness as our best actually available pastime.

New Yorker, February 9, 2009

LAURA OWENS: A PROFILE

Serious but friendly, a woman who rarely jokes but readily laughs, the Los Angeles artist Laura Owens, forty-seven years old, was pleasantly disheveled in mom attire: shirt, baggy shorts, sneakers, big glasses. "Don't be afraid to make mistakes," she said to the children in each of the five classes she spoke to on Career Day, in June, at her nine-year-old daughter, Nova's, public elementary school. She accompanied the advice with a PowerPoint slide of herself after falling from a low scaffold and being splattered with blue paint from a pail that had followed her down—a studio mishap, in 2013, that an assistant had paused to snap before helping her up. The next slide showed her paint-smudged face, smiling—no harm. The kids seemed fascinated but perplexed, as well they might have been. An essay could be written on the semantic distinctions, which Owens had just elided, between mistakes and accidents, and between accidents and pratfalls. I recognized one of the turns of mind that characterize Owens's influential inventions of new things for the old medium of painting to do. I couldn't match it when a fifth-grade girl asked me, as a drop-in careerist, how to become a writer. I said that she was one already, if she was writing. With a thought to Owens, I added that she should carry a notebook around, so that people would see that she is a writer. Owens has grounded her life, since childhood, on being, and being regarded as, an artist. The Whitney Museum's description of an upcoming show of her work there as "a midcareer retrospective" seems superfluous for someone who has never not been in midcareer.

The first slide that she had shown the children was of a drawing she said she had made when she was a teenager. It will be included in the Whitney show. Dark and smudgy and heavily worked, it depicts a silhouetted figure in a jail cell, reaching forward through the bars, which cast long shadows, toward a dog dangling a key from its mouth. The dog appears uncooperative. She told me that the image may have come to her in a dream, which she has no wish to analyze. The second slide documented a civic-poster contest that she had won when she was

fifteen—promoting a county foster-care program for children—in her hometown of Norwalk, Ohio. Third, from four years later, came a painstaking pencil copy of a photograph of the Beatles. She demurred when I remarked on her evident early giftedness. "I don't believe there's such a thing as innate talent," she said. "It's about desires and passions that lead to a focus on certain things and seeing the world in a certain way."

For the retrospective, Owens and the Whitney curator Scott Rothkopf have created an astonishing catalogue, both epic and intimate: six hundred and sixty-three pages of reproduced works, critical essays, literary texts, photographs, clippings, memoirs by friends, journals, correspondence, exhibition plans, and ephemera. (Each of the eight thousand copies comes with a unique silk-screen cover, handmade in Owens's studio.) The first major item in the catalogue is a memoir by her mother, Carol Hendrickson, a public-health nurse, who recalls once having casually suggested to Owens, then a teenager, that she consider pursuing commercial art or teaching art to children. Hendrickson writes that her daughter "was very upset with me, and tearful, and said, 'Don't you think you'll ever see my art in a museum?' And I thought, 'An art museum? Wow!' So I stopped short for a second and said, 'Well, yes, of course I think that.'" In a journal that Owens kept in her early twenties, she wrote a fourteen-point list entitled "How to Be the Best Artist in the World." Among the dictates: "Think big," "Contradict yourself constantly," "No Guilt," "Do not be afraid of anything," "Say very little," and "Know that if you didn't choose to be an artist—You would have certainly entertained world domination or mass murder or sainthood."

Owens showed the children a slide of an effortful drawing from a life class that she had taken while still in high school. She followed it with mostly abstract works from her years at the Rhode Island School of Design, where she graduated with a bachelor's degree in fine arts, in 1992, and at the California Institute of the Arts, where she earned a master's, in 1994. At RISD, she said, "I was so happy to be among people who like to make things"; and, at CalArts, "I learned philosophies and ideas of art right now." She displayed one work that wasn't hers: *The*

Blue Window (1911), by Matisse, a still life set against a landscape. She said, "I love that because it is so very beautiful." But mostly she stuck to themes of enterprise—"Send your poems out into the world," she told a girl who said that she wrote poetry—and resilience. "When you make a mistake, see what's good about it," she said. "Mistakes are little windows into what is possible." She told me that her most productive time for working has always been between ten at night and three in the morning, nowadays often after a multitasking day at her studio in Boyle Heights, just across the Hollywood Freeway from downtown—a low-income neighborhood where she also runs a celebrated art-and-performance space, 356 Mission Road, which has lately found itself a target of anti-gentrification protests. In the hours around midnight, she said, "I get down and focused. Making mistakes, wiping them off. Really communing. At night, it's a matter of hearing the work, after walking past it all day."

Owens's soft-spoken earnestness held the kids' attention even when she flashed images of complicated abstractions, such as a series, *Pavement Karaoke* (2012), that congregates thick impasto, crisp grid designs, effulgent stains, silk-screen newsprint (from a nineteen-sixties underground paper, the *Berkeley Barb*), collaged gingham, and fragments of lava rock. But the figurative ones went over best. One, from 2004, was of a cartoonish, gangly horse that appears scrunched to fit onto the canvas. "How do you make horses?" a girl in a class of hearing-impaired first graders asked. Owens said, "I look at a lot of pictures of horses." A teacher suggested a demonstration. On a large sheet of paper, Owens drew three rectangles. In one, she swiftly limned a more straightforward equine. In the others, she rendered a rudimentary mountain range and an owl. "See?" she said. "You can do anything!" The results looked simple and guileless in the way of art by children, but fluent and decisive. (Not easy for an adult to do.) A small boy lit up when, on the spot, the teacher taught him the binoculars-like hand sign for "owl." A girl demanded a mermaid, which Owens drew beside the horse. The drawings stayed with the class when we left.

I first became aware of Owens in 1996, when one of her paintings in a SoHo group show invaded my sleep. The strongest young artists of that time, drilled in critical theory and wielding newer mediums, disdained painting as weak-minded and archaic. Most of the picture *Untitled* (1995), about six feet high by seven feet wide, is taken up by a few red diagonal lines on a pinkish ground. They indicate a floor seen in perspective—or half of one, because the lines converge toward the right edge of the canvas—topped by a triangular slice of mottled green wall spotted with some four dozen tiny abstract paintings-within-the-painting. (Artist friends of Owens had daubed in some of those, at her invitation.) A couple of nights after viewing the work, I dreamed that an annoying young man was pestering me to tell him if paintings by an old woman, perhaps his grandmother, were worth anything. To get rid of him, I gave them a glance. They had an aura redolent of the Owens. I became so wildly enthusiastic that the guy backed away from me. I believe that his qualm crept in when I reviewed the group show for the *Village Voice*. I wrote that Owens's work, although charismatic, was perhaps clever to a fault: "an advancing weather front of tacit quotation marks" and "not beautiful, but 'about' beauty."

I wasn't ready to accept that Owens had hit on a necessarily willful new direction—not exactly forward, but fruitfully sideways—for painting, my favorite art form. She knew the critical challenges, from Draconianly avant-gardist CalArts, and was taking them head-on, with crackling wit and a haunted heart. Was new art supposed to enforce awareness of its physical and institutional environs? Owens envisioned an exhibition space, such as the one that you stood in to view her picture. A painting about looking at paintings, from an alienated distance, this *Untitled* is itself a painting to be looked at, as closely as you like. The dinky abstractions, fictively remote, are smack on the surface. Funny, faintly melancholy, and fantastically intelligent, the work somewhat recalls the philosophical cartooning of Saul Steinberg, but vigorously brushed at a commanding scale. I think that there is a figure in the picture, albeit an invisible one. It's the viewer: you, or, in my case, me.

I came to see that what I had taken for arch skepticism was strategic sincerity.

Unusually for Owens, the painting was inspired by a specific work of a past artist—*Studio Interior* (circa 1882), a sumptuous piece by William Merritt Chase, in the Los Angeles County Museum of Art—while not much resembling it. She never imitates a style or, really, has one of her own. Rather, she has adopted craft techniques and teased out iconographic and formal ideas from whole fields and genres of the pictorial. Gestural and Color Field abstraction, digital imaging, American folk art, Japanese landscape, children's-book illustration, dropped shadows, greeting-card whimsy, clip art, wallpaper design, silk screen, tapestry, typography, stencils, recorded-sound elements, and mechanical moving parts (in one series of paintings, shapes with hidden motors function like clock hands) take turns or combine. Slam-bang visual impact co-occurs with whispering subtlety. Owens's art imparts a sense, from first to last, of being in the middle of a process that doesn't evolve but that spreads, deltalike, from a mysterious headwater. However strenuous technically, her work is reliably featherlight in feeling, even at architectural scale. *Ambitious* seems both too heavy and too petty a word for her. Her drive seems impersonal: a daemon, which she hosts. Recently, I posed that notion to her. It seemed to strike her as over the top. She said, "I think about what is required of me."

Owens was a contrarian at RISD, chafing at male painting teachers who pushed latter-day variants of macho Abstract Expressionism and condescended to their female students. One of them suggested that the women in his class paint from life, encouraging abstraction among the men. Owens, painting abstractly, organized a club with other dissatisfied students to pursue a curriculum of their own. At CalArts, she imbibed intellectual rigor, including from the late conceptual artist and legendary teacher Michael Asher, who intended his site-specific, temporary works to undermine the conventions of art institutions. (One whole show of his consisted in removing a wall in a gallery to expose the business office.) He discounted painting. Yet Owens took to "using house paint and making a lot of big canvases," she told me, with "giant

shapes and then small, concentrated moments of things," such as bits of still life. You know at a glance that they are by Owens, not from their looks, which are miscellaneous, but from how they feel: vaguely familiar and acutely strange.

Owens took a keen interest in whatever her peers were up to, eschewing competitiveness. "It's debilitating to think that this person is above me and this person is below me. I want to be in a conversation with someone. Why can't I think I'm talking to my favorite painters?" For example? By making a "painting for Cézanne to see," Owens said. What would she and Cézanne discuss? "Definitely paying attention to what each mark is doing." She said of Cézanne, "He is the god of paying-attention-ness." Owens's marks have a secondhand feel—indeed, with ghostly quotation marks, the echt Gen X finger gesture—but they breathe liberty. ("You can do anything!") The effect has nothing to do with virtuosity. She said, "I don't like somebody fetishizing their skill level. Painting is one of the few mediums—I don't know, maybe cinematography is another—where the skill level can just take over and really seduce people. It's not that I don't appreciate pieces of art that are done well. But how do you keep things moving along?"

Owens told me of her first visit, when she was a young girl, to the superb Cleveland Museum of Art. She saw at a distance an immense Color Field painting by Morris Louis and walked toward it. As she approached, "the painting got bigger and bigger and I got smaller and smaller." Add that memory to CalArts smarts and you have a take on Owens's first New York solo show, at Gavin Brown's Enterprise, in 1997, and her first in London, at Sadie Coles, the following year. The former featured a vast painting of a blurry seascape with two curly W shapes, representing seagulls in flight, which appeared to cast shadows onto the sky behind them. A landscape at Coles was similarly large and customized for the space. (Owens has stayed stubbornly loyal to those two middle-range dealers, and to Galerie Gisela Capitain, in Cologne, despite wooing from richer and more prestigious galleries.) The work at Coles was installed facing a window across a room that had a pillar in the middle. Owens painted a shadow of the pillar onto her canvas. Both

paintings felt as much like places as like pictures, anticipating Owens's engulfing installations of recent years.

Critics were wary. Roberta Smith, in the *Times*, detected "cynicism" in the seagulls painting: "monochrome meets kitsch." But, as with me, her initial resistance gave way as the seriousness of Owens's intentions sank in; Smith became one of the artist's most discerning observers. Meanwhile, certain artists caught Owens's drift immediately. Rachel Harrison, the daring and influential sculptor, recalled for me the Gavin Brown show, with its "thick paint and comical flat shadows": "I found it exceedingly deft formally, while demonstrating that although painting was pretty unfashionable at the time, it was still possible to throw a bomb."

Owens's idea of suiting paintings to sites, in a sort of conceptually self-conscious new baroque, has paid off in such dizzyingly complex recent works as a one-off installation, *Ten Paintings*, last year at the Wattis Institute for Contemporary Arts, in San Francisco. The paintings didn't exist yet, except in the potential form of concealed panels that shared a continuous surface of room-girdling handmade wallpaper: in effect, a single painting, more than fourteen feet high and more than a hundred and seventy-three feet long, executed in acrylic, oil, vinyl paint, silk-screen inks, charcoal, pastel, graphite, and sand. Non-repeating bitmap patterns, derived from a scanned piece of crumpled paper, underlay passages of newsprint reproductions, fugitive brushwork, a micrographic version of Picasso's *Guernica*, and attached whatnots, including a watercolor of a sailing ship by Owens's grandfather, patterns of embroidery by her grandmother, and a drawing by her younger brother Lincoln, who is a chef in New Orleans. Prevailing blacks, whites, and pale blues, with purple accents, imposed a gently rhythmic unity. At intervals on the walls, phone numbers were printed, with invitations to text any question that a viewer might have. The nearest of eight concealed loudspeakers would deliver an answer in a male, female, or robotic voice, to spooky or daffy effect, from a computer that Owens, with technical help, had programmed to recognize a hundred

key words. (Imagine an ultra-high-tech Magic 8 Ball.) To the query, "Where are the paintings?," all the speakers replied, "Here!"

When the show closed—with no prospect, Owens said, of ever being repeated—the supports were cut out. I saw the results hanging at her studio, each nine feet high by seven feet wide, and terrific: arbitrary fragments of the wallpaper that, owing to the formalizing power of rectangles, feel discretely composed. Cropped, the installation's ambient energies become compressed dynamisms. The works' derivation makes them highly original aesthetic objects. On the model of Duchampian readymades, perhaps call them "made-alreadies": created by being revealed. In the studio, heaps of the surplus wallpaper, like outtakes on a cutting-room floor, awaited possible roles in works to come.

In a vertiginously hilly part of Echo Park, near Dodger Stadium, Owens shares a tidy two-story house, clinging to a steep slope, with her second husband, Sohrab Mohebbi—an Iranian-born writer and curator who works at Redcat, a CalArts-affiliated art center in downtown Los Angeles—and her two children, Nova and Henry (who is twelve), from her previous marriage, to the painter Edgar Bryan, who lives nearby. She told me by e-mail that when she moved to Los Angeles to attend CalArts, in 1992, she was put off by how "dry" a place it is, the climate and architecture "so jarring." "But after two years I felt very differently. Felt easy and familiar." Oak, deodar, citron, and pepper trees and capricious gardens crowd up to the stairs and patios around Owens's house. A sleek building below contains a studio and room for guests.

I was invited for dinner one summer evening. Owens's mother—who moved from Ohio to Los Angeles eight years ago, and, last year, into a house next door with her second husband, Richard Hendrickson, a retired small-city-newspaper reporter and editor—brought salad. Pasta and sauce materialized amid the comings and goings and breezy chat, in the open kitchen, of Owens and of friends from her capacious circle of artists, musicians, writers, filmmakers, and other creative Angelenos. ("I would be nowhere without them," she told me.) Two or three times, the frenetic family dog, a rescue mutt named Molly, escaped

the house and had to be recaptured. Downstairs, Henry and Nova took turns practicing the piano.

At twilight, we all took a walk—or a hike, what with the hills—a half mile or so to a park and back, in a sort of mood, at once energized and haphazard, that I now associate with Owens. In company, she is cordial and voluble—nice, in a word—but with what often seems a fraction of a mind that is occultly busy elsewhere. The first thing that you notice about her is her gaze, wide-eyed and fixed on you, as if you had dropped from the sky. It takes a moment to realize that you are not obliged to be commensurately interesting. She consumes so little social oxygen that people around her tend to get a bit high, laughing at anything. She submits to being interviewed as you might to being treated by a trusted dentist: it's endurable and over with soon enough. I found myself repeatedly apologizing to her for the imposition. She seemed not to hear. She was answering questions.

Owens's father died of complications following knee surgery this year, in July. He was a flamboyant attorney who strutted around Norwalk in a Stetson. Her parents divorced when she was seventeen. She credits her father with having instilled in her a fervent liberalism, which has prompted her to engage in feminist causes and in campaigns for Democratic candidates but which is only rarely and obliquely expressed in her art. Raised Catholic, she left the church in rebellion against its anti-abortion doctrine. I was startled when, in her car one day, as she drove us between gallery shows, her usual mildness gave way to flaming rage. We had seen a policeman hassle a young guy whose offense, it appeared, had been to cross a street so lackadaisically as to impede the cop's car for a few seconds. "That is so like them!" she said of uniformed authority. She told me a maxim imparted to her by her father: "Never tell the police anything."

But Owens adores rules, even, or perhaps especially, trivial ones. In an interview with one of her close friends, the novelist Rachel Kushner, in 2003, she described a summer job that she had had when she was seventeen: checking trucks hauling trash and garbage into a landfill. She recalled, "I had the power to say, in a logical and non-emotional way,

'You can't deliver that without a tarp over it.' People would get frustrated and respond, 'What do you mean? You want me to just pull out of here, put a tarp on, and then come right back?' I would look at them and say, 'Yes, that's what you'll have to do if you want to dump your trash—it's the law.' It had its appeal." An anarchic stickler: that's Owens.

Owens can be certain that her Echo Park house was built in 1942, because a renovation, in 2013, discovered paper stereotype plates (used to cast lead cylinders for printing) of the *Los Angeles Times* from that year. They had been employed as flashing beneath the shingled exterior. Transferred to silk screens in a complex procedure involving monoprint molds, the antique reports of distant war and of local events, and the commercial and classified ads, now do double duty as text and texture in some of Owens's paintings. The source and content of the plates both do and don't matter to her, it seems. What counts is their specificity, as things distinct from other things that are like them. "All art now is collage," she said to me, with reference not just to cutting and pasting but to the incorporation of methods and images with prior uses. "Heterogeneous in form," she explained. "Against the different paradigm of the Gestalt object, like a Jackson Pollock painting—a single image that jolts you. Now art is all about being constructed out of relationships between parts."

"Say very little," Owens told herself in her early-nineties journal. And, in a way, she maintains that policy, even when going on at length about her art. Her public talks, delivered with an air of professional duty, tend to be remarkably boring. But get her on the subject of another artist and she brightens. She and I discussed by e-mail the country-music paragon Patsy Cline. I commented on Cline's way with the 1952 chestnut "You Belong to Me," rather a high-class number for a country girl: "Fly the ocean in a silver plane . . . Just remember till you're home again / You belong to me." Cline sings it with wondering respect for its decorum, such that the song is no longer about a fancy girl remonstrating with her fancy guy, but about Cline's imagining of what it's like to be such a girl, with such a guy. Owens commented, "She has a way of singing that feels like she is so relaxed and confident, that what

she says, it could be anything and I'd believe she meant it but on an even deeper level than the words could convey." That's the very tenor of the borrowed images that Owens paints: not appropriations but vicarious embodiments.

In 2003, Owens became the youngest artist ever to be given a retrospective at Los Angeles's Museum of Contemporary Art. By that time, she had begun to gravitate from abstraction toward fanciful figurative imagery, loosely brushed. "I decided I needed to bring in the human figure, because it was something that I was leaving out, and to break the habit of working for sites. To push myself." In 2006, she returned to Ohio for a year. She helped her mother buy a new house with a four-car garage, which became her studio, and painted her baby, Henry, Edenic landscapes, flowers, and wacky animals, such as the horse that she showed to the schoolchildren. The works often suggest to me the state of mind of a new mother too tired to think while too dedicated not to work. Owens confirmed the impression in an e-mail: "Being a mom and still making art involves absolutely opposite parts of your brain. One is really selfish and the other is absolutely selfless." The domestic turn in Owens's life and subject matter dismayed friends when she returned to LA. "It was uncool. I was told by many people, 'Well, that's the end of your art career.'" How did that make her feel? "Angered," she said. I think that the gawky pictures were a way for Owens to reconnect with the soul of the girl who had tried to get just right the vision of a figure in jail and a sassy dog. She wasn't going to be embarrassed about it.

Owens was asked, in 2003, to contribute to a feature, in *Vogue*, of self-portraits of women artists. She says in the Whitney catalogue, "I said no several times because my work doesn't really deal with self-representation." Finally, she made an insouciant watercolor of herself, seen from the back, standing in a small boat and talking to the sun. A bird perches on a wave, and Owens's dog bobs past on a piece of driftwood. "I sent the image off to *Vogue*, and Anna Wintour rejected it." Such occasional offenses to elegant taste may explain a wobbliness in the market for Owens's paintings. Her works sell briskly to devoted collectors but less well on the investment-minded secondary market,

which favors reliable product lines. Her peak at auction—three hundred and sixty thousand dollars, at Sotheby's, a year ago—is hardly peanuts, but it lags behind the millions for works by some of her contemporaries, all stylistically consistent and nearly all male. Even after two decades of growing fame and esteem, her art's values retard transposition into prices.

One day, I met with Owens in her main studio. Consumed by preparations for the Whitney show, she had no special work in progress. She was wearing an off-the-shoulder cashmere sweater but over a white T-shirt that rather sabotaged the chic. As usual, her long brown hair was pulled up in a knot with no evident advice from a mirror. I watched while she and an assistant, David Berezin, huddled at a computer to color-correct pages for the Whitney catalogue—difficult by computer, she said. "Digital color shoots out. Real color is reflective." Getting the right blue for the sky in a photograph of Owens and a friend on an outing in Death Valley took most of a minute. Other assistants worked at other computers. Phone calls were frequent. Owens Skyped at one point, also about the catalogue, with Scott Rothkopf, in New York, in editorial detail so granular that I almost fell asleep. The studio is like a cross between a factory and a laboratory. One colossal space is equipped with worktables and contains leaning stacks of big, well-used silk screens on heavy metal frames. Another room, merely vast, is hung with unfinished paintings in what seemed a tentative simulacrum of a museum or gallery show. She said, "I want to see how they look with each other. What works, what doesn't." The mismatched paintings on the day of my visit felt like actors at an audition. If someone looked at me the way Owens was looking at them, I'd be scared. Crowded bookshelves, a couch, a large coffee table, chairs, and kitchen accessories furnish rough amenity.

The studio is in a building next door to 356 Mission Road, a two-story stuccoed-brick hulk, built in 1926, that was once a printing plant and then a piano warehouse. It sports a stately corner entrance on a dusty, all but untrafficked stretch of blocks, zoned for light industry, that are quiescent by day and deserted at night. It was vacant when

Owens found it, in 2012, while in search of a space as a studio that could also house an exhibition—her first in LA since 2003—of works that she would make there. She rented it with support from her longtime dealer Gavin Brown and her friend Wendy Yao, the owner of an avant-gardish Chinatown bookstore, Ooga Booga. The show, *12 Paintings*, installed on a dramatic scale with the austere immensity of the building's ground-floor space, proved to be more than the sum of its parts. The effect gave Owens the idea, in partnership with Brown and Yao, to make 356 Mission Road a Kunsthalle—a non-collecting museum for exhibitions, performances, community workshops (there's a weekly one in anima-tion, for children), lectures, a branch of Ooga Booga, and fund-raisers for liberal causes (never for itself and never taking a commission). The venue has hosted hundreds of events. Subsisting on sales from shows and, whenever needed, on contributions from Owens, it amounts to a work of art in itself—and, lately, a bull's-eye for controversy.

A shadowy group, the Boyle Heights Alliance Against Artwash-ing and Displacement, has picketed and otherwise publicly opposed 356 Mission as a symbol of the increasing gentrification of the largely Latino neighborhood. This agonizes Owens. She wrote to me, "I have conducted myself and lived my life as an engaged citizen in my city and my various communities," and she has empathy for victims of dis-placements that are "tragic and very real." Last spring, she sought and got a meeting to discuss the situation with members of the activist group, who proved unbending. "Their single and inflexible demand is that we hand over the keys of the space to them and end 356. It is also very important to them that I 'leave graciously' by signing a document saying I agree with all their ideas and I have learned from them." Sub-sequently: "All of the staff and our friends have talked this over, asked community members, done research and do not believe we have found any evidence this will result in the reversal of gentrification." It's a fact of experience that the appearance of artists and galleries in low-income areas reliably portends rising real-estate values, with dire consequences for many residents. What's rare in the case of 356, which owns no prop-erty and has no monetary investment in Boyle Heights, is the sensitivity

of its leader, on the horns of an irremediable dilemma. An adage about the inevitable fate of good deeds springs to mind. So does an unlucky resonance of Owens's creative disposition.

"A painting seems to never not be art . . . even whether it is sitting on the shelf in the art-supply store or in the dumpster," Owens said in a symposium, earlier this year, at the Museum of Modern Art, on the heroically perverse French Dadaist Francis Picabia. (Why bother vying to win at a game that can't be lost?) Analogously, an art space can never not stand for art, whether up your street or on the moon. "Making mistakes is part of the work," Owens told the children at her daughter's school. Will 356 Mission turn out to have been a mistake for her? It will be an illuminating one, if so. Conceived in the hope of opening a window of social possibility, 356 may instead have hit a stone wall of political rancor.

Owens said to me, "I really believe in art, that art can do things that other things don't do. It's important to try, and fail, and to believe that things can do things." She is a genius of revelations, along the lines of that premise. She revealed twenty years ago, and has kept doing it, that what seemed a terminally exhausted state of painting could be a garden of unlimited, freshening delights. Now she confronts a larger imbroglio. Does art still, if it ever did, matter beyond the commercial and institutional bubbles of the art world? Can aesthetic pleasures have ethical payoffs, imparting lessons for life? Or does life overrule rationales for art altogether? These are not abstract questions for Owens. They spur her to propositions that, availing or not, solicit dead-honest responses of eye, mind, and heart.

New Yorker, October 30, 2017

GOYA

People I talk to are disappointed by *Goya and the Spirit of the Enlightenment*, at the Metropolitan Museum. It really is dull, keyed to numbing amounts of information about politics in Spain during the artist's career. The art is forced to illustrate the history, which one doesn't necessarily care about. Nor is a reason for caring proposed. The show was conceived on the Planet of the Scholars, where every question is considered except "So what?" There is the nice touch of a reading room halfway through. It should be equipped with oxygen tanks.

But part of the disappointment must be laid to Goya, a painter often overrated in this century. He disappoints even in Madrid's Prado, where his strongest works reside. He is one of the greatest graphic artists who ever lived—a distinction best savored in the intimacy of a book rather than in ranks of little prints at a mobbed show—and he is a heroic artistic and historical figure: appalled discoverer of the modern condition, the first Old Master who feels like one of us. But a degraded Baroque tradition weighed heavily on his painting, despite his extraordinary command of color.

We might term Goya the artist *of* disappointment, the bard of smashed hopes. That could have given point to the Met show, had its organizers not been so eager to portray Goya as an Iberian Henry Fonda. I have no problem with the facts laid out. Goya (nearly an exact contemporary of Thomas Jefferson) identified with a late-eighteenth-century liberalization in Spain, which was effectively obliterated in 1814. But it's as an artist of defeats, not a watery liberal evincing "sympathy for the common man," per the Met show's treacly surmise, that Goya looms for posterity.

I can guess why an upbeat myth might be favored in Spain today, still only fourteen years into that snake-bitten nation's post-Franco perestroika. But it falsifies Goya. We are left to have what experience we can of his art amid a didacticism that's as energetic about the many inferior works as about the few masterpieces present. A tip: seek out the five Goyas in the Met's permanent collection, better than almost anything in the show.

My favorite picture in the show is *Maja and Celestina on Balcony* (1808–1812): an ambiguously winsome young prostitute and an ambiguously gleeful old procuress behind her, apparently as a lure and a warning to men. The figures glimmer out of the black background full of an awful knowledge that dawns suddenly: the lure is taken, the warning too late. The thought is as good as the deed. This is a very modern sort of perception, which arrives full-blown in history with Goya (and William Blake). All of the Met show's nattering about progressive attitudes is cold cant compared to the traduced subjectivity that is Goya's caveat to Enlightenment values. Deaf for the last thirty-six years of his life, he saw the irrepressible beast within the supposedly rational citizen.

The first thing many people note about *Maja and Celestina* is its prediction of Edouard Manet, who, as a painter, learned from and improved on Goya while domesticating the beast. Manet's world is erotically alert, but people don't go around overtly brutalizing one another. What would we make of Goya if Manet had not picked up on him? We can't know, any more than we can really assess Cézanne without the retroactive gloss of Picasso and Braque.

The single most definitively Goyaesque tone is, to put it directly, gross-out: hilarity plus shock, with an aftereffect of feeling pawed. Mocking the show's prissy wall labels, the *Disasters of War* are a delightful encyclopedia of garroting, hanging, stabbing, shooting, axing, spearing, stoning, starving, and poisoning, not to mention fun with corpses. And what of the print from *Caprichos* touching on pedophilia: a witch wields a naked boy like a bellows, using his farts to swell a fire? You can only hoot or tremble, or both.

Goya inhabits the moral twilight of extreme satire: ambiguity of being "against" things whose pleasures you have imagined. He groans and cackles in the attic of modern culture. The Goya who will haunt us until the end of time is beyond politics and beyond art.

7 Days, May 31, 1989

PART II

—

HEAVY & LIGHT

HEAVY

BERLIN, 1989

A small hammer I bought in Berlin at the beginning of this month dislodged only sparks and dust from the Wall—that sucker is *hard*—so I had to glean bits from tailings left by better armed others. *Had* to? It did occur to me as I grubbed in the dirt that such keenness for crumbs of concrete, with or without the traces of spray enamel that elated me when found, might be idiotic. But, yeah, had to. That's the way with collecting, which no sooner battens on a species of thing than it applies a hierarchy of qualities—size, presence of spray paint—for greed to glamorize. Once you let something symbolize—let a wall be the Wall—you are lost to yourself and must possess it to be whole again.

I ♡ Berlin, smoky and haunted, gap-toothed city teeming with symbols, and pretty soon, now, among the main cities of the world. Rabbits still inhabit the weedy acres of Potsdamer Platz, the bomb-obliterated and Wall-riven former crossroads of Europe that is going to be incredibly expensive real estate when the Germanys reunify, which they will. In Berlin you feel the inevitability not in what people say to you—usually some cagey, befuddling German bullshit—but in the air, with a momentum like the hero and heroine rushing to embrace on the train platform so that the movie can be over.

The serious hammerers were at it behind the Reichstag, north of Potsdamer Platz, and, to the southeast, in the bohemian environs of Kreuzberg. (A friend who went with me to explore the latter place after midnight later discovered, on the sole of his shoe, dog shit with a guitar pick embedded in it: a Kreuzberg haiku.) Though maybe mauling for money now, with prices listed for different grades of fragment, the hammerers raised a lovely clamor in the winter city. Through holes here and

there I could glimpse weirdly smirking East German border guards and their confused police dogs. At one gap, I saw a guard intensively flirting with a West Berlin girl. Love conquers all, if you can wait long enough.

I fell for Berlin on another visit seven years ago, when the city felt like the bottom of a cold ocean and a fever burned in the nightlife that made the local, shrieking Neo-Expressionist style of painting feel natural. Only tourists so much as glanced at the Wall then, as if it were an evil eye whose gaze could shrivel. It was ground zero of the world, on the exact brink of ever-impending doom. The first shot would be heard there. I was aware of my heart beating, as of a clock ticking, and felt almost unbearably alive.

Now it's as if the place blew sky-high, with people looking around as if to say, "I'm flying? I'm flying!" That's in the West, where the window-shoppers from over yonder have the look of backwater folk in Times Square. I visited East Berlin for the first time: last chance to sample Communism in place, unless Albania consents to become a theme park. I saw a few people smiling, which someone knowledgeable told me is without precedent. But the East's decrepitude, soft-coal stink, rudeness, and all-around senselessness were as advertised. What a dump!

Art? What happens next in the sphere of German creativity, already more energetic and consequential than ours, is a prospect so tantalizing that my curiosity about current events dims. You can turn the world upside-down in a matter of days—now everybody knows *that*—but artistic expression is slow to register, digest, and further the will of history. Give it a few months.

My wife and I have set out our bits of the Wall in a candy dish for holiday visitors.

7 Days, December 27, 1989

REMOVAL OF THE *TILTED ARC*

There is something new this week on the plaza of the Javits Federal Building in Lower Manhattan: nothing. It's worth a visit. You may never in your life see anything more not there—quintessence of gone, Absence City—than Richard Serra's *Tilted Arc* now that it has been lumbered off in pieces to a Brooklyn warehouse, leaving a slab of sparkling vacancy twelve feet high and a hundred and twenty feet long. You may or may not feel, as I do, sweet relief, like that of a kid when the school bully moves away.

On the bright, cool afternoon after the removal, passersby gazed at the slit in the plaza where the sculpture had stood. They seemed amazed, as I was, that a thing so overpowering could have fit into so narrow a fissure. This being New York, a spontaneous symposium was under way, with people person-on-the-street-interviewing one another. There was a mood of wonderment and the odd twinge of regret, such as the loss of an old antagonist may entail.

A woman with frizzed hair and cowboy boots said, "I liked walking by it. I liked the graffiti on it. I liked everything about it." A group of what looked like young lawyers listened. One said, "Richard Serra didn't want you to *like* it." An old guy, courtroom-gofer type, seemed moved by an automatic grievance against anything done by the government. "I didn't like it for years," he said to no one in particular. "Then I got used to it. It just turned into another thing." But he was smiling.

I never stopped hating the placement of *Tilted Arc*. That it was a good sculpture in Serra's obstreperous manner made it all the worse for an already cheerless setting. I wrote as much in the *Village Voice* in 1981, with the result that I got screamed at by people who deemed it treason to impugn an artist's carte blanche by implying that the public should have a say in public art. Did *Tilted Arc*, which walled off a rare open space in the area, make people feel every kind of oppressed? Some mandarins thought that was fine. "It'll do them good," a famous artist said to me of the thirteen-hundred office workers who had petitioned

for the work's removal. "They'll quit and get new jobs. It will change their lives."

With characteristic delicacy, Serra told Gerry Marzorati, at the *SoHo News*, that my dissent smacked of "fascism." He went on, "When people say they want *Tilted Arc* removed, I can smell the books burning." But it was never an issue of his freedom. It was about government saddling its employees with a bummer of a sculpture. Parallels with fatwa-imperiled Salman Rushdie do not apply, unless you imagine a federally mandated recitation of *The Satanic Verses* over loudspeakers in a public place, twenty-four hours a day forever. Which sounds kind of neat, actually, but anything might until you have to live with it.

No longer Berlinized, Federal Plaza now looks its banal and naked self, badly wanting the benches and greenery that you'd think someone would have deemed preferable to Serra's rusted cancellation mark. The festering split in our society down the middle of the phrase "public art" won't be healed so efficiently. Think about it while having lunch from a bag there, as I did the other day. That has become one of the world's great philosophical sites, its voluptuous void a monument to the cultural *tsuris* of democracy.

7 Days, April 12, 1989

CONCRETE AND SCOTT BURTON

CONCRETE

Concrete is the most careless, promiscuous stuff until it is committed, when it becomes fanatical. Liquid rock, it is born under a sign of paradox and does not care. It doesn't care about anything, lazy and in love with gravity but only half in love. Pour concrete out on the ground and it will start to puddle and spread, enraptured by gravity, but then will think better of it: enough spreading! Concrete can't be bothered; it heaps up on itself in glops, as sensual as a frog.

Concrete takes no notice of what is done with it, flowing, regardless, into any container; but the containers, the molds and forms, must be fashioned with laborious care, strong and tight, because concrete is heavy and feckless. Promiscuous, doing what anyone wants if the person is strong enough to control it, concrete is a slut, a gigolo, of materials. Every other stuff—wood, clay, metal, even plastic—has self-respect, a limit to what it will suffer, and at the same time is responsive within that limit, supple in the ways it consents to be used. Not concrete. Concrete is stupid and will do anything for anyone, without protest or pleasure, if the person will indulge its half-love of gravity, its passion for lying down. Only give it a place to lie down, of any shape, and it will oblige.

But let concrete set, and note the difference. Concrete hardens in the shape of whatever container received its flow, its lazy abandon in thoughtless submission to half-loved gravity. Once it has set, concrete becomes adamant, a Puritan, rock, Robespierre. It declares the inevitability, the immortality—the divinity!—of the shape assumed, be it a glopped heap on the ground or a concert hall. Concrete that has set will have no thought, no monomaniacal obsession until the end of time, except that shape. No other material—not brick, not wood, not the stone blocks of the Pyramids—forgets itself to such an extent. Bricks, planks, and blocks whisper from their configurations of a willingness to become something else, on the understanding that the fashioner will

186

respect their dignity, their compunction against doing just anything for just anybody. Even whorish but ironic plastic demurs at the form it takes, ready if given heat, some lovely heat, to melt into another form. Likewise metal and glass. Not concrete when concrete has set.

Set concrete insists, insists, insists. It extols the rightness, permanence, godliness of the shape into which it flowed. You must smash set concrete to bits if you would shut it up, and even then the smashed bits will lie around piping. I was in Berlin in 1989 and remember a hundred hammers attacking the Wall. The hammers said, "Die, die, die!" The concrete said, "Wall, wall, wall!" I brought fragments home, and the ones that retained any flat surface still shrilled in tiny voices, totalitarian for eternity.

There is something not right about the notion of "working" concrete—finely finishing it, making its forms true, smooth, and elegant. This insults concrete's strength and simplemindedness, mocking it as if by forcing fancy dress on a rough worker. Unlike the worker, however, concrete isn't truly mockable. It is impervious. Go ahead and make fun of it. Concrete won't notice.

Concrete has no feelings to hurt. It does have feelings, as we know, but they are fanatic, untouchable by anything. Clay is touchy, wood is as woundable as the flesh that it is, and brick has a yeoman's pride, stolid and prickly. All have good reason to resent misuse and to exude sadness when misused. But kick concrete as much as you like, you will hurt only your toe.

Concrete is the perfect exercise device for unrequited loving. It is like Don Quixote's Dulcinea, only colder. Coarse and stupid beyond compare, it combines those base qualities with the froideur of a goddess, of Pallas Athena. It is a dominatrix blind, deaf, and dumb, dumb beyond anything.

Concrete has its one fleeting moment of slovenly bliss, half giving itself gloppity-glop to gravity, and then it burns coldly forever with its idée fixe. You must be a masochist to love concrete, enjoying the strength that your capacity to love displays, until your strength is exhausted, when the loved one is a pitiless idiot.

SCOTT BURTON

The above description of concrete partly fits Scott Burton, who died at age forty-nine, in 1989, as I remember him: his sensual presence, his lazy humors half in love with gravity, though also animate and volatile. He was virile and handsome with a touch of cute. He liked to lounge, perhaps not incidentally for the best sculptor ever of things to sit on. Most of all, his imagination flowed like liquid and set like rock. He profoundly plumbed histories of art and design and theories of form and function. He espoused a politics of radical democracy. He effervesced with ideas. But once he settled on something, bam.

I have missed Scott terribly. But whenever I encounter one of his works, he takes a break from being gone.

A piece by Scott is monomaniacal but never stolid. There are always reasons of history, analysis, function, and beauty. It's as if a force of some inevitability, a Hegelian demiurge, had fulfilled itself in this thing. You couldn't find seams in Scott's conviction once he was decided. I believe that he understood concrete with an occult understanding: the intelligent artist enjoying the resistance of the imbecilic stuff.

Scott's active involvement with concrete was brief, during a period when he experimented with all manner of building materials, including brick and glass. His concrete opus, conceived in the late seventies and executed in the early eighties, consists of three works: a group of sixteen small, squat, differently geometric tables; a single wide conical table, set on its point; and an inverted-pyramidal table with four stools of the same shape.

The masterpiece is the conical table, a feat of steel-reinforced engineering. But most Scott-like is the set of tables, with geometries that share short, small-waisted, large-shouldered proportions with his body. Paired, the units are like ballroom dances of Scotts. They were hard to do. He told me that he would have preferred to pour and let them be, as "natural" concrete. But a look of naturalness in the supremely unnatural medium required a lot of finishing work.

Scott made fun of concrete by treating it with lapidary finesse and escorting it to the ball. It is faintly preposterous to see the pieces in the sorts of space that are designed to display art. "Whoever invited *that*?" someone might say. Be its forms ever so beautiful, concrete is an ugly duckling that grows up to be an ugly duck.

As well as slightly shocking, with an admixture of humor, Scott's exquisite working of concrete amplifies the purity of his formal ideas. When he used marble, granite, and even terrazzo—poor people's marble, concrete in disguise—he honored them with worthy functions. In return, they softened with seductiveness the severity of his sensibility. Pure form and fine material—think of Brancusi, whom Scott understood better than anyone—enter into an erotic unity that is sociable in the best company.

Concrete may be gotten up as swankily as possible and not fool anyone. But the form establishes its nobility by way of aristocratic condescension in the old, positive sense of that word. There is a vivid quality of high conception, as of a perfect drawing, though the object may weigh half a ton.

You know by looking that Scott could love concrete with the requisite masochism. But there was a limit. He did things, as he said things, thoroughly but not repeatedly, always on to the next. I cannot forget the sheer economy of a beautiful man—he was kind, by the way, as great artists often are not—who would gravitate to the comfiest spot in any room, luxuriate, and smile.

Max Protetch Gallery catalogue, 1992

PICASSO SCULPTURE

Picasso Sculpture, a show at the Museum of Modern Art of nearly a hundred and fifty works by the definitive artist of the twentieth century, always figured to impress. It turns out to astound. I came away from the exhibits, which date from 1902 to 1964, convinced that Picasso was more naturally a sculptor than a painter, though all his training and early experience, and by far most of his prodigious energy, went into painting. He made mere hundreds of three-dimensional works, in episodic bunches, amid a ceaseless torrent of about four and a half thousand paintings. When moved to mold, carve, or assemble, he sometimes borrowed artist friends' studios and tools and enlisted their collaboration—most notably, starting in 1928, with Julio González, who worked in iron. Picasso could be feckless about the standards of the craft. (The director of the ceramics workshop in Vallauris, where, in the late forties, Picasso took up the medium of fired clay, noted that any apprentice who went about things as the artist did would never be hired.) But, because Picasso was an amateur—nearly a hobbyist—in sculpture, it revealed the core predilections of his genius starkly, without the dizzying subtleties of his painting but true to its essence. At this magnificent show, curated by Ann Temkin and Anne Umland, I began to imagine the artist's pictures as steamrolled sculpture. Most of his paintings conjure space that is cunningly fitted to the images that inhabit it. When the space becomes real, the dynamic jolts.

The show's first gallery features the best known and, instructively, the least successful of Picasso's early forays into the medium: *Head of a Woman* (1909), a bronze, cast from clay, which is complexly rumpled, in the manner of incipient Cubism. The work fails because the energetic surface articulation bears no organic relation to the head's sullen mass; it amounts to a wraparound relief. The piece is a painter's folly, which Picasso did not repeat (except with the similarly hapless plaster *Apple*, of the same year), even as its style vastly influenced such subsequent sculptors as the futurist Umberto Boccioni. (No innovation of Picasso's was too tangential to spawn a modern-art cliché.) Picasso put sculpture

aside for a few years, then returned to it as an extension of his break-throughs, with Georges Braque, in the revolutionary aesthetics of col-lage. Two versions of the large, wall-hung *Guitar* (1912–14)—the first in cardboard, paper, and string; the second in sheet metal and wire—did for sculpture something of what Picasso had already done for painting: they turned it inside out. The term *negative space,* for the air that he let into the anatomized musical instrument, doesn't suffice to describe the effect. The voids register as active forms, which the shapes passively accommodate. No longer set apart from the world, his art after *Guitar* adds the world to its inventory.

Then came the most talismanic of modern bibelots: *Glass of Absinthe* (1914), a small bronze of a cubistically fissured, ridged, and whorled vessel with, atop it, a filigreed metal spoon bearing a bronze sugar cube. Picasso created it the same year that the liquor was banned in France, in the mistaken belief that it made people crazy. (Actually, it was just fancied by people prone to craziness.) All six casts of the work, from as many collections, are convened here for the first time since their cre-ation. Each incorporates a differently designed spoon and is differently slathered or dappled with paint. The brushwork, especially in sprightly dot patterns, blurs the objects' contours, rendering them approximate in ways that wittily invoke intoxication. But these are true sculptures, as judged by the essential test that they function in the round. Circle them. Each shift in viewpoint discovers a distinct formal configuration and image. Picasso here steps into the history of the art that, in order to move a viewer, requires a viewer to move. The best of his other Cubism-related works, such as *Still Life* (1914), which fringes a tipped shelf with upholstery tassels, run to assembled and painted reliefs, like pop-up pictures. Their dance of everyday stuff with august form—reality mar-rying representation—has never ceased to inspire generations of visual hybridists, from Kurt Schwitters to Robert Rauschenberg and Rachel Harrison, and it never will. But these works mainly harvested ideas from Picasso's painting. His attention to sculpture lapsed again, until 1927.

Picasso's creations in plaster, wood, and metal between that ban-ner year and the mid-thirties belong in the first rank of sculpture since

ancient times. Most are massy: female forms that can seem swollen to the point of bursting, or tumescent and writhing with sexual abandon. A glory of the show is the number of works rendered in fragile plaster, straight from the artist's hand; he rarely paid much attention to the surface quality of the final bronzes, which tends to be dull. His initial masterworks of the period, made with González, are open networks of thin iron rods, vaguely suggesting jungle gyms, which gave rise to the somewhat misleading catchphrase "drawing in space," coined by Picasso's dealer, Daniel-Henry Kahnweiler. More truly, the rectangular arrays encage space. They yield an image—coalescing into a kind of drawing, of a geometrically abstracted figure—when viewed from either end. That's delightful. But the wonder of the works is their appearance from other angles: the image pulled apart, accordion fashion, to drink in the ambient air. Again, emptiness becomes substance.

Notice, incidentally, how the rods meet the bases. As always when a Picasso sculpture rests on more than one point, each footing conveys a specific weight and tension, like the precisely gauged step of a ballerina. It presses down or strains upward in a way that gives otherwise inexplicable animation to the forms above. Few other sculptors play so acutely with gravity. David Smith is one. Another is Alberto Giacometti, whom Picasso befriended, admired, and mightily affected. Works in this show directly anticipate Giacometti's skinny figures and even, by a few months, his classic, harrowing *Woman with Her Throat Cut* (1932).

Of the scores of pieces that merit lengthy discussion, I'll cite one: *Woman with Vase* (1933), a bronze of a plaster sculpture that, cast in cement, accompanied *Guernica* in the Spanish Pavilion at the World's Fair in Paris, in 1937. She stands more than seven feet tall, with a bulbous head, breasts, and belly, on spindly legs. Her left arm is missing, as if ripped off. Her right arm extends far forward, clutching a tall vase. Seen from the side, the gesture suggests a tender offering. Viewed head on, it delivers a startling, knockout punch. What isn't this work about? It conjoins Iberian antiquity and Parisian modernity, love and loss, hope and anger, celebration and mourning. Another bronze cast of it stands at Picasso's tomb, in the Château de Vauvenargues, as a

memorial and, perhaps, as a master key to the secrets of his art. Certainly, it overshadows the somewhat indulgent—and, now and then, plain silly—sculptural creations of his later years, such as the gewgaw-elaborated bronze *Little Girl Jumping Rope* (1950). Exceptions from that time include a stunning selection of his riffs on ceramic vessels, lively bent-metal maquettes for public art, and a group of six *Bathers* from 1956: flat figures, one almost nine feet tall, made of scrap wood and standing in a shared, beachlike bed of pebbles. Its éclat might well sink the hearts of contemporary installation artists.

The herky-jerky intermittence of Picasso's involvement with sculpture might seem an obstacle to a reconsideration of his achievement, but it proves to be a boon. Each generation looks at Picasso in its own way. This show gives us a Picasso for an age of cascading uncertainties. The story it tells is messier than the period-by-period, not to mention mistress-by-mistress, narratives of the past. Instead, each piece finds the artist in a moment of decision, adventuring beyond his absolute command of pictorial aesthetics into physical and social space, where everything is in flux and in question. We are in Picasso's studio, looking over his shoulder, and wondering, along with him, What about this?

New Yorker, September 21, 2015

DONATELLO

Sculpture in the Age of Donatello, a splendid small show of early-Renaissance Florentine works at the Museum of Biblical Art, on Broadway at Sixty-First Street, impelled me to haul down my long-neglected copy of the Good Book. What I read—which I'll get to—startled me. It lends dramatic irony to *Prophet* (1435–36), a statue of an Old Testament minor seer, thought to be Habakkuk, which Donatello created for the bell tower of the Florence Cathedral. It is one of the greatest sculptures in the world, and among the most mysterious.

Habakkuk? Which one was he? In gray marble, he stands about six feet tall, a ravaged man of forty-something with a bald and almost, but not quite, impossibly elongated head. (Early on, in Italy, the work had the nickname Lo Zuccone, for pumpkin.) He is electrically tense. One hand grips a strap beneath his flowing robe, of which the drape and crumple are rendered with striking economy. (The best of Donatello shares with the classical Greeks and with no one else, Michelangelo included, a confounding unity of earthy realism and refined abstraction.) The other hand clutches the robe's fabric. You sense from the hands, arms, neck, and one bare shoulder, and the sandaled feet, the whole of a gaunt, sinewy body, which you all but smell.

He seems anxious, if not anguished: fraught with pent-up emotion. His head tilts forward with eyes wide and the lips of his large mouth parted. He appears about to say something. A legend recounted by Vasari, a century later, has it that Donatello was so affected by the lifelikeness of the statue that, while working on it, "he would look at it and keep muttering, 'Speak, damn you, speak!'" Keep this in mind as we turn to the Old Testament.

The short Book of Habakkuk is beautifully written. Almost nothing is known of the man, except that he must have lived in Jerusalem in an era, starting circa 612 BCE, when Babylonian invaders repeatedly despoiled the land of the Jews. He complains to God (in the New English translation), "How long, O Lord, have I cried to you, unanswered? I cry 'Violence!,' but thou dost not save." He details the savagery of raiders

"like vultures swooping to devour the prey." But a vision of eventual rectification allays his despair: "At the destined hour it will come in breathless haste." He vows, "I will take up my position on the watchtower." (Echoed by Bob Dylan,) Habakkuk warns his people against greed and dissipation, in general terms. Then he delivers a specific reproach to sculptors of "dumb idols" in wood or stone: "Woe betide him who says to the wood, 'Wake up,' to the dead stone, 'Bestir yourself!'"

Does Varsari's tale of Donatello demanding conversation from his carving reflect a garbled memory of the Biblical text, confusing the artist's Habakkuk with a very sin that the prophet denounced? Or did that misreading lead to an otherwise unfounded belief that Habakkuk is the work's subject? The alternative possibility, once you've thought of it, may haunt you as it does me: Donatello, an artist of unfathomable intelligence, was inspired, or somehow driven, to play out in stone a spiritual danger intrinsic to art.

To spend enough time with the work is to incur a trance of anticipating the words that are forever on the tip of the figure's tongue. They are apt to be extremely important, in the way of a prophesy of the historical Habakkuk: "If it delays, wait for it; for when it comes will be no time to linger."

New Yorker online, March 2, 2015

AUGUSTUS SAINT-GAUDENS

Augustus Saint-Gaudens's gilded bronze equestrian statue of General William Tecumseh Sherman, at the southeast corner of Central Park, across from the Plaza, is my favorite public art work in New York. I always pause, when I have time, to contemplate the grizzled warrior and the Angel of Victory who strides ahead of him, arm raised in joyous salutation, and "seems to be leading the horse into Bergdorf's," as Frank O'Hara observed in a poem. There is so often a pigeon atop the General that it might as well be gilded, too. Old-fashioned monumental statuary attracts jokes and pigeons, of course. For generations now, we have lacked the mental means for taking it seriously, even when we notice it. But this work moves me. It is fantastically adept, for one thing. Willem de Kooning once remarked of its creator, "He got the guy to sit *right on the horse*! You know how hard that is?" The bluff oneness of rider and steed is indeed striking. And Sherman's ravaged, ornery visage convinces utterly, crowning Saint-Gaudens's signature feat of investing idealist art with realist grit. Modeling the head, in 1888, took eighteen two-hour sessions, during which the artist asked Sherman to button his collar and straighten his tie. The dishevelled sitter demurred: "The General of the Army of the United States will wear his coat any damn way he pleases."

The angel is a wonderment of alacrity. Facing southward, she flourishes a palm frond—nettling some Southerners, who are still apt to repeat the hoary wisecrack "Just like a Yankee: make the lady walk." Henry James winced at the symbolism when the statue was unveiled, in 1903, twelve years after Sherman's death. The writer deplored "all attempts, however glittering and golden, to confound destroyers with benefactors"—in this case, a man "symbolizing the very breath of the Destroyer" with "embodied grace, in the form of a beautiful American girl, attending his business." That's spot-on but peckish. The sculpture's metaphorical conflation of grisly war and blooming hope is precisely what enthralls me. It addressed a contemporaneous national yearning, most vivid in the cult of Abraham Lincoln, to wring a heart's comfort

from the awfulness of the Civil War. The work is at once vulgar and sublime, in ways that invoke a common term: American.

Augustus Saint-Gaudens in the Metropolitan Museum of Art, a scholarly show of some four dozen works from the museum's collection, augmented with loans, gives me a chance to comb out tangled thoughts about a very American, chronically underrated artist, who died in 1907, after suffering from cancer for several years, at the age of fifty-nine. I have taken the occasion to visit, at last, the Saint-Gaudens National Historic Site, the sculptor's painstakingly preserved estate, on rambling hilltop grounds, in Cornish, New Hampshire. Among the abundant works to be seen there is a copy of his most powerful achievement, the Shaw Memorial (1884–97), on the Boston Common. Colonel Robert Gould Shaw commanded the 54th Massachusetts Regiment, a corps of African American soldiers that included two of Frederick Douglass's sons, during the Civil War. In an audacious combination of high and low relief, the mounted officer leads his richly individualized troops, their ranks bristling with shouldered rifles, beneath a wafting, solemn angel. Shaw and much of the regiment were killed in an assault on Fort Wagner, in Charleston Harbor, in 1863. The shared expression of the many faces harrows. It strikes me as the courage, indistinguishable from indifference, of the already dead. Morbid and exalted in equal measure—an epic of sacrifice—the work has a European parallel in Rodin's *The Burghers of Calais* (1889), representing the legend of six men who, in 1347, volunteered to be executed in return for the lifting of an English siege of their city. Saint-Gaudens became friends with Rodin during a sojourn in Paris in the eighteen-nineties, and also with James McNeill Whistler. Like them—and like other superb contemporaries, including the muralist Puvis de Chavannes and the architect Stanford White—he was modern in spirit but retained conservative forms, consequently landing afoul of histories of modern art that venerate avant-gardism. Might we have reached a point of being allowed to praise Saint-Gaudens without apologizing to Picasso? It would rekindle a long-lapsed wish for art that is both of the moment and genuinely public.

Saint-Gaudens became an American in infancy, brought to New York by his French father and Irish mother after his birth, in Dublin, in 1848. He passed a rough-and-tumble boyhood downtown, where his father, a cobbler, had a shop on Lispenard Street. Saint-Gaudens left school at the age of thirteen and apprenticed as a cameo-maker. He studied drawing at the Cooper Institute (now Cooper Union) and at the National Academy of Design. In 1867, he went to Paris and immersed himself in academic training. Fluent in French and a charmer, he gained a wide social circle, paving the way to recognition and commissions. In Rome, where he lived from 1870 to 1875, he carved a marble *Hiawatha* in the going sentimental mode, for a former New York governor, which he bragged would "amaze the world and settle my future." He soon improved on that work, his style deepening under Italian influences, including that of Donatello—the favorite Renaissance sculptor of those of us whose favorite Renaissance sculptor isn't Michelangelo. Saint-Gaudens won renown with consummate portrait busts. He returned to New York to seek a fiercely contested commission for a statue of the Civil War hero Admiral David Glasgow Farragut, of "Damn the torpedoes! Full speed ahead!" fame. His *Farragut* (1877–80) stands, looking rumpled by a stiff breeze, in Madison Square Park, on a beautiful base by Stanford White. It is terrific. The triumph made Saint-Gaudens the leading sculptor in an American flowering of Beaux-Arts design, the so-called American Renaissance, which foundered with his death and that of White, who was murdered, just a year earlier, at the age of fifty-two.

Saint-Gaudens married Augusta Homer, of old Boston stock, in 1877. They had one child, a boy. From the eighties, he is thought to have maintained a separate ménage, in Connecticut, with a mistress, Davida Johnson Clark, a Swedish-born model, who gave birth to another son. Clark's is the face of *Diana*, the nude archer he created as the weathervane—a skyline-topper, eighteen feet high and some thirty-two stories in the air—for White's Madison Square Garden, which was finished in 1890 and demolished in 1925. Reproductions of the great bauble, on scales from monument to bric-a-brac, became a money-maker for the artist. A gilded eight-footer dominates the courtyard of the Met's

lately revamped American Wing. Willowy and taut, she rests the toes of one foot on a sphere and leans forward a bit, into her shot, with athletic allowance for the coming recoil. Good luck deciding what she symbolizes. *Diana* seems to me sui generis, embodying sheer, somewhat mad inspiration in a manner that wasn't uncommon in the era of Art Nouveau but was realized nowhere else with such Apollonian aplomb. It affects me as one of those moments—certain sentences by F. Scott Fitzgerald, say, or turns of Fred Astaire and Ginger Rogers—when an oxymoronic American dream of aristocratic democracy comes suddenly, briefly true.

Logically, Saint-Gaudens's two monumental statues of Abraham Lincoln, both in Illinois, with copies in Cornish, should be his greatest works. They aren't. Their relative failure exposes the unbridgeable fault line in the artist's attempted synthesis of the ideal and the real. His searching of the most searched face in history, based on a life mask that is in the Met show, is impeccably sensitive, alert to Lincoln's peculiarly mingled humor and pain. But the man's inward gaze palpably contemplates not a self but a myth, as if Lincoln himself were transfixed, as we are, by the mystery of Lincoln. Still, there is resonant drama in the stretch of Saint-Gaudens's ambition. His Lincolns apostrophize all we can't help but want from that backwoods politician—rather like the impossible consolations that we may want, when we fall to wanting, from art.

New Yorker, August 24, 2009

THE GREEKS

I never got Ancient Greek art in the way that the cradle-of-civilization pieties imply you're supposed to. At the Acropolis in 1965, during my only Greek sojourn, the July sun hit me on the head like a transparent hammer, and I gazed lethargically at the bleached rubble. I was more stirred by the smelly, raucous Plaka, where in a restaurant an impromptu dancer gashed his hand slapping the floor littered with broken glass, grabbed a napkin to stanch the bleeding (in vain), and kept dancing. That was great. I wandered into a political riot at Syntagma Square and was introduced to tear gas, from which kindly Greek strangers helped me recover. I bought a black knit beret and worry beads and went native, in my dreams. I fell in love with Byzantine churches, which breathed kinship—as the Parthenon did not—to the life in the street. I was twenty-three and sided with the present.

I think a lot of people are ambivalent about the Greek thing, which has been subject to more solemn hype than anything else except Jesus. A Victorian sentimentality hangs especially heavy. The British liked old Greece so much, they took it home with them. OK, I had sensed, through literature, the greatness of a people who seemed, first and often forever best, to have thought everything thinkable and imagined everything imaginable. But it all felt so already-known, and encrusted with learnedness. In my pleasure-seeking self-education in art, I skipped Classicism.

Now the Metropolitan has the exhibition for me and anyone else ready to outgrow adolescent sulks. A greatest-hits sampler, it might be titled "It's the Greeks, Stupid." Anything would improve on *The Greek Miracle*, which sounds like a skin cream, and the subtitle that ends, *the Dawn of Democracy*. Some half dozen pieces made me intensely happy. It may have helped that I had just reviewed the 1993 Whitney Biennial, which proves that long indifference to formal fundamentals has lamed new art. That, more than the notorious emphasis on politics, is the biennial's bad news.

The Greeks were plenty political. But only at a stretch does a city-state whose majority was voiceless women and slaves yield a present sense of democracy. The art at the Met speaks of theocracy and militarism even as it does tenderly celebrate individuals, including women, children, and at least one servant. What counts is how they did things, with apparently magical ease. Everything seems a falling-off-a-log snap for those people, though you know it wasn't. It may be that they never considered doing anything except from, with, and for love.

Bodily nuances as subtly known as the nape of your lover's neck deliver the goods, even in a battle piece. What remains of a marble naked warrior who may be Theseus—minus an arm, a hand, both feet, and his penis—is sword-fighting a lost enemy. His face has a slack-jawed, almost sleepy, contented expression. (War is fun for him.) He appears to lunge forward. But tell me which leg takes his weight. I swear that he is shifting between one and the other, and you can't tell which. Theseus jukes! He is faking his opponent off-balance. The sculptor had to feel himself inside that body as he carved, to achieve that. For the full effect, take a head-on, about-to-die-enemy's view of it.

The most beautiful thing in the show is a four-foot length of the Parthenon frieze of horsemen. Four young riders and their trotting steeds bunch up three abreast in a relief that is just two and a quarter inches deep. The horses are spirited. The guys are loose, cool. The forest of equine legs is machinelike clatter. The riders are buoyant and swinging. You can just about hear ambient music: pipes and drums.

The torso of a running nereid is the suddennest hunk of stone you ever saw. Her speed plasters her thin garment to her with a wet-T-shirt effect, but she is nobody's babe. She is all fluid power. She can run for days and will arrive, where she's going, like a thunderclap. Then there is the Nike reaching back and down to adjust a sandal, a goddess doing something gawky. It is a carving of a body to which a carving of flowing drapery is formed. The nereid and the Nike are adjudged Hellenic—decadent turns from Classicism to show-off virtuosity. The Greeks got decadence right, too.

Military defeat and plague ended the peak Athenian moment. Sculptors who had worked on the Parthenon eked out livings carving grave steles for the moneyed. One relief at the Met, picturing a dowager going through her jewel box with a servant, memorializes "a woman who loved pretty things and has left them behind in death," per the perfect catalogue description. Another shows a little girl bidding goodbye, with a kiss, to a pet dove. I imagine the commissioned artist, before starting work, interviewing the parents. What had been remarkable about their daughter? "Well, she sure liked those birds."

I talked with someone art-knowledgeable who deprecated the Met show. Her favorite thing in it, she said, is a pre-Classical standing figure in rigid, Egyptian-influenced style. This struck me as a very modern opinion, and it made me realize that my own long antagonism toward the Greeks belongs to an educated contempt for both realism and idealism—opposites that are seamlessly joined in Greek art as in none other since. I hereby renounce that idiocy. Athena rules!

Village Voice, March 30, 1993

CHARLES RAY

Shows of new sculpture by the LA artist Charles Ray are rare—his labor-intensive works may be years in the making—and reliably amazing. He targets aesthetic and conceptual bull's-eyes that you didn't know existed. So it is with his three pieces at Matthew Marks. *Father Figure* is an enormous blowup, in machined and glossily painted solid steel, of an old (made in America, that old) toy tractor with a benignly beefy driver. It weighs a Richard Serra-esque eighteen and a half tons. *The New Beetle* is a life-size nude, cast in steel and painted white, of a young boy seated on the floor and playing with a toy Volkswagen. Its astute beauty reflects Ray's ongoing fascination with the integration of realism and abstraction in Classic Greek sculpture. Then there's the tiny *Chicken*, a pedestaled egg in white painted steel with a circular cutout revealing a porcelain chick about to be born. The gristly little bird struggles to get out; we look in. The show seems to be about childhood as an ever-recurring state of nature, history, and the soul.

New Yorker, December 17, 2007

BRUCE NAUMAN

I take it as a rule of thumb in our civilization that sophistication begins with disdain for mimes. Someone in a cute little suit and whiteface, with leaning-on-air tricks, trying to make us go warm and chuckly inside presumes a willingness to be charmed that, as we mature, we come to sell dearly.

Leave it to Bruce Nauman, who has an instinct for civilized bedrock and for causing cracks in it that reveal abysses, to make a mime suffer for the effrontery of her ilk and thereby to stir an appalled empathy in the viewer. The work is a four-monitor, four-projector video installation called *Shadow Puppets and Instructed Mime* at Sperone, part of an unsettling and magisterial current three-gallery show with which Nauman confirms that he has the most formidable intelligence in contemporary American art.

The intricately programmed video comprises, besides sequences involving the mime (a young woman, Julie Goelle, in New Mexico, where Nauman has a home), a montage of shadows cast on a scrim by backlit, pendulum-swinging sculpted heads. (Head games? On some level, all of Nauman's works are that: manipulations of states of mind.) Every so often, one head is violently bashed into by another. Even when you think you're ready for it, this doesn't fail to startle. Images jump from screen to screen around the room at gradually quickening and then slowing tempos. A full cycle takes twenty minutes.

An off-screen male voice (not Nauman's) reads instructions to the mime that range from dog tricks ("lie down," "roll over," "play dead") through increasingly tortuous tasks with a table and chair ("foot on your hand on the chair," "your hand in your mouth," "your head on the table") to combinations that are physically impossible in the time that the calmly hectoring voice allows, or at all. With as much mime-y cuteness as she can muster, Goelle must select from the torrent of commands. She shows frequent signs of stress.

Like almost everything Nauman makes—and in twenty-five years he has made more kinds of thing in more mediums than any other

artist—*Instructed Mime* has an element of cruelty. Its immediate predecessor is a suite of tapes, recently featured in the Whitney Museum's *Image World* show, unequivocally titled *Clown Torture*: clowns striving to be funny while trapped in circular jokes or stunts. Both works project a fascination with the will to perform—how bizarre it is and how powerful: clenched, primitive, practically reptilian.

Goelle sometimes seems about to be overwhelmed with frustration, but she does not succumb. (Or, if she did, it was edited out.) When she gazes off-camera with a despairing look that as much as says. "OK, now what?" your heart may go out to her. Little by little, her perseverance becomes an amalgam of horror and heroism, fusing a child's desperation to please, an athlete's gameness, and the self-abnegation of a true artist. The nakedness of the situation might make you cringe, but stay with it. The payoff is a feeling of lucid compassion and a surprising exaltation of art.

Fire-and-ice meshing of hot content and cold form is a definitive Nauman effect. It requires trust from the viewer. You must give yourself over to the comfortless premise of the work in order to test its truth. Nauman once said he wanted to make art that is "like going up the stairs in the dark, when you think there is one more step, and there isn't."

It helps that he sculpts, draws, and designs like an angel. This has been apparent ever since a legendary debut at Castelli in 1968 that incidentally marked his first visit to New York (where he never lived until his marriage to the painter Susan Rothenberg a year ago). Now forty-eight, he has affected the course of just about every visual medium except painting, earning a prestige among serious younger artists on the order of Marcel Duchamp's.

Nauman weighs in at Castelli and 65 Thompson Street with some animal sculptures that feel like instant classics. They are made from taxidermist's forms, which are spookily nude-looking, generic casts in polyurethane foam of flayed creatures—moose, deer, coyotes, bobcats—in "lifelike" poses, for covering with real skins. Nauman recast some in aluminum and assembled sawed-up pieces of others

to make ceiling-hung configurations of from one to four beasts and a twelve-foot pyramid of five caribou, eight deer, and four foxes.

With his characteristic no-fuss jury-rigging, Nauman's animal assemblies invigorate the lifeless shapes with a vitality of hand and eye, an energy of *making*. The effect is exciting in proportion to the weirdness of the reconfiguration: torso sections skewed, heads on backward, legs bristling from sides. The creatures surge more to life the more their bodies take forms that would spell death for anything living. The series amounts to a war between the aesthetic and the biological, which both win.

The pyramid is destined to be cast in bronze for permanent outdoor installation in Des Moines, Iowa. That's going to be wonderful. The triple-decked lumbering caribou, rearing deer, and leaping foxes radiate primeval force, as of a tribal creation myth, but with a lightness, as made things, that forbids sentimental projection. The foursquare dignity—the *thereness*—of the work calmly anticipates viewers who don't require mime-type cues to start feeling and thinking. It will be very damned handsome, too.

7 Days, March 28, 1990

RACHEL HARRISON: A PROFILE

The work of the sculptor Rachel Harrison is both the zestiest and the least digestible in contemporary art. It may also be the most important, owing to an originality that breaks a prevalent spell in an art world of recycled genres, styles, and ideas. Her work suggests standard categories of modern art—assemblage, construction, readymades—but evades them all, attaining a stalemate between figuration and abstraction. With Harrison, there is no more postmodernism but a nameless epoch that starts now. She is best known for her large, clumsy-looking sculptures—she wants to make "shapes that can't be described," she says—made of Styrofoam covered in cement, painted in acrylics, and equipped with banal objects: a case of grape soda placed on top, a water cooler nested in a side, an embedded photograph or video monitor. "She takes a bad thing and makes it worse," the critic and art historian Hal Foster remarked to me, approvingly.

Sculpture is the hardest art. Unlike diffidently wall-mounted painting, it intrudes on an already crowded world: mediocre painting is easily ignored; mediocre sculpture is exasperating. To be tolerated, let alone welcomed, a sculpture must have immediate and persistent drama, often announced by a certain shock. Ann Temkin, the chief curator of painting and sculpture at the Museum of Modern Art, told me, "When I first saw work by Rachel, I actively disliked it. I thought, Uh-uh! Then I couldn't get enough of it." That's not an infallible indicator of true innovation in art, but it bodes well.

The fact that Harrison is hardly a household name owes something to the nature of her work, which defies photographic reproduction, and a lot to her prickly abhorrence of market-driven promotion. She shows with the respected but low-profile Greene Naftali Gallery, in Chelsea, whose co-owner, Carol Greene, is a close friend. Her work sells at prices that are substantial—from about ten thousand dollars for a photograph to two hundred thousand for a large sculpture, Greene said—but nowhere near the millions that shower more biddable contemporaries. Yet, at least since 2007, when her piece *Huffy Howler*,

featuring a bicycle and a picture of Mel Gibson, from *Braveheart*, was a hit at *Unmonumental*, a pace-setting show of new sculpture at the New Museum, Harrison has been vastly influential among younger artists. "There's a version of Rachel everywhere" in art schools, the Whitney Museum curator Elisabeth Sussman told me. From what I've seen, Harrison's imitators readily produce jazzy complexes of vernacular materials and objects, but they lack the formal command and the rhetorical specificity that make every nuance in her work feel destined.

Harrison also draws. A tempestuous series, from 2011, combines caricatures of the tragic, big-haired British singer Amy Winehouse, who died that year, with, in some cases, sketches of modern-art icons—Picasso or the late German artist Martin Kippenberger, painting in his underwear—and, in others, with images by Picasso (of his lover and muse Marie-Thérèse Walter) or Willem de Kooning (*Woman V*). The attitude seems to be part ridicule and part homage; it is altogether confounding. In addition, Harrison photographs constantly. In 2000, she was lured to a house in Perth Amboy, New Jersey, by the news that an apparition of the Virgin Mary had been detected in the glass of a living-room window. The pictures that Harrison took reveal no such semblance but record the handprints of believers on the pane and the refractions of light from changing skies. They are beautiful. What we make of the associations to religion is not the artist's affair. "People see what they want to see," Harrison told me. "My art is always loaded. There is too much, on purpose, because I'm not going to give you the thing you want."

Her work has abounded with artifacts of popular culture and politics, such as a framed photograph of Leonardo DiCaprio and, during the Iraq War, a Dick Cheney mask. When expressed, her political leanings register in whispers rather than shouts—most explicitly, so far, in a series of sculptures from 2012 that are best imagined in the homes of rich collectors. They incorporate cleaning products and appliances and are collectively titled *The Help*. But, first and last, all the objects and images in Harrison's art are stubbornly real entities, taken from the world and returned to it without comment. Their topicality begins to

date, aging pungently, the moment she chooses them; they aren't signs of anything, just more or less resonant facts.

Harrison's sculpture appears to be pictorial, encouraging a frontal view. But walk around it. There is no front. Each step discovers a different configuration and an altered mood, inflected by colors on an ably managed scale ranging from clanging garishness to exquisite subtlety. It takes time to realize that a work's oddities submit to an overall, exacting rightness of form. About a decade ago, I mistook Harrison's work for a neo-Dada pastiche of "junk" aesthetics. (That reaction lingers for some, including an *ARTnews* reviewer, who, in 2012, reviled "the gimcrack, bauble-encrusted assemblages of Rachel Harrison.") But then it dawned on me that the stylistic echoes establish a cogent tradition: a past that she revises and propels into the future. The reshuffling effect impresses and reconciles critical theorists like Foster and aesthetes like me, who are apt to bristle at one another. As for "junk," Harrison exposes the arbitrariness of the word, which, like the use of "weeds" to describe ungoverned plants, insults things that are no less particular for being unwanted.

Always, there's an undertow of comedy in her work, as in a wall piece, *Teaching Bo to Count Backwards* (1996–97), that is composed of a shelf made of an inverted roof gutter, bearing thirty brands of canned black olives. The cans are organized, singly or in stacks, according to the number of olives pictured on the label—from one to a countless mass, decreasing from left to right. The array is punctuated by three photographs of the sinister-looking actor John Derek with his beautiful young wife, Bo, whom he groomed for her role in the 1979 movie *10*. In the picture on the left, Bo huddles against John and seems unhappy, as if daunted by a quantity of olives beyond her ken. In the center, as the sum diminishes, she brightens and moves a little away from him. At the right, she stands fully apart, with an exultant expression and a raised index finger: one! Is the work a wishful feminist allegory of Bo Derek's emancipation or just a nexus of different orders of reality and logic? It runs the engine of your perception and cogitation on all cylinders. Incidentally, it is elegant.

Harrison, now forty-eight, is a friendly, fast-talking woman, quick to contradict herself from one remark to the next, who dresses down, wears no makeup, keeps her frizzy hair pulled back, and looks, in any weather, like someone just in from a brisk winter walk. She is funny but rarely laughs, as if to do so would waste time. She resists being photographed and asked me not to name the neighborhoods in Brooklyn where she works, on two floors of a former industrial building—seldom with an assistant, a point of pride for her—and where she shares an apartment with her partner of ten years, the writer and editor Eric Banks. (Her studio is new. She had to abandon her previous one, in a garage in Williamsburg, to make way for a bar.) She told me, "I need to be anonymous at the local falafel place if I'm sitting one day thinking about art. I know no one cares about artists, and that is a good thing, but there are too many art people out here who do."

Harrison and Banks, a courteous Mississippian, who is a former president of the National Book Critics Circle and now the director of the Institute for the Humanities at New York University, are lively company. They are voluble with interests that include, for him, horse racing and baseball and, for her, whatever comes up. "Say that I like plants," she offered. Their conversations are like a badminton match in which neither keeps score. Banks told me, "Rachel is an amazing shopper. Going to a Walmart with her is an adventure." Harrison responded, "I never go to Walmart anymore," plainly meaning it, although with an air of having altered her policy at that moment. They are both steeped in classic and contemporary literature. A literary bent sparkles in the titles that supplement Harrison's works, generally without describing them: *If I Did It, Conquest of the Useless, Schmatte with President, Hail to Reason, Long Inexcusable Title, Frumpy at 38, Who Gave You This Number?* A 2009 show of her work at Bard College was billed *Consider the Lobster,* from an essay by the late David Foster Wallace.

Both Harrison and Banks dote on their dog, a self-possessed bluetick coonhound. She told me in an e-mail, "The rescue place, where we got her, names dogs as they arrive alphabetically, like hurricanes. She got Flower, we shortened it to Flo but often refer to her as The Flower.

Flo is also short for Flaubert, Florida, and, of course, Florence." She added, "Be sure to say I am mean and hate people but love my dog and will give her anything she wants." She savors the view from their apartment, of scarcely distinguishable rooftops sprawled to the horizon, "because it's banal," she said. On display are many paint-it-yourself, plaster-cast hobby busts of Abraham Lincoln, who interests Harrison as someone whom everybody likes. For years, she collected the busts—blond and blue-eyed, in one instance—on eBay, with an idea, since abandoned, that they might find a new home in her sculpture. Her most commonly used adjective is "amazing," often uttered just before she stops dead in front of something—an oddly formal pile of sidewalk trash, an unusual detail in a building's façade, a sign with eccentric spelling or grammar—that few other people would notice. From her studio, she can see a derelict lot, which is partly divided into parking spaces. On one of my visits, we noted the comings and goings of an old Mercedes, colored an arrestingly ugly tan.

Harrison's work adduces a novel canon of modern art. It owes little to the reigning godheads of contemporary cool—Duchamp and Warhol, although she esteems them greatly—and much to the renegade audacities of Kurt Schwitters, Jean Dubuffet, Tony Smith, Anne Truitt, Robert Rauschenberg, Eva Hesse, and Paul Thek, with collegial inflections from numerous more recent artists, including Franz West, Mike Kelley, Haim Steinbach, David Hammons, and Isa Genzken. Harrison reveres, for their spirit, Ellsworth Kelly, Ed Ruscha, and Bruce Nauman and shares their refusal to respect—much less to play by—any rules not their own. When I told Harrison that her Amy Winehouse drawings suggested a possible style of sophisticated cartooning, along the lines of Saul Steinberg, she responded that it was "good to know for the future this possible misreading." She enacts an idea of sculpture as an invasion of normal circumstances—as when, in 2007, she crammed Zurich's Migros Museum with scores of sculptural pedestals and plinths, which she slathered with plangent colors and, here and there, hung with amateur paintings that she had found in thrift shops. It is like her to focus on display units as objects in themselves.

So that I could better understand her taste, Harrison and I toured the Metropolitan, the Frick, and MoMA. At the Met, she asked me to choose my favorite pieces in the African and Oceanic collections. Soon we were sorting out best from next best, with attention to formal themes and variations in works ranging from tiny figures of various tribal origins to colossal Indonesian totems. At the Frick, our first glimpse of Velázquez's portrait of Philip IV caused her to exclaim, "Boyfriend!" She meant the painter. I failed to sell her on my enthusiasm for Fragonard's delirious suite of murals, *The Progress of Love*. She said it made her sick but wouldn't say why. Instead, she zeroed in on *Diana the Huntress* (1776–95), a delectable small sculpture by Jean-Antoine Houdon. She seemed pleased by its inconspicuousness, installed like bric-a-brac in the busy room. At MoMA, we gloried in a splendid sequential hanging of Mondrians, but Harrison's mood darkened at a grouped presentation, on a plinth projecting from a wall, of Brancusi masterpieces. "You can't see a sculpture unless you can move around it," she said. Anyway, some of her favorite works of Brancusi's are the dusky photographs that he made of his studio—"the way light reflects off the metal pieces and soaks into the different kinds of wood." She added, "He showed that sculpture is about light."

Another day, we met outdoors, at Dubuffet's *Group of Four Trees* (1969–72), the immense, four-footed painted sculpture, white and crazed with black lines, that stands in front of the former headquarters of the Chase Manhattan Bank, near Wall Street. For me, it's the best modern public artwork in the city, for its melding of the august and the affable. Harrison agreed, but tepidly. The piece interests her only, she said, because it shows how linear pattern can affect the perception of material shape. She despises nearly all public art, for its obliviousness of the actualities of public life. The colorful food venders' carts in Zuccotti Park, the scene of the first Occupy Wall Street demonstrations, are far more to her liking.

I received another comeuppance after asking her to meet me at Augustus Saint-Gaudens's gilded equestrian statue of General Sherman

with an Angel of Victory, across from the Plaza Hotel, on Fifty-Ninth Street. I had promised to alert the skeptical Harrison to the work's virtues, but we found that it is now hidden in a huge beige box, for a restoration of the site. She was thrilled. The box and the picturesquely jumbled rubble and machinery around it looked like an outsized version of one of her own works-in-progress. Later, noting that repairs to the statue will entail entering it through a trapdoor concealed behind the horse's saddle, she mused that "every sculpture should have a trapdoor."

Harrison's only public artwork was installed temporarily last year on a plaza behind the Dallas city hall. In steel painted Post-it-slip pink, a twenty-five-foot-high shaft supported a massive arrow, which pointed downward, at an angle, to another work in the plaza, *The Dallas Piece* (1978), a typically solemn bronze of organic shapes by Henry Moore. The arrow teetered ambiguously between scorn and praise—a common tendency in Harrison's art. She told me that she likes Moore well enough but was irked by the work's sententious grandeur in a place that is little frequented except, at night, by "homeless people with dogs." She was responding, as well, to the "earthy browns" of the Moore and the city-hall building, designed by I. M. Pei. Both works were commissioned, she surmised, "to help brand a new city after the JFK assassination." She likes the fact that the arrow is a diagrammatic form, directing viewers' attention elsewhere, which becomes overwhelming as a physical element of her sculpture. In a blunt, "stupid way," she wrote to me—noting, "I'm not afraid of stupid"—it serves "a conscious effort in my art to get at the act of looking. Luckily this gets all messed up, because I don't want my work to be literally about any one thing." I deduce a stratagem: one thing in thought that is another in reality, forcing a pause in the information tornado of our time.

The first year of Harrison's life was spent in New Jersey, where her father, a lawyer, had clerked for William J. Brennan Jr., before Brennan was appointed to the U.S. Supreme Court. Her father was born in Brooklyn, her mother in New Jersey; both came from Russian and Polish Jewish stock. "I had a lot of Great-aunt Roses," Harrison said,

and was administered regular doses of Borscht Belt comedy and Mel Brooks—who "might have been one of the few things my whole family could agree on." Her fervently liberal mother studied Arabic and Middle Eastern history at Radcliffe. While raising Harrison and an older brother, who is now a business consultant, she worked at Sarah Lawrence College as an associate dean, then went on to earn a Ph.D. in psychology. Harrison calls her father "an erudite man." She told me, "When I was little, he collected stamps, tearing them off envelopes, and maybe once a year we'd have the Big Soak, where we'd put them in bowls of water and then have them dry on the back of baking sheets. You can't get less hip than that. But I'm OK with it."

When she was a year old, in 1967, the family moved to Hastings-on-Hudson, then dominated by an Anaconda Wire and Cable Company plant. The plant closed in 1975, leaving a middle-class village with a Superfund site of residual toxins. Harrison attended public school and, three times a week, Hebrew classes, which had a backlash effect. She said, "I was an agnostic as soon as I heard that word. After my bat mitzvah, I evolved into an atheist." The local Metro-North train station afforded her, as a teenager, frequent escapes to the city. In 1980, when she was fourteen, she had "a very intense experience of *Guernica*" in a Picasso retrospective at MoMA: "I couldn't stop staring at it. It communicated chaos." But her active involvement in art didn't start until she was twenty. That was when she discovered the sensational work of the Conceptual artists Chris Burden, who, for one piece, had a friend shoot him in the arm with a rifle, and Adrian Piper, who soaked her clothes for a week in cod-liver oil, eggs, and milk, then wore them on the New York City subway at rush hour. Harrison still enjoys thinking of the "sculptural space" that Piper thereby cleared around her. She cites with pleasure, as well, a misanthropic piece by Bruce Nauman: an empty room in which his recorded voice growls, "Get out of this room. Get out of my mind."

In 1984, Harrison enrolled at Wesleyan University, where she declared a major in comparative religions, but she dropped out after her

sophomore year and drove with a friend to California, taking such odd jobs as cooking at a San Francisco pizza parlor called All You Knead. Uninspired by "all that hippie stuff," she said, she was no more pleased by a semester at the School of the Art Institute of Chicago, which admitted her on the strength of drawings that she had made in a life class at Wesleyan. (Although she has taught in art departments—at Columbia, Yale, Cooper Union, Bard College, and elsewhere—she questions the value of M.F.A. programs. She told me, "You shouldn't have to go into debt to learn about art.") She returned to Wesleyan in 1987, where she was strongly influenced by two teachers: Jeffrey Schiff, a sculptor, and Alvin Lucier, a composer who makes sound installations. Another teacher introduced her to the poetry of William Carlos Williams, who appealed to her partly because, in his other career, as a family doctor, he delivered the artist Robert Smithson in 1938, in New Jersey. A line from Williams's epic "Paterson" became a watchword for her: "No ideas but in things."

In 1989, she moved to Williamsburg, where she shared a loft with a boyfriend and, later, with various roommates until, one by one, they departed. In 1993, shortly after Harrison launched her art career, her mother died, from non-Hodgkin's lymphoma. "She was my best friend, my favorite person on earth, and I continue to miss her all the time," Harrison said. "I was alone. I was severely depressed, with massive anxiety." But her art blossomed. She began to participate in group shows at marginal galleries. Her first solo show, in 1996, took its title from a question asked in a *Times* article on scientific preparedness for hurricanes: "Should home windows or shutters be required to withstand a direct hit from an eight-foot-long two-by-four shot from a cannon at 34 miles an hour, without creating a hole big enough to let through a three-inch sphere?" The show included installations of wood paneling and photographs and many cans of green peas, which related to the title in that they were three inches in diameter. ("I don't do obvious," she said, while citing a close call: *Fats Domino* (2007), a brown-painted, jerry-built wooden tower topped with a can of Slim-Fast. Not obvious, until

you think of it, is the anagram "fast/fats.") She attained some renown on the Brooklyn and downtown-Manhattan art scenes, but "not of the warm-and-fuzzy variety."

Throughout the nineties, Harrison worked for a nonprofit organization called LeAp, as a peripatetic art teacher in troubled elementary schools, including some in the South Bronx and Brownsville. She liked it, finding that she could engage the students in group projects, such as using math to plan and build a model of Michael Jackson's Neverland ranch. In 1999, she was hired to teach photography classes at Columbia—photography being a field that was relatively open to women. She attributes a subsequent job there teaching sculpture, previously dominated by men, to a sort of feminist affirmative action. Her work was also increasingly included in otherwise all-male, or nearly so, group shows in New York and London.

Harrison's relation to feminism is at once rock solid and casual. It may bear on a quality that Hal Foster noticed in her: a way of responding to past titans of art, up to and including Picasso, with neither piety nor any trace of generational revolt. I asked Harrison about this. She replied, "Women can't have heroes." The absence of the "anxiety of influence," which the critic Harold Bloom posited as essential to originality, may or may not be definitively female, but it differs pretty sharply from the one-upping bravado of a Jeff Koons, a Damien Hirst, or a Richard Prince. Intriguingly, many of the cultural figures whom Harrison has apostrophized in her art are men—Amerigo Vespucci, Charles Darwin, and Claude Lévi-Strauss, as well as DiCaprio, Cheney, and, in his *Scarface* role, Al Pacino. I sense a determined and cagey policy toward maleness: keep an eye on it.

Harrison isn't displeased by the high regard in which her work is held, or by the fact that it is sought after by such leading contemporary collectors as the New Yorkers Martin and Rebecca Eisenberg and the Frenchman Bernard Arnault. But she doesn't appear to be much impressed by it, either. She had a well-received show at the Galerie Meyer Kainer, in Vienna, in October, of new works that she terms "framing devices": piquantly clunky forms, thickly painted in bright

colors, which anchor parachute cords, stretched from the ceiling and the walls to the floor, outlining imaginary shapes. (Her use of the cords pays tribute to the signature motif of the late American minimalist Fred Sandback, ringing vigorous changes on an idea that would have seemed played out.) But it took her dealer, Carol Greene, to inform me that an exhibition is being planned at the new Whitney Museum downtown, and that a show is projected for spring 2016 at Greene Naftali. Nor did Harrison mention other upcoming shows, at the Cleveland Museum of Art and at Regen Projects, in Los Angeles. It seemed that she didn't want to think about the exposure, partly because she is loath to participate in the current brutish art market and partly because she was still adjusting to her new studio. She even told me, at one point, that she isn't making new work. Only she is.

When I last visited the studio, a half dozen large sculptures loomed, in various states of fabrication or abandonment, and smaller pieces occupied tabletops and shelves in the not yet comfortably cluttered cavernous space. She showed me a huge cement lump painted a patchwork of vengefully strident colors that segued into lovely filmy golds and violets. She said that she had thought of displaying it leaning against a washing machine—an echo of works in *The Help*—but decided against it. Now a Weedwacker perched in the work as a "placeholder" for an object that had yet to present itself. She drank from a mug of tea and paced from piece to piece. One was the size and shape of a phone booth, containing a broken antique telephone and a raincoat, with a slim phone book (the 1969 Aurora, Kansas, edition) protruding from a pocket. Part of a series that she has been working on for a couple of years, it was as striking in form as in wit, but she wasn't yet sure how she would finish it.

We began talking about photography, and she drew me a sketch to explain an early work, from 1996, which I had seen and wondered about: a contact sheet of fifteen shots of people walking past a pile of green trash bags on a London sidewalk, interrupted by three pictures that show a roadside field, the interior of Salisbury Cathedral, and a mummy in the British Museum. Harrison took all the photographs on

one roll of film, then simply rearranged the images on the sheet. But the apparent detour away from the trash bags and back is acutely mystifying if, like me, you read the sheet as a truthful sequence in time. (Harrison likes posing riddles with easy answers which, somehow, we are unlikely to guess.) Next, she picked up a wooden tray that held some toy insects and placed it experimentally here and there on various pieces. Then she showed me an old small sculpture painted iridescent purples, blues, and greens—the colors "are hideous," she acknowledged—and draped it with a hood of greenish mosquito netting. The addition fit perfectly and turned the now barely legible offending hues mistily seductive.

I asked Harrison if she contemplated any new themes in her work. She grabbed a few bits of wood and, with a red Magic Marker, wrote on them some phrases from recent news stories that had been on her mind—and her nerves. One was "vertically integrated digital media"—"Doesn't mean anything," she said—from reports on the shift in direction at *The New Republic*, led by a CEO who had promised, employing a Silicon Valley cliché, to "break shit." Harrison is irritated, in general, by "startup companies calling themselves the new counterculture" when it's really "just business."

She also wrote "vertical patrolling," the practice followed by New York City police officers in the stairwells of high-rise housing projects, which had figured in accounts of the fatal shooting of an unarmed African American man in Brooklyn. That phrase, too, struck her as anodyne words obscuring their consequences and, perhaps, as material—a verbal object—fit for her use. She plunked down the signs, as sample titles, at the bases of random sculptures in the studio. How, if at all, these matters will register in her work, she wouldn't say. They already had, to my mind, as she retrieved the signs and tossed them onto a table.

New Yorker, December 22/29, 2014

THOMAS HIRSCHHORN

This year's most captivating new artwork—Thomas Hirschhorn's summerlong *Gramsci Monument*, an installation at a city housing project in the South Bronx—excites so many thoughts that you may, as I did, want help thinking them. Start with the artist. Hirschhorn, fifty-six, a rangy and intense Swiss, is on hand all day, every day, at his tree-house-like village of purpose-built shacks, set on open land amid the brick towers of the Forest Houses, which are home to thirty-four hundred people. The sprawling construction bridges a walkway and is shaded by sycamores that poke up through its raised plazas. It incorporates a library and a museum of memorabilia commemorating the humanist Italian Communist Antonio Gramsci (1891–1937), a theater for daily lectures and performances, an office for a photocopied free daily newspaper, a micro radio station, an art classroom, an Internet center, a food kiosk, and a children's wading pool. Residents were hired to build the facilities—of cheap lumber, Plexiglas, tarpaulins, and the signature stuff of works by Hirschhorn, shiny brown packing tape—and to staff most of them. The sponsoring Dia Art Foundation foots the costs. This is the last of four constructions in poor and working-class neighborhoods dedicated to Hirschhorn's favorite philosophers. The others celebrated Baruch Spinoza in Amsterdam, in 1999; Gilles Deleuze in Avignon, France, in 2000; and Georges Bataille in Kassel, Germany, in 2002. The materials and the equipment of the *Gramsci Monument* will be distributed to the residents via a lottery, once the installation has been dismantled, a week after the closing date of September 15.

Sitting at a plywood table in the installation one recent steamy day, Hirschhorn drew a circle on a piece of paper and quartered it. He labeled the segments *love, philosophy, aesthetics,* and *politics* and located his heroes at the radius points: Spinoza, love/philosophy; Deleuze, philosophy/aesthetics; Bataille, aesthetics/politics; and Gramsci, politics/love. Gramsci, who died after nearly a decade in prison under Mussolini, and whose *Prison Notebooks* are classics of political thought, qualifies as a revolutionary with a heart. He veered from Marxist economic

determinism to describe class conflict in terms of culture—the "hegemony" of dominant ideas and forms requiring a growth of contrary ideas and forms from below. "All men are intellectuals," Gramsci wrote.

Hirschhorn shrugs off the political failure of Gramsci's hopes. His allegiance to the charismatic Italian seems a personal faith, thrown open to the world. The world, as we spoke, was peopled largely by running and playing children. On a subsequent day, tracks from Jay-Z's *Magna Carta . . . Holy Grail* pulsed from the radio station, and local poets read in the theater. The newspaper reprinted an interview with the blaxploitation diva Pam Grier. With Hirschhorn's consent, the monument's raw wooden architecture had been graced with gorgeous murals by the graffiti crew of a community organization called Xmental, one of them showing a black youth and a white youth slapping hands, with the nearby elevated No. 5 train in the background. The artist's often stated ideal, a "nonexclusive audience," was making the place its own.

Hirschhorn emphasizes that the monument is no social-work experiment but "pure art." This rings true. On three visits, my cynical antennae scanned in vain for hints of do-good condescension. Hirschhorn had solicited cooperation from forty-six projects of the New York City Housing Authority before forming a warm if sometimes bumpy partnership with Erik Farmer, the president of the tenants' association at the Forest Houses. Farmer, who is forty-four and has used a wheelchair to get around since he was injured in a car crash while a college student, is an impressively sage politician, committed to the interests of his community. He was the only one of the artist's housing-project contacts who asked to read texts by Gramsci, Hirschhorn said. Farmer selected the monument's construction crew of fifteen residents and calmed local skeptics. (He told me that while the work was under construction "some old women said it looked like clubhouses, and they'd had enough of clubhouses.") He considers the monument a "boost" to family life at the complex. Hirschhorn, for his part, carefully eschews any agenda. He cradles a hope that some people's experience of the work might enhance their lives, but he makes clear that that's out of his hands. His contributions to the program of public events brook

no concession to popular appetites: the sparsely attended lectures by a young philosopher from Berlin, Marcus Steinweg, included one, the other day, entitled "Ontological Narcissism."

The monument is art in the mind rather than of the eye. Hirschhorn has a slogan: "Energy = Yes! Quality = No!" His penchant for wrapping things in miles of irredeemably ugly packing tape neatly exemplifies both principles. Beauty has no promoter in Hirschhorn. Nor does humor, as distinct from intellectual agility and a showman's flair. In the course of a career that began in the late nineteen-eighties, when he was rebuffed by a left-wing graphics cooperative in Paris for wanting to work on his own projects, he has consented to show in galleries and museums and at biennials and art fairs—and to sell collages that relate to his installations—but always with disregard for the habits of the market and of institutions. His past exhibition works have run to labyrinthine environments on themes including war and peace and consumer culture. An unforgettable one at the Gladstone Gallery, *Superficial Engagement* (2006), intermingled images of ethereal abstract art with crudely Xeroxed photographs of human bodies blown apart in terrorist bombings. The point was elusive, but the dramatization of the peaks and abysses of human behavior profoundly moved many viewers, including me.

Hirschhorn can be heavy-handed, as in an enormous rendition, last year at Gladstone, with real and simulated furniture and fixings, of the tilted and submerged casino in the *Costa Concordia*, the cruise ship that capsized off the coast of Tuscany in 2012. Géricault's Romantic vision of doomed shipwreck survivors, *The Raft of the Medusa* (1819), was reproduced on one wall. The irony thudded. Worse, a satirical emphasis on the casino's kitschy decor had the effect of seeming to memorialize the disaster's victims chiefly for their bad taste. But, even when his work misfires, Hirschhorn remains the most meaningfully independent of contemporary artists. At the monument, I felt safely remote from the current art world's pressures of ravening money and pandering institutions. The democracy of the place, leveling the artist with the kids asplash in the wading pool, brought tones of Walt Whitman to mind.

Hirschhorn has said, "I'm interested in the 'too much,' doing too much, giving too much, putting too much of an effort into something. Wastefulness as a tool or a weapon." He cites the potlatch rituals of Northwest Native Americans, in which leading members of the tribe both affirmed and atoned for their standing by spectacularly splurging their wealth. The French renegade philosopher Georges Bataille made much of the potlatch, as a model for economics based on gift-giving rather than exchange, and Hirschhorn follows suit, in the coin of gratuitous service and toil.

Artistically, his method of principled generosity recalls the career and the aura of Joseph Beuys, whose assurance that "everyone is an artist" established the zone of participatory art events that Hirschhorn advances. Hirschhorn pays homage to Beuys—and to Andy Warhol, for collapsing high culture into popular culture with iconic imagery that is universally understood at a glance. There's a Warholian tang to a grisaille painting on plywood of a photograph of the handsome young Gramsci, which fronts the monument. Only, unlike a Warhol Marilyn or Elvis, the image doesn't float free of its historical moorings but invites a dive into the legacy of an exemplary thinker. The divers may be few, but there's sorcery in the simple gesture of folding philosophy into daily life. Politically, the work steers hard toward realms of leftist theory, but in ways that are as likely to humble tenured theorists as to exalt their vocation. Nobody counts as special at the monument, except everybody.

New Yorker, July 29, 2013

JAY DEFEO

Most artists fail in what they try to do. The reasons range from an encyclopedia of standard faults and mistakes to the myriad variants of bad luck. The fact is too melancholy to tempt contemplation. But, now and then, an aesthetic misadventure may be so peculiar, and strangely resonant, that it achieves cult status. Such is the case with the gifted and bedeviled San Francisco artist Jay DeFeo, who died, of cancer, in 1989, at the age of sixty. A retrospective at the Whitney unfolds her tale. DeFeo's career began, around 1951, with terrifically promising paintings; and twenty years later she was doing fine work in painting, drawing, collage, and photography. In between, there's an abyss occupied by a single object: the painting-relief called *The Rose* (1958–66), a composition more than ten and a half feet high and nearly a foot thick, weighing well over a ton, of radiating white ridges of palette-knife-carved oil paint which devolve into gray clumps, sparkling with bits of mica. DeFeo's seven years of toil on it came to an end only when she was evicted from her apartment, on Fillmore Street, in November 1965.

There had to be an "uncontrolled event to make it stop," DeFeo's friend the late artist Bruce Conner said of *The Rose*, in an interview. Conner had filmed the eviction, which entailed knocking out part of the wall around a window to remove it. DeFeo "had gotten so crazy," he said. "It was the end of Jay." He wondered whether she "was going to go out the window herself." The film shows her, a piquantly lovely woman, dangling her legs from a fire escape as she watches the defenestration. During the next four years of living in towns north of the city, she made almost no art at all. *The Rose* was shown twice in her lifetime—in 1969, at the Pasadena Art Museum and at the San Francisco MoMA— and then it was installed in a conference room of the San Francisco Art Institute. A wall concealed it for two decades, until it was retrieved and restored for a 1995 show at the Whitney, *Beat Culture and the New America: 1950–1965*. That show celebrated DeFeo's role, as a friend and a muse, in the San Francisco literary world. She attended Allen

Ginsberg's first public reading of "Howl," in 1955, at the Six Gallery, where works of hers hung. *The Rose* is now in the Whitney's collection.

The starburst motif of the piece is generic. Nothing that DeFeo did could transcend that, as she must have suspected, at times, while refusing to believe it. But, for sheer density of material and effort, there is nothing like *The Rose.* You may not look at it so much as gawk at it, in the chapel-like black chamber, with dramatic lighting, that it commands in the show. It strikes me as neither good art nor bad but as a sui-generis folly that lends itself to mythic reflections. I think of Balzac's short story "The Unknown Masterpiece" (1831), in which a master's long-labored crowning achievement, when finally revealed, is a chaos of paint, with just one of its female subject's feet legible. The artist, Frenhofer, destroys the picture and dies. The meaning seems clear: a warning against ambition that will brook no compromise with art's conventional limits—a peril that, for the greatest artists, simply sets in at exceptionally high levels. DeFeo was not a great artist. But the ferocity of her commitment and the anguish of her frustration make her a totemic figure for people who can understand them from experience. Artists' voices are apt to drop in tone when she is mentioned.

DeFeo was born in Hanover, New Hampshire, in 1929, the only child of an Italian-American medical student and a nurse from an Austrian immigrant family. In 1932, they moved to the San Francisco Bay Area, where DeFeo's father enrolled in the Stanford University medical school. The marriage was tumultuous, and when DeFeo was four she spent a year in institutional care. After that, she was frequently sent to stay with her maternal grandparents in rural Colorado. Her parents divorced in 1939, and DeFeo moved with her mother to San Jose. Mentored in art by a neighbor—a commercial artist named Michelangelo—and by a devoted high-school teacher, she went on to study art and art history at Berkeley and to explore the blossoming art scene in San Francisco, where Clyfford Still and Mark Rothko taught, and Richard Diebenkorn, Sam Francis, David Park, and Elmer Bischoff were rising stars. Abstract Expressionism was the moment's watchword, and DeFeo embraced it.

In 1951, a fellowship staked her to a year in Europe. She traveled widely while tending to neglect sightseeing for chances to paint: she made more than two hundred works during three months in Florence. Back home, she took odd jobs. In 1953, a conviction for shoplifting two cans of paint got her fired from a position at the California College of Arts and Crafts, teaching art to children. She was making and selling jewelry—deft wire confections, which are sampled in the show—when she met and, in 1954, married the artist and Beat doyen Wally Hedrick, a proponent of what was described as "personalized Dada." With some other artists, they shared a building on Fillmore Street that became a hotbed salon and party place, frequented by writers and jazz musicians. The artist Billy Al Bengston remembered DeFeo as having "style, moxie, natural beauty, and more 'balls' than anyone."

The first rooms of the Whitney show, featuring DeFeo's abstract paintings from the fifties, astonish. Previously unknown to me, the work is canny, sensitive, and dashing—world-class, in its day. DeFeo combined a sure grasp of Abstract Expressionism with a signature emphasis on texture, building membranes of paint with thick, fast strokes that are as abrasive and as precise as the caress of a cat's tongue. Having little use for color, she excelled, too, at grisaille drawing, as witness a fantastic graphic rendering, seven feet wide, of her own blankly gazing eyes. Reportedly, she disparaged her draftsmanship; this makes me want to go back in time and shake her. DeFeo plainly had gifts equal to strong formal invention. I surmise that she was hampered by, even while being nurtured on, a scene that was dominated by men, including her husband, who steered art-making toward literary conceits and rapscallion gestures. It's conceivable that her withdrawal into obsessively reworking *The Rose* amounted to a tacit protest—a standup strike—against the pressures of her milieu.

DeFeo had divorced Hedrick and begun a thirteen-year relationship with a much younger man and was teaching at the San Francisco Art Institute, when, in 1970, she got back to concerted studio work. She did so notably with photographs and paintings of her own dental bridge, which a gum disease had necessitated. Alternately grotesque

and weirdly seductive, like a darkling grotto of sensuous forms, the images celebrate a triumph of rigorous aesthetic detachment over self-absorption. That remained the key, heroic quality of DeFeo's later work in several mediums, which lately, I am told, has made her a charismatic influence on numerous young artists, particularly women. Especially acute are painstaking drawings of odd objects—a camera tripod, heaped erasers, samurai armor—that appeal less to vision than to touch, as if they were excavated by hand from pictorial space.

DeFeo's life brightened. In 1987, she fulfilled a long-harbored dream of traveling to Africa, which led to a series of splendid, hieratically mysterious abstract drawings called *Reflections of Africa*. She stayed prolific after receiving a diagnosis of lung cancer, in 1988. Three hundred people attended her sixtieth-birthday party. One of them, the ceramist Ron Nagle, gave her a pink cup that she abstracted in several beautiful small paintings. The final work in the show, *Last Valentine* (1989), is of a heart shape in brown and white, with feathery strokes melting into a delicately rumpled, cream-white ground. It took my breath away.

New Yorker, March 18, 2013

ALICE NEEL

"All experience is great providing you live through it," Alice Neel said, adding the caution: "If it kills you, you've gone too far." She spoke from authority. The great American portrait painter (1900–84), who is the subject of two current New York gallery shows, led the kind of disheveled life that was thought of, in praise or in blame, as bohemian, before it got stamped dysfunctional. She was a character. Remember characters? Joseph Mitchell published two Profiles in this magazine, in 1942 and in 1964, of a prime specimen, the unwashed Greenwich Village rapscallion Joe Gould, who claimed to be at work on a revolutionary literary opus, *An Oral History of Our Time*. Mitchell's fascination eventually became the basis of a movie, *Joe Gould's Secret* (2000), in which Susan Sarandon logged an airy cameo as Alice Neel. In 1933, Neel painted Gould, a casual friend, naked. He grins demonically and sports two uncircumcised penises, with a third dangling from the stool he sits on. For Neel, the savoring of foibles, in herself and in others, was the most reliable entertainment in a life beset by the loss of one baby daughter to diphtheria and another to an absconding husband; a severe mental breakdown; chronic poverty; and the irksomeness, or worse, of assorted lovers. Her invincible commitment to painting won Neel a fitful career in New York, first in Depression-era radical circles—she was briefly a Communist and always a leftist—and then, starting in the nineteen-fifties, after a decade of near-total obscurity, as a living legend. Outlasting insult and condescension, a woman among competitive men, and a figurative artist in times agog for abstraction, she triumphed, and her star continues to rise.

Neel grew up in Colwyn, Pennsylvania, a small town that she hated, in a family dominated by her cultured mother, whom she adored. Her shyly ineffectual father, from a family of opera singers, was a railroad clerk. Neel made art—largely in secret, she said—starting in childhood. After high school, she acquired secretarial skills and landed civil-service jobs. She attended art schools, including the Philadelphia School of Design for Women (now Moore College of Art and Design), but avoided

the Pennsylvania Academy of the Fine Arts, because she "didn't want to be taught Impressionism, or learn yellow lights and blue shadows. . . . I wasn't happy like Renoir." She met and married an upper-class Cuban artist, Carlos Enríquez, and lived with him in Havana for a year. In 1930, he left her in New York, taking along their surviving daughter (who later killed herself). Neel fell apart. Suicide attempts and hospitalizations, in nightmarish wards, followed. "I died every day," she said of the experience. The spell lifted in the autumn of 1931. The next year, she moved to Greenwich Village, with a sailor, Kenneth Doolittle, who proved a bad bet—he destroyed much of her work in a fit of rage. Then she lived for five years with José Santiago Negron, a Puerto Rican nightclub performer, who left her soon after the birth of their son, Richard, in 1939. Next was an ill-tempered leftist photographer and critic, Sam Brody. In 1941, they had a son, Hartley, whose son, Andrew Neel, made a well-received documentary about his grandmother in 2007. In *Selected Works*, a show of sixteen portraits, from 1942 to 1982, at David Zwirner, we see Brody grasping a frightened-looking Hartley with a clawlike hand, around 1945, and, in another painting, gloomily reading war news. (*How Like the Winter*, that work is subtitled.) Living for twenty years in Spanish Harlem, Neel often made sitters of neighborhood children. *George Arce* (1959), a terrific painterly cadenza, portrays a boy with whom she stayed in touch even after he was imprisoned for murder, in 1974.

Nudes of the 1930s, the other new show, at Zwirner & Wirth, samples a theme in which Neel excelled, and an epoch of stark poignancies. It includes a watercolor, from 1935, that is the funniest and funkiest visualization of intimacy I know. Cute, blowsy Alice urinates on a toilet while her solemn boyfriend, John Rothschild, does the same in a sink. Another watercolor from that year, and perhaps from a memory of the same day, has Alice voluptuously supine on a bed, while Rothschild stands over her, wearing only slippers, in a tense, withdrawn posture. Neel titled it *Alienation*—Rothschild was in anguish, having "just left his wife and a couple of children." (A successful travel-agency entrepreneur who specialized in trips to the Soviet Union, Rothschild was the

steadiest of Neel's men, a friend until his death, in 1975.) Both pictures are beautifully drawn. Rougher, and ruthlessly honest, are paintings and drawings of women Neel knew. A psychoanalyst once asked her, "Why is it so important to be so honest in art?" Her answer: "It's not so important, it's just a privilege." She visits unsentimental dignity on bodies that are pert or sad, and on the spirits, robust or pinched, that animate them. The nudes aren't erotic, but they exude carnal wisdom. They share with much other American figurative painting of the nineteen-thirties a bituminous tonality; the sun of that decade struggled to shine. They are modern in their frontality, nudging subjects off the wall and into the room, while utterly free of stylistic affectation. Neel liked Cézanne but preferred Munch and Soutine; she came to admire the taciturn violence of the Abstract Expressionist Clyfford Still. Her psychologically jangling, impulsive manner can look awkward until you notice that it is a sum of swift, local accuracies, both descriptive (a peculiarly knobby knee) and expressive (a whiplash contour like a shoreline). When most engaged, she was superbly indifferent to overall design.

Selected Works is a bit disappointing in its undoubtedly market-conscious emphasis on formally accomplished pictures, which make me realize that Neel's most elegant works tend to indicate her relative lack of emotional exchange with her subjects. She makes it obvious that people with pulled-together public faces bored her. She titled an arrogantly assured, plaid-shirted, long-haired hunk of an unnamed guy *The Druid* (1968). Good luck to him, and to the *Young Woman* (circa 1946), whose jewels and fur shield a dishearteningly timid niceness. *Annie Sprinkle* (1982) observes the porn actress and militant feminist in dominatrix regalia, with exposed breasts and pierced genitals and a sappily self-approving smile. Sprinkle is painted off-center on a big canvas, with lots of blank surface that says, to me, "No comment." Neel jolts us in portraits of couples and children. In *The Family (Algis, Julie and Bailey)*, from 1968, a pretty woman appears as a doll-like appendage to her macho, wired-looking husband, who casually holds their unhappy baby boy. There's trouble afoot but also surging vitality. The family is young. It's 1968. The picture is a spiritual snapshot of a convulsive

time. *Cindy* (circa 1960) is a little girl in a jumper, with a pageboy hair-cut, anxiously clutching one knee while gazing out, wide-eyed. She is rendered on a narrow, vertical canvas; she might be falling down a rabbit hole. Neel conveys her vulnerability—she's a target for the unseen incoming missiles of life—without alarm. Cindy will likely be OK the way most people are: OK enough.

Neel liked quoting, with amusement, a strange remark made to her by Malcolm Cowley: "The trouble with you, Alice, is you're not romantic." In truth, she was a capital *R* Romantic in a very late, modern way: starched by experience. Art was not a refuge for her—she had no refuges, only respites. It was her life lived by other means, in which she enjoyed some moment-to-moment control. Rather than reflect on the peremptory realities of other people, she took them head-on, turning their force around and sending it back out. At times, every brushstroke can feel like a victory, against tall odds, of high humor fringed with deadly seriousness. Lots of celebrated twentieth-century art has seemed dated and tame lately. Not Neel's, which, beyond being something to look at, is something that happens to you.

New Yorker, May 25, 2009

PHILIP GUSTON

Philip Guston's last style was born in 1968 with cartoony images of Ku Klux Klansmen. Their raucous goofiness was very sixties, as if the artist were taking Bob Dylan to heart: "I was so much older then; I'm younger than that now." It scandalized most of the art world. Not only no kid, at fifty-five Guston owed his prestige to a restrained and elegant, highly grown-up abstract style, undertaken in the early fifties. For many who cherished his hypersensitive abstractions, including me, the new stuff was as welcome as a fart in a crowded theater.

The new stuff was anguished and hysterical. Whose problem would that be? Would it be Guston's, marking one man's disintegration? Or would it be the culture's, in the way that Cezanne's anxiety and Picasso's aggression became psychic baggage for everybody incautious enough to love modern art? The answer seesawed through the seventies as more and more young artists, but few critics and collectors, embraced the later Guston. When he died in 1980, he had a cult following larger than many successful artists' mainstream audiences.

Eight years later, on the occasions of a show of his drawings at the Museum of Modern Art and a biography, *Night Studio*, by his daughter, Musa Mayer, the verdict is in. The cult has dissolved into the mainstream like a dye. "Gustonesque" now recommends itself, like "Kafkaesque," as a term in the standard glossary of twentieth-century feelings.

The Gustonesque is a love of art rampaging like a bull in a china shop among the more common emotions. You wouldn't like it in your father. From *Night Studio*:

> One day, when I was very small, no more than three or four, my mother had made gingerbread cookie dough and rolled it out for my father to cut. Philip spent hours making a cookie for me, cutting up currants, marking the reins and halter of a beautiful Greek horse. It was put in to bake with all the other cookies. When I saw it, I cried, "Oooh, my cookie," and reached for it. "But you couldn't touch your horse cookie, that Philip had made for you,"

Becky Phelps [a family friend] tells me now. "It was nailed on the wall, as a great sculpture."

As she tells it in her lively, honest, bittersweet book, Mayer never did get the cookie of her father's love. It wasn't for her. Nor was it for her mother, also named Musa, who emerges as a touching archetype of the Artist's Wife, deferring to her husband's obsession. Guston was vulnerable and generous, a nice guy on the whole, and he did love both Musas, as the younger comes to recognize. But nothing was quite real to him, or available to anyone else, that couldn't end up on canvas.

Guston grew up in Los Angeles. When his father, a Russian immigrant junkman, hanged himself, Guston, ten years old, discovered the body. Jackson Pollock became his best friend and was expelled with him from high school for political radicalism. Embarking on an art career, Guston changed his name from Goldstein, for which he felt miserably guilty later in life. He came to New York in 1935 via an apprenticeship to the muralists in Mexico and worked in social-realist styles that brought him national recognition while distancing him from Pollock and the other inceptors of Abstract Expressionism.

Coming around to abstraction, he pulverized his conservative techniques into a trembling kind of not-quite-resolved picture that was briefly dubbed, at the time, "Abstract Impressionism." The aching tentativeness of his drawings, circa 1952–1965, still ravishes me. I feel that it is about wanting something so impossibly good that achieving it might redeem the world.

In retrospect, Guston's abstraction is too high-toned to be quite true. This was a man, as Mayer shows us, who was frantically self-absorbed, an alternately garrulous and self-isolating heavy drinker, subject to mood swings. (The isolation was progressive, eventually confining him to the cinder-block studio of his home in Woodstock; he worked mainly at night with a turned-off telephone, unreachable even by soul-mate friends including Philip Roth.) The abstract work was a mask.

So, too, perhaps, is Guston's post-1968 style, but this mask bleeds. When you attend the MoMA show, proceed slowly through the early

stretches, the better to be jolted when the demons come out to play. Suddenly Guston's excruciating line finds, or stops fleeing, what it yearned to confide: scenarios of childish fear shading into middle-aged abjection.

Guston's Kluxers come by a subterranean route from the political-protest art that he made as a youth, only now they are figures not of caricatured evil but of funny-horrible self-portraiture. They whip themselves and each other, take spins around cities in bulbous cars, smoke cigars, engage in bang-bang-you're-dead finger-pointing, and paint pictures of themselves.

Gradually the slot-eyed, sutured hoods give way to lima-bean-shaped heads as weighty as cannonballs, with cyclopean eyes transfixed by paintings, books, and bottles or staring into comfortless space. Belligerent arms wield garbage-can lids, and legs form grisly chorus lines on red and black killing grounds. Cigarette butts, old shoes, and studio detritus accumulate: junk for the junkman's son.

Between heart attacks just before his death, Guston drew a gray boulder-head swathed with bandages and gazing dubiously up a slope, as if gauging the possibility of ascent or beholding something rolling its way. Like nearly all the late work, the picture is bold and vigorous, unquench-ably alive. Guston had gotten the whole, sweet meat of his being where he had always wanted it, into the enchanted pictorial rectangle. There, it could thumb its nose at the mortal man wheezing at the easel.

The Gustonesque—guts on display for art's sake—is now a perma-nent reference for future artists. Whether excited or repulsed, how you feel about it is primary information about yourself. Having faithfully registered its human costs, Musa Mayer merits a final word:

> Now that he is really gone, and not in hiding, pursuing his "sacred foolishness," now that it is no longer his hunger for painting that keeps me from him, but death itself, now that I can at last give up trying to get his attention, I find myself welcoming that passion at last, for what it has left of him for me, for the world.

7 *Days*, September 28, 1988

MARTIN LUTHER

On October 31, 1517, Martin Luther either did or did not nail a paper titled "Disputation on the Power and Efficacy of Indulgences," better known as the Ninety-five Theses, to a church door in Wittenberg, Germany. (The evidence is murky.) But, by whatever means, on that day the Augustinian monk made public a multipronged attack on the Roman Catholic hierarchy's sale of indulgences—get-out-of-Purgatory-early guarantees—to raise funds for the completion of St. Peter's Basilica in Rome. The revolutionary theology that Luther thereby introduced held that only personal faith can obtain divine grace, rejecting any intercession between an individual and God. (In 1520, he declared that "all Christian men are priests, all women priestesses.") Thanks to the relatively recent technology of the printing press and to widespread discontent with Rome and with Pope Leo X, Luther's ideas convulsed the Holy Roman Empire. Three new museum shows kick off the five-hundredth anniversary of the originating deed: *Word and Image: Martin Luther's Reformation*, at the Morgan Library, in New York; *Law and Grace: Martin Luther, Lucas Cranach and the Promise of Salvation*, at the Pitts Theology Library, in Atlanta; and *Martin Luther: Art and the Reformation*, by far the most comprehensive, at the Minneapolis Art Institute.

I grew up churched and Sunday-schooled Lutheran in Minnesota towns. As a pious kid, I was thrilled to imagine Luther pounding on that church door, and though I didn't know what "theses" were—the plural of "these"?—I gloated over the quantity of them. I raged at Catholic schoolmates who jeered that Luther had turned the world upside down for sex. (He married a former nun, Katharina von Bora, in 1525.) My side taught me to deem Catholics "idolaters" for praying to saints, but I secretly envied the glamorous ornament and rituals of their church. That feeling foretold my discovery of art as a make-do creed. Say what one will about Leo's monetizing of forgiveness, it helped pay the wages of Michelangelo and Raphael.

The art quotient of the three shows would be slight but for Lucas Cranach the Elder, Luther's close friend and tireless propagandist. (The Morgan focuses on the moment of the theses.) The German Renaissance master became the richest man in Wittenberg partly by being willing to work for almost anyone, including fanciers of erotic and comic imagery—and Luther's enemies. But Cranach readily adapted his crisply contoured, infectious art to charismatic portraits of the Reformer and Katharina, as well as of the local ruler, Frederick the Wise, who shielded Luther from the wrath of Leo and Charles V, the Holy Roman Emperor. The Atlanta show, which I haven't seen, centers on Cranach's *Law and Grace* (circa 1550), an intricate, definitively Lutheran allegory of the soul's despair under the impossibly exacting law of the Old Testament, and its liberation by the New.

Luther was born in Saxony in 1483, the son of a well-to-do mining entrepreneur. He studied law but later wrote that a terrifying experience during a thunderstorm, in 1505, led him to enter a monastery. He became a priest in 1507 and a theology professor in 1512. Nevertheless, he was racked by doubts about God and about his own mind and heart. That qualified him, in Kierkegaard's words, three centuries later, as "disciplined in all secrecy by fear and trembling and much spiritual trial for venturing the extraordinary in God's name." But Kierkegaard noted a flaw: Luther was ambitious, and to gain converts he effectively excused them from the inner struggle that gave his beliefs their meaning. W. H. Auden picked up the theme in a sonnet, "Luther": " 'The Just shall live by Faith . . .' he cried in dread. / And men and women of the world were glad, / Who'd never cared or trembled in their lives."

In 1521, Leo excommunicated Luther, and Charles V summoned him to trial at the Diet of Worms. There Luther scored an oratorical triumph with a speech adducing Scripture in defense of his heresies. "Here I stand. I can do no other," he is reputed to have said. On his way home, agents of Frederick the Wise intercepted him and hid him in a castle, for protection from what amounted to an imperial dead-or-alive warrant. Living under the alias Junker Joerg (Knight George), Luther

translated the New Testament into German, from the original Greek, in eleven weeks. He then returned to Wittenberg and translated the Old Testament, from the Hebrew. The Luther Bible became the fulcrum of the Reformation and did for vernacular German roughly what Dante had done for Italian. Heavily worked manuscripts, in the Minneapolis show, document his labor. Luther's version is tendentious: he consigned the Book of James to the Apocrypha, because it posited good works, rather than faith alone, as a route to salvation.

The Minneapolis show is divided into eight chronological sections, with exhibits ranging from items from Luther's childhood home, and the immense pulpit from which he preached his last sermons, to liturgical garments and such kitsch relics as a sixteenth-century commemorative beer tankard. But the main fare is linguistic: manuscripts, books, and broadsheets. Lutheranism is a religion of the logos. In that context, the show forthrightly confronts Luther's notorious anti-Semitism, which fed on the disappointment of his early belief, based on his reading of the Old Testament, that Jews would accept Jesus as the Messiah. In 1523, he sympathized with their suffering under Christian persecution, in a tract titled "That Jesus Christ Was Born a Jew." But, by the end of his life, in writings that included a sixty-thousand-word screed, "On the Jews and Their Lies" (1543), his hatred verged on the genocidal. The show also acknowledges Luther's betrayal of the peasantry's hopes that his religious populism would extend to common cause with the oppressed. (They may have been misled by his mythologizing of himself as a man of humble birth.) Instead, he promoted the brutal crushing of insurrection in the Peasants' War of 1524–25, siding with the secular authorities on whose backing he depended.

Luther did rein in followers who engaged in iconoclastic destruction of Catholic art. His own attitude toward art was pragmatic: it could be used for doctrinal instruction. (He made an exception for music, calling it "the mistress and governess of the feelings of the human heart.") In Minneapolis, there's an astonishing polyptych—the *Gotha Altar* (1539–41), from the workshop of Heinrich Füllmaurer, an artist

previously unknown to me—that arrays a hundred and fifty-seven painted panels, on fourteen hinged wings, which tell Bible stories with a Lutheran spin, emphasizing the Gospel teachings of Jesus over the Catholic litany of martyrs and miracles. Luther also countenanced a media onslaught of polemical prints that identified the Pope with the Devil or, in a woodcut from Cranach's workshop, pictured him emerging from the womb (or perhaps the anus) of a female demon. Such grotesqueries, including those of Catholic counterattacks on Luther, vivify an era of sulfurous passions.

Consequences of the Reformation for civil life set in immediately. Luther's discounting of personal charity as a self-deluding substitute for faith prompted state welfare to compensate the poor. More generally, his emphasis on personal responsibility gave rise to the Protestant ethic of gainful hard work. He believed firmly that the Second Coming of Christ was imminent and seemed to feel that, time being short, life should be lived to the fullest. He celebrated conviviality—no great novelty in Wittenberg, where one out of three houses was licensed to brew beer—and was unusually supportive of women. In his view, a woman with an impotent or unwilling husband should seek a divorce and, if he refused, request sex with one of his relatives or friends. Failing that, she might leave and start fresh in another town. Luther, who lived out his life in familial contentment, undertook considerable legal wrangling to will his entire estate to Katharina, rather than to their sons. He died in 1546.

In Minneapolis, a circa-1600 copy of Cranach's painting *Martin Luther on His Deathbed* (1546) shows the fleshy Reformer tranquilly at rest on cloudlike pillows. The image had a propaganda purpose: it was intended to counter the Catholic belief that Luther, in merited agony, went straight to hell. In fact, he left a Europe that was subject to bloody religious wars and, incidentally, to the Catholic backlash of the Counter-Reformation, which strove to co-opt the Protestant emphasis on personal devotion in new styles of traditional piety. (Keep in mind, when beholding the aesthetic glory and spiritual intensity of an El Greco or a Caravaggio, that we have the goad of Martin Luther's legendary hammer

indirectly to thank for them.) As of last week, that seed of compromise had come to at least diplomatic fruition with Pope Francis commemorating the anniversary of the Ninety-five Theses at the Lutheran World Federation, in Lund, Sweden. Catholic conservatives have denounced the gesture. What would Luther say about it? Excellent question.

New Yorker, November 14, 2016

THE GHENT ALTARPIECE

Several of the world's top experts in the conservation of very old wood covered with very old paint met recently in a windowless, cramped room of the St. Bavo Cathedral in Ghent, Belgium. For two days, they worried over planks that had been cut from Baltic oak trees six centuries ago, probably in Poland because the Low Countries were already running out of timber. The room, named the Villa Chapel, houses the multi-paneled Ghent Altarpiece, a six-hinged polyptych, measuring twelve feet high by seventeen feet wide when it is fully opened, which is sometimes called *The Adoration of the Lamb*, after its largest panel. The work is believed to have been begun by Hubert van Eyck in the early fourteen-twenties and finished in 1432, six years after his death, by his brother Jan van Eyck, a revolutionary innovator who was at least as important to Northern European painting as Giotto, a century earlier, had been to Italian painting.

The altarpiece originally inhabited a more elegant but even smaller space in the cathedral, the private chapel of Joost Vijdt, a wealthy textile merchant who had commissioned it. It remained there through six centuries, except for a number of prudent removals—most urgently, to rescue it from Protestant iconoclasts, in 1566, and from a fire, in 1822—and two confiscations, by French soldiers, who filched the central panels in 1794, and by Hitler, who, in 1942, had most of the altarpiece taken from where it had been stored for safekeeping, in France, and hauled first to a castle in Bavaria and then, to avoid Allied bombing, to a salt mine in Austria, where it was discovered by American soldiers in 1945. In 1986, it was relocated to the Villa Chapel, for reasons of security, and enclosed in a huge, aquarium-like box of bulletproof, reflective, greenish safety glass that renders it scarcely seeable and which the restoration experts loathe. Nevertheless, the work is the premier tourist attraction in Ghent, which cannot rival Bruges, Antwerp, or Brussels for their abundance of Flemish art created in the fifteenth and sixteenth centuries under the reigning dukes of Burgundy—notably, Philip the Good, Jan van Eyck's principal patron, who is otherwise famous for having captured Joan of Arc.

The experts had been charged with assessing the physical con-
dition of the altarpiece, which last underwent a major restoration in
1950–51, and with recommending a site and a design for its future
display. Overseen by Anne van Grevenstein-Kruse, from the Univer-
sity of Amsterdam, and the art historian Ron Spronk, from Queen's
University, in Kingston, Ontario, the group included José de la Fuente,
from the Prado, in Madrid; Ray Marchant, who works in the Hamilton
Kerr Institute's restoration studio in London; the leading local author-
ity, Jean-Albert Glatigny, from Brussels; and Ingrid Hopfner, from the
Kunsthistorisches Museum, in Vienna. They were attended by four
"mid-career" conservators from New York, London, Los Angeles, and
Budapest, and by three "emerging-level" conservators from Amsterdam,
Haarlem, and Brussels, for what amounted to a master class, funded
by the Getty Foundation's Panel Paintings Initiative, in response to an
incipient crisis: the majority of the people who are most entrusted with
preserving paintings on wood are now in their sixties and seventies and
are soon to retire. The category of their expertise encompasses nearly all
early-Renaissance paintings, by artists from Giotto to Fra Angelico—
except for frescoes, and for works that were subjected to a once common
process that involved gluing paper or fabric to the paint, and, the wood
having been chipped away, transferring it to canvas—as well as many
Renaissance works, among them the *Mona Lisa*.

New recruits to the field are exhaustively versed in the ethics
of conservation and the chemistry and the physics of the materials
involved, and they may be adept with X-rays, infrared reflectography,
digital macro photography, and other analytic gear. But the intuitive
skill that is born of hands-on experience resides chiefly with the aging
generation. That group coalesced between the nineteen-fifties and sev-
enties, particularly after the Florence flood of 1966, when sodden mas-
terpieces were fished from the muddy overflow of the Arno—a huge
wooden crucifix by Cimabue, from 1288, was submerged for two days—
and public and private funding brought experts together to share their
ideas and apply their talents. Panel restoration was finally standardized,
after centuries of miscellaneous and, at times, ruinous procedures.

There is no more astounding work of art than the Ghent Altar-
piece. Historically, it is a clutch of firsts: it represents the first really
ambitious and consummate use of oil paint, though with some admix-
tures of tempera, and it marks the birth of realism as a guiding principle
in European painting, with a nearly immediate and decisive influence
in Florence and Venice. Oils—of linseed, walnut, and other plant
extracts—were employed as binders for pigments in Afghanistan in
the seventh century and in Europe a century later. Some thirteenth- and
fourteenth-century Norwegian altar fronts are all in oils. But nothing
that we know of anticipated the eloquence of van Eyck's glazes, which
pool like liquid radiance across his pictures' smooth surfaces, trapping
and releasing graded tones of light and shadow and effulgences of bril-
liant color.

The effects serve sharply limned figures whose sculptural round-
edness, warm flesh, splendid raiment, and distinctive personalities
leap to the eye. Anatomical details enthrall: hands that touch and grip
with tangible pressures, masses of hair given depth and definition by
a few highlighted strands. Overall, the pictures generate a sweet and
mighty visual music—which is illustrated in two panels depicting girl-
ish, wingless angels singing and playing instruments. Some scholars
have said that the notes they sing are discernible from the shapes of
their mouths; an organ is so detailed that a working replica has been
made of it. The altarpiece is the sort of art that changes lives. One of
the assembled experts, the Belgian art historian and conservator Hélène
Dubois, remembered seeing it, as a teenager, in the Vijdt Chapel. She
said, "The warden opened the wings for us, and I was absolutely baffled,
fascinated." She "became obsessed with becoming a conservator of Old
Master painting," she added. "So here I am, in the place I have dreamed
about for thirty years."

There are two ranks of panels, as if of two altarpieces, stacked—a
format unique in art history. On the left of the lower tier are views of the
horse-riding *Just Judges* and *Knights of Christ*—the former a bland copy,
installed in 1945, of the original panel, which was stolen in 1934 and is
still missing. (The anti-heroic "judge-penitent" of Albert Camus's novel

The Fall secretly possesses that panel, which he contemplates with existentialistically mixed feelings.) To the right are two crowds of hermits and pilgrims, shepherded by St. Christopher. These four panels flank the panorama of the Lamb, which visualizes a verse from Revelations: "After this I beheld . . . a great multitude, which no man could number, of all nations, and kindred, and people, and tongues, stood before the throne, and before the Lamb." In a wide and deep landscape of grass and trees, with towering cities and blue mountains in the distance, clerics, pagan philosophers, martyrs, saints, and angels approach the Lamb, which stands on an altar. A sparkling fountain trickles water to the bottom of the picture, from where it probably fell to thirsting souls in Purgatory on a predella—a strip of small narrative scenes—that was lost sometime before 1568, when a local writer lamented its ruin by restorers with "calves' hands."

The seven pictures on top are surely all Jan van Eyck's work, except for later retouchings. The central painting is a mystery: Is the youngish, enthroned and bejeweled male figure, holding a crystal sceptre and raising two fingers in blessing, Christ the King or God the Father? Might he be both? The third member of the Trinity appears as a tiny dove in a sunburst over the Lamb. (And isn't the lamb a symbol of Jesus? The altarpiece still defies confident interpretation.) The figure is flanked by panels of John the Baptist, who points to him, and the Virgin Mary, who reads a book. (She is beautiful and heart-tuggingly personable: somebody's daughter, somebody's sister.) On either side of them are the musical angels. At the far left and right stand Adam and Eve, naked and melancholy, presented like statues in narrow niches but naturalistically vibrant with carnal candor. One of Adam's feet protrudes, appearing to rest on the frame. When the wings are closed, the Adam and Eve can be swung back open on either side of the central male figure—returned to grace. Painted above them are dramatizations, in grisaille, of Cain's resentment, and then his murder, of Abel. On the backs of the wings, stonelike figures include an Annunciation: Mary and the angel given slight flushes of color and separated by two panels of the intervening empty room, with a window that overlooks a city. Joost Vijdt, the work's

bald and formidable-looking patron, and his modestly cowled wife, the high-born Elisabeth Borluut, kneel prayerfully in panels of their own. The panels had carved frames, almost all of which have been lost.

On the first day of the examination, the experts, along with junior restorers and students—about two dozen people in all—circulated around the dismounted Mary, John the Baptist, and the "Godfather," as some of them had taken to calling the ambiguous deity. Other panels had been inspected at an earlier meeting; the major focus this time would be the Lamb. The exquisitely detailed but erratically composed panel, eight feet wide and almost five feet high, displays vestiges of medieval style, as in the clunky clouds which contrast with the meteorologically correct ones on adjoining panels. It also evinces the hands of painters besides Jan van Eyck, who in 1432 employed about a dozen assistants in his workshop. They may include the elusive Hubert, who is not conclusively known to have produced any other painting.

A technician operating big, elaborate cameras was taking hundreds of close-ups of the panel, in visible and infrared light spectrums, which will help restorers identify and study the retouchings. The participants came and went through crude plywood-and-steel double doors from the street, temporarily added to a street door for the project. With a few exceptions, including the chic Anne van Grevenstein-Kruse, the group—a guild aristocracy—was unprepossessing, dressed any old way. The white-ponytailed Ray Marchant, who came to the craft from boat-building and cabinetry, was a quiet but palpably formidable presence in the conversations that ebbed and flowed around the room. Ton Wilmering, the project coordinator for the Getty Foundation, spoke of him with awe: "Just picking up a panel in his hands, Ray can exert little pressures and immediately tell you the areas of strength and weakness." Marchant is a curmudgeonly skeptic of overeagerness in his profession. "Some of the best preserved Old Master paintings," he wrote to me later, are "those that have been denied 'improvement' by restorers." Accompanying him was his protégée, Britta New, who looked far too young to be a mother of two who lives in a house, outside London, that she refashioned by hand from a barn. New gave offsparks of fascination

while scrutinizing and touching features of the altarpiece's ancient oak. Tourists were able to view the group, and to see what could be seen of the altarpiece, from a large glass booth, for four euros a person. A junior restorer from Amsterdam, Renzo Meurs, imagined being watched "by the eyes of all art-loving people worldwide."

On the second day, the Lamb panel reclined, facedown, on saw-horses. It struck me as a virtual post-minimalist sculpture: four abutted planks, with numerous wooden cleats of two different sizes glued and screwed across the joins. The smaller cleats were affixed sometime in the nineteenth century. The larger cleats and two heavy iron staples, pounded into the ends of the central join, probably date from 1822, when the panel broke during a panicked removal after the cathedral's roof caught fire. (The restorers are charged with recommending an emergency procedure for getting the altarpiece out of the building in less than an hour, something that is impossible now, given the con-straints of the glass box.) Dings and scratches and traces of an original coating of minium (red lead) on the back of the panel, which was dust-ily aglow with old wax from the 1950 restoration, looked almost pur-poseful, like the mechanical "distressing" in faked antique furniture. Contemporary restorers disparage wax, which, a half-century ago, was regarded as a panacea for the ills of old wood. It can be too airtight, for one thing. If the painted front of a panel inhales and exhales any mois-ture at all, it will swell and shrink by turns, and the wax will prevent the back from moving with it. Eventually, paint may blister.

Recent flaking has been most rampant on the modern copy of the *Just Judges*, owing to a preparatory sizing of the wood, with glue and resin, that was far inferior to the van Eyck brothers'. The original panels prove to be in fantastically good shape. The restorers checked off one thing after another that needed no correction. No significant cracks have emerged since the last restoration, when the paint surfaces were "consolidated"—their gaps filled in, Anne van Grevenstein-Kruse wrote to me in an e-mail, "with a solution of animal glue (a protein). After that, the surface was covered with a mixture of beeswax, colophony,

and lavender oil (to soften the paint). This mixture was melted into the paint structure by using strong heating elements. The surface was then flattened with metal spatulas." Again, wax introduced a problem: "a wax impregnation, being irreversible, precludes to a certain extent other consolidants."

The planks are of extraordinary quality. They were produced by lengthwise radial cuts to the core of the oak trunks, with the bark and the outer layers of soft sapwood then removed. The tree's age rings thus evenly stripe the faces of the boards, making them resistant to both warp and flex. The experts' meeting was preceded by months of tests to measure movement in the wood with the changes in temperature and relative humidity in the room—where hot lights are turned on and off at intervals, and weather intrudes from the street. Though the recorded temperatures swung through thirty-six degrees and the humidity between thirty and eighty percent, the wood had reacted barely a whisker. When Britta New was asked her opinion of what needed doing, she noted, as if reciting a school lesson, the wrongness of setting cleats against the wood grain. But she immediately acceded to a collective verdict that, absent any sign of ill effect, and given the risks attendant on any intervention, the cleats should stay. Speaking for the instinctive reluctance of responsible restorers, van Grevenstein-Kruse told me that sometimes it is "comforting" to let things be, to "close the door of the bedroom after having covered the child with a warm blanket."

The distinguished restorer George Bisacca, of the Metropolitan Museum, couldn't join his peers in Ghent, as he was needed for the installation of the museum's show of works by the sixteenth-century Flemish painter Jan Gossart. Bisacca is a sturdy, brisk man of fifty-five, the youngest member of panel restoration's international élite. In the Met's painting-conservation studios, he briefed me on the arcana of wood. He had trained, in the seventies, at the Workshop of Hard Stones and Laboratories of Restoration, in Florence, the only restoration school in the world where the mastery of woodworking tools is still de rigueur. (The nearest runners-up include the Courtauld and Hamilton

Kerr Institutes, in England.) "Other schools have given up," Wilmering told me, because of the scarcity of qualified teachers on a par with the revered faculty in Florence, and the length and breadth of such training.

Bisacca recalled an exercise: take a four-centimeter cube of wood and plane it down to a three-centimeter cube. I asked his associate Alan Miller, who was one of the mid-level conservators in Ghent, if he had tried that. He said, "Yeah, four or five times." How close did he come to perfection? "Not very," he said, wincing. But the effort distinguishes him from academics who are numb to the muscular feel of planes and chisels wielded with hairsbreadth precision. Wilmering told me, "When you watch George use a chisel, you see him bearing down on the top of it. What you don't see is the almost equal force, upward, of his other hand."

I had seen video images of Bisacca and the tall, long-fingered José de la Fuente at work in the Prado on Dürer's *Adam* and *Eve*, the life-size panels painted in oil in 1507. Dürer used cheap pine for the panels, possibly because he painted them on spec, for later sale. (Most museum-grade Northern European panel paintings are on oak; most Italian panels are on European poplar, a close relative of cottonwood— not the tulipwood that Americans call poplar.) First came the removal, from the back of *Adam*, of a cradle that had been affixed about seventy years ago. Cradles are lattices of glued wooden bars intended to defeat warps and flexes. Usually done by common carpenters, cradling was a standard practice from the middle of the eighteenth century until some years after the Second World War, when curators and conservators began to notice an epidemic of cracks in panel paintings, caused by the wood's frustrated responses to atmospheric conditions and its own aging. Cradling was regularly performed in combination with a truly miserable tactic: that of thinning—sawing the fronts of panels from their backs. "People were obsessed with keeping the paint film flat," Bisacca said. "They didn't see paintings as whole objects, which need to be cared for as such." Panels painted on both sides were sometimes split, to make two works out of one. Thinning exposes the fragile inner life of ancient boards, which, if they are of a wood other than oak, often

harbor damage from chomping and tunneling insects. (Bugs dislike the tannins in oak.) "It makes the wood much more reactive," Bisacca said—sometimes to the point of becoming a "cookie," which you could crumble in your hand.

Six of the eight double-sided panels from the wings of the Ghent Altarpiece were sawn apart in 1894, in Berlin. The panels were in Berlin because, in 1816, after the central panels had been returned to Belgium, following the fall of Napoleon, the Diocese of Ghent sold the wings to a dealer in Brussels, and he, in turn, sold them in Germany, where they ended up in the collection of the King of Prussia. (Today we would call that a deaccession, and screams of protest would fill the air.) They were repatriated more than a century later, as war reparations dictated by the Treaty of Versailles—a loss ominously begrudged by, among other Germans, Hitler. The thinning reduced the panels' thickness to less than a quarter of an inch. In the nineteen-thirties, they were rejoined with steel frameworks. The paintings appear remarkably little the worse for their ordeal, and the experts in Ghent have opted to recommend letting them be, for now.

At the Prado, with the Dürer resting on its face, Bisacca attacked the cradling on *Adam* with an alarmingly brawny circular saw, adjustable to minutely measured depths, cutting the elements crosswise into hundreds of slices that were then snapped off by hand. It was hair-raising to watch. Then, he and de la Fuente routed out cracks, some of them steeply angled from back to front, almost to the layers of animal glue and gesso that underlie the paint, and filled them in with synthetic resins and adhesives and with wedges and trimmed blocks of centuries-old wood. (Such wood was once readily available in Europe, from orphaned painting stretchers and derelict furniture, but restorers now must hoard it.) Finally, the flimsy masterpiece received a device of the Met conservation department's invention, a wooden support inset with small steel springs and spot-glued to the panel. The springs are tensed to calculated ratios of restraint and forgiveness, sliding from side to side and pushing and pulling in and out, to cope with any future whim of the pine. Paint restorers then repaired the picture, which, before Bisacca

and de la Fuente set to work, had suffered more than sixty discrete cracks. Agleam with fresh varnish, *Adam* and *Eve* will be reintroduced to the world at the Prado this week, looking just about brand-new.

Bisacca told me about a day, in 2004, when a Duccio popped. He had never experienced anything like it. He was sawing away a mahogany cradle, installed ninety or so years ago, from the back of the small, thick, internally worm-eaten poplar plank that bears Duccio's *Madonna and Child*. The early-Renaissance painting—it dates from around 1300—is really ur-Renaissance in its epochal leap from medieval taciturnity to humanist pathos: the baby nudges aside his mother's cowl with one small hand, the better to behold her, and she meets his gaze. The Met had paid a headline-grabbing forty-five to fifty million dollars for the eight-by-eleven-inch item, which works out to more than half a million dollars per square inch of wizened tempera and gold leaf.

Under Bisacca's hand, a section of the cradle jumped, with a sharp sound that, upon anxious inspection, proved to have been wood language for "Whew!" (Bisacca later imagined having to call the Met's then director, Philippe de Montebello, with less cheerful news: "Hi. You know that little painting we just got?") The poplar had been striving to warp, convexly, and was building pressure on the cradle as it did. Eventually—in years or decades—the cradle might have won, rending the panel from top to bottom and crumpling paint adjacent to the split. The Duccio now hangs at ease on velvet under glass at the Met, its subtle curvature no distraction from its dreaming loveliness. Talking with Bisacca has given me new eyes for the physicality of panel paintings. The Met's show of Jan Gossart (also known as Mabuse) is artistically no great shakes—Gossart brought Italian influences to bear on an Antwerp style that had roots in van Eyck, to an energetic yet decadent effect—but I found myself savoring its sheer quantity of delicate lumber.

One issue concerning the Ghent Altarpiece will be decided by the church wardens of the St. Bavo Cathedral, in consultation with provincial and federal authorities: should the paintings be cleaned? A tiny

patch of sky on the Lamb panel had just undergone a test cleaning with mild solvents, including ethanol. It was a far lighter and more resonant blue, of white mixed with ultramarine from lapis lazuli and azurite; the difference was dazzling. But worry dogs the decision. At a meeting of the restorers, a PowerPoint image magnified a zone of lead white that resembled a sun-fissured mud flat, the raised, or "tented," edges of the cracks having been knocked off by previous cleanings, which, however, had missed ugly brown puddles of decayed varnish. The terrain looked scarily precarious. And, even with highly reliable X-rays, it is not absolutely certain that all of the many retouchings can be distinguished from van Eyck's brushstrokes: the bathwater might blur the baby. (Today, retouchings are done on a layer of new varnish, so that they can be easily recognized and, if necessary, removed.) That glimpse of sky made me enthusiastic for a cleaning, and I burned with resentment at the bygone meddlers. I told the restorers, "I want to see as much as remains of what van Eyck saw when he finished painting, and nothing that he didn't." They all gave me some variant of the same weary look, as if to say, "Oh, to be naïve again." Dubois later told me that the process would require "extreme concentration, without losing a view of the ensemble." It is "not for the fainthearted nor the hurried."

Restorations of much-loved works invariably arouse controversy, as in the furor organized against the removal of grime from the Sistine Chapel frescoes between 1980 and 1994. (The result there was sensational, a revelation of Michelangelo's previously underrated gifts and shoot-the-works gusto as a colorist.) Quite apart from a reasonable wariness of paint loss, sheer loyalty to the wonted look of a work, dirt and all, prejudices many. The experts all tell the story of how, in the thirties, at the Franz Hals Museum, in Haarlem, in the Netherlands, restorers stripped yellowed varnish from some of the paintings. Visitors were so distraught at the change that the museum's director issued them yellow-tinted glasses. There are also academics who militate against the removal of retouches and even of over-paintings, holding that they embody history in themselves. That's fine if you dote on

archaic hackwork but maddening if you'd rather view a master's unadulterated touch.

During the two days of the meeting in Ghent, the Mary, John the Baptist, and "Godfather" panels leaned against a wall in strong light. I got to study them from a nose's length away. Their sophistication is staggering. The intricacy and sumptuousness of the images are achieved with economical technique. Each of the hundreds of pearls that fringe Mary's robes is just a dollop of gray hit with a spot of white, so perfectly judged in relative tone that, from any distance, it exudes pearlescence. A seductive softness in the flesh of Mary's throat owes to one long stroke, indicating a crease, of slightly varied flesh color. Van Eyck understood that realism doesn't require verisimilitude but only just enough visual cues to exploit the mind's credulity. We know now, from brain science, that seeing is not a direct register of what meets our eyes but a fast mental construction that squares sensations with memory and desire: what we believe and wish reality to be. Our science would have seemed childishly obvious to van Eyck. His style is synthetic, a repertoire of finesses—some derived from manuscript illumination, which was then the most common mode of painting, and some from the advanced modeling of bodies and drapery found in the sculpture of the time. Van Eyck's younger contemporary Rogier van der Weyden, in Brussels, improves on it, with a still powerful but more seamless manner; and Hans Memling, later, is smoother yet. But nothing beats the bristling inventiveness of the Ghent Altarpiece. For me, imprinted like many of us with a belief that Renaissance art is a story of Italy, with mere sidelights in other lands, getting to know van Eyck amounts to a crash reeducation. That isn't easy to get, however, even in Ghent.

By the end of the second day, I felt more confident talking to the restorers than I had when I promoted a cleaning, but my view was even less welcomed when I deplored the four stated options for displaying the altarpiece: where it is now, in the Villa Chapel; where it was originally, in the Vijdt Chapel; in another, somewhat larger, chapel, off the ambulatory of the cathedral's apse; or in a new chamber to be built in a

courtyard of the cathedral complex. The argument for returning it to the Vijdt Chapel, where full-size color photographs of it are installed now, was bolstered by the observation that van Eyck painted all the shadows in the work with the light striking on an angle that aligns with that chapel's tall window—which, however, has been partially blocked, since 1663, by an obese Baroque altar. Visitors to the smaller room would have to be limited in number, perhaps twenty at a time. "Imagine how special that would be!" van Grevenstein-Kruse said. I wondered, first, about an exhausting wait in line, and then about a ticking time limit for exposure to a work so overwhelming that some minutes of recovery are needed before you can even really start to look at it. The apse chapel has ungainly proportions and would be hard to light and weatherize. A custom-made space in the courtyard would enable climate control but not much more square footage.

I envisioned the altarpiece standing in the center of a vast museum gallery, free of glass and perfectly illuminated. That situation would put into greater play a cultural touchstone that now cannot be truly experienced even by people who visit it more than once. I was given to understand that this will never happen. The prestige and the financial sustenance of St. Bavo and its commercial environs depend on holding van Eyck hostage. The restorers' final report will appear early next year. It is sure to recommend replacing the grim box with some new configuration of clear, less reflective glass, but to keep the work where it is for now. A general renovation of the cathedral's interior has begun and is expected to take ten more years to complete. Maybe then the question of where to put the altarpiece can be taken up again.

New Yorker, November 30, 2010

GIORGIO MORANDI

In my ideal world, the home of everyone who loves art would come equipped with a painting by Giorgio Morandi, as exercise equipment for daily toning up of the eye, mind, and soul. I want the ad account: "Stay fit the Morandi way!" Take your dream pick from among the hundred and ten works in the potent retrospective of the Italian modern master now at the Metropolitan Museum. You can hardly go wrong with anything dated after 1920 or so, once Morandi, who died in 1964, at the age of seventy-three, had worked through his early involvements with Cézanne, Cubism, futurism, and the *pittura metafisica* of Giorgio de Chirico and Carlo Carrà. But make your choice a still life. Morandi painted some striking landscapes and the odd, tentative self-portrait, but the arenas of his greatness were the tabletops in his small studio. He passed nearly his entire life in an apartment in Bologna with his mother, until her death in 1950, and three younger sisters, who, like him, never married. (His businessman father died in 1909, four years before Morandi's graduation from Bologna's art academy.) Morandi's stagings of his repertory company of nondescript bottles, vases, pitchers, and whatnot are definitive twentieth-century artworks. They breathe intimacy with the past—Piero della Francesca, Chardin—and address a future that still glimmers, just out of reach. They remain unbeatably radical meditations on what can and can't happen when three dimensions are transposed into two. Morandi will always rivet painters and educate all who care for painting.

He seems to have cared for nothing else. If he ever had a sexual interest, it is unrecorded. He first set foot outside Italy in 1956, and then only in Switzerland. His most frequent forays were to Florence, to consult Piero, Masaccio, Giotto, and Uccello. A man "unwilling even to squash an insect in his garden," according to a fine biography by Janet Abramowicz, *Giorgio Morandi: The Art of Silence*, he suffered a breakdown when he was drafted into the Italian army, in 1915, after which he was excused from service. He supported himself by teaching painting and etching. (His etchings amaze, triggering subliminal sensations

of color with nothing but crosshatched black lines.) He had friends, and he liked to laugh, with the ironic and at times scathing humor of a sensitive man. The academic establishment in Bologna, a university town, disparaged him until late in his career. He participated in the right-wing, ruralist Strapaese movement of the late nineteen-twenties. His attitude toward Mussolini, whose regime gave him teaching jobs, was more positive than not, although he was briefly imprisoned in 1943 for associating with anti-Fascists. (If ever an artist merited political amnesty, on the grounds of unworldliness, it would be Morandi.) Fame came to him after the war: he won first prize for an Italian painter at the 1948 Venice Biennale and became so revered in Italy that filmmakers, notably Federico Fellini, in *La Dolce Vita*, used his work as a ready symbol of lofty sensibility. Morandi had a last adventurous phase of nearly abstract drawings and watercolors that condense into swift marks a lifetime of looking.

The still lifes vary from bright to crepuscular in tone, from crisply limned to almost illegibly blurred, and, in texture, from creamy to arid. To describe any one of them as exemplary is to provoke tacit protests from the rest. So, in general: the paintings present objects singly, side by side, or in overlapping groups. They feel monumental because they are viewed at eye level, or from just above. Morandi, who stood six feet four, built a high table that he often used for that purpose. He disregarded the receding plane of the tabletop, often shrouding the back edge with brown paper so that it wouldn't distract him. The horizon of that edge commonly seems arbitrary, and the tabletop itself may be woozily indefinite. Morandi anchors his objects frontally, pressed against our gaze. He often paints them all but flat, adding only dim highlights and perfunctory shadings, which at first excite and then gently relax our automatic effort to read roundedness and depth in the pictures. It can take time—minutes, not seconds—to get over what we think we are seeing and to behold what's there. But a sensitive eye may catch on right away. The most helpful piece of writing on Morandi that I know is the painter Vija Celmins's description of her first encounter with one of his still lifes (in 1961, when she was twenty-one), which "projected an

extraordinary set of grays far into the gallery and into my eyes. On closer inspection, I discovered how strange the painting was, how the objects seemed to be fighting for each other's space. One could not determine their size or location. They appeared both flat and dimensional, and were so tenderly painted that the paint itself seemed to be the subject."

The ambiguity of "size or location" is key to Morandi's indelible modernity. It's as if he had set out, time and again, to nail down the whatness of his objects but couldn't get beyond the preliminary matter of their whereness. (He didn't much value the things in themselves. Photographs show that some were slathered or, in the case of clear glass bottles, filled with pigments—they were dedicated to painting the way farm animals are raised for food.) Morandi was free of the organizing prejudice of perspective. Go look at a Cézanne after seeing this show. It will seem old-fashioned. Conventional pictorial space remained a safety net for the great Frenchman, whose influence Morandi subsumed. Even Picasso didn't as fully abandon perspective—smashing it to localized bits in his Cubism, letting it creep in where it was convenient thereafter. Morandi fumbled, thrillingly, amid the ruins of mental concepts of space. He reversed the thrust of his beloved early-Renaissance inventors of perspective. In an Uccello, say, we register both a mathematical formula of spatial recession and the fact that it is clumsily artificial. Even the majestic Piero fell short of dissolving the preeminent appeal of the painted surface into the fiction of a window view. (Leonardo would do that.) Morandi's eye and mind lived in the surface, marooned there by honest, anxious skepticism. Dramatic uncertainty intensified in his work as he aged. In one of the show's last paintings (the one I want to take home), a jug, whose ochre hue interpenetrates with that of the wall behind it, abuts a tall box in livid, very pale blue; a corrugated ball, half ochre and half greenish blue, rests on the gray table in what would be the foreground—were not the picture, in its effect, all foreground. Dark, jittery outlines startlingly anticipate a look of late work by Philip Guston. That's not unusual in Morandi, whose explorations fortuitously scout the distinctive qualities of subsequent artists. The step from some of his landscapes—with forms at once filmy in color and corporeal in

substance—to certain works by the brilliant Luc Tuymans is almost no step at all.

Painting for Morandi was manual labor, first and last. For a time, he ground his own pigments. He stretched his own canvases, constantly varying their proportions. (In the Met show, there are almost as many different sizes of picture as there are pictures.) No one work builds on another. Infinitely refined, Morandi never succumbs to elegance. Even his effulgently pinkish floral still lifes abjure virtuosity, though they beguile. (One might be made of ice cream; another stiffens to marzipan.) That's because the exigencies of rendering—tiny slippages between eye and hand—constituted, for him, a permanent emergency, requiring incessant adjustment. (Rose petals may jam up like large people competing to pass through a small doorway.) He did not have a style. He had a signature: *Morandi*, written large, often, to broadcast that a picture had done all it could. He is a painter's painter, because to look at his work is to re-create it, feeling in your wrist and fingers the sequence of strokes, each a stab of decision that discovers a new problem.

Color works hard in Morandi. His hues tend toward muddy pastels, always warm. He employs an unabridged dictionary of browns. Even his blues and greens usually secrete invisibly admixed red or yellow, insuring the projection of "an extraordinary set of grays far into the gallery" that Celmins noted. The colors are muted like voices lowered so as not to disturb a sleeper, but their melody and tone penetrate. A Morandi grabs your eye at any distance. Moreover, it's the same picture at any distance, as resolved and unresolved near at hand as far away. (His comprehension of art history skips the Baroque and every other type of synthesized illusion.) Morandi has never been a popular artist and never will be. He engages the world one solitary viewer at a time. The experience of his work is unsharable even, in a way, with oneself, like a word remembered but not remembered, on the tip of the tongue.

New Yorker, September 22, 2008

PIET MONDRIAN

Look hard. That's how to love Mondrian. It's a dumb tack to take with most painting: to stare, to pitch into with your gaze, to burn holes in like a rube or a humorless child. Normal painting involves learned conventions. Not Mondrian. I promise you stabs of delight if you can gawk stupidly enough at the classical pictures, from the two decades before his death in 1944. The earlier work is great, too, but yields itself to regular looking.

I stumbled on the trick as a youth desperate to understand modern art. Most of what I saw in museums wouldn't play with me. I didn't know enough yet. I couldn't sort out the unusual from the usual. But looking at Mondrians was like throwing myself off a cliff and being caught by a trampoline. It made me high. It still does, to my surprise. I had forgotten. I went to this tidy retrospective feeling bored with the modernist canon. But then there I was, reeling anew

The standard theories and explanations of modern art have become almost as embarrassing as Communism. Decades of cogitation about "abstraction" circle history's drain. Contemporary smarts hold that all possible pictures are both abstract and figurative, so never mind. Mondrian's writing palls, too. His early Theosophical mysticism and later Utopianism are alike in tedium—the mysticism slightly less so, because critics have been so unfair to it. (But Madame Blavatsky?!) As a result, people may feel that they've had enough of him when actually they've had very little. One problem is the work's ubiquity in reproduction, which gives not the slightest hint of its drama in person.

Mondrian's pictures are now about only the experience that they offer. To have it, I suggest first going through the show studiously. Read the damned wall texts, because who can not read writing on walls? (It's primordial, maybe dating from "Beware the Sabre-Toothed Tiger.") Register the boilerplate "march toward abstraction." Remind yourself that you don't care. Mondrian could have marched to Pretoria for all it mattered. (It matters as a difficulty that he incurred and that made him sweat.) Then, after a stroll in MoMA's garden, return to stalk joy.

Maybe start at the end, with *Broadway Boogie Woogie*. You have seen this jigsaw of colored lines and little squares many times. It is always up at MoMA. Now look hard. It is three pictures in one, each starring a color: red, yellow, blue. When you think red, the other hues defer. They do a jiggling routine in praise of the hero, red. When you think blue, blue steps out, and red joins the chorus. Then yellow, the same. (A fourth color, gray, shyly holds to a supporting role.) It really is like boogie-woogie piano, ping-ponging between left and right hands. You could also take it as an allegory of democracy. Don't, though.

Or start in the alcove of "Sea and Pier" drawings from 1914 and 1915. At a quiet coast in a world at war, Mondrian reduced a pier, the ocean, and starlight to a digital code: this horizontal a wave, that vertical a gleam. It is not a representation. It is a construction, shimmering in the mind. As humble as worship, the drawings evoke a world unutterably lovely and, even as I behold it, alien because bodiless. These are Mondrians that I particularly cherish. (I want one.)

Start wherever your heart leaps in recognition of the artist's radical pertinacity. Do the show sideways, wandering to evade the hanging's chronology. Again, the harder you look, the better, and the more moving. I melt with gratitude at the work's catching and holding, tender firmness.

Finish with the hallmark Mondrians: right-angled black lines on white or off-white with blocks of primary colors. Confronting one stirs a sensation in the gut. Observe how it is hung: as Mondrian dictated, with the midpoint below eye level. This involves you physically. (The diamond-shaped canvases, cropping the corners of squarish motifs, are hung high. They are like prison windows giving fragmentary glimpses of a cosmos out there.) I believe that the sensation centrally involves balance, bringing to awareness our constant unconscious efforts to defeat gravity by standing.

Think of how complicated it is to stand, let alone to walk or, for heaven's sake, to dance. (Ascetic Mondrian loved to fox-trot.) Neurons fire and muscles twitch to maintain the one condition—verticality—that defeats gravity's will to horizontalize everything. Mondrian eschewed

diagonals, which in his scheme could only be anecdotal: something propped or toppling.

Each Mondrian presents an equilibrium subject to stresses: the vertical preserved amid asymmetries. We intuitively gauge weights and tensions that constitute the picture's stability. Epiphany happens when you grasp how finely calibrated the stability is, poised at a breaking point. Move any line a millimeter or vary the ballast of a given color—replacing a blue, say, with a lighter blue—and not only would you fall down but the universe would fly to pieces with a reverberating twang.

Of course this is an illusion. Mondrian built it backward, starting with the equilibrium of a blank canvas and engineering into it the perils that he then brought under control. But the control feels triumphant: upright in every way, and expressing a bedrock condition of our survival.

The work that pried me open this time is *Composition No. 9* (1939–42): black lines with red and yellow patches. I noticed a small vertical bar of red that lies like a bandage across three black horizontals. The shape's presence implies, by appearing to remedy, a structural insecurity. I imagined the lines bursting apart if deprived of the bond, and the rest of the picture disintegrating in a chain reaction. Every square inch of the canvas started to vibrate for me.

My account of Mondrian is exaggerated and partial. Contrary accounts are possible, such as telling the work's story from the point of view of the horizontal: embattled serenity. Mondrian is dialectical, which does not mean ambivalent or ambiguous. He delivers extremes at clarified, full strength, encouraging total responses. His art can't be grasped as a whole any more than life can. Like life, it is equal to rough uses. Lay into it. It wants you to.

Village Voice, October 17, 1995

MANTEGNA

"Andrea Mantegna gives us as many reasons to dislike him as any great artist," Lawrence Gowing writes in the catalogue of the Metropolitan Museum's show devoted to a runner-up in the Renaissance popularity contest. I had decided as much before reading that. The fifteenth-century master is remarkably inimical, given how impressive he could be with his great big clarities of design and tiny delicacies of line and light. How could someone so dour hatch such loveliness? And why would his contemporaries abide the effect, which is like being caressed by a fist? Some bitter thing, some spleen, drove Mantegna.

The Met show occasions my first solid take on him. It is exciting, as it always is to catch on to one of the true Old Masters—those deep-dish personalities who simmer beneath the museum's dull crust until, suddenly, they colonize your mind. The experience is a soulful expansion, like falling in love (or in hate, no difference), that reveals unsuspected possibilities of feeling.

The image of Mantegna's that you know, if you know any, is the weird *Dead Christ* (1490), which did not travel from Milan to this show: defunct Jesus radically foreshortened, his lacerated feet in our faces. Most peculiar is how, having hatched the motif, Mantegna hedged it, rendering the feet far smaller than the perspective calls for. This Christ would take a man's shoe about size four. So first you're hit with a grotesquerie and then with a manipulation of it. That's Mantegna: show-offy, high-handed.

But come to close quarters with the paintings and treat yourself to the miracle of their modeling, as if drifts of light clung to forms of rock-like density. The incredible touch is Mantegna, too, as is the structural rigor of even his smallest compositions. Once an image of his gets into your head, it stays.

He is reputed to have been a major and perhaps even homicidal sourpuss. (A certain rival mysteriously got dead.) A portrait bust of him, in the show, confirms this with a look to make dogs whine and children cry. I have loved learning that Mantegna's brother-in-law was

Giovanni Bellini, the Venetian with the sweetest human spirit of any painter, ever. What were the family dinners like? I imagine Bellini finding excuses to retire early. I wonder if Mantegna made his home in Padua, among university scholars, rather than nearby Venice, because loath to be the second-best painter in town.

It's perfect, though coincidental, that his favorite paint medium is called distemper. Tempera made with animal glue, distemper enables an inner glow of transparent glazes like that of oils but without their melting sheen. Where not wrecked by posthumous layers of varnish, Mantegna's surfaces are bone dry, worlds removed from the swimmy brilliance of Bellini's oils.

What ate Mantegna? He never lacked for success in a six-decade career from his days as a teenage prodigy in Padua to his death in 1506 in Mantua while under the patronage of Isabella d'Este—for whom he painted a preposterous allegory, *Pallas Expelling the Vices from the Garden of Virtue*, which belongs in the select category of artworks that are great without being good. He was criticized by contemporaries for rendering people as if they were made of stone. Was it defiantly that he went on to make so many paintings—ultimate faux decor—of fantasized stone reliefs?

Mantegna was terrific at depicting physical weight, a talent that, in painting as opposed to sculpture, is easier to admire than to enjoy. "He has deposited something angular and painful under the skin of European art," Gowing writes, calling him "one of the great archetypes"—of what? I hazard that it's the mandarin professional who pursues the mastery of a discipline for mastery's sake. He wants to stick his preeminence to the world. Mantegna wowed the Paduan academics with erudite references to Greek and Roman antiquity. They responded with poems of tribute monotonously comparing him to Apelles. If anyone wanted lyrical content, no problem—but forget tenderness. A Mantegna Madonna is like a treatise on the physics of baby-holding.

Quite a few artists have a Mantegna streak, but in modern times the world rarely yields to them. Success for the type requires a personal power base, in touch with but independent of the uncontrollable

metropolis. (As a strategic investment, marry the sister of the metropolitan star.) Crucially enabling is a time of rapid cultural change—like, say, the Renaissance—which raises the stakes of artistic competition and provides critical aficionados to keep score. The key is a culture that holds art in sky-high reverence. People less enthusiastic might resist an overbearing sort with only novelty and finesse to recommend him. But when art is exalted, novelty and finesse are tickets to ride.

I have talked about Mantegna rather than the Met's Mantegna show, which, more than half made up of things identified as possibly or probably or certainly not by the artist, is largely a demolition derby for scholars. I had fun kibitzing the tortuous wrangles that wend from wall text to wall text, especially dense in sections of engravings by, after, or *way* after Mantegna. (He is given in my dictionary as "painter and engraver," but some experts now think he never engraved.) The excitement of specialists when they emerge, blinking, in the glare of a major exhibition is touching. But don't be distracted from getting to know a formidable character from the high noon of painting on Earth.

Village Voice, May 26, 1992

YOUNG REMBRANDT

Seeing an unfamiliar painting by Rembrandt is a life event: fresh data on what it's like to be human. A remarkable case in point is *Judas Returning the Thirty Pieces of Silver* (1629), now on rare loan from a private collection in England to the Morgan Library, where it headlines the show *Rembrandt's First Masterpiece*, augmented with drawings and prints. The artist completed it when he was twenty-three, still living in his native Leiden and sharing a studio with his friend Jan Lievens. When Constantijn Huygens, the secretary to the Prince of Orange, visited the studio, he declared Rembrandt's picture equal to "all the beauty that has been produced throughout the ages."

In the smallish canvas, Judas kneels, writhing in anguish, amid a circle of elders in a busy temple. The coins—count 'em, thirty—lie strewn in a pool of light on the floor. Judas's head is bloody; some of his hair is torn out. His open mouth, showing teeth, suggests an utterance less coherent than his words in the Gospel of Matthew: " 'I have sinned,' he said, 'for I have betrayed innocent blood.' " Rembrandt similarly intensifies the elders' cynical response—"What is that to us?"—with recoiling postures of fear and disgust.

Light pours in from an unseen source to the left, casting somber shadows, illuminating an open Torah and glinting, here and there, on iridescent fabric or reflective metal. To the right, beyond an archway, an oblivious man ascends stairs. A masterpiece? The overused honorific distracts. Never mind congratulating the painting. Look at it. No, the ovoid space in which Judas kneels doesn't fully convince. The tyro artist went for broke, straining at limits he would soon enough overcome. The work impresses as an audition piece, proving its maker to be the hands-down choice for whatever employment would arise.

Profoundly, the unusual subject projects a personal and philosophical identification. Rembrandt embarked not only on an art career but on an extended plumbing of souls, including his own. Has anyone in the annals of human experience been more alone than Judas at the pictured moment? Abandoned to bottomless guilt, he appeals to the

only human contacts left to him. He tries to change the terms of their relationship from financial to forgiving and redemptive. The pathos burns like acid. After this, Judas will leave the temple and hang himself.

How did the young Rembrandt know so much about existential extremes of emotion? The answer is that he didn't. Rather, whenever he put brush to canvas, pen to paper, or burin to metal, he posed some puzzle to himself about the meaning of a particular story, social order, or person. As he worked, a solution would come to him, but without finality. It pended completion in other eyes, minds, and hearts: our own, now.

New Yorker, August 1, 2016

CLEMENT GREENBERG, 1909–1994

I chanced to share the backseat of a car with the Man Behind the Curtain for a couple of hours one winter night in 1981. Art criticism's Jehovah turned out to be a jowly imp who chain-smoked unfiltered Camels, giggled at his own audacities, and relished a fight. We argued zestfully. I told him Brice Marden was a better artist than his guy, Jules Olitski. He professed fascination that anyone could think so, and we went at it. I felt that I won my case with room to spare, only later realizing that my seatmate had conceded nothing. Had he patronized me? It didn't matter. That was the only time I met Clement Greenberg, who died this month at the age of eighty-five, and it took a weight off my soul.

To have come up as an independent art person in the sixties was to know the intellectual terror of the "Greenbergian," a style of critical mandarins like Michael Fried, institutional pooh-bahs like MoMA's William Rubin, and other art worldlings given to winning through intimidation. The manner lacked Greenberg's too rarely noted confessions of taste's subjectivity. Greenbergians fused theories of aesthetic transcendence from Kant with historical determinism from Hegel. Try boxing with someone whose right fist can tag you as a yahoo and whose left can deck you as retardataire.

In terms of actual art, it was hard not to notice that those people were nuts. The Color Field painting they had to regard as the living end—because it embodied the medium's "effects exclusive to itself," in Greenberg's formula—was insipid. They snooted Pop, minimalism, and most other signs of intelligent life in new art. Greenberg himself had withdrawn from the fray even before the 1961 publication of his great book of selected writings, *Art and Culture*. Behind the scenes, he took a dubiously active hand in the careers of pet artists. He chatted up collectors who bought Color Field by the acre.

Why couldn't I shrug off Greenberg as, in the sixties, nearly everyone with smarts came to do? It was the majestic tone, the seraphic clarity. He might be overbearing, with a T. S. Eliot–like pretension to be high culture's secretary of state, but he held himself to standards of

cogency that made opponents seem dishonest and scatterbrained. I thought that as a would-be critic I should have answers to Greenberg, while suspecting that it was hopeless. Someone who wrote like that must be a superior being. Then came the car ride, and I saw the kind of being he was: an artist!

Greenberg's *Times* obituary by Raymond Hernandez contains a plausible nugget of psychobiography:

> He was the oldest son of a Jewish immigrant from Russia who owned a clothing store. By the time he was 4, he drew with great zeal, propelled by his own ability to bring objects and people to life.

> But his parents did not share his love of art or even appreciate it. Later in life, he described them as "barbarians," who threw away every scrap of his artwork and who perhaps unwittingly laid the foundation for their son's theorizing on the mutual antagonism between art and the average person.

This has the minor virtue of explaining everything: an abused spirit taking vengeance on its abusers. But thwarted children don't automatically become art critics, let alone great ones. Greenberg, who early on taught himself Latin and German and immersed himself in literature, happened into the vocation the way everybody used to: by accident. In the late thirties, the *Partisan Review* crowd of New York intellectuals lacked a voice for art. Greenberg, who knew the scene through his friend Lee Krasner, accepted the job at a God-touched moment, when a few impecunious painters in downtown Manhattan were groping toward a revolution.

He educated himself in public, he said. (I know how that works: painfully, but the lessons stick.) His most famous essay, "Avant-Garde and Kitsch" (1939), made much of a reference to the nineteenth-century Russian painter Ilya Repin, which, due to the critic's still spotty knowledge, mischaracterized Repin's work as kitsch. To his credit, Greenberg called attention to the mistake when reprinting the essay. To get the

physical, formal, and stylistic facts of any art right was the beginning and end of his method. If you can see what's there, and how and why, you will know its worth.

Greenberg's artistry arose in how he threshed the harvests of his eye. Describing painting since Manet almost brushstroke by brushstroke, he hatched ideas parallel to the new American painting's revaluation of the European avant-garde. He was no mere commentator on the Abstract Expressionists; nor was he mainly a promoter, unlike his eloquent rival Harold Rosenberg. He was one of the gang, as truculently ambitious. (Did they despise him? They tended to despise one another.) His best work is to criticism what Barnett Newman's is to painting: a breathtaking reduction of complex ideas, in command of what it omits.

Don't bother trying to pick apart any page of *Art and Culture* apropos Picasso, Braque, Leger, et al. The point of view may be narrow and the tone arrogant. Greenberg ends one essay, "We can ask whether Braque has misunderstood himself since 1914." ("Misunderstand *this*!" I fancy the artist responding.) But the analysis glints likes machinery. Ironically, a passage of the same essay applies to Greenberg's own career after the fifties: "a period of decadence, when personal gifts are no longer borne up by the circulation of new ideas and new challenges."

Greenberg's was a quandary common to New York thinkers of his generation: cheerleading the postwar triumph of American culture and then discovering with horror the culture's true colors. It was one thing when Jackson Pollock evinced American pragmatism in trumping Picasso, quite another when Andy Warhol and Donald Judd squared art with the mass-cultural and corporate givens of American actuality. It was still worse—and here I could empathize a little—when avant-gardism congealed, by the end of the sixties, into attitudes that discounted personal aestheticism.

Greenberg cherished his artistic pleasures as he did his Camels, which killed him with emphysema. I can identify in my more timid way, here with my unsteady passions and Marlboro Lights. Where I draw the line is against his rage for purity, theorized as an automatic tendency of modern arts. That idea, which lingers as the "modernist" straw man

in "postmodernist" criticism, impoverishes anyone's experience of any art—perhaps except Color Field painting, a reductio ad absurdum like that of a person who, seeking ever sweeter foods, ends up eating pure sugar. No wonder Greenberg's critical teeth fell out.

Fortunately for his immortal fame, greatness in or about art has precious little to do with being right. It most involves telling a story that imprints itself, when and while it counts, on the eyes and brains of your contemporaries. Greenberg's tales of surface flatness and framing edges lent efficient self-consciousness to an era of intense creativity. He made people who hated him keener than they would have been otherwise. By saying some things about pictures, he altered history.

Take that, Mom and Dad.

Village Voice, May 25, 1994

LEO CASTELLI

In 1975, when I was a critic for the *Times*, a new editor sat me down and told me that the paper was cutting back on reviews in favor of features. He added that there was a big future for a young man who wanted to be an investigative reporter in the art world. What story did he have in mind? The dealings of Leo Castelli. Perhaps I shouldn't have been surprised. That year, a celebrated conviction of the dealer Frank Lloyd, for conspiring to plunder the estate of Mark Rothko, fed popular suspicions that the art world was a quasi-criminal enterprise zone, in which Castelli—who had a near-monopoly on the top artists and sold their work for prices that seemed fantastic—figured to be the gangster-in-chief. And what young journalist didn't ache for the laurels of a Woodward or a Bernstein?

I didn't. I liked the art world, and I revered Castelli, though he made me nervous. Treated to the silken manners and melting gaze of the small, neat man from Trieste—with his unplaceable accent, which Tom Wolfe described as "soft, suave, and slightly humid, like a cross between Peter Lorre and the first secretary of a French embassy"— I felt like a farm boy with cow pies in my pockets. He sensed this, I'm convinced, and left me alone when I visited the holy of holies that was his gallery, first at 4 East Seventy-Seventh Street and, after 1971, at 420 West Broadway, flashing me the odd, quick, knowing smile. Leo (almost no one who met him even once called him anything else) wielded custom-tailored ways of making people feel special—all people, because he crowned his Continental glamour with a faintly comic and completely endearing American-style openness.

The *Times* did run a piece that year that probed Castelli's handling of his thoroughbred stable: Johns, Rauschenberg, Twombly, Warhol, Lichtenstein, Rosenquist, Oldenberg, Kelly, Stella, Judd, Flavin, Morris, Nauman, Serra, Ruscha, et al. It reported that he gave special consideration to favored collectors and might refuse to sell anything significant to others and that he cultivated a network of cooperating galleries in other cities, which showed works by his artists and split the

commissions on sales with him. No scandal there. The sole whiff of impropriety was unsourced: "It is said that throughout the late sixties Castelli had collectors bidding up works on his behalf at auction." But the first germane auction didn't take place until 1970, and inflating market bubbles wasn't Castelli's style. He played a long game, aimed at securing art-historical, institutional recognition for his artists. Rising prices kept score, but where a work went was more important to him than what it went for. He set his sights beyond collectors, on museums and the academy. The article missed the one arguably shady aspect of Castelli's enterprise: the seduction not of pocketbooks but of hearts and minds. His mentors (whether or not they consented to the role) included Marcel Duchamp; Alfred H. Barr Jr., the founding director of the Museum of Modern Art; the critic Clement Greenberg; and the collector and dealer Sidney Janis. Castelli's first wife, Ileana Schapira, who was at least his equal in taste and intellect, was never more helpful than after their divorce, in 1959, when she emerged as a formidable gallerist with her new husband, Michael Sonnabend. In Paris in the sixties, the Sonnabend Gallery raised the flag of Castelli's American artists, to the horror of the French art establishment and the corresponding ardor of many other Europeans. At one time or another, Castelli's brain trust numbered the art historians Leo Steinberg and Robert Rosenblum; Alan Solomon, the brilliant director of the Jewish Museum (in the early sixties, a showcase for avant-garde art); the talent-scouting dealers Dick Bellamy, downtown, and Irving Blum, in Los Angeles; and no end of critics. Castelli's network allowed him to change the culture of art from the inside out.

Who was he? A biography, *Leo & His Circle: The Life of Leo Castelli* (Knopf), by Annie Cohen-Solal, written in French and elegantly translated by Mark Polizzotti and the author, immerses the question in facts and sensitive analysis without exactly answering it. Something impenetrable survives the best efforts of Cohen-Solal, who met Castelli at a dinner in New York in 1989, soon after she became the cultural counselor at the French Embassy. "So, you are the new one," she remembers him saying to her. "Well, you're going to take the city by storm with your

orange skirt and your long gloves! Why don't you come to the gallery tomorrow around five? You'll see the show, you'll meet Roy. He has an opening, and you'll stay for the party!" With that personal note, the first and almost the last in an impeccably judicious book, Cohen-Solal establishes her membership in the community of the bedazzled-by-Leo. It's an important credential. The impressions that Castelli made on people are not incidental to his story. In a way, they are his story.

He was born Leo Krausz, in Trieste in 1907, the second of three children of a prominent Hungarian banker and an Italian merchant heiress, both of whom were Jewish. The family took his mother's maiden name in 1934, when the Fascist government banned non-Italianate patronymics. The family's eventful history, reaching back on his maternal side to Renaissance Tuscany, brims with the frequent tribulations of Jewish experience at the fringes of the Austrian and the Austro-Hungarian Empires. Castelli didn't conceal his heritage. He ignored it, subjecting his Jewishness to "unreflective and absolute erasure," Cohen-Solal writes. She provides a backstory, spanning centuries, that is so detailed—her protagonist doesn't occupy center stage for most of the book's first hundred pages—that it initially exasperated me. But I returned to it, later, for its absorbing and, after all, highly relevant scrutiny of the historic loam that produced a bloom as exotic as Castelli.

A slight child raised in luxury in Trieste—and, during the First World War, in Vienna—he was expected to follow a career in finance. He asserted his independence by becoming both an athlete in several sports, notably mountain climbing, and a passionate student of literature in four languages. "I wanted to be a Renaissance man, and physically strong," he recalled. At first unsuccessful with girls, he profited from a single session with a Freudian psychoanalyst, whose advice—to consider the girl's point of view—helped to launch him on his lifelong sideline as a Casanova. Cohen-Solal evokes a world of "the Finzi-Continis of the Adriatic"; the gathering menace of Mussolini raised only mild alarm among people who were almost used to occasional spells of persecution. Castelli, whose father prudently took party membership, remembered thinking, languidly, of the Fascists as "rather intolerable."

In 1932, at the age of twenty-five, Castelli took a job with an insurance company in Bucharest, where he courted the elder daughter of Mihai Schapira, a business tycoon. Rebuffed by her, Cohen-Solal writes, Castelli turned his attentions to her "impish, refined" sister, Ileana, who later said, none too sentimentally, "as I wanted to get out of Romania at any cost, I married him." The couple relished the Dada art scene in Bucharest, their sensibilities agreeing in "iconoclasm, refusal of convention, love of subversion, insatiable curiosity, juvenile humor." In 1935, a job transfer for Castelli brought them, via the Orient Express, to Paris. He was ecstatic there, while she, for all her striving and Schiaparelli raiment, felt awkwardly out of step, even as they "developed their taste in the zone between the abstraction of Klee and Kandinsky, the Surrealism of Miró, and the Dadaist loyalties" of the critic Michel Tapié. They had a daughter, Nina, in 1937, then commenced to lead separate lives.

Anxious to forestall a final breach, Ileana's father lent Castelli the money to start a gallery, on the Place Vendôme, which was named for its co-director, the fashionable decorator René Drouin. It opened in July 1939, with a show of modern and antique furniture, including commissioned pieces by Max Ernst, Meret Oppenheim, Leonor Fini (a former girlfriend of Castelli's from Trieste), Eugene Berman, and other artists in the force field of Surrealism. The business closed two months later, when war broke out. The closing peeved Ileana, who had been elated by Leo's new vocation. She recalled (ruefully, I hope), "We were so carefree—what did the war matter to us? It was unimportant. What *was* important was what we were doing, which was so much more fun!" They were in Cannes when Paris fell and managed to acquire visas for a departure by ship from Marseilles. By way of Oran, Oujda, and Casablanca, then overland to the north of Spain and with a subsequent docking in Havana, the family reached Ellis Island on March 12, 1941. A few days later, Castelli made his first visit to the Museum of Modern Art. That year saw an auspicious influx of European artists and intellectuals to New York, where they joined a starry cohort that already included Duchamp, Mondrian, and Dalí. Castelli fit right in. He lived with his family in a graceful brownstone that Mihai Schapira had bought: 4 East

Seventy-Seventh Street. Leo and Ileana enrolled at Columbia University, where she studied psychology and he, thinking that he might become a teacher, took up economic history, with a concentration in Renaissance mercantilism. In March 1942 he volunteered for the army. (The promised shortcut to citizenship may have bolstered his courage.) Trained in intelligence for a mission in France that was later aborted, he found himself back in Bucharest, serving as a translator. In May 1945, Sergeant Leo Castelli visited the ruins of Budapest, where his parents, having taken refuge there with his sister Silvia and her Christian husband, had just died—his mother of drowning during a panicked relocation across the Danube and his father of an infected wound.

Returning to New York, Castelli took a managerial position with his father-in-law's new clothing factory, which he performed lackadaisically. He also embarked on what Cohen-Solal calls "the strangest ten years of his life"—1946 to 1956—which happened to be "precisely the same years as the transformation of the New York art scene." Castelli took as gospel Alfred Barr's modernist genealogy—a flow chart of styles from Impressionism to Surrealism and varieties of abstraction—with its open book of illustrative masterpieces at MoMA. (In 1987, he lamented that model's dissolution: "I never thought it would come to this. I've always believed in development, one movement following another. . . . But everything today is very much in flux.") Hoping to ingratiate himself with Barr, in 1946 he donated an Arshile Gorky drawing to the museum. Barr remained aloof, but that didn't daunt Castelli, who revealed a gift for unstinting service to anyone he esteemed. Clement Greenberg introduced Castelli to the emerging American painters, whom he quickly befriended—shifting his loyalty from the surrealists as, later, he jumped to the insurgents of Pop Art and minimalism. He bought works, often on layaway, by Klee, Mondrian, Gorky, Pollock, and other still-inexpensive masters. (His later wealth, such as it was, owed largely to the appreciation of his collection.) His first exercise as a private dealer came through Drouin, in 1947: some hundred canvases by Kandinsky, consigned by his widow, Nina, a gorgon who seems to have driven a previous agent to a nervous breakdown. Castelli had to

cope with creditors and tangled legal claims while seeking exposure and buyers for the work. Mme. Kandinsky hectored him and as much as accused him of dishonesty. Finally, he wrote to her in a tone that, for him, amounted to frothing rage: "I would like to remind you that it was because of me that a considerable number of very important paintings have been sold here in America, and that these sales have cost me a huge amount of work without earning me a dime." He added, "It is not my habit to blow my own horn." (Rudeness always flummoxed him. In the sixties he smoothly handed off boors to his less politic chief assistant, Ivan Karp.) The widow wasn't mollified, but the ordeal gained Castelli valuable contacts and taught him a great deal about the diplomatic challenges and the back-room ins and outs of the upper-tier art trade.

In 1950, Castelli inspired Sidney Janis to mount a showdown between European and American painters, pairing works by de Kooning and Dubuffet, Pollock and André Lanskoy, Rothko and Nicolas de Staël, Franz Kline and Pierre Soulages, and so on. (Poor Europe!) Castelli puzzled the downtown artists, who, he recalled, "figured there must be some financial angle to it. In reality, money played no part in what I was doing. While they didn't know what to make of me, I had tremendous admiration for them." The same year, Leo and Ileana became two of only three non-artists (the other was the much-loved, eccentric dealer Charles Egan) who were founding members of the Club, the legendary discussion group that met three times a week for the next six years. In 1951, Castelli financed—paying a few hundred dollars for rent and publicity—and helped hang the breakout Ninth Street Show, of sixty-one artists, including the cream of the New York School. After the opening, he had the signal pleasure of going to the Cedar Tavern with Alfred Barr, who, previously having resisted the local avant-garde, humbly wrote the artists' names on the backs of photographs of work that Castelli handed him.

For two years, Willem and Elaine de Kooning summered with the Castellis in East Hampton. That friendship soured, first when Ileana proclaimed her preference for the art of Jackson Pollock, and then when Castelli opted not to represent the great Dutchman. (Ileana explained,

"Leo was more interested in what was coming up than in what had already bloomed.") The long, relative eclipse of de Kooning's art-world prestige, until the eighties, may have stemmed from that decision. Castelli altered a situation in which critics and curators had wielded guiding authority. He became, effectively, the scene's predominant critic. What he showed didn't invariably succeed, but what he wouldn't show came to bat with two strikes against it. His winning bets came to seem self-fulfilling prophecies. Cohen-Solal puts it plainly: "Castelli gave the impression of having internalized Orwell's insight that history is written by the winners. And so he determined to write his own part in it, and that of his artists."

Castelli was nearly fifty when he underwent a "lightning metamorphosis from dilettante dandy and financial dependent to master gallerist," Cohen-Solal writes, opening his gallery, in the wake of a snowstorm, on February 3, 1957, in two rooms of the family home: the living room and Nina's bedroom. The show was a dazzling foray in subtle taste, juxtaposing first-rate modern and contemporary works by Europeans and Americans. (At the entrance, a Pollock hung next to a Delaunay.) Castelli's first roster of young artists, mostly second-generation Abstract Expressionists, was undistinguished, except for the irrepressible Robert Rauschenberg. Then Rauschenberg introduced him to Jasper Johns. Castelli's discovery of Johns's Flag, Target, Alphabet, and Numbers paintings, at the artist's loft near Coenties Slip, is an event steeped in mythological significance. The taciturn images, tenderly brushed in fleshy encaustic, announced an American revolution in art. Johns remembered "a lively few minutes," during which Castelli offered him a show. Within days of the opening, in January 1958, Barr had acquired four Johns paintings for MoMA.

The next big find, the following year, was the sensationally dour "pinstripe" black paintings by the twenty-three-year-old Frank Stella. Leo Steinberg recalled that Castelli, distressed to learn that before he could launch the work some of it would appear in a group exhibition at MoMA, dispatched Rauschenberg and Johns to Princeton, where Stella, a recent graduate of the university, was living, to dissuade him from

showing at the museum. (They failed.) Then came Castelli's years of miracles. Starting in 1962, with a show of Lichtenstein's comic-book-panel paintings, the revelatory debuts came in a torrent. Steinberg remembered Ivan Karp remarking, "We should discover a genius! It's been two weeks since we last discovered a genius!" Castelli, to hold on to his artists, paid them regular stipends, on a scale unheard of in America, whether their work sold or not. In 1963, Castelli married a Frenchwoman twenty-one years his junior, Toiny Fraissex du Bost. They had a son, Jean-Christophe, later that year, and she began managing a branch of the business devoted to prints.

Castelli's repeated efforts on behalf of Rauschenberg, in the teeth of stubborn resistance from Barr and some of his successors at MoMA to the artist's extravagant style, are a leitmotif of Cohen-Solal's detailed and savvy account of the dealer's doings in the sixties. His chief coup, which doubled as a somewhat obnoxious triumph for postwar American art in general, occurred at the Venice Biennale of 1964, where Rauschenberg became the first American to win the Grand Prize for Painting. Under the auspices of the United States Information Agency—beefed up during the culture-smitten Kennedy Administration—predominantly outsized works by Rauschenberg and seven other artists, including Johns and Stella, arrived in an Air Force Globemaster C-124. The scale of the effort, extending to an auxiliary show at a palazzo on the Grand Canal, was imperial, if not imperialistic. Cohen-Solal's chapter on the Biennale presents it as a play in eight acts, complete with an extensive dramatis personae. The politicking was intense. Ileana, who represented Rauschenberg in Europe, remarked, "I hate the game of politics that goes on here, but I think if we are going to play it at all, we should play to win." In the end, arrogant French opposition proved more off-putting to the mostly Italian judges than arrogant American ambition. (It may also have mattered that Rauschenberg's art was wonderful.) Castelli's labors for the artist were crowned in 1989, when he was hailed for the munificence of his personal donation to MoMA of Rauschenberg's iconic *Bed* (1955), a paint-slathered quilt, sheet, and pillow. He dedicated the gift to Barr, who had died in 1981.

Castelli was a quick study, obviously, though not an instantaneous one, the Johns epiphany aside. He was wary of Warhol, who frequented the gallery as a collector and craved admittance as an artist. (Rauschenberg and Johns disparaged Warhol, as they had Lichtenstein; a kind of crisis recurred whenever the gallery's artists begrudged a newcomer, activating Castelli's skills as a conciliator.) He was reluctant, too, to take on James Rosenquist, whose billboard-derived montages of commercial imagery struck him as too akin to Surrealism. In both cases, he was swayed by advisers in his network. Castelli's recruitment of Donald Judd, Dan Flavin, and Robert Morris confirmed his sovereignty by conjoining the yin of minimalism to the yang of Pop, in a catholic overview of the new. He even played host, briefly, to exponents of Color Field painting, a mode of abstraction that took its bearings from Greenberg's nostalgic ideals of progressive modernism and aesthetic purity. But Color Field couldn't be squared with Castelli's loyalty to art that gratified the intellect as well as the eye. Another dealer, André Emmerich, absorbed the Greenbergian artists, marking a historic fissure in the avant-garde, which soon fragmented beyond Castelli's power to unite it under his hallmark.

He debuted his last genius early in 1968: Bruce Nauman, who, with Richard Serra and Eva Hesse, established the context-sensitive aesthetics of post-minimalism that still condition new art today. Later that year, Castelli opened a temporary annex, the Castelli Warehouse, on West 108th Street, with a stunningly innovative show, organized by Robert Morris, of environmental sculpture by nine artists, including Nauman, Serra, and Hesse. But Castelli's anxiety to corral the spread of artistic novelties, including the newfangled medium of video, grew frantic. He was stung by an immense exhibition at the Met, *New York Painting and Sculpture, 1940–1970*, organized by the then thirty-four-year-old curator and scene-making gadabout Henry Geldzahler. The spectacular yet soft-headed survey included many of Castelli's artists, but its heavy emphasis on Color Field marginalized his painstakingly discriminated vision. Meanwhile, Castelli mistook a trend in art—Conceptualism— as a movement along classical lines, with leaders and followers. But

Conceptualism proved to be a miscellany of ploys for exalting ideas over objects. His anointed Conceptualists—Joseph Kosuth, Lawrence Weiner, Robert Barry—were faces in a crowd.

In 1971 came the expansion to SoHo, in a five-story building bought with a cooperative of dealers. Castelli took the second floor and the Sonnabend Gallery the third. Ileana outflanked him with a wave of new European artists and outrageous Americans, including Vito Acconci (who, in his performance piece *Seedbed*, hid under a ramp and masturbated while vocally fantasizing, via an amplifier, about the viewers above him). Sales of Johns and Lichtenstein kept Castelli afloat, but, what with production costs for grandiose minimalist and post-minimalist works that sold slowly, if at all, and the never interrupted outlay of stipends, amid a recession, the business was hard put by the time I declined the chance to trigger a Castelligate. Judd left, ending up at the Pace Gallery. Rauschenberg was lured away by the Knoedler Gallery. One after another, gallerists arose, including Mary Boone and Larry Gagosian, who usurped Castelli's primacy even as they voiced tribute to him as a hero. Castelli took it as a "truly poisoned shaft," Cohen-Solal writes, when, behind his back, Arne Glimcher, of Pace, arranged the watershed million-dollar sale of Johns's *Three Flags* from a private collection to the Whitney Museum, in 1980. Joint shows with Boone, of Julian Schnabel, in 1981, and David Salle, in 1982, amounted to strategic capitulations. Castelli's once-mighty business model began to seem almost quaint. For one thing, he rarely worked the secondary market in already owned works, a money machine for Gagosian. Of the top galleries today, only Marian Goodman's hews closely to Castelli's paradigm.

Castelli's prestige began to count against him, with his former partisans in the press "growing weary of the art scene's more-fabulous-than-thou aura," Cohen-Solal observes. His competitiveness waned. He took victory laps. He received the rosette of the French Legion of Honor, apparently in exchange for donating works by Johns to the Pompidou museum, and he visited Trieste four times (with as many female companions), where he was hailed by journalists as the "lord of art" and the

"magnificent Triestine." The mayor made him the honorary director of the Revoltella Museum, where, however, the real director vetoed a show of Castelli's artists, declaring, "No merchants in the temple!" (The polyglot city had not ceased to be a twisty place.) Castelli collapsed in public more than once from a heart ailment that required surgery and a pacemaker. But he strove onward, if not so much in art and business, at least in love. His union with Toiny had inevitably faltered, given his wandering ways, but they remained married until she died, in 1987. Gagosian recalled the dealer's invitation to join him and an artist girlfriend: "Come, let's have a drink with her, and we'll go to her studio and you can tell her you like her paintings." Marriage to the Italian critic Barbara Bertozzi, in 1995, finally slowed him down. She "took away his Hermès appointment book," Castelli's gallery manager, Susan Brundage, said. The SoHo space closed in 1997. But Castelli remained socially active, refulgent with verve. He died at home, at the age of ninety-one, on August 21, 1999.

At a memorial service at MoMA, Jean-Christophe Castelli confessed his jealousy of the art world, for so consuming his father, but added a note of gratitude: "Instead of baseball, my father gave me the Italian Renaissance." It was no flip remark. A friend, Bob Monk, related an astonishing scene after the funeral of Jean-Christophe's mother: "When Leo saw that I had arrived, he lit up, came to me, and said, 'You must see Toiny, you must see Toiny, she is *beautiful*.'. . . They removed the red roses, undid the screws, opened the top, and we looked at Toiny together. 'Doesn't she look *beautiful*?' Leo asked." I can't decide if that story is more touching than macabre, or vice versa. Either way, it feels close to the incomprehensible core of the man, whose grief, no doubt tinged with hysteria, found outlet in aestheticism. Perhaps art was the mode in which he assessed everything and everybody, himself included, as if fitting each passing sensation, personality, and event into an evolving composition.

New Yorker, June 7, 2010

CINDY SHERMAN AT METRO PICTURES

"Art never seems to make me peaceful or pure," Willem de Kooning once said. "I always seem to be wrapped in the melodrama of vulgarity." The remark is subtle, because no one in our culture is more purely an artist than de Kooning. In effect, he warns us not to envy him and cautions against the dilettantish supposition that art is about "the finer things." He could have been speaking of, and for, Cindy Sherman, who after a decade of consistently astonishing photographic art has proved no less "wrapped in the melodrama of vulgarity" and impure, unpeaceful, and heroic.

Sherman's new color photographs of toys and other arranged and lighted studio props, including vomitous-looking substances, are sensationalist beyond anything that can be savored even as bad taste. She has been upping the ante of grotesquery in her art for several years, defying her own reputation as an enchanting woman-of-a-thousand-faces. After hundreds of pictures that enlisted her extraordinary acting talents, she no longer appears in her work, which was always about painful mysteries of identity but often got regarded as light entertainment. She has fixed that. Her nine new works are ferocious.

In the two-panel largest picture, a face that originally belonged to a Styrofoam jack-o'-lantern has glass eyes and a painted tongue and is almost illegibly embedded in an oleaginous, gleaming mass of melted candy. A geek mask in another big work is hauntingly personalized with painted flesh tones, Romantic wisps of blond hair, plastic breasts, and an intruding human hand. Elsewhere, a small toy monster seems to be dissolving in a greenish bath, and an eviscerated teddy bear reveals what (ghastly gunk) it contains.

A series of three pictures employing old-fashioned baby dolls seems intent on debunking the sweetness of early childhood. Slime-covered on wet fur, one doll may just have been born from something you would rather not know. Viewed from the low angle of a doll-audience, a grinning performer-doll exudes menace. Yet another doll, cute destroyer of worlds, sprawls amid shattered electronic gear.

This brings us to a *really* disquieting new photograph. It shows a partially deflated, life-size inflated sex doll loosely held on a sort of rack with metal cables, suggesting bondage, amid piles of party favors. Her silly cartoon face dangles upside-down, smudged with lipstick. A mirror doubles the scene, confirming what is at first hard to make out and then hard to believe: a clothed, living man is going down on her. (Another photograph—an obstetrician's-eye-view of a pregnant nude assembled from doll legs and arms, a witch mask, and artificial breasts and belly, the latter sporting, in lieu of the navel, a pig's snout—had been planned for the show but was left out at the last minute.)

What is all this about? It is not about cinematic genres and fairy tales. Horror movies, *Blue Velvet* noir, and Grimm tales may legitimately come to mind, but they are not of the essence. The essence is pictorial. Except in her earliest "film stills"—one-frame movies, starring herself—Sherman's work has always functioned, aesthetically, more in the here-and-now way of painting than in the there-and-then of photography. At present, it is absolutely painting-like: confronting the viewer with precisely scaled and colored compositions that symbolize consciousness. You don't so much look at as enter into and *live* them, as if they were your idea, for as long as you can bear.

To say that the works are meant to shock seems true but beside the point. Shock is their element, a territory they inhabit. As always with Sherman, they entail questions of identity and even existence—"Who am I?" "What am I?"—posed by images that are receptacles of emotional projection. Her current subjects are broken and degraded, merging personality with insulted bodies, bodies with organic substances, substances with mineral and synthetic stuff, and everything with the yakking flux of bad dreams. And yet she does it all with virtuosic, disciplined, festive artifice, letting us in on her harrowing explorations as a form of play.

Formally, Sherman's pictures are masterfully ordered and gorgeous. This is important. It points to the aesthetic seriousness—a seriousness about play—with which she has laid hold, one after another, of our culture's most potent pictorial tropes, from the presumably high

forms of art photography, Baroque painting, and theater to the presumably low of B movies, fashion advertising, centerfold erotica, fiction illustration, and the party snapshot. No cynical appropriator, Sherman surrenders to each mode. She is like a scientist mixing unstable chemicals in quest of an important invention, undeterred by the experiments' tendency to explode—yielding the grotesque, which is the inevitable aspect of anything human that is studied with sufficiently prolonged and fearless detachment. (Try it with one of your own hands, looking steadily and asking yourself, "What *is* this?" You may scare yourself sick.)

Using an immense range of pictorial lexicons in combination, now, with the prefab fantasies of gross-out paraphernalia, Sherman pushes her scrutiny of the uncanny to the psychological equivalent of higher mathematics. A state of shock, in the result, simply guarantees the honesty of the procedure, guarded against irony.

Frigidly hot, Sherman's work brings together the polar extremes of adventurous art in the past decade: contemplation of collective images by Pictures artists and Neo-Expressionist dramatizing of individual emotion. Both extremes are in art-world decline now, submerged by a wearily sophisticated muddle of hybrid means and uncertain ends, aptly termed by the critic Ronald Jones "hover art."

Sherman's intensity consequently feels unfashionable—much as Willem de Kooning's has since about 1960, when he proved helpless to adjust to cooling sensibilities. But she may very well emerge in eventual retrospect as the single most important American artist of the eighties—even as, "wrapped in the melodrama of vulgarity," she bears witness to a blessing of genius that can be indistinguishable from a curse.

7 Days, April 12, 1989

CINDY SHERMAN AT MoMA

The first sentence of the first wall text in the Cindy Sherman retrospective now at the Museum of Modern Art reads, "Masquerading as a myriad of characters, Cindy Sherman (American, born 1954) invents personas and tableaus that examine the construction of identity, the nature of representation, and the artifice of photography." The images do no such thing, of course. They hang on walls. The pathetic fallacy of attributing conscious actions to artworks is a standard dodge, which strategically de-peoples the pursuit of meaning. Such boilerplate language has trailed Sherman since her emergence, more than thirty years ago, in the "Pictures Generation" of media-savvy artists who tweaked conventions of high art and popular culture, sometimes in tandem with iconoclastic critics. The association made for a rich episode in the history of ideas and a spell of distraction in that of art. The intellectual vogue is long over, though the pedantry lingers, presuming that the mysteries of Sherman's art—photographs that are like one-frame movies, which she directs and acts in—demand explanation. (She is remarkably tolerant of interviewers who keep asking her what she means, as if, like any true artist, she hadn't already answered in the only way possible for her: with the work.) But the mysteries are irreducible. Alive in the experience of viewers who reject being told what to think, they qualify Sherman, to my mind, as the strongest and finest American artist of her time.

The show is theatrical. A hundred and seventy-one pictures hang in exquisitely lit rooms, on differently colored walls. Visitors are greeted by an eighteen-foot-high photomural, from 2010, displaying five monumental, sweetly gauche visions of Sherman, variously bewigged but with minimal makeup, most in historical costumes, set against grainy black-and-white landscapes. There is some juvenilia, including a 1975 film in which Sherman appears as an animated paper doll, but the selection favors recent work, from a series of faux portraits of aging society women in swank surroundings, and is a calculated sequence of visual knockouts. I'm disappointed as a critic, hankering for a denser,

more chronological array—encompassing the more than five hundred works she has made since 1977—to enable a full career analysis. Beyond sharing most artists' reluctance to be thus anatomized, however, Sherman clearly takes her duties as an entertainer seriously. The show is as good as the movies. Picture by picture, we are tripped into feelings that she quickens and manipulates as deftly as a Hitchcock or a Kubrick. To switch mediums, we respond to the mastery of performance and presentation as we might with Baroque paintings.

The seventy pictures from the "Untitled Film Stills" series in the show, though delightful and historically illustrious, are immature art. They were Sherman's first project in New York, when she arrived from Buffalo State College, in 1977. As an art student, she had switched from painting to photography and, encouraged by trends in conceptual art, had resumed a favorite pastime of her Long Island suburban childhood: dressing up. The Film Stills are the body of Sherman's work most congenial to cultural-studies cogitation, owing to their tacit commentary on women's roles in the popular imagination. She enacted actresses acting in films that are recognizable in kind—art-house European, noir, B melodrama—though invented in fact. The waifs, vamps, sex objects, career girls, and housewives add up to a living inventory of hand-me-down feminine enchantments and miseries. But the Film Stills are brittle as art, limited by the same game-playing that makes them such fun. The generic settings are prosaic in contrast to the poetry of the acting.

Sherman remedied that, first with a series of would-be sophisticated young women posed against rear projections of urban locales, and then, in 1981, with a breakthrough show: a dozen two-by-four-foot "centerfold" images of socially assorted females lost in introspective moods. No longer burlesquing film, these works mobilize a forthright range of cinematic potencies. The effects of acting are inseparable from those of framing, set, lighting, makeup, costume, and color. Scripts are implied—blatantly, in the case of a melancholy girl clutching a scrap of newspaper lonely-hearts ads. More ambiguous are young women vulnerably hunched or sprawled in the grip of nameless memories and fears: awakening the worse for wear in a bed with black sheets, or

transfixed by the apparent light of a campfire, or embracing a blanket as a surrogate for someone or something. You can winkle out social commentary, if you like—at the time, many viewers projected rape scenarios—but you will have stopped looking.

Starting in 1982, Sherman countered another distorting response to her work: a popular clamor to discover "the real Cindy," as if she were the latest shtick-wielding show-biz celebrity. First came terrifying pictures of her huddled in a cheap bathrobe, looking out with defenseless, stricken despair. (Here's real for you. Happy now?) Then she brought the grotesquerie latent in all make-believe to noxious flower, effacing or eliminating her presence in scenes carefully contrived to shock. Id-drenched fairy-tale monsters revel in crepuscular depravity—at times with bottles at hand, to explain, as drunken, their hideous glee. Prosthetic body parts perform decidedly anti-erotic sex scenes. One creature delicately fingers her huge, bloody tongue amid tiny toy human figures, likely her nutriment. Slasher-movie tropes of gore and dismemberment passed in review. (In 1997, Sherman made an actual, not very good horror film, *Office Killer*, about a mousy copy editor turned serial killer. An obvious discomfort with directing actors confirmed her customary wisdom in working alone.) Poised between disgust and hilarity, the works in these series are consummate pictorial art, in which Sherman perfected her formal virtuosity. They don't feel like photographs, passively recording slices of reality. They feel like paintings, infused with decision throughout.

It made sense that, once her audience had suffered enough, Sherman plumbed the history of painting with delectable pastiches of Old Masters in antique-looking frames, which were a major hit when shown at Metro Pictures, in 1990. Like the characters in the Film Stills, the period ladies and gents portrayed (with the notable exception of a Fouquet Madonna and a Caravaggio Bacchus) seem instantly familiar but are dreamed up. The deluxe appearance of beauty and splendor, at first glance, disintegrates, upon a second, into the purely ersatz effect of tatty fabrics and obtrusive makeup. The desultory facts cast the viewer as a collaborator in the works' ultimate payoff as superlative art.

Some people find cruelty in Sherman's recent pictures of wealthy dames fighting losing battles with age. They're right. But a kind of cruelty pervades all her art—along with a wafting compassion that falls some degree short of reassuring. Sherman hammers ceaselessly at the delusion that personal identity is anything but a rickety vessel tossed on waves of hormones and neurotransmitters and camouflaged with habits and fashions. She does this by conveying inner states of feeling at odds with outer attitudes. (Only her monsters are exactly what they think they are.) Hapless self-images are the ordinary stuff of comedy, but Sherman pushes them beyond laughter. She makes hard, scary truths sustainable as only great artists can. Her work's significance naturally exercises village explainers of every stripe. But let's leave the future some brainwork to do. What she means will become clear in retrospect. A line from *Hamlet* comes to mind: "in thy orisons be all my sins rememb'red." Sherman assures us that certain of our own offenses—and prayers, too—will outlast the present day.

New Yorker, March 5, 2013

JEFF KOONS: SYMPATHY FOR THE DEVIL

To hear some people talk about Jeff Koons, you would think he is the Devil. But he is really only a subaltern demon: Beelzebub, Satan's minister without portfolio and ambassador at large. Koons attends to details of the Evil One's plan. Satan, who is mutability, schemes a period of meaningless change that will leave no one and nothing what they were before—change in accord with no one's hopes and confirming no one's fears, not even for change's sake. For no sake.

Artists are courtesans of history. (Critics are sex workers of art history.) Artists accept the positions in which history puts them and try to make history come. They are nymphs to history's Zeus. (Satan, Zeus: miscellaneous mythology for a miscellaneous time.) Be the whim of history ever so perverse, artists will deem it brilliant.

When history is stabilized, not fundamentally changing, its wants are conventional. Then what's required of art is predictable and easy to learn, to the point of making rebellions against it dramatic. But when history is changing deeply, thus hiding from consciousness, a principle arises to which I give the name Satan: incessant arousal, always about to come and never coming. No performance can be consummated.

Koons is neither conservative nor avant-garde. He is radically reactionary. Both "conservative" and "avant-garde" mind-sets in art hanker after reigns of Zeus. Conservatives want conventions, nostalgic for the past. Avant-gardists want anti-conventions, nostalgic for the future. Conservatives dream of normalizing art's concubinage, matrimony with history. Avant-gardists maneuver to be favorites in the harem. Both conservatives and avant-gardists desire what cannot be had when Zeus is absent and Satan takes charge. They meet on common ground at last. Both are ridiculous.

By "radically reactionary" I mean that Koons reacts against movement in time—any movement at all, never mind "progress." His political model is feudal: classes bound by ascending ties of fealty and descending ones of noblesse oblige. Consider his series of liquor-advertising posters printed with the actual posters' original screens but in oil dyes

on linen for an amplified jolt, each ad targeted by market research to a particular demographic.

Koons has offered analyses of the liquor ads' class appeals, from realist images of luxury for the lowest classes to luxurious images of nearly total abstraction for the highest. Koons doesn't deplore the ads' covert manipulativeness. He deems the manipulation splendid because not covert at all but generously revealing. It salutes the lower-middle-class, middle-class, upper-middle-class, and rich (leaving out the poor, who have no money) according to their styles of intoxication. Koons wants people to know and enjoy their places in the social order. As a good American, he does approve of upward mobility, but, as a bad American, he identifies it with "stardom." He trades in the allurement of what is the case: how real things really are.

If Koons is not complaining about society, neither is he cynical. Complaint and cynicism are historical attitudes, differently confident that time's march will alter an offending society in ways specific to its offense. Complainers hold out for alteration, hoping to be on history's side. Cynics exploit what they despise, saying, "After us the deluge." Today history's obscurity leaves people no intelligible future either to attract or to repel their passions. Koons projects society's given state as immutable, thus making the mutability of human passions gratuitous: Satan's playground.

Koons is chaste. Relative to history—except when he made a literal exhibition of himself having sex with Ilona Staller—he's a virgin. His relations with Satan are submissive but Platonic. The Devil's goatish reputation is undeserved, anyhow. He is incessant unconsummated arousal—effectively the same thing as impotence. Koons delights in history's withdrawal, not to be obliged to serve history's lust. He is free to serve his own wants, which are sterile. His career is a story of accommodations and affronts to the institutional order of art.

Koons's first mature works were vacuum cleaners encased in Plexiglas. They are monuments to sterility. They are poems, hymns, paeans to sterility and shrines to the primitiveness of bourgeois cleanliness. ("Cleanliness is next to godliness," goes an awful old Protestant saying;

and from that angle, in a certain light, the two are one.) The vacuum-cleaner works are melancholy because, like everything else on a filthy planet, they are imperiled by dirt. They rely on the institutional order of art, including the mechanism of market value, to preserve them.

Similarly, Koons's basketball-suspension tanks require constant maintenance. The proper flotation of the balls (symbols of potency, maintained in impotence) is a sign that someone cares enough to keep adjusting the fluid. The treated water materializes the imaginative, non-world space that beams upward from a sculptural pedestal. (Koons returned the pedestal to contemporary sculpture while retaining the outer-directed dynamics of minimalism, which had short-sightedly banished it.) More generally, the basketball tanks stand for the institutional order's invisible buoying up of so many assumptions and presumptions, so many complacencies.

To this point, Koons had not significantly departed from Marcel Duchamp as a courtesan of history, though frigid. History could look but not touch. That was Duchamp: a sacred dancer in the harem. Only in the middle nineteen-eighties did Koons attain virginity.

With his stainless-steel figurines and drinking paraphernalia, accompanied by liquor and basketball posters, Koons began to abandon the institutional order as a sustaining medium. His art became funerary: immortal because deathly. With stainless steel—"poor people's platinum," he said, a material that simulates the one quality (expensiveness) that most people now associate with art—he anatomized society in terms of its dreams of taste.

Every such dream is an indirect dream of art. It seeks unknowingly to emulate a real person who once really loved a real artwork—the person, occasion, and object gone but for a faint glow that lingers: a folkloric ectoplasm. The most ignorant people respond to it. Sensitive dogs may smell it. The dream of taste—poignant compensation for an existential lack—may lead ordinary folk, as if sleepwalking, to buy kitsch. That is, the things are "kitsch" to educated eyes. But what can education teach of the great lack?

In the middle of the stainless-steel phase came *Rabbit*, the divine bunny reflecting and accepting the world's entirety. This was Koons's first masterpiece. His second is *Puppy*, the forty-foot-high terrier covered with living flowers. By conjoining the animal with high human artifice and merging kitsch with true art, *Rabbit* and *Puppy* activate at a stroke the whole of ahistorical life. *Rabbit* is mutable from without, by promiscuous reflections, and *Puppy* from within, by organic growth. Each is satisfied with and satisfies life as it is—meaning life as it is not, identified with the great lack. Neither seeks to be impregnated by history.

Koons called his 1988 exhibition of ceramic and wood sculptures the Banality Show, which brought the sociological poetry of the stainless-steel pieces to fruition in colorful, big, immaculate objects. It packaged, yes, banality in refined embodiments of class sensibilities. That show made my mind race and my heart sink. I wrote that "Koons symbolizes the apotheosis of corporate culture, the increasingly sacrosanct authority of money, the eroticizing of social status, and other emergent diseases." I was mostly wrong because hysterically fancying that Koons was at one with certain social trends. I didn't yet grasp that he stands against all trends, all movements in time. "Eroticizing of social status" is right, though.

Koons's art is about eroticism without distance: no physical space or interval of time between wanting and having. At no point in the loop of his art does desire emerge and at no point is it consummated. A viewer is free to hold back emotionally from identification and to say, "I do not desire that. That desire is not mine." But a viewer cannot say, "That desire is not real." The craving for love is recognizably very real, an engine of the world. The ceramic and wood sculptures are beyond being fetishes, in this regard, because they are cold and dead. They symbolize the human hunger for love totally, as a force edgeless and endless.

Professional art people keep misunderstanding Koons because expecting to grasp essences of his art that only professionals can understand. There is no such essence. There is a quality, or a set of qualities,

growing from modern-art history and from aesthetics of Duchamp, Pop, and minimalism. But to grasp it is to hold an empty garment. No privilege is gained over the most vulgar or naïve perception. On the contrary.

A connoisseuring eye that correctly detects in *Puppy* a sculptural principle akin to Richard Serra's will miss the piece's richer content, which was not lost, once when I saw it, on children capering around it. Viewers who sneer with derision also have an authentic response. There is stupidity aplenty in the work, carefully provided for the pleasure of stupid people. The only really disfiguring error possible in the face of a Koons is the presumption to a specially qualified comprehension—the vanity of art professionals. (Of course, the Devil adores all presumptions and vanities, which lead humans astray.)

Though rarely, Koons has proved susceptible to overthinking, the misery of the professionals. He succumbed in his inkjet paintings and ceramic and glass sculptures of himself with Staller. Those pieces make too much sense as advertisements of sunny sensuality and have too little integrity as artworks. One could cite Baudelaire: "Fucking is the poetry of the masses." But the wisdom in that is undercut by the factiousness of two biographical entities: arbitrary individuals, exasperating Satan and, by the way, gross.

Koons regained his balance with *Puppy*. He opened a line, proceeding out of the art world into the world at large, that may be tremendously fruitful: public art. Normally either a lie (under tyrannies) or a contradiction in terms (in democracies), true public art seems realizable by Koons as by no other living artist, because he gives the term *public* a weight exactly equal to that of *art*, or even identical with it. There ought to be a Koons sculpture in a park or plaza of every city. The planet would not improve, but it would be more frankly itself.

The Satanic will rule in culture of the near future because something must always rule, and because no political imperative (or none that is constructive) promises to legitimize any power arrangement anytime soon. At such a time, civilization feeds on itself, ulcerously digesting its own contents. The world of meaningless human behavior,

which is Satan's petri dish, is the only world. You are free to mourn and perhaps to resist, and definitely to destroy. But you will have to live out every twenty-four-hour day. To do so with accurate consciousness seems better than to do so blindly. I don't recommend Koons as a hero, but as a person (if *person* is the word) useful to know.

Stedelijk Museum catalogue, 1992

LIGHT

FIREWORKS

It is the Fourth of July weekend as I write, art is elsewhere, and what I like now is to set off fireworks. I'm talking backyard pyrotechnics with the traditional bottom-of-the-line ordnance—cheap little gunpowder devices that blow up, zoom skyward, and/or emit colored fire—that is an everlasting miracle of human invention. Thank you, ancient China, for the firecracker, upon which no improvements are anticipated or desired. Thank you especially for what we term in our vernacular the "bottle rocket," perhaps the world's single most satisfactory manufactured object.

A contemporary bottle rocket ("Air Travel" brand, made in Kwangtung) is a two-inch-long cylinder of paper-wrapped propellant and explosive attached to a splinter-thin, nearly foot-long, red-dyed stick. Stand it upright, ideally in a beer bottle, and ignite. *Fsss. Swish*, trailing sparks and smoke. A hundred or so feet up, a flash followed by a crisp bang. Then, if it's daylight (who can wait for night?), you see the bare red stick drift innocently down.

I know that fireworks can injure people, but so can a lot of benignly intended things in an accident-prone world. I know they are illegal in New York State, but I assume that law-enforcers are embarrassed to deny us time-honored simple pleasures. Out of respect for the enforcers' feelings, I ignore the law.

Acquiring firecrackers has led me at length, two years in a row, to smiling Chinese women in Chinatown doorways—smiling, perhaps, because I am no kind of haggler. But even at sucker rates, bottle rockets should come to little more than a nickel a pop. You can get more potent items, too, and I do: rockets that scream, rockets that make

semiprofessional-type fire flowers in the air, all manner of blazing gizmos that jump and spin, and fireball-spitting (*thup thup thup*) Roman candles. The trouble with the more expensive things is that you get too precious about expending them, making sure that everyone is looking and so on. The optimum spirit of banging away is lost.

I leave out the giant firecrackers like cherry bombs and M-80s ("silver tubes" whose waterproof fuses, when I was a kid, made for low-effort, high-yield fishing in the town creek). Their specifications approach the military's. Fireworks should be only dangerous enough to encourage presence of mind.

Light a firecracker and, quick, toss it. *Bang.* A feathery burst of shredded paper. Repeat until sated. You will like to explode a few whole packs. *Bangbbbangbbang bang.* But that's excessive—unless you could go all the way with it as they do on Bayard Street, in Chinatown, at the Chinese New Year: dozens or scores of people on fire escapes throwing masses of crackers as fast as they can light them to feed a continuous roar, guaranteeing a year of good luck. After a day like that, it looks as if a red blizzard blew through. In this city, Bayard Street knee-deep in drifts of fluffy red paper is an annual spectacle as beautiful as Christmas lights on Park Avenue.

Some will say that I would feel different if I had to live near Bayard Street. Some will be right. I do my exploding at an isolated rural place upstate in cahoots with my small daughter and nephew. (To avoid feeling like an idiot, it is useful to pretend that your fireworks are for the entertainment of children. If you lack kids, borrow one.) To the city-bound who suffer the din, I extend a sympathy that they may find unallaying.

Some, who are never wrong, will say further that my joy in fireworks is regressive. You bet it is—and none too soon after dreary months of approximating grown-upness. With fireworks, I discover old, inchoate excitements probably pertaining to a boy's dim anticipations of sex—an idea supported by Alfred Hitchcock, eternal sniggering brat, when he mocked the coupling of Cary Grant and Grace Kelly in *To Catch a Thief* with cutaways to airbursts over Monte Carlo.

Do-it-yourself fireworks satisfy a limited appetite for the pyromaniacal. (Once a year is plenty for me.) The craving is exacerbated, I find, by the academic splendors of professional displays, which deliver the vicarious arousal and intrinsic bleakness of watching somebody else's fun. There are people out there shooting stuff off. I want to be one of them.

The alienating beauty of the professional spectacle impresses without moving. It can make you feel dead inside. Emotion is added in dollops of sentimentality by references to the ceremonial occasion. You may fall for this, as when, a few years ago, a centennial celebration of the Brooklyn Bridge was capped by having that adorable structure spew fire into the East River night. It's a matter of what symbols your heart will buy into.

No such thematic necessity burdens Fourth of July bottle-rocketing, which is bang for bang's sake. Patriotism? Well, sure. It's a likable country that maintains such a tradition, when you think of it—but you needn't. The point is not to congratulate America but to go ahead and be an American in the classic mold: free, a bit obnoxious, and up for a good time.

Village Voice, May 26, 1992

FELIX GONZÁLEZ-TORRES

Felix González-Torres gently shakes the tree of art-world eminence, at the Guggenheim, and the prize falls into his lap. He is now everybody's favorite installation artist. Just try to resist the sibylline Cuban. You will hate how Grinch-like you feel. Then he will have you, too.

Born in 1957 and living in the United States since 1979, González-Torres has been an active but elusive collaborator in the theoretical-political wing of the avant-garde since the early eighties. For years he was a leading member of the art-and-politics collective Group Material. Somewhere among my unsorted possessions are sheets from previous shows of the "inexhaustible" print editions that he stacks for the taking. And over the years I must have consumed a dollar's worth or so of the wrapped candies that he presents in continually replenished, take-one piles. I long deemed his art lightweight though provocatively puzzling.

Now I get it.

Showing at a major museum, González-Torres is a major artist. Just like that. His way is to seep like dye into the fabric of whatever community, institution, or venue he interacts with, no more or less august than wherever he appears. He used to imbue marginal situations and was accordingly minor. Invading and pervading the big time, he becomes inseparable from it. To be a González-Torres fan is now to have a hero in high places.

The works in this show, which I can't decide whether to call blatantly subtle or subtly blatant, include giveaway offset prints ranging from a blank blue sheet titled *Untitled (Loverboy)* through gnomic phrases of a political cast to moody photographs of sea and sky, and offerings of cellophane-wrapped candy including a seductively glossy one of black licorice and a lyrically pretty one, like a grassy hillock, of green sweets.

There are jigsaw-puzzle reproductions of family snapshots, love letters, and sinister news photos; two abutted electric clocks telling the identical time (*Perfect Lovers*); a dreamy curtain of white, silvery, and transparent beads; printed poems that list historical and personal

events in dropped-out white type on shiny black grounds; and poignant photographs of an empty, trampled beach. Of special note are the artist's recent strings of low-wattage lightbulbs in porcelain sockets. He instructs collectors to arrange them in any way they like. Here, one is draped swag-fashion and another is heaped on the floor.

I have decided not to say what social issues González-Torres's work is about—or is supposed to be about, according to ham-handed prose in the show's catalogue and wall texts. So delicate is the pitch of González-Torres's communication that curatorial intrusions grate more than usual. Why do artists put up with it? Only artists and zoo animals, that I can think of, regularly suffer the indignity of being bracketed with officious verbiage in on-site labels. Both should bite their keepers.

But to bite wouldn't suit González-Torres. The charm of his work flows insinuatingly through and around any discursive rigidities or arch attitudes, engaging viewers on a basis of shared pleasures. To be nonchalantly wised up, rather than indoctrinated, seems his profit from two decades of "critique," which too commonly employs arrogant intellect to insult ordinary intelligence.

Consider a typically overbearing sentence from the catalogue: "By exposing religion, philosophy, psychology, and other legitimizing 'narratives' of Western thought as ideological constructs designed to maintain the hegemony and presumed superiority of Western civilization, Postmodernism challenged the very legitimacy of cultural authority." Now compare the tone of that with the effect of works by González-Torres in the Guggenheim's second-floor, two-story gallery.

Light strings dangle in a row from the ceiling. Along the top of the walls runs a jumbled time line suggestive of a particular life in a world where public and private passions intermingle, and memory is a constantly reshuffled deck of culture, politics, work, and love. The references range from "Poland 1939" through "Barbie Doll 1960" and "Year of losses 1966" to "Hunger for life 1995."

With his bulbs, González-Torres is the first artist since Dan Flavin and Bruce Nauman to realize a new and cogent content in luminous sculpture: a witty evocation of "bright ideas" that both creates

and occupies an atmosphere that drenches the eye and the mind with tender sentience. They make the lofty room a sort of low-key chapel, in which it is lovely to linger with whatever feelings and thoughts present themselves. González-Torres plainly assumes that the viewer is an individual with tastes, memories, and problems of his or her own. With silky modesty, he indicates troubles that he has with our society and culture. Again, I won't say what they are. I'll let him tell you.

Exiting the museum with a roll of prints under my arm and, in my pocket, a licorice, a Bazooka bubble gum, and something in a shiny blue wrapper, I wondered if I had accepted bribes. Well, yeah. But isn't any art show a proffered, though immaterial, bait? González-Torres's material subornation implicates all parties. The owners of the print and candy piles finance the handouts. The museum sets up the meet.

Let's go to live action. As I write this sentence, I am sucking on the hard candy that I just took from the blue wrapper. It's an OK-tasting "grape" whatsit probably containing lots of chemicals. I am also, as I write, mentally savoring, turning over on my mind's tongue, the flavor of González-Torres's sensibility, which will last longer. (It already has; the candy's gone.) But aren't all sensibilities synthetic and laced with additives? González-Torres's emanates worldly knowledge in a vein of no-big-deal sophistication, available to anyone with time for it. You may feel your mind and heart open wide in response, as mine do.

New Yorker, March 21, 1999

PIERO DELLA FRANCESCA

The supreme early-Renaissance master Piero della Francesca is like no other artist in my experience: not better, exactly, but loftily apart, defying comparison. Seven paintings—all but one of his works that are currently held in American collections, plus a loan from Portugal—are on display at the Frick Collection, in the first show dedicated to works by Piero in this country. A Madonna enthroned, with angels; a small Crucifixion scene; and five individual saints glorify the Frick's Oval Room. The Madonna, seen in an ornate interior with Corinthian columns, gazes down at a rose—a symbol of the Crucifixion—that she holds and which a naked baby Jesus reaches for. One angel looks out at us and gestures toward the child's open hands. All the faces, while individualized, are impassive; they are not quite expressionless but preternaturally calm. The figures are rounded and sculptural. The oil colors—reds, blues, browns, whites, grays—glow in a soft, raking light. The picture has a magnetic dignity, typical of Piero. He makes a viewer's spirit sit up straight. The work is only three and a half feet high, but it feels monumental and, at the same time, intimate, as if it were addressing you alone. It's a kind of art that may change lives.

One hot August, when I was twenty-three, I traversed Tuscany on the back of a Vespa driven by a painter friend, George Schneeman. We had seen Piero's magnum opus, the *Legend of the True Cross* frescoes, in Arezzo, which I found bewildering, and were headed northeast, to the artist's home town of Sansepolcro, the site of his famous *Resurrection of Christ* ("the best picture in the world," according to Aldous Huxley), which I also failed to make much of. Then we stopped at a tiny cemetery chapel, in the hill town of Monterchi, to see Piero's highly unusual *Madonna del Parto*. An immensely pregnant but delicately elegant young Mary stands pensively in a bell-shaped tent, as two mirror-image angels sweep aside the flaps to reveal her. One angel wears green, the other purple. Here was the circumstantial drama of a ripeness with life in a place of death. George told me a sentimental, almost certainly untrue story that the work memorialized a secret mistress of Piero's

who had died in childbirth. This befitted the picture's held-breath tenderness and its air of sharing a deeply felt, urgent mystery. In another age, the experience might have made me consider entering a monastery. Instead, I became an art critic.

Piero has visited some such epiphanies on a lot of people since his rediscovery, around the turn of the twentieth century, after a long period of obscurity that was due, in part, to the fact that much of his work had been lost, and because a lot of what remained was to be found in largely untouristed towns. American collectors were smitten, including Isabella Stewart Gardner; Robert Sterling Clark, who bequeathed the *Virgin and Child Enthroned with Four Angels*, the Madonna in the Frick's show, to the Sterling and Francine Clark Institute, in Williamstown, Massachusetts; and Henry Clay Frick's daughter Helen, who acquired three of the museum's four Pieros. If money could have pried more than seven Piero works out of Europe, it would have. (Incautiously avid Americans fell for at least four forgeries that we know of.) Outside Tuscany, most of Piero's work resides in the National Gallery in Urbino, London's National Gallery, and the Louvre.

The great Renaissance expert Bernard Berenson explained the sudden, virtual cult appeal of the artist in terms of an emerging modern taste for "the ineloquent in art," by which he meant a turn away from dramatic illustration toward the aesthetics of conceptual design and candid technique. Berenson cited Impressionism and, especially, the phlegmatic, intellectually bracing method of Cézanne as spurs to the new appreciation of Piero. That's apposite. His style also resonates in the marmoreal figures of Picasso's neoclassical period; and his way of seeming to capture something fundamental, once and for all, reminds me of abstract paintings by Piet Mondrian. Looking at Piero's work may impart a sense of being steadied and elevated. You might even forget momentarily that you were ever less noble, or that any other art has held more than a passing interest for you.

Piero was born in Borgo San Sepolcro, as it was then called, circa 1412, and died there in 1492. In between, he traveled widely in Italy, executing commissions for rulers and prelates. His father was a tradesman;

his mother came from an aristocratic family. He trained locally. (An early reference has him painting decorations on candlesticks for religious processions.) By 1439, he was in Florence, listed as a collaborator on frescoes, now lost, by Domenico Veneziano. Piero's inspirations as a young painter included a thriving late-Gothic genre of polychrome wooden sculpture—as may be seen in the medieval hall at the Metropolitan Museum and at the Cloisters—and the scientific painting theories of the Genoese polymath Leon Battista Alberti. Alberti advised using shades of color, according to their "reception of light," to give shape to figures, though when his theories were strictly applied, as by Veneziano, they led to a static, decorative effect. (I take this analysis from a great little book, *The Piero della Francesca Trail*, by the late art historian John Pope-Hennessy; it includes Huxley's essay, from 1925, "The Best Picture.") Piero, who wrote his own treatises on mathematics and perspective, leavened Alberti with an apparent inspiration from Masaccio's slightly earlier depiction of figures in breathing space, with an appearance of air around them. "Luminous and rational," the art historian Machtelt Israëls, writing in the show's catalogue, finely terms Piero's style, which remained consistent throughout his career. It projects both a formal rigor, like that of geometry theorems, and a religious devotion so serene that it seems only natural.

Piero was strikingly original in his emphasis on physical weight. His figures stand plunk on the ground. The bare feet of the Frick's own *St. John the Evangelist* (1454–69) hug a marble floor. He has gathered up his red cloak, across his body, to help support the massive book that he is reading. You feel the downward drag. The effect is a bodily identification: the saint and you, both strenuously upright on earth. Piero's characters are sometimes described as remote, without personality. But he simply combs out anything incidental to being a human creature, in solid flesh. I am reminded of the title of Simone Weil's profound collection of spiritual reflections, *Gravity and Grace*. The central Christian enigma—God incarnate, as a man who lived, suffered, and died—plays like a bass line beneath every passage of Piero's art.

The show's Crucifixion scene and the five saints—John, Augustine, Monica, Apollonia, and, perhaps, Leonard (his identity is uncertain)—all belonged to an otherwise lost, grand altarpiece in Borgo San Sepolcro. A photographic montage, on one wall, documents how they may have been arrayed. In the view of Calvary, a crowd of people and horses around the Cross looks random at first glance but, upon scrutiny, reveals an exquisitely worked-out pictorial structure of vertical, horizontal, and diagonal alignments. The smallest saint panels—Monica with a scroll, Apollonia presenting a tooth, held with tongs, in token of a martyrdom that involved her teeth being yanked out or broken—are stark and almost perfunctory but intense. They are building blocks of piety. The large St. Augustine, from Lisbon, which is new to me, is among the most glamorous of all Pieros. The church father stands grasping a red book and a crystal staff in bejeweled white gloves. His cope is lined with pictures narrating the life of Christ, from the Annunciation to the Crucifixion, with its later, miraculous episodes concealed in a fold of the cloth. Augustine's face is grim—he looks burdened by responsibility and by knowledge of things past and to come. His mood strikes a balance of austere seriousness with the temporal splendor of the ecclesiastical costume.

Certainly, Piero was devout, but in a manner that, as Berenson noticed, segues easily into a modern, secular reverence for art. The art historian Nathaniel Silver, who organized the show, tells in the catalogue of how the artist embraced the local legend of Borgo San Sepolcro: two pilgrims returning from Jerusalem with shards from the Holy Sepulchre awoke in a walnut wood to see the relics perched high in a tree and, thereupon, founded the city on that spot. (The Borghese of Piero's time deemed their town the New Jerusalem.) Piero left bequests to religious confraternities in the region that maintained holy relics and cult images—representations of saints and the like that served as insignia of the orders and as objects of worship themselves. But there is no forcing of dogma in his art, which points toward the thoroughly urbane religiosity of his younger contemporary Giovanni Bellini, in

Venice, whose Madonnas are as personal as young women you might know. A civilized spiritual poise marks that moment of transition to the Renaissance, which, through Botticelli to Leonardo, gave way to worldly mystiques of artistic genius, with Christian sentiments becoming merely conventional. Piero's achievement stands for an aspiration that has no sect or date: getting something—anything—of ultimate, universal importance exactly right.

New Yorker, March 4, 2013

GIOVANNI BELLINI

While you're looking at Giovanni Bellini's big oil on wood *St. Francis in the Desert* (circa 1475–78), in the Frick Collection, it seems to satisfy every personal use you've ever had for art. Wanting any other work would betray gluttony. Now the museum has organized a little show around research into this most perfect of pictures. There's not much to discover. X-rays of the scene, in which the saint stands transfixed in a multitudinous landscape, find a completely worked-out drawing, across which Bellini applied the skin of paint as deftly as if he were pulling a blind. The jewel-like precision rivals that of contemporaneous Flemish oils but is suffused with Italian tenderness. The painting stuns with its conception of physical and spiritual vision as one and the same. We are seduced by naturalistic and poetic details—that personable donkey, unforgettably—while being set back on our heels by the crystalline style. Like the humility of St. Francis, the work makes you want to be worthy of it. Change your life.

New Yorker, July 11/18, 2011

AGNES MARTIN

The abstract painter Agnes Martin died in 2004, at the age of ninety-two, and a new retrospective at the Guggenheim Museum affirms that the greatness of her work has only grown in the years since. That's something of a surprise: no setting would seem less congenial to the strict angles of Martin's paintings than the curves of Frank Lloyd Wright's creamy seashell. I also worried that the work's repetitive formulas—grids and stripes, mostly gray or palely colored, often six feet square—would add aesthetic fatigue to the mild toll of a hike up the ramp. But the show's challenges to contemplation and stamina turn out to intensify a deep, and deepening, sense of the artist's singular powers. The climb becomes a sort of secular pilgrimage, on which you may feel your perceptual ability to register minute differences of tone and texture steadily refined, and your heart ambushed by rushes of emotion.

Each canvas, as selected and installed by the curators, Tiffany Bell and Tracey Bashkoff, evinces a particular character. Drawings and "On a Clear Day" (1974), a remarkable suite of silk-screened grids and lines in inks that uncannily mimic graphite, provide rhythmic relief. The cumulative effect is that of intellectual and emotional repletion, concerning a woman who synthesized the essences of two world-changing movements—Abstract Expressionism and minimalism—and who, from a tortured life, beset by schizophrenia, managed to derive a philosophy, amounting almost to a gospel, of happiness. There is nothing cuddly about Martin. (You will know the feeling of one close acquaintance to whom she said, "I have no friends, and you're one of them.") But there is joy.

The show starts with a late climax: "The Islands I-XII" (1979), a dozen paintings in acrylic that at first glance appear almost identically all-white but which deploy differently proportioned horizontal bands and penciled lines. Admixtures of light, almost subliminal blue cool some of the bands. The design stops just short of the sides of the canvas. When you notice this, the fields of paint seem to jiggle loose, and to hover. If you look long enough—the minute or so that Martin

deemed sufficient for her works—your sensation-starved optic nerve may produce fugitive impressions of other colors. (At one point, I saw green, and then I didn't.) It helps to shade your eyes. This causes tones to darken and textures to register more strongly. Looking at Martin's art is something of an art in itself. Motivated by continual, ineffable rewards, you become an adept.

"The Islands" crowned the second act of Martin's career. The first peaked in the mid-nineteen-sixties, when she was living in New York, with the public success of the grid pictures—typically, uniform rect-angles penciled or incised on painted square canvases. She had begun making them in 1958, at the age of forty-six, after a long apprenticeship in modern art. In 1967, she stopped working and left the city, heading out in a pickup truck for a year and a half of solitary wandering and then the building of an adobe house for herself near Santa Fe. It was several years before she resumed painting.

Martin was at no pains to explain the interregnum, beyond remark-ing with satisfaction, in a letter to a friend at the time, "Now I do not owe anything or have to do anything." (She added, "Do not think that that is sad. It is not sad. Even sadness is not sad.") In recent years, she had been hospitalized for spells of psychosis, tending toward catatonia, and was plagued by doomy thoughts. ("I have tried existing, and I do not like it," she wrote.) Stardom in the art world imposed pressures that she seemed to find intolerable. But her flight, even from her own creativity, remains a mystery—comparable to Arthur Rimbaud's abandonment of poetry for adventuring in Africa.

As detailed in a crisp and penetrating recent biography, *Agnes Martin: Her Life and Art*, by Nancy Princenthal, the artist's hard exis-tence began, in 1912, in a small town on the plains of Saskatchewan, as the third of four children of Scottish Presbyterian parents. Her father, who farmed wheat, died two years later. Her mother, Margaret, was, by Martin's account, harsh and unloving. (Martin seldom spoke of her past, and what she told wasn't always to be trusted.) Margaret eventually moved the family to Vancouver, where, in high school, Martin excelled at swimming; she just missed qualifying for the Canadian Olympic

team for the 1936 Games in Berlin. She reportedly attended the University of Southern California on a swimming scholarship but dropped out and taught in elementary schools for a couple of years before completing a degree at the Teachers College of Columbia University in 1942.

Then, at the age of thirty, Martin found a vocation in painting. She made figurative work, while working odd jobs in New York, and went to study art at the University of New Mexico in 1946. Five years later, she returned to Columbia to earn a master's degree in fine-arts education. During that time, she absorbed principles of Taoist and Zen philosophy that would thenceforth guide her thinking, or, more accurately, her refusals of thought, even as she developed sternly logical solutions to the problems of painting. (Never religious, she was the most matter-of-fact of mystics.) Exposed to the high noon of Abstract Expressionism in the city, she destroyed most of her early works and gravitated to abstraction.

Martin was back in New Mexico when, in 1957, the august New York dealer Betty Parsons saw her work—which at that point ran to abstracted landscapes incorporating jagged shapes reminiscent of Clyfford Still—and offered her a show, on the condition that she move back to the city. Martin took a loft, which had electricity but no running water and little heat, downtown on Coenties Slip, the most justly fabled address of budding artistic revolutionaries since the Bateau-Lavoir of Picasso, Juan Gris, and their associates. Her neighbors included Robert Rauschenberg, Jasper Johns, Ellsworth Kelly, and James Rosenquist—most of them gay (she was a lesbian) and determined to counter the histrionic paint-mongering that was then in vogue. Her works from that seedbed period tell a gripping tale of borrowed stylistic ideas—redolent of Arshile Gorky, Mark Rothko, Barnett Newman, and other Abstract Expressionists, and of Johns and Kelly—which she didn't so much follow as test, one by one, and expunge. Amid the time's crossfiring models of aesthetic and rhetorical innovation, she struggled less forward than inward. She wanted, passionately, to be alone.

Martin had, from the start, an extraordinary sensitivity to subtleties of light and touch. When she hit, at last, on the format of the

grid—a motif that was tacit in modern painting after Cubism but never before stripped, and kept, so bare—she found ways to make those qualities the exclusive basis of a wholly original, full-bodied art. She insisted that the results did not exclude nature but analogized it. She said, "It's really about the feeling of beauty and freedom that you experience in landscape." (Apropos of the slightly varied forms in some series of her paintings, she recalled studying clouds in the sky: "I paid close attention for a month to see if they ever repeated. They don't repeat.") The effect of Martin's art is not an exercise in overarching style but a mode of moment-to-moment being.

The relation of Martin's mental illness to her art seems twofold, combining a need for concealment and for control—the grid as a screen and as a shield—with an urge to distill positive content from the oceanic states of mind that she couldn't help experiencing. She knew herself profoundly, because she had to. In a marvelous 1973 essay, "On the Perfection Underlying Life," she coolly contemplates the "panic of complete helplessness," which "drives us to fantastic extremes." But the problem produces its own answer. She concluded that "helplessness when fear and dread have run their course, as all passions do, is the most rewarding state of all."

New Yorker, October 17, 2016

VERMEER

A useful myth of aesthetic experience took shape when, in *À la Recherche du Temps Perdu*, the ailing writer Bergotte weighed the value of his life against that of a "little patch of yellow wall, with a sloping roof," in Johannes Vermeer's *View of Delft* (circa 1660–61), and then, with a fleeting thought that undercooked potatoes at lunch were causing him indigestion, fell dead of a heart attack. The "little patch" had filled Bergotte with remorse for his "too dry" writing style, which had not risked such gorgeous emphases. Anyone who pays open-hearted attention to very good art (dying is optional) may have had similar feelings. Beauty of the sort that Proust dramatizes is a wordless sermon, urging our betterment. As usual with Proust, the passage—written after he had left his own sickroom in Paris, in 1921, to attend a show of Dutch art that included *View of Delft*—suspends profundity and triviality in a sort of vapor, which we breathe as we read. It happens to be wrong. There is no yellow wall under a sloping roof in Vermeer's cityscape. (There is a yellow sloping roof.) Scholars have earnestly debated what Bergotte saw, failing to consider that, like most of the rest of us, Proust had a lousy memory.

Vermeer's Masterpiece: The Milkmaid, at the Metropolitan Museum, centers on the eponymous painting (1657–58), from the Rijksmuseum, in Amsterdam, and includes the museum's own five Vermeers and related works from the Dutch Golden Age. *View of Delft* isn't present, remaining, like *Girl with a Pearl Earring*, at the Mauritshuis, in The Hague. *Delft* doesn't do a lot for me, anyway. It is so bizarrely special—a fairyland city persuasively identical to a real city—that I have mainly gawked at it, lacking whatever Bergottean itch it scratches. But a little patch of lapis-lazuli-tinted white, describing backlit linen in the head scarf of the Met's *Young Woman with a Water Pitcher*, would have killed me a long time ago, if paint could. The young woman is a serene bourgeoise at her morning toilette, easing open a leaded gate window. The entering sunlight sustains all manner of adventures, throughout the

picture, but the detail of the head scarf has affected me like a Pentacostal secret, whispered to me alone. I revel each time I see it—having misremembered it, of course, since the last time, helpless to retain the nuance of the color and the velleity of the painter's touch.

Young Woman with a Water Pitcher is a Sermon on the Mount of aesthetic value, in which the meek—or, at least, the humdrum, in a prosperous but typical household on an ordinary day—inherit the earth. Beholding it, I feel that my usual ways of looking dishonor the world. At the same time, I know that my emotion is manipulated by deliberate artifice. An artist has lured me out of myself into an illusion of reality more thrilling than any lived reality can be.

That work is one of the dozen or so home runs among Vermeer's thirty-six authenticated paintings. (Three in the Met's collection fall short: the age-muddied *Woman with a Lute*, the goofily winsome *Study of a Young Woman*, and the jaw-droppingly weird *Allegory of the Catholic Faith*.) Maintaining the level of his best works must have tormented Vermeer, demanding a labor-intensiveness hardly convenient for a father of eleven. Most of his Dutch peers averaged fifty or so pictures a year; Vermeer clocked in with two or three—although they sold at the top of the market. When luxury commerce collapsed in the Netherlands, after the French invasion of 1672, Vermeer appears to have stopped painting. He died three years later, at the age of forty-three, perhaps of a stroke.

The Milkmaid—a diminutive picture, just eighteen inches high by about sixteen wide—is another of the elect, though it's a mite less absorbing, for me, than the more mature *Young Woman with a Water Pitcher*. Like *Delft*, *The Milkmaid* exercises more dazzling virtuosity than I know what to do with. Sensational colors, in particular, strain the scene of a husky young servant pouring milk, in a careful dribble, from an earthenware pitcher into an earthenware bowl on an odd-shaped table laden with a wicker basket, a loaf and fragments of crusty bread, and a stoneware beer jug. (She may be making bread pudding.) She wears a white linen cap, a yellow woolen jacket with green work sleeves,

a red skirt, and an apron of a stunningly sumptuous blue. The hues jump out from the painting's miraculous rendering of soft sunlight from a bleared window with a small broken pane that reveals the full brightness of the day. The light spills in a static wave of modulated tones across the dilapidated walls of an apparently dank room; the odd stain or nail hole in a wall can grab your eye and not let it go. A boxy foot warmer on the floor calls attention to small baseboard ceramic tiles, one of which, with a blue cartoon of Cupid, may drop a hint.

In a catalogue essay, the Met's curator of European paintings, Walter Liedtke, makes much of the work's possible erotic content, from a time, in the Netherlands, marked by a "reputation of kitchen maids and especially milkmaids for sexual availability." Liedtke presses the point by augmenting the show with blatant works, including a big painting by Peter Wtewael, *Kitchen Scene*, from the sixteen-twenties, in which the gestures of a jolly maid and a smirky lad are laugh-out-loud lewd. The museum's haunting *Maid Asleep*, by Vermeer, supports the theme, mildly. A girl drowses at a table, stocked with wine and beer, next to an open door. (X-rays show that Vermeer painted a man in that space and then painted him out.) Liedtke argues that the common viewer of the time would have registered a tease. I wonder. We have come a long way, lately, from a once de-rigueur prudery among art historians. We may go too far in the opposite direction. The sturdy dignity of the milkmaid forfends prurience. The majesty of her presentation would stand me off, reverently, even if she were naked.

Vermeer was about twenty-five when he painted *The Milkmaid*. That's hard to deal with. What so advanced him, so early? I hazard that it was the locomotive logic of a simple stylistic idea: to recast conventional genre painting in the terms of a perceptual realism as thoroughgoing as the medium allowed. The conviction of reality extends from subtleties of light to significations of character. Loyalty to his technique drew from the artist an approximation of wisdom probably far beyond his personal capacity, as a young man. It's not unknown for klutzes in life, if sufficiently disciplined, to become angels in their work. Liedtke

nails the effect: "Something well worn in Dutch art (like an old shoe) has become something never seen before (like a glass slipper)." That's beauty in action, of the kind that Proust memorialized: not a transport to an exalted realm but an abrupt crystallization of where, with full alertness, we may already be.

New Yorker, September 21, 2009

PETER HUJAR

Peter Hujar, who died of AIDS-related pneumonia in 1987, at the age of fifty-three, was among the greatest of all American photographers and has had, by far, the most confusing reputation. A dazzling retrospective, curated by Joel Smith at the Morgan Library & Museum, of a hundred and sixty-four pictures affirms Hujar's excellence while, if anything, complicating his history. The works range across the genres of portraiture, nudes, cityscape, and still life—the stillest of all from the catacombs of Palermo, Italy, shot in 1963, when he was there with his lover at the time, the artist Paul Thek. The finest are portraits, not only of people. Some memorialize the existences of cows, sheep, and—one of my favorites—a goose with an eagerly confiding mien. The quality of Hujar's hand-done prints, tending to sumptuous blacks and simmering grays, transfixes. He was a darkroom master, maintaining technical standards for which he got scant credit except among certain cognoscenti. He never hatched a signature look to rival those of more celebrated elders who influenced him, such as Richard Avedon and Diane Arbus, or those of Robert Mapplethorpe and Nan Goldin, younger peers who learned from him. His pictures share, in place of a style, an unfailing rigor that can only be experienced, not described.

Hujar's celebrity was, is, and always will be associated with a downtown bohemia that flourished in New York between the late nineteen-sixties and the onset of the AIDS plague. Tall and handsome, volatile, epically promiscuous, and chronically broke, he had a starry constellation of close friends, including Andy Warhol and Susan Sontag. Portrait sitters—male, female, and very often ambiguous—came and went at his cheap-rent loft above the Eden Theatre (once the Yiddish Folks Theatre and now a multiplex), at Twelfth Street and Second Avenue. He lived the bohemian dream of becoming legendary rather than the bourgeois one of being rich and conventionally famous. But he craved more, hungering to have his art recognized while repeatedly forestalling the event with bristly pride. (His friend the writer Fran Lebowitz remarked at his funeral, "Peter Hujar has hung up on every

important photography dealer in the Western world.") His personal glamour consorts so awkwardly with his artistic discipline that trying to keep both in mind at once can hurt your brain. But the conundrum defines Hujar's significance at a historic crossroads of high art and low life in the late twentieth century.

That period left no image more memorable and subtly—sneakily, even—profound than Hujar's of the transgender performer and Warhol's Factory regular Candy Darling, made in 1973, in the hospital bed where she was dying of lymphoma. An inky-black background sets off blazing-white sheets under a banal fluorescent-light fixture. Flowers, including a rose ostentatiously placed beside Darling like a small partner, lend a frail elegance. But the picture forfends mourning. Head sideways on a pillow and arms vampishly raised, she gazes with exaggerated calm from heavily mascara-shadowed eyes: a death mask, in effect, but one that she selected for the occasion. (Hujar later wrote, of the session, that Darling was "playing every death scene from every movie.") Thudding frankness fuses with exultant fantasy. The effect epitomizes the practical intimacy with which Hujar, typically through hours of shooting with a twin-lens reflex camera (discreetly looking down to view the subject), got beyond what people look like to what—from the depths of themselves, facing out toward the world—they are, conveying, at once, their armor and their vulnerability. But they couldn't be just anybody. "I like people who dare," he said.

Hujar needed no introduction to the low. He never met his father, who abandoned his mother, a diner waitress, before his birth, in 1934, in Trenton. She left his raising to her Ukrainian-speaking Polish parents in semirural surroundings in Ewing Township, New Jersey, until, when he was eleven, she took him to live with her and a new husband in a one-room apartment in Manhattan. The home wasn't happy. Hujar moved out at sixteen, at first sleeping on the couch of a mentoring English teacher at the School of Industrial Arts (now the High School of Art and Design): the fine poet, editor, and translator Daisy Aldan, a free-spirited lesbian who is portrayed in the earliest of his works in the Morgan show, from 1955. Aldan advised him to seek jobs, however

menial, with professional photographers in Manhattan. This set his course for the next fifteen years, as he worked for artists of no special distinction while pursuing his own art and leading an intense social and sex life. In 1967, his brilliance in a master class with Avedon and Marvin Israel led to assignments from *Harper's Bazaar, GQ,* and other publications. In 1969, he made his one and only political work, for the Gay Liberation Front: a staged scene of ebullient marchers. But commissioned work repelled him, and he began to shun it for a career of shoestring independence.

Without a story that is conveyable in a sentence, you can't be famous in America. Hujar bitterly resented the pearly, opulent "art look" of the style that made a star of Mapplethorpe; and he had to watch from the sidelines as his friend Goldin achieved renown with the narrative power of the pictures that became her chronicle of maverick love and squalor, *The Ballad of Sexual Dependency,* an evolving slide show that appeared as a book in 1986. Those two generated legends and got to be rich and popular, too. In his life, Hujar had few substantial solo shows, attracting little press notice, and only one book, *Portraits in Life and Death* (1976), which unwisely juxtaposed two splendid series: portraits of people in his circle, half of them reclining, and shots of ancient corpses in the Palermo catacombs. "Why not? That's life," he joked of the distracting conceit to an interviewer, Henry Post, who supportively observed, "in any case, all the people in the book are supposed to be from the underground." Sontag opted for solemnity, hazarding in a preface that photography "converts the whole world into a cemetery." (No, it doesn't.) The book went over poorly even with some of Hujar's fans. His one curatorial coup on his own behalf, aided by a performance artist named Sur Rodney (Sur), was a show at Gracie Mansion Gallery, in 1986, of seventy pictures of identical size densely hung in two frieze-like rows with an eye to abrupt differences in subject and form. At the Morgan, the forty shots in a version of the staccato ensemble perfectly represent Hujar's total investment of himself in one-off images. Each photograph shoulders aside its neighbors and stops you dead: a glittering nocturnal view of a West Side high-rise above a soulfully trusting

Italian donkey, a naked young man and an expanse of unquiet Hudson River waters, William S. Burroughs being typically saturnine and a young man placidly sucking on his own big toe, a suavely pensive older man and a pair of high heels found amid trash in Newark, a dead seagull on a beach and a Hujar self-portrait. The works have in common less a visual vocabulary than a uniform intensity and practically a smell, as of smoldering electrical wires. Hujar's is an art that disdains the pursuit of happiness in favor of episodic, hard joys.

A friend of Hujar's, Steve Turtell, has recalled the photographer saying, "When people talk about me, I want them to be whispering." The writer and literary intellectual Stephen Koch, to whom Hujar willed his estate, said in a 2013 interview, "One of the keys to his personality, I later figured out, was that anyone who had been an abused child was automatically on Peter's A list." Hermetic appeal and an identification with psychic damage came together in Hujar's last important relationship, with the meteoric younger artist David Wojnarowicz, who was a ravaged hustler when they met at a bar in late 1980 and who died from AIDS in 1992. They were lovers briefly, then buddies and soul mates. Wojnarowicz said that Hujar "was like the parent I never had, like the brother I never had." In return, he inspired fresh energies in Hujar's life and late work. In a breathtakingly intimate portrait of Wojnarowicz with a cigarette and tired eyes, from 1981, the young man's gaze meets that of the camera, with slightly wary—but willing and plainly reciprocated—devotion: love, in a way. Their story could make for a good novel or movie—as it well may, in sketched outline in your mind, while you navigate this aesthetically fierce, historically informative, strangely tender show.

New Yorker, February 5, 2018

HENRI CARTIER-BRESSON

Henri Cartier-Bresson (1908–2004) was a taker of great photographs. Some three hundred of them make for an almost unendurably majestic retrospective at the Museum of Modern Art, from his famous portly puddle-jumper of 1932 (*Behind the Gare Saint-Lazare, Paris*) to views of Native Americans in Gallup, New Mexico, in 1971, one of his last visual essays as the globe-trotting heavyweight champion of photojournalism. (Thereafter, he mostly rested his cameras and devoted himself to drawing—sensitively though not terribly well—in the vein of his friend Alberto Giacometti.) Nearly every picture displays the classical panache—the fullness, the economy—of a painting by Poussin. Any half dozen of them would have engraved their author's name in history. Resistance to the work is futile, if quality is our criterion, but inevitable, I think, on other grounds.

Cartier-Bresson has the weakness of his strength: an Apollonian elevation that subjugates life to an order of things already known, if never so well seen. He said that the essence of his art was "the simultaneous recognition, in a fraction of a second, of the significance of an event, as well as the precise organization of forms which give that event its proper expression." Too often, the "significance" feels platitudinous, even as its expression dazzles. Robert Frank, whose book *The Americans* (1958) treated subjects akin to many in the older photographer's work, put it harshly but justly: "He traveled all over the goddamned world, and you never felt that he was moved by something that was happening other than the beauty of it, or just the composition." The problem of Cartier-Bresson's art is the conjunction of aesthetic classicism and journalistic protocol: timeless truth and breaking news. He rendered a world that satisfies the eye and the mind while numbing the heart.

Cartier-Bresson was the eldest of five children; his mother was a cotton merchant's daughter and his father a farmer's son who became a wealthy thread manufacturer. He had "a nearly feminine beauty,"

Peter Galassi writes in the show's catalogue, "marked by fine features, blue eyes, blonde [sic] hair, and rosy cheeks." Headstrong, he declined to follow in his father's footsteps. After a lavishly cultivated childhood, Cartier-Bresson left the august Lycée Condorcet when he was eighteen, determined to paint. He was encouraged by Proust's friend the society portraitist Jacques-Émile Blanche and studied under the post-Cubist artist and rigorous pedagogue André Lhote, whose emphasis on the rules of classical composition proved a lasting influence. He hobnobbed with surrealists, frequented brothels, embraced Communism. Blanche wrote an affectionate burlesque of the young man who had "the air of a girl in pajamas" and preached social revolution "at the Splendide, before a very cold magnum of champagne." (He also introduced him to Gertrude Stein, who, Galassi writes, "looked at his paintings and advised him he would do better to join the family business.") In 1929, Cartier-Bresson began his year of compulsory military service with, he said, a rifle in one hand and Joyce's *Ulysses* in the other.

In 1931, he fled an unhappy love affair with a woman in Paris to Africa, where he roamed for a year and began taking pictures. (His lover had been a photography enthusiast.) Recuperating in Marseilles from a nearly lethal case of blackwater fever, he acquired a Leica and gave himself over to camera work in a surrealist spirit, alert for odd events on city streets. He said he suddenly realized "that photography could reach eternity through the moment." The short form of that insight is the English title of his best-known book, *The Decisive Moment* (1952). (In French, it is *Images à la Sauvette*—roughly, "images on the fly," with an implication of rascality.)

A regular at hunting parties during his youth—besides playing a servant in his friend Jean Renoir's *The Rules of the Game*, Cartier-Bresson served as the offscreen gunman for the film's massacre of rabbits—he now applied a hunter's instincts to his art. He blackened the shiny parts of his diminutive camera to keep it inconspicuous, as—"feeling very strung-up and ready to pounce," he said—he stalked

epiphanies in Paris, London, Madrid, and Mexico City, among other places, in the nineteen-thirties. But form determines content in even the most spontaneous of his street shots. Let one tour de force stand for many: *Valencia, Spain* (1933), which finds a boy in a strangely balletic pose against a battered wall, his eyes mysteriously raised (following the flight of a ball, which we don't see). The subject piques and charms, but what makes the picture great is the gorgeousness of the wall, with its weary testimony to times past.

The hallmark of Cartier-Bresson's genius is less in what he photographed than in where he placed himself to photograph it, incorporating peculiarly eloquent backgrounds and surroundings. His shutter click climaxes an artful scurry for the perfect point of view. This made him a natural for photojournalism, whose subjects, their "significance" prejudged, unfold unpredictably in space and time. In 1934, he met the photographer David Szymin, known as Chim, who introduced him to a Hungarian colleague, Endre Friedmann. Friedmann, who soon changed his name to Robert Capa, urged Cartier-Bresson away from fine art and into the booming field of news photography. "Keep Surrealism in your little heart, my dear," he recalled Capa advising him. "Don't fidget. Get moving!" In 1937, Cartier-Bresson joined the staff of *Ce Soir*, a Communist daily, and covered the coronation of King George VI—turning his lens away from the pomp to the attending crowds. He was still a loyal fellow-traveler as late as 1959, when *Life* published his fawning shots of workers, peasants, students, and soldiers gladly engaged in Mao's Great Leap Forward. His eye was singular, but his attitudes were standard issue. His road-tour typifyings of Americans reek of condescension. (Robert Frank countered that view of us.)

Having joined the French Army in 1939, Cartier-Bresson was captured by the Germans in 1940 and spent three years in prison camps, finally escaping on his third try. While an evidently unhounded fugitive, he traveled in France, taking portraits of Camus, Matisse, Bonnard, and other notables. (His portrait work is magnificent to a fault,

marmoreally elegant. No one smiles—except Capa, at a racetrack in 1953, infectiously gloating over betting slips held like a hand of cards.)

In 1945, he made a film for the United States Office of War Information, *The Return*, about the repatriation of liberated prisoners and displaced persons in Europe. That project yielded his dramatic shot of a female collaborator being denounced—and hit, though it's not quite apparent—by a woman she betrayed, as an interrogator calmly takes notes. Work brought Cartier-Bresson to New York, where, in 1947, he became a cofounder of the Magnum agency, with Chim and Capa. He then quickened the always brisk pace of his travels, popping up in China for the Communist Revolution and in India for the end of the Raj. (In a secretly funny coup, he caught a starchy Lord Mountbatten, the last viceroy, as his wife shared a laugh with Jawaharlal Nehru, with whom she was rumored to be having an affair.) Mural-size maps of the world introduce the MoMA show, with colored lines tracing the photographer's dizzyingly numerous peregrinations, including jaunts to Russia, Mongolia, Indonesia, the Middle East, and Japan. This suggests a novel measurement of artistic worth: mileage. It seems relevant only to the glamour quotient—a cult, practically—of Cartier-Bresson's persona, pointing up what seems to me most resistible in his work.

He developed little, in any sense. His exposed film went to labs; juxtaposed prints of the boy in Valencia, toned softly in the early thirties and sharply in the late sixties, evince changing fashions in commercial printing. Opulent blacks and whites suggest a house style of the Cartier-Bresson Foundation, in Paris, which provided most of the prints in the show. In creative approach, Cartier-Bresson indeed carried Surrealism in his heart, playing specific appearances against general ideas, as in crowd shots that discover spiky personalities amid collective passions. His strongest works, for me, are precisely those which take playfulness, or leisure, as their subject, from his canonical shot of workers picnicking by a pond, in 1938, to bikinied Club Med lunchers on Corsica, in 1969. An aesthete and a sensualist, Cartier-Bresson is authoritative, and even profound, in all matters and manners of pleasure. The

consummate ease of such work resonates with his attractively reticent remark that photography is "a marvelous profession while it remains a modest one." But that self-immunizing stance palls on the occasions of historic tumult and human suffering that presented Cartier-Bresson with, always and only, chances to achieve beautiful and yet more beautiful pictures.

New Yorker, April 19, 2010

HELEN LEVITT

There used to be a world that was the real world. Everyone was in it, though some were more in it, or with it, than others. Helen Levitt photographed it. She took a camera into poor neighborhoods, where reality was understood to be most real. She made amazing pictures, starting when she acquired a Leica in 1936 and hitting an artistic peak in the early forties. She collaborated with James Agee, a prose poet of the old real world, and her friend Janice Loeb on a silent documentary film, *In the Street*, that shows small children living in East Harlem like small animals in a forest.

In the Street, only fifteen minutes long, made me ache. Its wide-awake, laconic takes are like great still images come to life. Levitt is among the best of all street photographers and perhaps the single strongest, for the intensity of her flavors both empirical and emotional. Her work stuns the mind while breaking the heart in two and then in four and finally to pieces.

Levitt sought revelations—humans becoming mythic in moments of transport or trouble—that occur fleetingly in the course of things, usually glimpsed from the corner of the eye when seen at all. She was cunning. She would use an angled viewfinder to fool her subjects into believing that she was photographing something other than them. Her pictures need no analysis if you are familiar with them, and they beggar description if you aren't. They are so simple in impact while, in form and nuance, so subtle.

The work can appear generic to an overeducated contemporary glance. The word *sentimental* offers itself as it commonly does, today, at any hint of unembarrassed feeling. As if we're not sentimental! (We prove it possible to be sentimentally cynical and sentimentally cruel.) In the thirties, when the Brooklyn-born Levitt was a follower and friend of Henri Cartier-Bresson and Walker Evans, she joined a creative insurrection against euphemism. Her street photography embodied a reality principle that, new then, is exotic now.

The old real world is gone not because there is less reality, of which we have the normal, total complement, or because poor kids no longer play on stoops. The loss registers in Agee's way of speaking, in his preface to the film: "The streets of the poor quarters of great cities are, after all, a theater and a battleground. There, unaware and unnoticed, every human being is a poet, a masker, a warrior, a dancer; and in his innocent artistry he projects, against the turmoil of the streets, an image of human existence."

Nobody hip would be caught dead with so universalizing a tone today. It is the voice of liberal will. The old real world was liberal. It ran on a hope for human redemption that has proven too general—with Ronald Reagan, with multiculturalism—to overcome political exigencies. Viewers of a 1997 redo of *In the Street* would shift uneasily, awaiting the point. We see filthy urchins behave, by turns, enchantingly and badly. Where's the critique?

Levitt and Agee presaged the American generation that produced Abstract Expressionism, bebop, and the Beats. They put faith in transformative powers of art. The beautiful probably, and the sublime certainly, couldn't help but change the world. They found a key to human possibility in the sprung rhythms, savage and balletic, of kids roughhousing in rubbled lots: deep-down suchness of all souls. It's not that we no longer believe in suchness and souls. It's that we won't authorize anyone to profess the beliefs on our behalf. Just to use the word *we* is a provocation, for which I'm not in a mood to apologize right now.

The show puts me in mind of a great and singularly neglected aesthetic theorist, the late dance critic Edwin Denby, who in the forties and fifties explicated the ballet revolution of George Balanchine. Denby's principle of ceaseless attention—conveyed in the title of his book *Dancers, Buildings, and People in the Street*—gives me a way into Levitt's work that renews its freshness. Denby thought that art organizes the epiphanies—the sparks leaping between the in-here of ourselves and the out-there of something else, which could be anything—that occur in sentient lives every day. Epitomizing that spirit, Levitt set herself a

standard of found theatricality so extravagant that we might doubt its validity. But look hard. It's true—truth in action—and incredibly brave, with a fearlessness that, for reasons to be wondered at, seems beyond the ability of anyone today.

Village Voice, June 24, 1997

THOMAS STRUTH

Toward the end of the nineteen-seventies I saw somewhere a black-and-white photograph of Greene Street, in SoHo. It was a view straight down several blocks, with a parked car or two under the off-white pie slice of an overcast sky. The focus was sharp throughout, etching even tiny details and making for a surfeit of impartial information. I was fascinated by patterns of heaved cobblestones and broken sidewalks. I remember the sullen charm, in the picture, of cast-iron buildings, whose familiar architectural prose-poetry seemed more pungent for the fact of their marginality, like side-walls of a stage, to a scene that centered on nothing.

I also recall being rankled—made defensive, I suspect, in my pride at being hip to going pictorial styles—by the photograph's sensibility, which was strange to me. It seemed naïvely "realist" in one way and self-consciously "formalist" in another way, each with a maddening lack of emphasis. Was this something to take seriously, to learn about? I didn't want to think so. I may have reflected that no one imbued with properly New Yorkish aesthetics (succinct, smart, punchy) would be caught looking at our city in so wide-eyed a manner.

If I thought that, I was right. The photograph was one of a series done in 1978 by a twenty-four-year-old West German visitor on a scholarship from Düsseldorf. But my judgment was dead wrong, blinkered by a parochialism then still barely possible for an untraveled New York art person. I would travel presently, when the sophistication of new European, especially German, art redrew the art-world map. But it took me a decade to catch up on the author of the street scene.

He is Thomas Struth, one of a generation of photographers whose work is the latest strength of a German art culture that seems to have no end of aces up its sleeve. He is showing new black-and-white cityscapes, taken in the former East Germany; large color family portraits; and huge Cibachromes of peopled museum interiors in a group show of German photographers at the downtown Guggenheim. The show excludes "straight" photographers except Struth and the portraitist

of bland young Germans at billboard scale, Thomas Ruff. (Glaringly absent is Candida Höfer.)

Struth studied with Bernd and Hilla Becher, the arch "typologists" whose deadpan, dead-on black-and-whites of old industrial structures are icons of photographic minimalism. His urban shots apply Becheresque formulas of static, unpopulated (surely early-morning), shadowless views with a feel for the "typical" or "average" aspect of a subject. (As if in compensation, Struth's astonishing family portraits burn with human presence: each sitter vulnerably alone within an aura of shared intimacy. His museum pictures are wittily theatrical apostrophes of the "art-space" situations in which they are displayed. They are also beautiful.) Struth's work has taught me to appreciate, in retrospect, the fecundity of the Bechers, who helped form the aesthetic and ethical alphabet with which their former student composes poetry.

Struth's East German streets have common features. Most of their buildings are pre-Second World War—a condition rare in cities to the west, which took the brunt of Allied bombing and have been subject to insipid restoration. The eastern sites are preserved by their neglect, apparent as slow-motion ruin in the foregrounds of the pictures and an ineffably soiled, sad quality farther away. As with most of Struth's cityscapes, there is a disorienting compound of absolute specificity of place and seeming arbitrariness in point of view. It is as if we were walking with a companion who abruptly stopped at a spot with nothing obviously special about it, facing ostensibly nothing much. Following his gaze, we slowly register that we are seeing, for lack of a better word, *everything*.

We see a space of passage formed by structures eloquent with history, culture, time, chance, and vernacular use. The deep-spaced structure of the picture inserts us into the scene, then lets us be. We must hatch our own explanations of what we are doing there, as we go to work on the information given. A conviction of meaningfulness, like a pressure in the brain, grows. It is not a matter of anything normally interesting. The place is merely real. At the same time, it seems a rebus urgent to be read, as if it secreted evidence of a crime. We do not feel

necessarily that the photographer knew the secret. He is not toying with us. It is rather as if he had a Geiger counter for meaning, whose meter happened to buzz at this location.

Did some miserable modern apartment blocks appeal to Struth because located in Weimar, where the Bauhaus fostered the architectural language here debased? Maybe, but discursive connections are swamped by a visual congeries of desultory patterns—molded-aluminum facade, beetle-browed balconies, sidewalk tiles, cobblestones, cars parked in tidy rows—that speak of "order" and "design" as rampant as jungle growth. It is a kind of shock to see so completely, with such fierce clarity, what people who live in the buildings take for granted, though it enters into the warp and woof of their being.

I may overrate Struth somewhat because so starved, by psycho-politico-babbling trends in recent American art, for honest attempts at objectivity. But why worry? It is wonderful to be reminded that the human organism features eyes in a head that contains a brain. It is wonderful to feel one's capacity for disciplined looking being pushed to maximum efficiency and even beyond it, into a vertigo or paranoia of contemplation. Of course, other people's photographs do this as well. Maybe every photograph does it a bit. But count on a German to go to extremes. Walking in the city the other day, I was remembering the image of Greene Street that once baffled me, and suddenly I was seeing every street according to its omniverous, unprejudiced, hypersensitive model. I gawked, but not like a tourist. It was Struth out everywhere.

Village Voice, March 2, 1993

MOTHER LOVE (WHISTLER)

A couple of weeks ago, I visited two mothers in Massachusetts. One was my own, Charlene, who lives in a retirement home in Lenox. The other was the black-clad lady portrayed in *Whistler's Mother*—the popular name of the masterpiece that James Abbott McNeill Whistler painted in 1871 and titled *Arrangement in Grey and Black, No. 1*. Anna Matilda McNeill Whistler, who lived with her son, in London, from 1864 to 1875, sits in profile with an air of infinite patience, gazing steadily at, apparently, nothing. The work is on loan to the Clark Art Institute, in Williamstown, from the Musée d'Orsay, in Paris. In 1891, it became the first American artwork ever bought by the French state, and it remains the most important American work residing outside the United States.

The painting represents the peak of Whistler's radical method of modulating tones of single colors. The paint looks soft, almost fuzzy— as if it were exhaled onto the surface. There is some bravura brushwork, where Anna's lace-cuffed hands clutch a handkerchief, with unprimed canvas peeking through, and daubed hints of Japanese-style floral patterning on a curtain that commands the left side of the picture. A few of the daubs faintly echo the pink of Anna's flesh. She wears a gold wedding ring: a spark of harmony with the muted gilding of the frame that Whistler designed for the picture. Practically subliminal whispers of reds and blues underlie areas of the silver-gray wall behind her, and a dark purple smolders in the curtain, where the artist's signature emblem—a butterfly—hovers.

The chromatic subtleties contribute to an unsettled feeling. A more substantial jolt occurs when you register an overall spatial distortion: the forms stretch horizontally, so that the length of Anna's concealed legs, angled and descending to an upholstered footstool, suggests the anatomy of an NBA draft pick. The more you notice of the composition's economies—such as the cavalier indication of the bentwood chair legs, at the lower right, and, at the lower left, three perfunctory diagonal strokes that do for establishing the plane of the floor—the more happily manipulated you may feel, in ways that, like the camera tricks of

a great movie director, excite a sense of the scene as truer to life than truth itself. It took me an hour of inspection to take in an inconspicuous, brownish strip across the bottom of the canvas. Anna's dress falls smoothly past it and out of the picture. It is the edge of a stage or a platform. Whistler is looking up at his mom.

"Yes, one does like to make one's mummy just as nice as possible," Whistler allowed years later, answering friends who praised the speaking likeness of the portrayal. But he was exasperated by sentimental responses to the work. He regularly preached that subject matter should be regarded merely as a pretext for adventures in aestheticism. He said, "To me it is interesting as a picture of my mother; but what can or ought the public to care about the identity of the portrait?" Was he kidding? (He was sly.) Of course we care, if not to the extent of a civic group in Ashland, Pennsylvania, which in 1938 erected a monumental statue of the seated Anna, on a base inscribed with words from Coleridge: "A mother is the holiest thing alive." At any rate, the answer to Whistler's question touches on what many have noted is iconic about history's short list of artistic icons. The *Mona Lisa*, *The Scream*, *American Gothic*, and the best of Andy Warhol's "Marilyn"s all share with the Whistler the distillation of a meaning instantly recognized and forever inexhaustible. In this case, it's the mysteries of motherhood. Everybody has a mother, and something close to half of everybody becomes one.

I'm the oldest of Charlene's five kids with our late father, Gilmore, an inventor and entrepreneur. When I walked into her building, she was at the piano accompanying a sing-along that concluded with a briskly rendered "Yellow Rose of Texas." Charlene is ninety-eight, but her memory is sharp, and I had hoped that it would yield associations with Whistler's portrait. Her father was a postmaster in a North Dakota prairie town. Could she recall the 1934 stamp that reproduced the image with the words "In Memory and in Honor of the Mothers of America"? No, she said, "It was a fourth-class post office, the smallest. I don't think we got the fancy commemoratives." She was never much for art, she reminded me. But, having thought about the painting, she

e-mailed me later that it put her in mind of her own mother, who "was born in 1875 and continued to wear rather long dresses and never cut her hair. Her opinions were a reflection of the Victorian age." Charlene was amused to learn that, when the portrait was made, Anna Whistler was sixty-seven: "So young!"

Anna, born in Wilmington, North Carolina, was a daughter of the antebellum South; she was the niece of a slave owner, and, through him, the cousin of a reported nine mixed-race children. She married George Washington Whistler, a West Point graduate and a brilliant civil engineer, and they had five sons, only two of whom, James and William, survived to adulthood. She was described by a sister-in-law as "so *unshakeable* that sometimes I could shake her." Beginning in 1842, the family spent six years in St. Petersburg, Russia, where George served Tsar Nicholas I as the chief engineer of a rail line to Moscow, and the artistically precocious James, at age eleven, enrolled in the Imperial Academy of Fine Arts. In 1849, George died, after a bout of cholera, and the family returned to America.

James followed his father's example and his own military fantasies by entering West Point. But he proved a feckless cadet—the superintendent, Robert E. Lee, liked but despaired of him—and he flunked out in his third year. He evinced no better discipline in government jobs as a geographical draftsman. Then, in 1855, Whistler went to Paris and launched himself as an artist, a dandy, and a lover of women. He knew Courbet, Baudelaire, Manet, Monet, and Degas, and closely befriended Henri Fantin-Latour. Whistler's first touchstone painting, *Symphony in White, No. 1: The White Girl* (1862), was a sensation in the epoch-making 1863 Salon des Refusés (though it was eclipsed by Manet's *Le Déjeuner sur l'Herbe*). He was never less than esteemed in France, notably by poets and writers. (The young Proust kept as a talisman a pair of gray gloves that Whistler had worn.) It seems a pity that he took his act to London, by stages beginning in 1859, and refined his genius in the pokier precincts of British art, meanwhile lavishing rather too much of it on flamboyant combats of wit, artistic doctrine, and personal grudge

with artists, critics, and patrons who, Oscar Wilde excepted, were little worth the candle. (At first a devoted fan, Wilde came to complain that Whistler spelled art "with a capital I.")

Polarizing opinion in the London art world, Whistler pioneered the modern trope of the artist as scandalous celebrity. But he tempered his raffish ways with stratagems of genteel respectability, which his mother's presence supported. When Anna moved in with him—her other son, William, was serving as a doctor in the Confederate Army—the artist moved his current mistress out to other quarters. He wrote to Fantin-Latour, "I had to empty my house and purify it from cellar to eaves." The religiously pious Anna sighed at what she viewed as her son's flaws, but she graciously hosted his friends and became positively fond of one of them, the decadent's decadent, Algernon Swinburne.

Whistler's painting of his mother overcame fierce resistance to appear in the annual exhibition of the Royal Academy of Arts, in 1872. It is unique among his portraits. Every other teases out a nuance of personality in the sitter—the works are often seductive but never conventionally so in the way of portraits by his follower John Singer Sargent. In *Whistler's Mother*, Anna's blank forbearance speaks of capitulation. She will do anything for him. She is his. Such exclusive devotion is the primal dream of every mother's son, isn't it?

New Yorker, August 31, 2015

KAREN KILIMNIK

The dopey-looking little paintings in this show at 303 Gallery bemuse and move me in ways that I have learned to expect from Karen Kilimnik, the late-blooming problem child of contemporary art. They also impress me as signs, among others lately seen, of a sneakily strong trend in painting generally. That they would seem, at first and even second glance, to be lackadaisical contributes to a rough magic that could use a name: Kilimnikesque.

Kilimnik, forty, has been on the scene barely four years, winning fame with delicately demented scatter-art installations hinting at the meltdown of Western civilization in the imagination of a museum-haunted, fanzine-besotted, CNN-bombarded, waifish American teen. Her fierce charm is deemed delightfully faux naïve by observers who, it seems to me, miss the truth that Kilimnik really is naïve, self-abandoned to ingenuous obsessions not always comfortably distinguishable from derangement.

The Kilimnikesque is a quality of innocence not just steeped in fantasies of celebrity and suchlike vicarious exaltations—a common enough state of pubescent Americans—but steeped for a very long time, becoming rich and strange. It is a capacity to fall wholeheartedly for even the tackiest manipulations of mass-mediated glamour. Kilimnik adores supermodels and Calvin Klein, albeit with an undercurrent of jealousy. She also fancies late-eighteenth-century English painters, who, among other things, were the Calvin Kleins of their day.

A Jewish girl who until three years ago still lived in her parents' house in Philadelphia, she can suggest a cross between *A Tree Grows in Brooklyn* and the Sandra Bernhard character in *The King of Comedy*— except that, like the Robert De Niro character in the same movie, Kilimnik actually delivers the goods when given her chance onstage. Through immersion in kitsch culture, she has somehow intuited the authenticity that all kitsch dimly remembers, reinventing the wheel of sure-enough art. The Kilimnikesque is a difference that art makes.

Her new paintings are indifferently skilled oils. They are neither good nor bad as paintings because they invoke no model more specific than that of painting itself as a craft activity. They make an essentially anonymous stylistic impression that becomes more absorbing the longer you stay with it, because it works both calmly to distance and frictionlessly to convey particular content. This effect reminds me of Joseph Cornell, another artist of generic formality and regressive ardors.

Kilimnik renders figures of her omnivorous affection—actresses, models, Old Masters, pets—in circumstances of witchy or criminal menace. In *Tabitha*, the little-girl character of the old TV series *Bewitched*, all grown up, gloats over freshly killed small animals. *The Great Hamptons Fire*, its smoke rising against a blue sky, appears to have been ignited by a malign mood of model Amber Valetta's. *Strangler's View* copies a young woman in the outdoors from a Gainsborough painting. She is seen from the neck down—the p.o.v. of a crouched stalker. *Mother and Child* depicts a seriously crazed dog and its unwisely trusting pup. A young Diane Lane is an angel of paranoia in *Witchcraft*, simpering in a manner that the background interprets as lightning and a tornado. The depressed *Bavarian Princess* adjusts the sleeves of her chic gown beneath a deer-head chandelier.

You positively cannot look at these pictures in a disinterested way. Well, I suppose you could stroke your beard and psychoanalyze the artist, if you don't mind being the dreary sort who does that. The paintings' extremes of abjection and rapture admit no middle take, between rejection and absorption, but only a toggling switch, a click in consciousness, to and fro from one extreme to the other.

A fine late-twentieth-century sport is watching painting rebound from periodic spells of being dead again. The medium's most recent demise was notably grim: petrification, whereby we came to believe that any painting is an objective relic, an artifact, of painting. From Gerhard Richter through David Salle to Peter Halley and beyond, artists elegized painting's long goodbye. The medium got set in quotation marks. Then

the quotation marks got set in quotation marks. Younger artists decided to hell with it and went photographic or installational.

Today some established installation-makers, like Kilimnik, seem to be discovering that all along they really wanted to paint and that, painting being rid enough of its former prestige, at last they can. They proceed with expertise only in what it is like to be them. The signal painting of our moment is small, scraggly, tentative, and, by default of any discernible style, sincere. Its sharpest creator is the Belgian Luc Tuymans, who makes sketchy pictures of remembered banalities—pictures of memory itself, somehow—with a European-ish philosophical resonance. Kilimnik counters with what Americans are often good at: presenting a self like a blank slate to be scrawled on in big block letters by the world.

By embodying a specific individual vulnerable to collective forces, Kilimnikesque painting makes an onerous demand on artists: that they be interesting people. That's tough in a culture where art schools discount personality on principle. It so happens that, after college, Kilimnik was turned down by every art school she applied to. Her successful development in ragamuffin isolation proves that we want, from art now, most especially what can least be taught.

Village Voice, December 19, 1995

DAVID HOCKNEY

Starting when he arrived from England at age twenty-six, in 1963, David Hockney has had lovely effects on American culture. He is a redemptive popularizer of things that some people didn't think they could or were supposed to like, from decorative painting and academic drawing to homosexuality, Los Angeles, and opera. He has done it with elfin insouciance, a fierce work ethic, and good manners. Though with a mildly naughty streak, he is the Platonic houseguest, flattering his hosts with wit and tact equal to the challenges of modern art, naked boys, "*Rosenkavalier,*" and other likely underminers of aplomb.

The unavoidable word to spring the transition that I will now make is *alas*. Alas, Hockney is his own worst—and really only—enemy, driven by an urge to regret, somehow, the very nimbleness from which his blessings flow. With the rankling yen for respect that sometimes afflicts lovable people, he keeps trying to impress with talents suited strictly to please.

Hockney's recent output is leaden with pointlessly tricky pastiches of Cubism, seemingly to suggest an aesthetic deep thinker advancing art's frontiers. This from someone with a flair that anyone else, deep thinkers very much included, would trade an arm or a leg for. His best work still is the cornucopia of swimming pools, still lifes, interiors, and portraits that he painted, drew, and printed, in Los Angeles and London, between 1964 and 1972. Realist, for all their extremes of stylization, those pictures are about joys of absorption in pleasant people, places, and things.

Hockney's showers and pools let us know how wonderful it is to have bodies that can get wet. His fond and quizzical pictures of Henry Geldzahler and other friends call for a term akin to but milder than love poems: like poems, maybe. Throughout, delight in beauty and in having skills to render it make for a contented and seemly, sociable eroticism—a visceral niceness, if that's conceivable.

In 1973, Hockney moved to Paris for a couple of years and suddenly went arty. It has been touch and go, in terms of his work's quotient of

satisfaction, ever since. He took it into his head that Western pictorial conventions needed revamping (after a century of modernist tinkering, a rash proposition) and that he was the one to do it (given his temperament, absurd). With plodding literal-mindedness, he began picturing subjects in reverse perspective, from multiple viewpoints, and so on: reinventing wheels, answering questions no one had asked, chewing more than he bit off.

At best, as in some photo-collages, the results are fun to puzzle out. At worst, in mural-sized treks through houses and landscapes, they are tedious. The one genre that rarely fails Hockney is drawn or painted portraiture. The presence of a congenial face distracts him from baleful urges to overturn conventions. A wit like Hockney *needs* conventions in the way outlaws, as opposed to revolutionaries, need laws. His 1979 portrait of the late Divine is a knockout not on account of its borrowings from Matisse, but for how Divine's funny imperiousness, so winningly observed, holds all merely aesthetic considerations at bay.

7 *Days*, May 11, 1988

FRANS HALS

I'd cross the street to avoid meeting most of the people Frans Hals painted. They impress me as bores of one caliber or another: oafish, supercilious, run-of-the-mill. The fact that they have been gone for more than three centuries—Hals died in 1666, in his early eighties (his birth date is uncertain)—spared me the trouble but not the thought at *Frans Hals in the Metropolitan Museum*. The show features the eleven paintings that the Met owns by the dashing portraitist of Haarlem gentry in the Dutch Golden Age, augmented by two striking paintings on loan and apposite works by some of his contemporaries. Supplementary exhibits illustrate the problems of telling Hals's works apart from those of his many imitators and point up his lasting influence, as in a crackling little portrait, from 1907, by the American Robert Henri. It's a vigorous show, as any focus on Hals is sure to be. He was one of the three main geniuses of the Dutch Baroque, with Rembrandt and Vermeer, and you can't beat him for liveliness.

His celebrated brushwork is at times ostensibly slapdash but always acutely descriptive, and it excites at a glance. Witness *Boy with a Lute* (circa 1625), in which a jovial lad calls for a refill of his empty glass. The motif recalls images of fetchingly louche youths in the light-in-darkness style of Caravaggio, but with a speediness that is remote from the Italian's frozen radiance. Hals is an avatar of style as a free-floating value, all but independent of its subjects and occasions. This explains the ascent of his reputation, after long neglect, in the mid-nineteenth century, when budding modernists, especially Manet, found in his ways of drawing with paint an escape from the fuss and polish of academic convention. Hals showed how candid technique could register people and things as they really appear, in a streaming present tense.

Hals was born in the Flemish city of Antwerp, which his family fled in 1585, when, after a siege, Holland lost it to Spain. His father was a clothworker, and it made sense to settle in Haarlem, a flourishing center of the textile industries. Frans was apprenticed to another Flemish émigré, the Mannerist painter Karel van Mander, and became

a member of Haarlem's painters' guild in 1610. A fine catalogue essay by the Met's curator of Dutch and Flemish painting, Walter Liedtke, recounts the decisive effects on Hals of a return visit to Antwerp, in 1616. There he would have beheld the explosive inventions of Rubens and the young van Dyck, among others, from whom he absorbed, Liedtke posits, an all-around "pictorial literacy." So Hals's originality came not out of nowhere but from several sources at once, all perhaps indebted to the "rough style," as it was termed then, of late Titian. Hals's panache, notably in dazzling early group portraits of local militias, quickly charmed Haarlem, becoming emblematic of the city's entrepreneurial zest and robust self-regard.

What was Hals like? Early biographers, writing decades after his death, promulgated legends of loose living, drenched in alcohol. Liedtke finds no basis for them. Yes, Hals may have associated with brewers, but, in 1619, twenty-one of the twenty-four members of the Haarlem city council plied that trade. Liedtke sets aside, as moot, "the question of whether brewers drank a large part of what they produced." Their profession was highly honored. (Liedtke adds that the beer of the Golden Age was low in alcohol content and a lot safer to drink than the available water.) A story that the artist abused his first wife, who died young, came from court records that turn out to have involved another Haarlemite, also named Frans Hals. But the canards speak to a lingering mystery: Hals's lack of stylistic development. His energy never flags, but his tone seems stuck at a lazy bonhomie. Something kept him distracted.

Hals's relentless jolliness isn't confined to his genre scenes of rollicking topers, such as *Young Man and Woman in an Inn* (1623). The euphoric hero hoists a glass while being attended with fawning approval by a prostitute, a dog, and an innkeeper—three parties, according to a Dutch adage of the time, whose affections come at a cost. (A fourth could be added to that roster: the expensive portraitist, in the person of Hals himself.) But there's no bite to the moralism; it's purely jokey, for the amusement of a self-satisfied commercial class. Hals figures in history not only as a stylist but as an emergent type: the independent

contractor to the bourgeoisie, dependably exalting values of identity and status. After his Antwerp sojourn, he rarely left Haarlem, whose newly rich all but lined up at his studio door to be immortalized. He did indeed individualize them, specifying their extroverted, typically waggish attitudes. But they all seem to be on the same drug, which imparts silly confidence. Hals's lowlife scenes reassure such citizens that the poorer orders pose no threat to society. The ravishing *The Fisher Girl* (circa 1630–32) shows a pretty, weather-ruddied urchin grinning as she offers a silvery fish to an unseen customer. Everybody is happy in Haarlem!

Hals outlived his success. By the end of his long life, he was out of fashion and impoverished, which has led some critics to seek signs of embitterment in his late work. John Berger, in *Ways of Seeing* (1972), thought that he detected a proto-revolutionary resentment in group portraits of charity officials that were among Hals's last commissions. One of the worthies looks spectacularly drunk. Malcolm Eden, of the rock band McCarthy, expatiated on Berger's speculation in the song "Frans Hals": "The poor . . . know your names and they know your faces / they will deal with you." That's a stretch based only on a certain slackening of the artist's earlier people-pleasing friskiness. Class content is so dominant in Hals that it's tempting to imagine a changed ideological perspective, attendant on his fall; yet Berger's reading seems to me strictly a projection. It belittles Hals as an individual. But, then, so does Hals.

Hals's works are stunning as paintings, but paintings are also pictures: windows on a world. I find Hals's world dishearteningly pedestrian. It hardly bears comparison to the realms whose Prosperos are Rembrandt and Vermeer. Hals was of his time to a fault. He caught the vitality of the new bourgeois individualism but not what, in human terms, it could be good for: the plumbing of souls in Rembrandt; the transfixion of the everyday in Vermeer. The life that counts in Hals is that of his own invincibly vivacious eye and hand. To a degree beyond such predecessors as Titian, El Greco, and Rubens, he is the first virtuoso of the visible brushstroke and its fundamental alchemy: materially flat while conjuring substance and space in the eye and rhetorical

tone in the mind. No other Old Master is more apt to interest a young painter today. But Hals's fungibility reflects how little he made art for his own fulfillment. My imaginative participation in his portraits consists mainly in sharing the pleasure of the sitters—commonly posed with arms draped over the back of a chair or, standing, with one arm akimbo—at being able to afford the great one's fee.

New Yorker, August 8, 2011

THE AUCTIONS

Money and contemporary art got married in the nineteen-eighties. The couple was obnoxious and happy. Money brought the allure of power to the match, and art brought the power of allure. They had the meaning of life covered for the guests who mattered, who were kin of money. Once embarrassed by money's crassness, the important people saw with delight how, since espousing art, previously filthy lucre showed up as fresh as soap flakes. Where did the dirt go? It was smeared on art's angelic body, which gained thereby an exciting piquancy. Like all leading couples, art and money understood their responsibility to model style and manners for society's improvement. Their style was naked-ness, and their custom was to fuck in public.

7 Days, November 22, 1990

MARKET VALUE

Four hundred and fifty million dollars spent for anything short of a next-generation strategic bomber, let alone a beat-up old painting, not only makes no sense relative to current markets in worldly goods; it suggests that money has become worthless. Certainly, what an anonymous buyer laid out last week at Christie's for *Salvator Mundi* (circa 1500), a probable though to some degree only partial Leonardo da Vinci work that emerged from overpainted oblivion in 2005, seems a stuff fundamentally different from what you and I use to secure food and housing—or a yacht, even. It's a cash Burning Man.

Art is sometimes sentimentally termed priceless. But anything is priceless until someone sells it. Then there may be a clatter of the tote board for related items, pegging numbers up or down. The purely subjective rating of art works, which are all but devoid of material value, encounters no rational financial limit in either direction. The art market is a fever chart. Its zigs and zags call less for explanation than for diagnosis.

Sentimentality has everything to do with the marketing of *Salvator Mundi*. A couple of factors seem involved in the exaltation of a dicey work, much damaged and the recipient of clumsy restorations before its recent rescue—to the extent possible—by an expert New York restorer, Dianne Dwyer Modestini. (Modestini painted the entire ivory-black background, guessing at the original look that had been lost when, at some point, it was partly scraped down to the walnut panel.) One inflationary circumstance is the soaring predilection of big money from Asia for touchstones of Western culture. With an apparent eye to China, Christie's downplayed the Christian subject matter and content of the picture by tagging it "the male Mona Lisa." Never mind religion. Think Renaissance superstar.

A more general aspect of the mania is today's global infatuation with technology, the source and the cult of newborn exorbitant fortunes. Leonardo was an eccentric sort of artist but a tinkerer beyond compare. The famous mysteries of his painting are achieved through wizardly

experiments in chiaroscuro glazing. The undoubted inscrutability of the *Mona Lisa* skips the question of whether there was ever anything about the subject to, well, scrute. It's a stunt, though a sublime one. Leonardo's chief quality of personal affect—cold calculation—recommends him as the geek's geek of all time. There is about him an air of an eternal twelve-year-old prodigy, smitten with warfare, natural disaster, and fantastic invention and twitchy about sex and other grown-up preoccupations. His racing mind continually conceived grandiose projects that his immature will then let slide. The one thing he never ceased to do was to think, brilliantly.

The extent to which *Salvator Mundi* approaches the effective success of the handful of Leonardo's masterpieces, among his fifteen or so surviving paintings, is up to each viewer. It looks wobbly to me. What kind of guy was Jesus? Every kind in reach of empathy, believers believe, and in comprehending the feminine as well. Giving an ambiguous character an ambiguous mien doesn't seem a stop-the-presses innovation. The trick of it, by the way, is the same as that of the *Mona Lisa*: painting different expressions in the eyes and in the mouth. When you look at one, your peripheral sense of the other shifts, and vice versa. You try to reconcile the impressions, with frustration that seeks and finds relief in awe. This feature of the features does argue for Leonardo's authorship—or auteurship, anyhow, if the handiwork that we see isn't fully his own—despite some more or less plausible doubts that Jerry Saltz, in *New York*, ticked through, with entertaining zest, before the auction.

Saltz assessed the picture as far beneath the standards of originality that Leonardo maintained for himself—not so much that the master didn't create it but that he wouldn't have. He cited, for one thing, the archaic, largely Byzantine convention of depicting Christ head on, delivering the usual raised-fingers blessing, at a time when Leonardo was doing wonders with figures turning in pictorial deep space—as with *The Virgin of the Rocks* and *Virgin and Child with St. Anne*, both at the Louvre. (And the *Mona Lisa* sits slightly angled toward a receding, immense landscape.) But I'm reminded of a spate of rampant challenges, in the

nineteen-eighties, to the authenticity of many paintings accepted as Rembrandts, sometimes with reference to their relative quality, and of one authority's defensive observation: "Even Rembrandt had Monday mornings." Accordingly, I class my misgivings about *Salvator Mundi* as mere disappointment. While never quite loving any Leonardo, I'm conditioned to expect from him more terrific painterly ingenuities. *The Virgin of the Rocks* has made me laugh, from sheer marvelling.

What got exchanged for nearly half a billion bucks at Christie's wasn't an art work. It was an attribution. The sale transferred a bragging right, padded with fatuous hype from well-qualified art people singing for their suppers, in a money-addicted system. Should anyone who isn't invested in the game care? I don't, long benumbed by such previous, now suddenly lesser, mockeries of sense and sensibility as the nine-figure hammer prices for a pretty good Modigliani, in 2015, and a second-tier Picasso, that same year. For anyone with intellectual, emotional, and spiritual uses for art, the spectacle might almost be happening on an alien planet populated by creatures with paddles attached to their arms.

New Yorker, November 27, 2007

FAKERY

"If a fake is good enough to fool experts, then it's good enough to give the rest of us pleasure, even insight," the art critic Blake Gopnik wrote in an essay, "In Praise of Art Forgeries," in the *Times* last Sunday. It's a cute argument that I reject but that gets me thinking. Gopnik's hook is a scad of forged Pollocks, Rothkos, and other big-name abstract paintings, sold by New York's venerable Knoedler & Company gallery for many millions of dollars over two decades, until 2011. Exposed, the affair ended Knoedler's hundred and sixty-five years in business. (Lawsuits creep forward.) Among the victims was the late, august Swiss collector Ernst Beyeler, who, in 2005, called his bogus Rothko "a sublime unknown masterwork." Wonders Gopnik, "Why not think of that picture as the sublime masterwork that Rothko happened not to have gotten around to?"

Well, because it's not a "work" at all but a pastiche whose one and only intention is to deceive. Its maker—reportedly, a guy in a garage on Long Island—wasn't concerned with emulating the historical Rothko but, instead, with mirroring the taste of present-day Rothko fanciers. Fakes are contemporary portraits of past styles. No great talent is required, just some art-critical acuity and a modicum of handiness. A forger needn't equal the artist's skill, only the look of it. Indeed, especially in a freewheeling mode like Abstract Expressionism, a bit of awkwardness, incidental to the branded appearance, may impress a smitten chump as a marker of sincerity—or even as something new and endearing about a beloved master.

Time destroys fakes by revealing features of the era—the climate of taste—in which they were made. "Forgeries must be served hot," said the art historian Max Friedländer. I've seen two "Vermeers" that were painted in the nineteen-twenties by the king of modern forgers, the Dutchman Hans van Meegeren (1889–1947), and that hung unchallenged, for decades, in the National Gallery, in Washington, D.C. They are ridiculous. Among other blinking cautions, there's an

interesting suggestion that the likes of flappers and Greta Garbo inhabited seventeenth-century Delft.

How could anyone have mistaken those howlers for Vermeers? That's easy. Connoisseurs are products of their times as much as anyone else, subject to the same assumptions. But it's usually a connoisseur who soonest smells a rat. He or she does so not by being wary but by becoming puzzled in a normal pursuit of pleasure.

Believing is seeing. What do we see when we look at a painting? Decisions. Stroke by stroke, the painter did something rather than something else, in a sequence of choices that add up to a general effect. If you're like me—and, yes, I count myself a middling connoisseur—you register the effect and then investigate how it was achieved; walking the cat back, as they say in espionage. As a trick, ask yourself, of details in a painting, "Why, if I did that, would I have done it in that way?" The aim is to enter into the mind, and the heart, of the creator. This entails trust, like that of a child hearing a fairy tale.

Looking with such absorption won't immunize you to falling for a fake, but you may become confused if the supposed artist's style is familiar to you. Something is different. The game then deepens. The forger hopes that, being credulous, you will revise your estimation of the artist to accommodate the difference. Or consider a reverse case: you're told that an authentic work is a forgery. Paranoically, you view everything in it as sham. Again you're bewildered, this time thrown into doubt about your powers of discrimination. You conclude that you're a hopeless sucker.

To judge a work of art involves self-surrender. You are something other than your own person when in art's spell. If you dread being made a fool of, you should perhaps steer clear of art altogether. But risking foolishness, and succumbing to it occasionally, builds up antibodies of wisdom. You become a harder target—while remaining a target, because eagerly persuadable—for flimflam. Art forgery fascinates by exciting the same susceptibilities that art does. The sanest response to

having been tricked, once the chagrin wears off, is gratitude for a lesson you won't forget.

So that may be the "insight" that Gopnik finds in fakes. The possible pleasure eludes me, except as akin to the good time you thought you were having the night before you woke up with a mother of hangovers.

New Yorker online, November 8, 2013

MARCEL BROODTHAERS

I keep waiting to like Marcel Broodthaers. The Belgian poet-artist, who died of a liver disorder in 1976 on his fifty-second birthday, has become known in the United States by fits and starts since the early eighties, when many of us first caught wind of his charismatic reputation (not quite a cult but assuredly a following). Broodthaers made his name on the Düsseldorf-Cologne scene of the sixties and early seventies, a great creative crucible. Joseph Beuys, Sigmar Polke, Gerhard Richter, and Anselm Kiefer, among others, hit their strides there. Like the also prematurely departed Blinky Palermo, Broodthaers is cherished by influential veterans of that scene who may agree on little else. His apostles to America range from the Marxist-oriented critic Benjamin H. D. Buchloh, who edited a Broodthaers issue of *October* in 1987, to heavyweight Cologne dealer Michael Werner, now showing the artist's prints and multiples in his New York gallery. Such variegated enthusiasm makes me feel I am missing something. The Werner show doesn't change the feeling.

Maybe you have to be European, at least vicariously—identifying with a trans-Atlantic intelligentsia opposed to bourgeois and/or American vulgarity. Refined resentments play in some critics' interpretations of Broodthaers's satirical texts, objects, films, and installations. For Douglas Crimp, Broodthaers represents "the necessary stance of the artist working under the conditions of late capitalism." For Buchloh, the Belgian artist prophesied cooptations of the rebellions of 1968 (in which Broodthaers somewhat gingerly participated) and "the complete transformation of artistic production into a branch of the culture industry."

That's a lot to lay on a gnomic poet who announced his midcareer switch to art with a wry statement in 1964: "I, too, wondered if I couldn't sell something and succeed in life. For quite a while I had been good for nothing. I am forty years old. . . . The idea of inventing something insincere finally crossed my mind, and I set to work at once." But the critics' determination to exalt Broodthaers as a political hero and seer,

tipped off by ritual references to Walter Benjamin, is as inexorable as Werner's drive to monetize him.

The target of the projections seems to have been an appealing character who should not be understood too quickly. As a young poet, he tended toward dreamy symbolism. His heroes included Baudelaire, Mallarme, and his older countryman Magritte. A biographical essay I've read, by Michael Compton, turns up amusing anecdotes. As a youth in the Belgian wartime Resistance, Broodthaers blundered when, on account of who knows what crossed associative circuits, he delivered a secret message to an address on a street named Lake instead of a street named Valley. No ill result is mentioned.

In postwar Brussels, Broodthaers penned verse bestiaries, wrote some art criticism, worked as a publisher of small-edition books, and struggled to raise a family in bohemian poverty. In 1962 he met the Italian artist Piero Manzoni, who wrote his signature on Broodthaers and declared him a work of art. That was an era of explosive development for European avant-gardes, which tended to be ambivalent about the triumphs of art. With a disdain then common, Broodthaers wrote that Pop Art was "only possible in a context of societies devoted to publicity stunts, overproduction, and horoscopes."

"At the end of three months," Broodthaers continued in his 1964 statement, "I showed what I had produced to Philippe Edouard Toussaint, the owner of the Galerie Saint-Laurent. 'But it is Art,' he said, 'and I shall willingly exhibit all of it'." The work included assemblages in the vein of French New Realism, redolent of domestic life: pots of mussel shells, arrangements of eggshells, faces cut from magazines and put in canning jars. He encased copies of his latest book of poems in plaster, transforming his unsaleable literary work into an art commodity.

By 1968 Broodthaers was issuing "open letters" tweaking the art game—light-handed texts offering Zen advice on the order of "Don't feel sold before you have been bought, or only just." Broodthaers's careful ambiguity, shyness of politics, and allergy to jargon do not, of course, conceal from his exegetes that he agreed, or would have, with their ideas. His most ambitious works were imaginary museums:

installations combining art reproductions, common objects, obsessive images (eagles a specialty), wordplay, and the wonted paraphernalia of wall labels, display cases, and vitrines. Broodthaers's art-world actions established him as a sort of drier, unmystical Beuys (Beuys Lite, perhaps), a thinking person's shaman.

The twenty-seven multiples at Werner reward contemplation, which is lucky, because they demand it. Most are book-printed compositions of words and pictures. The words are by Broodthaers and the pictures are from magazines, encyclopedias, comic books, postcards, and old illustrations. There is some drawing, revealing that he drew badly. His forte was layout-and-design, bringing order to cracked concepts.

In one work, a chart of cattle breeds is labeled with the brand names of cars. Another is a money-exchange chart in which initials of the artist are priced in Deutschmarks and dollars. Most of the rest, including a deluxe-packaged wine bottle making obscure reference to an Edgar Allan Poe story, defy description in one or several sentences. Some mildly haunt, such as the postcard image of a violent storm at sea titled from the message that someone wrote on it, in 1901: *Dear Little Sister.* Rebuslike puzzles abound. Some verbal riffs (in French) have lyrical bounce: "The man of letters. The woman of letters, the boy of letters. The woman of letters and her son."

There is a sense of being let in on an intensely private sensibility, in ways a bit reminiscent of Jasper Johns. Broodthaers communicates the fun of having secrets, which telling them would spoil. Still, the show is thin, overall, and grueling.

In contrast to Pop's vulgarization of fine art, Broodthaers's enterprise was reactive rather than responsive. Unlike his contemporaries Polke and Richter, who competed with Pop to the point of eclipsing it, Broodthaers was content to ironize in the margins of changing conditions. A conservative European at heart, he seems to have been offended not ideologically but spiritually by the brash new culture of commerce and entertainment. But he wouldn't let it ruffle him.

The feeling tone is a slightly smug self-withholding: a mask of affronted superiority. This quality seems the very thing that

recommends Broodthaers to critics who are nettled in their intellectual pride. They view his stoniness as "resistance" and take little note of the wit that softens it. For myself, I quite prefer the Resistance warrior who went to the right address on the wrong street because, perhaps, his poetic taste revised the nebulous "valley" to the sharper "lake." My Broodthaers smacks less of Walter Benjamin than of Don Quixote.

Village Voice, June 25, 1991

MARCEL DUCHAMP AND MAN RAY

Marcel Duchamp and Man Ray star in the best real-life buddy movie in modern art. They aren't as canonical as Picasso and Braque, who, while revolutionizing Western picture-making, swaggered around calling each other Orville and Wilbur, after the Wright Brothers. But they had a far longer run and an influence that may still be growing. They weren't equals in talent. Either Duchamp was a genius or the word has no meaning, while Man Ray was a jack-of-all-arts with a special knack for photography. But they understood each other. Between them, they anticipated pretty nearly every artistic move that is now labeled postmodernist—a word that surely would have made them laugh.

"They laughed a lot," Duchamp's widow, Teeny, told Virginia Zabriskie in 1993 when asked what united the men. This show at Zabriskie celebrates the fifty-three-year palship. It is light on art, heavy on memorabilia. Its jewels are photographs by Man Ray of the preposterously handsome Duchamp in drag or otherwise enhanced: with lathered hair shaped into devil's horns or shaved in a star shape, and with a Turkish coin necklace on his head that makes him look like a Roman governor gone native.

People in bad clothes were studying the show when I visited: bookstore types. Duchamp is the artist laureate of bibliophiles both theoretical and poetical; and a season of intoxication with Man Ray marks the youth of many a litterateur. I remember feeling, when I first discovered Duchamp, that my brain had died and gone to brain heaven. In Paris in 1965, I wrote an abject fan letter to Man Ray, begging an audience. I was relieved when he didn't answer. Later I met him at an opening. Still dark-eyed and devastatingly suave, though dependent on a cane, he spooked me by flirting with my female companion.

"We also think of the naked women we have held in our arms," Man Ray wrote of himself and Duchamp as old men together at a beachfront café in Spain in 1961, sipping Manzanilla and watching the bikinis go by. Duchamp died in 1968 at eighty-one, Man Ray in 1976 at eighty-six.

They were the guys.

Man Ray, born Emmanuel Radnitsky, from Brooklyn, helped open New York to Duchamp in 1915, and Duchamp presented Paris to Man Ray in 1921. Duchamp became an artist's artist's artist, Mr. Modernity, over here: a "one-man movement open for everybody," Willem de Kooning called him. Man Ray became a dervish of novelty and shady glamour over there. Both men made lots of love, played lots of chess, and treated the twentieth century as their delicatessen of delights. Be warned that I am writing about my Duchamp and Man Ray, despairs of my adolescence: terrifyingly intelligent, audacious, and off-the-charts cool. Have your own ideas of them. These are taken.

In a proprietary way that I suppose is typical of Duchamp fans, I think everyone except me gets him wrong. Maybe thousands of artists and intellectuals have rung changes, sometimes brilliant, on his gestures and preoccupations, but commonly in far too solemn a way. His influence can seem one long, fruitful misunderstanding, whether he is cast as a philosopher king, a saboteur of conventions, or both at once. Really he was a French kid at play: Pierre Pan. And his American crony was Boy Ray.

Duchamp had the last happy childhood. He was raised in turn-of-the-century, country-house-bourgeois Eros amid doting females and nonstop ingenious amusements. One older brother, Jacques Villon, became a leading painter, and the other, Raymond Duchamp-Villon, a great sculptor. Duchamp tried his hand in Jacques's line, which, I believe, proved too toilsome for him; and rivalling Raymond was out of the question. So he took a U-turn back to what he knew best. There ensued an extended summer afternoon of games and sex, laced with mockery of the grown-ups.

Man Ray, meanwhile, was a driven self-inventor whose horror of his plebian roots made him dashing and cruel. In his autobiography he recounts, as if it were a rite of passage, whipping his two-timing first wife with a belt, not for anything as humdrum as adultery but for demanding his attention too early in the morning. Did she take him for some schlub of a Radnitsky? She was contrite afterward, he says.

There is no getting around the roguishness of Duchamp and Man Ray. At their giggly peak in 1921, they made a film about a fellow bohemian incautious enough to be crazy about them: *Elsa, Baroness von Freytag-Loringhoven, Shaves Her Pubic Hair*. But unlike most of their circles in the pissing contests of the Dadaists and surrealists, they didn't peacock. They simply lived the liberties that Surrealism's pope, André Breton, kept trying to legislate.

Man Ray wrote somewhere that he made art not out of necessity but out of desire. That's one of my favorite ideas. It draws a line against the baleful impulse of avant-gardes to turn liberations into programs. If art isn't about freedom—freedom from art, even—who can bear it? Duchamp created logical systems that consume themselves in looping tautology. At the end of everything, *L.H.O.O.Q.* I think, therefore I am a dirty joke.

On view at Zabriskie are the sorts of thing that make Dadaism a permanent floating boutique for fetishists. There are the familiar *Box in a Valise* (a miniaturized auto-retrospective) and the para-scientific *Rotoreliefs*, by Duchamp, and, by Man Ray, bagatelles including a soft relief of a female breast for a book cover (*Please Touch*) and an image of Leonardo da Vinci with a three-dimensional cigar (apostrophizing Duchamp). You get to see video of René Clair's *Entr'acte*, in which the guys play chess on a rooftop until the board is cleared by a fire hose, and the anagrammatically titled *Anemic Cinema*, their collaborative filming of *Rotoreliefs* in action.

But the relationship is the main thing, a two-man guerrilla cadre that forever changed relations between the art worlds of Europe and America and between art and whatever isn't art except when you think it is. Someone should make a movie about them. But the dialogue would pose a problem. Usually, in shots of them together, the camera has interrupted a conversation denied to other ears. There is laughter in their eyes. Is the joke on you? Don't flatter yourself.

Village Voice, March 7, 1995

MUGHAL PAINTINGS AND ANDREW WYETH

Mughal miniatures struck me as perfect for a late-summer art column. But when I found the show, in the rambling pile of the Brooklyn Museum, I quailed. It is tiny. Not all of its thirty items are even Mughal—or Mogul, as the regime of Mongol emperors of India, from 1526 until the nineteenth century, used to be spelled. It takes time to winnow the few gems, in the show, of the most exotic of fabulous court styles. But then I had another sinking feeling that combined with the first to give me an idea.

The second was caused by a show of Andrew Wyeth's "Helga" paintings, drawings, and watercolors, which I had forgotten was there. The images of a catatonic-looking country woman have been trucking around the nation since their alleged discovery, three years ago, by Wyeth's wife, Betsy, in cahoots with a collector and a magazine editor. When first reported, the works made for the damnedest fireball of art-related hype since King Tut. They are exotic in their own way, as talismans of weird America.

Compare two pictures: *Woman on a Terrace*, a delicate little circa-1775 opaque watercolor of a nude with two female attendants on a terrace, probably by a team of late-Mughal artists in an imperial atelier, and *Overflow*, a coarse, largish 1978 dry-brush on paper of Helga nude on a bed, by Wyeth. Poor Andrew Wyeth? I think so, and I hope you do, too, though upon first glance the needle of your interest may veer toward Helga.

Wyeth's so-called realism—more an effect of show-off technique than of a grapple with the visible world—and this picture's risqué cues of arm-up pose and peekaboo sheet advertise satisfactions that the Indians' ancient mannerisms don't. Only with sustained looking will your attention swing the other way, but then it's game over.

The miniature lacks earlier Mughal art's unparalleled use of color: hyper-intense secondaries (green, orange, purple) that provoke in one

another the action, experienced without being seen, of primaries (red, blue, yellow). One such work in the show, a seventeenth-century portrait, is like an earthquake in the optic nerve. The Mughal taste for strong sensations had declined by 1775, surviving here as a subtle jangle where the deep purple and green of a cushion encounter the dusky pink that renders both flesh and fabric.

The women stand on a tipped-up terrace that is scaled to monumentalize them. In three trees and the sky behind them three pairs of white birds, three of black birds, and a lone white bird perch or fly. Dainty containers of flowers, drink, and food rest in the foreground. The bejeweled (mostly in pearls) nude is beautiful, with long, pale limbs and jet-black hair. Her exaggerated eye regards something offered by one attendant, and she meshes fingers with the other—an intimate gesture, at once formal and sexy, that no doubt encodes something beyond my ken. An etiquette of sensuality rules in an atmosphere of heat and, probably, music and perfume. The small scene that your first look contained opens out until you could fall into it.

Hold the thought and go downstairs to Helga, who is approximately as erotic as a quilted pot holder. Even in this, perhaps his single raciest image, Wyeth is immune to fevers of imagination except of a factitious sort. Did he have sex with Helga Testorf, his sister's housekeeper? Do you care? His skittish fans may be reassured by a finicky technique (count the pubic hairs) that conducts no libidinous charge unless of a sex-in-the-head kind that I would rather not think about.

Wyeth isn't exactly a painter. He is a gifted illustrator for reproduction, which improves his arid originals with slick surfaces and kicked-up color. In person, the works present expanses of moisture-starved pigment. Moving your eye across them is like sledding on gravel.

Sensuality is energy at one with what the senses like. No energy equals no arousal, no matter what's dished up. This Helga is death on a shelf. But might her stupefaction be a response to the painter? I like to think that Helga sparkled like Dom Perignon when away from his studio. Wyeth's smothered id is as outlandish in its way as the unguarded appetites of the Mughals are in theirs.

What would a Mughal mogul make of a Wyeth Helga? I imagine Akbar (1542–1605), the all-time most enlightened despot east of the Medicis, trembling at the evidence of a sullen power, somewhere in the world, so immune to delight that it would prove the Nemesis of beauty everywhere.

7 Days, September 20, 1989

FLORINE STETTHEIMER

This is a good time to take Florine Stettheimer seriously. The occasion is a retrospective of the New York artist, poet, designer, and Jazz Age saloniste, at the Jewish Museum, titled *Florine Stettheimer: Painting Poetry*. The impetus is an itch to rethink old orders of merit in art history. It's not that Stettheimer, who died in 1944, at the age of seventy-three, needs rediscovering. She is securely esteemed—or adored, more like it—for her ebulliently faux-naïve paintings of party scenes and of her famous friends, and for her four satirical allegories of Manhattan, which she called "Cathedrals": symbol-packed phantasmagorias of Fifth Avenue, Broadway, Wall Street, and Art, at the Metropolitan Museum.

She painted in blazing primary colors, plus white and some accenting black, with the odd insinuating purple. Even her blues smolder. Greens are less frequent; zealously urbane, Stettheimer wasn't much for nature, except, surreally, for the glories of the outsized cut flowers that barge in on her indoor scenes. She painted grass yellow. She seemed an eccentric outlier to American modernism, and appreciations of her often run to the camp—it was likely in that spirit that Andy Warhol called her his favorite artist. But what happens if, clearing our minds and looking afresh, we recast the leading men she pictured, notably Marcel Duchamp, in supporting roles? What's the drama when Stettheimer stars?

Born in 1871, in Rochester, New York, Stettheimer was the fourth of five children of a banker who ran out on the family when she was still a child, although they remained well off financially. The two oldest offspring married. Florine and her sisters Carrie and Ettie—"the Stetties," as they were known—never did. They lived with their mother, Rosetta, first on the Upper West Side and, later, near Carnegie Hall. Florine also maintained large and lavishly decorated rooms on Bryant Park, as a studio and salon. Carrie spent more than twenty years fashioning a doll-house mansion, now in the Museum of the City of New York, which contains miniature works by artist friends. (Duchamp

contributed a bitsy *Nude Descending a Staircase*.) Ettie, the most efferves-
cent of the sisters, wrote novels of female independence and romantic
disillusionment, under the bemusing pseudonym Henrie Waste. In
Florine's 1923 portrait of her, she appears as a flapper goddess on a
chaise adrift in a starry sky, next to a combined Mosaic burning bush
and Christmas tree. That ecumenical gesture is characteristic of the
Stetties' cosmopolitan fervor, which extended to an active interest in the
Harlem Renaissance, through their friend the critic, photographer, and
patron Carl Van Vechten. Shut out of New York high society, on account
of their being Jewish, the sisters made the most of their ostracism by
becoming doyennes of liberty.

Stettheimer's passion for art started early. Having attended the Art
Students League—figure studies in the show affirm her skills—she
sojourned for several years with her sisters and her mother in Europe,
studying art in Germany, attending lectures by Henri Bergson in Paris,
and immersing herself in museums. The women returned to New York
at the outbreak of the First World War. To say that Stettheimer was, at
that point, sophisticated is like calling water wet. She had a symbol-
ist bent, with affinities for Gauguin, Bonnard, Ensor, and Klimt, and
inflections of Sergei Diaghilev's Ballets Russes. In 1912, thrilled by
L'Après-Midi d'un Faune, in Paris, she composed a sort of fan-fiction bal-
let, *Orphée of the Quat-z-Arts*, in which a girl, separated from her father
during a festive procession of art students, finds herself at a bacchanal
with gods, goddesses, and Apache dancers. She dances with Orpheus
until Mars intrudes. The conception might have worked, based on her
terrific designs for it, which are included in the retrospective, but the
show was never produced.

Further evidence that Stettheimer could have been a major theater
designer is provided by the sets and costumes that she made, using
cellophane, feathers, and sequins, for Gertrude Stein's buoyantly befud-
dling opera, *Four Saints in Three Acts*. The production caused a sensa-
tion on Broadway, in 1934, with music by Virgil Thomson, choreography
by Frederic Ashton, and an all-African American cast. It seems clear
that Stettheimer might also have succeeded at some of the other careers

then open to women: couture, perhaps. But, after a solo exhibition at the Knoedler Gallery, in 1916, brought no sales and only tepid reviews, she swore off any public career, despite pleadings from friends such as Georgia O'Keeffe, who wrote to her, "I wish you would become ordinary like the rest of us and show your paintings this year!" She did contribute something every now and then to group shows, but the audience for her work was otherwise by invitation only.

In 1915, Stettheimer painted perhaps history's first full-length nude self-portrait by a woman, revealing herself to be a true redhead. The pose is taken from *Olympia*, by Manet, who had borrowed it from Titian's *Venus of Urbino*, but Stettheimer's left hand, instead of resting on her pubis, brandishes a bouquet of flowers. Appearing contentedly amused, she is short-haired, long-waisted, long-legged, and small-breasted: a period knockout, at the age of forty-four. No details of her love life are reported, though she liked men, if gingerly. (Ettie cut many pages out of Florine's diaries after her death—but, blessedly, she defied her command to destroy the works that remained in her studio.) In one of her deft poems, "Occasionally," she writes of a type who "Rushed in / Got singed / Got scared / Rushed out." Armored "Against wear / And tears," the speaker dismisses "The Always-to-be-Stranger," whereupon "I turn on my light / And become myself." Van Vechten described her as a "completely self-centered and dedicated person." He wrote, "She did not inspire love, or affection, or even warm friendship, but she did elicit interest, respect, admiration, and enthusiasm."

Stettheimer peopled her pictures with willowy figures—women in slinky gowns and men in close-fitting suits. They have individual-ized faces but might almost be clones beneath the cloth—they're not so much gender-bending as gender-averaged. She made Van Vechten, who was gay but married twice, appear both epicene and heroic in a painting of him in his apartment, amid symbols of his myriad vocations. She rendered the leading art critic Henry McBride as the judge of a tennis match. To finish a portrait of a sun-loving friend who was vacationing on Nantucket, she sent a card daubed with seven shades of tan, for him to select the one that pertained at the moment.

But Duchamp brings out more complex feelings in her work, whether she shows him helping to serve lobster at a picnic; operating a crank-and-spring gizmo, to conjure an apparition of his female alter ego, Rrose Sélavy; or appearing as a disembodied, mystic face, in the manner of Christ on Veronica's Veil. Like Stettheimer, Duchamp came from a well-to-do family and shunned a standard career in favor of a life-long vocation of entertaining himself. They were soul mates of a sort, you can tell. Two years after her death, he collaborated with McBride on a retrospective of her work at the Museum of Modern Art.

Rich kids seldom become committed artists, though the Dada generation featured another, Francis Picabia, who also attended Stettheimer's salon. She overcame what the card sharp played by Charles Coburn, in Preston Sturges's *The Lady Eve*, diagnoses as the tragedy of the rich—"They don't need anything"—by making it her subject. Life as a serving of whipped cream on top of whipped cream functions as a master theme of her visions of determinedly languid and deluxe but also intense conviviality. In one way, this jibed with the glamour of the Gatsbyesque twenties in New York. But in another, hugely consequential way, it focused the consolidation of a world-changing avant-garde. In her paintings, as in her homes, Stettheimer gathered the best and the quirkiest spirits and energies—the collective genius—of her epoch, gave them a whirl, and sent them spinning into the future. See the show. Become her latest interesting guest.

New Yorker, May 15, 2017

ALBERT OEHLEN

The German artist Albert Oehlen is the foremost painter of the era that has seen painting decline as the chief medium of new art. It's a dethronement that he honestly registers and oddly celebrates, as can be seen in *Home and Garden*, at the New Museum. The first New York museum show for the sixty-year-old artist, it features twenty-seven works from key phases of his career. Large oils, at times combined with silk-screened digital imagery, may initially look like unholy messes: blowsy abstraction jostling with derelict figuration. Even Oehlen's passionate fans will confess to having felt a fierce dislike on first seeing his work, which goes beyond offending good taste to obliterating it. His handling of paint, at times with his fingers, yaws between gesture and smear. Canvases in shrieking reds and greens alternate with ones in muddy hues or just grays—such as *Bad* (2003), in which a woman's head, a bathtub, and a leg in a high-heel shoe, all crudely drawn, wander in a brushy miasma of tones. (The artist has said that when he eschews color it is to intensify his appetite for it. You never know how seriously to take what he says, but it always tantalizes.) A black-and-white series, begun in 1992, deploys hectic designs created with primitive drawing software on a Texas Instruments computer; it made him the first significant artist to exploit, and incidentally to burlesque, the emergent lingua franca of computer graphics.

Give Oehlen a chance. There is as much philosophical heft to what he won't allow himself, in the ways of order and balance, as in the stuttering virtuosities of what he does. His pictures possess no unity of composition, only unremitting energy. Everywhere your eye goes, it finds things to engage it; they just don't add up. There are stabs of beauty in passages that reveal Oehlen to be, almost grudgingly, a fantastic colorist, as with tender pinks and yellows, which echo halcyon Willem de Kooning, in *More Fire and Ice* (2001); fugitive dreamy purples, in *Untitled* (2009–11); and a clarion blue, in an otherwise murky *Untitled* (1989). If Oehlen has a method, it is to recoil, stroke by stroke, from conventional elegance—strangling one aborning stylistic grace

after another. He has said that he was fascinated, early in his career, by American Action painting of the nineteen-fifties—a histrionic mode of pictorial rhetoric, superficially imitative of de Kooning, whom Oehlen cites as a hero. (The term was misapplied to Jackson Pollock's drip paintings, which exalt a steady control.) Oehlen's variant—call it "reaction painting"—fights back toward the Master's rigorous originality. (Oehlen's one prominently lacking resource is de Kooning's forte of drawing.)

Not for nothing is Oehlen a mighty influence on younger artists, showing them the rewards in freedom that may follow upon a willing sacrifice of propriety. (Witness, apart from outright imitators, the devilish impetuosities of Josh Smith, Joe Bradley, Oscar Murillo, and others in a recent survey at the Museum of Modern Art, *The Forever Now: Contemporary Painting in an Atemporal World*.) He shrugs off appealing to anyone who doesn't really—even helplessly—like painting, fulfilling a prophecy made years ago by the critic Dave Hickey: "Painting isn't dead except as a major art. From now on it will be a discourse of adepts, like jazz." In an interview in the New Museum catalogue, Oehlen speaks of "qualities that I want to see brought together: delicacy and coarseness, color and vagueness, and, underlying them all, a base note of hysteria." His is a dandyish aesthetic, savoring its own unresolvable contradictions. But it resonates with general conditions of art and life today. Among other things, Oehlen offers an insight into why digital pictorial mediums can be exciting—and certainly are triumphant in global visual culture—but still fail to sustain intellectual interest or to nourish the soul. They are all in the head. Oehlen attacks with paint the shallow clamor of transferred digital pixelation and, in some works, glued-on advertising posters. He wrestles their visual quiddities—how they look, irrespective of what they represent—down into the body and makes them groan.

Oehlen came out of the creative hotbed that flourished in northern West Germany, especially Cologne, for two decades beginning in the early nineteen-sixties. Mentored at the start by Joseph Beuys, the scene gave rise to Gerhard Richter, Sigmar Polke, Blinky Palermo, Anselm

Kiefer, Jörg Immendorff, the Neue Wilde Neo-Expressionists, and, as it disintegrated, Oehlen's close friend and collaborator, the lyrically self-loathing artistic provocateur and intermittent genius Martin Kippenberger, who died, at forty-four, of liver cancer, in 1997.

Oehlen was born in 1954, in Krefeld, a city intimate with neighboring Belgian and Dutch cultures. His father was a graphic designer; his mother died of complications from a neglected ear infection when he was four. At art school in Hamburg, in the late seventies, his primary teacher was Polke, whom he says he first enthusiastically emulated and then systematically opposed. Smoky, Maoist political frenzies, promoted by Immendorff, engaged him for a while, though not exclusively. "Mao was OK," Oehlen told me when I spoke with him recently, "but not without Frank Zappa and Andy Warhol." (When I asked who his favorite musician is, his answer seemed perfectly unsurprising: the free-jazz revolutionary Ornette Coleman.) An ambient skepticism about the viability of serious painting affected Oehlen, even as his gifts inclined him toward it. Such early, determinedly cloddish figurative works in the New Museum show as *Self-Portrait as a Dutch Woman* (1983)—in which he sports a white bonnet, against a field of sprocket gears left over from an abandoned earlier version of the picture—won from Kippenberger the thrilled endorsement "It is not possible to paint worse than that!"

At the time, there seemed little to distinguish Oehlen from a Cologne crowd of painterly rapscallions, whose equivalents in New York were led, and laced with home-brewed grandiosity, by Julian Schnabel. A decisive turn toward abstraction occurred in 1988, when Oehlen shared a house in Spain with Kippenberger, and the two artists closely tracked and critiqued each other's development. The result seems to have been less a Picasso-Braque melding of styles than an oil-water divergence. Kippenberger amplified his impulses as a hopscotching hellion, in work that included a torrent of images of his beer-bellied self, and Oehlen honed his focus on the problems of painting. An untitled work from that year makes a joke of the struggle: long white and gray strokes, which must have suggested tubular forms, receive lots of sketchy little red bracket shapes that would hold them down if they

could attach to anything. Ever since, Oehlen's process has evinced endless sorts of borderline-desperate improvisation—until a painting isn't finished, exactly, but somehow beyond further aid. He told me, "People don't realize that when you are working on a painting, every day you are seeing something awful." The dramatic mood of the work is comic, beset by existential worry. It's as if each picture wondered, "What am I? Am I even art?"

Lately, the demand for Oehlen's work has bubbled up from the middling range of the art market to the luxury zone. The happenstance disgruntles some observers—including, remarkably, the New Museum's superb director of exhibitions, Massimiliano Gioni, who notes, in the show's catalogue, that "the recent commercial success and mainstream assimilation of these works complicate their reception, stripping them of their critical edge." That would seem so only if relative penury and unpopularity define intellectual virtue. Today, moneyed interest can befall just about anything, not always fatally. We will see if it corrupts Oehlen, stirs in him a supplementary type of rebelliousness, or, as I suspect, makes no practical difference in how his pictures affront the eyes and unsettle the minds of rich and not-rich alike.

New Yorker, June 22, 2015

BILL TRAYLOR

Bill Traylor, the subject of a stunning retrospective at the Smithsonian American Art Museum, in Washington, D.C., *Between Worlds: The Art of Bill Traylor,* was about twelve years a slave, from his birth, in Dallas County, Alabama, in 1853 or so, until Union cavalry swept through the cotton plantation where he was owned, in 1865. Sixty-four years later, in 1939, homeless on the streets of Montgomery, he became an extraordinary artist, making magnetically beautiful, dramatic, and utterly original drawings on found scraps of cardboard. He penciled, and later began to paint, crisp silhouette figures of people and animals—feral-seeming dogs, ominous snakes, elegant birds, top-hatted men, fancily dressed women, ecstatic drinkers—either singly or in scenes of sometimes violent interaction. There were also hieratic abstractions of simple forms—such as a purple balloon shape above a black crossbar, a blue disk, and a red trapezoidal base—symmetrically arrayed and lurkingly animate. Traylor's style has about it both something very old, like prehistoric cave paintings, and something spanking new. Songlike rhythms, evoking the time's jazz and blues, and a feel for scale, in how the forms relate to the space that contains them, give majestic presence to even the smallest images. Traylor's pictures stamp themselves on your eye and mind.

Charles Shannon—a painter and the leader of New South, a progressive group of young white artists in Montgomery—noticed and befriended Traylor in 1939, providing him with money and materials and collecting most of the roughly twelve hundred works of his that survive. New South mounted a Traylor show in 1940. Nothing sold. The support ended amid the disruptions of wartime in 1942. All of Traylor's subsequent art is lost. He died in 1949 in Montgomery, and was buried in a pauper's grave. (A handsome gravestone was installed in March of this year.) Few people knew anything of Traylor until 1982, when work by him was the sensation of *Black Folk Art in America,* a show at the Corcoran Gallery, in Washington. And yet some of the pictures might have entered the Museum of Modern Art in 1942, on the occasion of a

little-noted solo show at the Fieldston School, in New York, had Shannon not disdained an offer, from the museum's director, Alfred H. Barr, of one dollar apiece for the small ones and two dollars apiece for the large. (This datum bewilders, given Barr's famous appreciation of what was still termed "primitive" artistry. What did he think he was looking at?) Shannon and his heirs, after he died in 1996, disseminated the cache through sales and donations—works in the show have been loaned by twelve museums and thirty-nine private collectors.

How should Traylor's art be categorized? What won't do are the romantic or patronizing epithets of "outsider" or "self-taught," which belong to a fading time of urges to police the frontiers of high culture. The terms are philosophically incoherent. All authentic artists buck prevailing norms and develop, on their own, what matters in their art. Traylor is one of three dazzling moderns in America—with Martín Ramírez (1895–1963), a Mexican-born inmate of a California mental hospital, and Henry Darger (1892–1973), a Chicago janitor—who especially swamp the designations. How to square assessment of such work with conventional judgment is a problem increasingly addressed by certain museums. *Outliers and American Vanguard Art*, a show this year at the National Gallery, interspersed recognized professionals with discovered amateurs. In point of attraction, the outliers pretty well blew the pros away. If there's a quality that sets Traylor, Ramírez, and Darger sharply apart from more acculturated artists, it's that they most compare in spirit to great art of the historical canon. They missed out on mediocrity.

The Smithsonian curator, Leslie Umberger, spent seven years preparing for the Traylor retrospective. Her effort bears fruit not only in the graceful installation of a hundred and fifty-five pictures organized by sixteen recurring themes, from "Horses and Mules" through "Chase Scenes" and "Dressed to the Nines" and on to "Balancing Acts & Precipitous Events"; there's also a remarkable catalogue, which exhaustively lays out what can be known of Traylor's life, in its historical context, and of the references in his art. An introduction by the African-American painter Kerry James Marshall sounds a note of challenge to superficial

perceptions of an artist who was so embedded in Southern black history and culture and forced, while he lived, always to reassure whites of his subservient harmlessness. Umberger and other critics have adduced careful veilings of provocative content in Traylor's work. Scenes of men chasing men with rifles or hatchets may or may not encode, in sportive guise, memories of plantation brutality. The figures are indistinguishable in form and color. Perhaps the artist's one clean shot at racism is a drawing of a diminutive white man holding a colossal and menacing black dog on a leash.

Marshall writes, "The way I see it, Bill Traylor has always been the property of a White collecting class." He poses the question of whether white and black viewers can conceivably see the same things in the work of an artist like Traylor. He thinks not. There's no immediate help for that, but the sore spot that it touches may usefully be kept in mind. At issue are not relics of a remote civilization but living roots of perennial social and political realities.

Traylor was the fourth of five children, born on the plantation of an owner whose last name they were assigned. He gave different answers for the year of his birth but insisted on the date: April 1, which, of course, is April Fools' Day. (Umberger told me in an e-mail, "Blacks without birth records often selected something their mother thought was close, maybe she knew the month—it's more likely she recognized the change in the light and foliage of early spring.") There was a good deal of the trickster about Traylor; he was given to telling truths but, in the great formula of Emily Dickinson, telling them slant. In 1863, his family was moved to a nearby plantation belonging to his owner's brother. Traylor remained there until about 1908 as a laborer—he was, at one point, a member of a surveying crew—and perhaps as a sharecropper. By 1910, he was a tenant farmer near Montgomery.

Traylor had three wives and at least fifteen children. What became of the first two wives isn't known. The last died in the mid-nineteen-twenties, after which he moved alone to the city and subsisted on odd jobs and a small welfare stipend, often sleeping in the back room of a friendly undertaker's funeral parlor. The welfare ceased

when Traylor was found to have a local daughter—who, however, hardly welcomed him. Nearly all his other children had joined the northward Great Migration of the nineteen-teens and twenties. In his last years, Traylor visited some of them in Detroit and other cities but always soon returned to Montgomery. In 1982, a number of his family members sued Shannon for possession of the art. An out-of-court settlement granted them twelve drawings.

The works are kinetic in their appeal: athletic and choreographic. A drinker swigging from a bottle curls backward as if about to spiral. (Shannon quoted Traylor as having said, "What little sense I did have, whiskey took away." But plainly neither that nor anything else impaired the humor and subtlety of his imagination.) Sinuous rabbits extend legs that sometimes look human in their paroxysms of flight. When figures preen, you feel that they've just added inches to their height. Gravity tugs at some elements and ignores others. Why do so many characters point fingers, either as a meaningful gesture—perhaps occult, as a hex—or at things unseen? (It seems that no one can decide.) Houses and strange open structures teem with runners and shooters, chasers and chased, and birds and animals keeping their own mysterious counsel. You can't know what's happening, but, at a glance, you are in on it.

There is some gorgeous color film footage in the show by the Swiss American New York artist Rudy Burckhardt, who shot it in 1941, while he was in the Army, as he explored the streets of Montgomery at the boundary of white and black areas. Smartly dressed citizens of both races stride or stand. Umberger told me that she can't help straining for a glimpse in it of Traylor at his sidewalk post. He was surely there. This makes for an apt analogy. Traylor's art generates a presence at once mighty and fugitive, forever just around the corner of being understood.

New Yorker, October 8, 2018

ABSTRACTION

In *Inventing Abstraction, 1910–1925: How a Radical Idea Changed Modern Art*, a historical survey at the Museum of Modern Art, the most beautiful work, for me, is *Vertical-Horizontal Composition* (1916), a small, framed wool needlepoint tapestry by Sophie Taeuber-Arp. An irregular grid of rectangles and squares in black, white, red, blue, gray, and two browns generates a slightly dissonant, gently jazzy visual harmony at odds with the fabric's matter-of-fact, nubbly texture. The work bespeaks a subtle eye, a sober mind, and an ardent heart. If you could make something like that, you would drop everything else and do it. You wouldn't need a reason. I was mildly shocked by how unshocking Taeuber-Arp's work is, amid rooms of strenuous sensations from abstract art's big bang. But, in a show that raises the question "Why?" at every turn, I kept coming back to it.

What possessed a generation of young European artists, and a few Americans, to suddenly suppress recognizable imagery in pictures and sculptures? Unthinkable at one moment, the strategy became practically compulsory in the next. Many of the artists cooked up answers. The trailblazing Wassily Kandinsky and the bulletproof masters of abstraction, Piet Mondrian and Kazimir Malevich, doubled, tortuously, as theorists. They initiated a common feature of innovative art culture to this day: the simpler the art, the more elaborate the rationale. That's easily understood. We need stories. When they are banished within art, they re-form around it. But most interesting to me are the artists' personal motives.

The Swiss Taeuber-Arp and her husband, Hans Arp, from Alsace, became Dadaists in Zurich during the First World War. They seem to have been excited by the prospect of a passably pure, toughly modest aestheticism that jettisoned the traditions of a Europe gone mad with slaughter. Arp was making sprightly geometric and free-form collages and reliefs, often composed by games of chance—for example, shapes in colored paper dropped onto sheets of white paper and glued down more or less where they fell. The couple took comfort and delight in

carefully irrational, morning-fresh ways of creating. Abstraction, for them, was a haven and a test of character. Little else in the show makes such humanly grounded sense, amid its flavors of an international aesthetic cuisine: French color, Italian locomotion, Russian tectonics, Dutch severity, American pep. More than three hundred paintings, drawings, prints, books, photographs, films, and music and voice recordings barely summarize the phenomenon's variety.

The invention and contrariety of that brainstorming age—a rewarding catalogue introduction by the show's curator, Leah Dickerman, cites "cars, photography, relativity, and the death of god"—conferred a special prestige on creators who dramatized the effects of change. Music led the way, as is often the case when cultural foundations shift; the composer David Lang, one of twenty-five essayists in the catalogue, tracks the abandonment of "functional harmony" from Wagner to Debussy and then, with a lurch, to the atonal Arnold Schoenberg. Analogies to music enabled painters to escape logical developments in their field— at the time, mainly Cubism, which Picasso and Braque derived from suggestions in the work of Cézanne. An ecstatic mess of a painting by Kandinsky, *Impression III (Concert)* (1911), registers his response to a Schoenberg concert, with sketchy hints of audience members assaulted by shapeless floods of black and yellow. There is something forced, a hysteria of the will, about the work, as there is about the drive of the Italian Futurists to represent motion, which stumbles on the fact that paintings hold still. But the intensity of ambition batters misgivings.

The show opens with a surprise to me: Picasso as a closet inceptor of abstraction. He painted *Woman with Mandolin,* and a few similar pictures, in the summer of 1910. It is a typically early-Cubist, dun-colored congeries of arrowing lines and shaded planes, nudging in and out of shallow pictorial depth. But it lacks any visible subject matter: no discernible woman, nary a mandolin. It is, in a word, abstract. So, it seems from Picasso's own testimony, were at least some of his later Cubist works before he added what he called "attributes"—a bottle, a mustache—to make them still lifes or portraits. This fleeting episode in

his career is obscure, because he would never take credit for conceiving non-figurative art, an idea that exasperated him.

Picasso's arguments against abstraction still carry weight. He reasoned that there can be no such thing as non-figuration. "All things appear to us in the form of figures," he said. "A person, an object, a circle are all figures; they act upon us more or less intensely." (One early term for abstraction, "non-objective," is especially fallacious in this light—as if any function of the human brain, let alone a work of art, could evade subjectivity.) Picasso also said that, without reference to things we experience as real, art sacrifices its one indispensable quality: drama. Such was the challenge for artists who embraced the new looks: how to make the manipulation of circles, say, and fugitive marks seem to matter. A few—certainly Kandinsky, by fits and starts; Malevich, for a torrid spell; and Mondrian, with steadily growing command—faced down the Spanish basilisk. They did it by activating a figure outside of the work: the viewer.

The MoMA show is unconcerned with rankings of quality. It aims to inform. Mere coincidence in time puts grandly scaled but clumsy painterly cadenzas by the Czech František Kupka, the Frenchman Francis Picabia, and the American Morgan Russell on an undeserved equal footing with Kandinsky. Pretty good color compositions by Robert Delaunay—which the dashing poet-propagandist Guillaume Apollinaire fancifully termed "Orphism"—are no match for Fernand Léger's joyously tumbling forms in red, white, and blue. A wonderful sequence of Mondrians—from a 1912 picture of semi-abstracted trees to the dawn, in the early twenties, of his mature manner of taut horizontal and vertical black bands, and of blocks of primary colors, all keyed to a physical sense of gravity—far outshines the designy efforts of Theo van Doesburg and his colleagues in Dutch Neo-Plasticism.

Just one movement, that of the Russian avant-garde, after it was cut off from Europe by war and revolution, achieved something like collective genius. A stunning array of Malevich's thumpingly material, lyrically gravity-defying Suprematist paintings affirms him as the

first among equals, including Vladimir Tatlin, who is memorialized by a reconstruction, from 1979, of his huge maquette for the *Monument to the Third International* (1920). It is a symbol, like none other, of twentieth-century political aspiration and tragic folly. Striking works by Liubov Popova, Alexandr Rodchenko, Ivan Kliun, and other Russians make for a superb cameo survey within the show.

Dickerman and her curatorial crew have worked up a flowchart of affinities and influences, along the lines of the famous chart that MoMA's first director, Alfred H. Barr Jr., created for the modern movements, circa 1936. Neuronlike webs converge on "connector" individuals, socially adept Pied Pipers who fostered the formation of the time's avant-gardes. The prime artists include Picasso, Picabia, and Léger, in France; Mikhail Larionov and Natalya Goncharova, in Russia; and Filippo Tommaso Marinetti, in Italy. There are two poets, Apollinaire and the Dadaist honeybee Tristan Tzara, and one dealer, New York's Alfred Stieglitz, the shepherd of the native modernist painters Marsden Hartley, Arthur Dove, and Georgia O'Keeffe, and of the photographer Paul Strand. The chart is an effective aid to memory, a free-fire zone for disagreements, and fine intellectual fun.

On the point of intellect, the show makes an awkward but compelling case that Marcel Duchamp stands centrally in the history of abstraction. Some of his jarring provocations—including a film he made with Man Ray, *Anemic Cinema* (1926), in which spinning, optically disorienting patterns alternate with punning French wordplay—share a room with works by Americans, in the Stieglitz orbit, on whom he exercised a catalytic influence. Dickerman analyzes Duchamp's mordant take on the problem of finding meaning in art that had no recognizable subjects. Far from trying to close the gap, he made it abysmal. His readymades give meaningless objects meaning-laden titles—most notoriously, the urinal called *Fountain* (1917). "The readymade was thing *plus* text," Dickerman writes. With abstraction as the hinge, Duchamp opened a trapdoor at the bottom of Western thought and feeling.

Between Picasso's conservative critique and Duchamp's radical one, abstract art was sternly tested. This returns me to Sophie

Taeuber-Arp's tapestry, which obliterates skepticism. The proof of any art's lasting value is a comprehensive emotional necessity: it's something that a person needed to do and that satisfies corresponding needs in us. Such a payoff remained intermittent in the abstract art of the period covered by the MoMA show. It came to fruition later, in the singing expanses of Jackson Pollock, Mark Rothko, and other Abstract Expressionists. But that's another story.

New Yorker, January 7, 2013

CREDO: THE CRITIC AS ARTIST

UPDATING OSCAR WILDE

Oscar Wilde's essay "The Critic as Artist," published in 1890, manifests art criticism as a branch of what is called, often dismissively, belles lettres. It's not an easy read today. It is dauntingly long and congested with purple rhetorical flights and flourishes. Wilde flaunts his knowledge and sophistication in a blizzard of references, variously obvious or obscure now, to art and artists throughout history. I suspect that the display excited readers in the eighteen-nineties as a sort of house tour of a fully and beautifully furnished mind in the latest art-for-art's-sake fashion. Now it's like a period room in a museum, behind a velvet rope. But, along the way, Wilde mounts razor-edged assaults on dreary, timid, deadening attitudes toward art, of kinds that have changed in form but that never die. While praising beauty, he demonstrates its utility as a weapon.

I pledge allegiance to Oscar Wilde's model of art criticism.

The model promotes intelligence and energy in culture, as all criticism should, while making the exercise as little forbidding and boring as possible. It posits pleasures of the text as a rightful expectation of readers. It is autobiographical. Ideas and even facts, as well as feelings, register as events in a life. The speaker both is and isn't the writer. While going by the names "I" and "me," the critic-as-artist is a fictional being, mysteriously hell-bent for cultivation and never tired or confused. No one knows better the flimsiness of that illusion than any actual writer, who is often tired and regularly confused. He or she bets that readers, if pleasurably engaged, will condone the masquerade.

The critic-as-artist conveys heightened states of mind. Not really belonging to the writer, the states are available to the reader. A name for the transaction is "style." Critics-as-artists are stylists, in key with tastes of their times. They operate in the flashing present, where everybody lives. Inevitably, if not terminally, they become dated. In exceptional cases, such as that of Wilde, the meat of what they say outlasts its sizzle.

In dialogue, a pleasant character named Ernest expresses common attitudes, and a smart-aleck named Gilbert shoots them down. Says Ernest,

> Why should the artist be troubled by the shrill clamour of criticism? Why should those who cannot create take upon themselves to estimate the value of creative work? What can they know about it?

Gilbert's answers go beyond a defense of criticism, as a rational profession, to a case for independent thought, as an ethical imperative. He begins by pointing out that artists themselves function critically, in what they choose to do and not do. They are critics narrowly but deeply focused on their own work. Their decisions become history. Says Gilbert,

> . . . there has never been a creative age that has not been critical also. For it is the critical faculty that invents fresh forms. The tendency of creation is to repeat itself. It is to the critical instinct that we owe each new school that springs up, each new mould that art finds ready to its hand.

Another critic-as-artist, Gertrude Stein, once said, "Artists don't need criticism. They need appreciation. If they need criticism, they aren't artists." This true statement supports Wilde's view. Proper art criticism is not written to benefit artists. It will never presume to guide them. Sensing the gap between what they get from criticism and what they want from the world can make some artists grumpy. Gilbert goes on,

> I am aware that there are many honest workers in painting as well as in literature who object to criticism entirely. They are quite right. Their work stands in no intellectual relation to their age. It brings us no new element of pleasure. It suggests no fresh departure of thought, or passion, or beauty. It should not be spoken of. It should be left to the oblivion that it deserves.

There is a world of significance in Wilde's phrase "intellectual rela-
tion to their age." I don't think it involves the value of critical ideas, in
themselves, much less of systems of ideas. Intellectual systems antago-
nize critics-as-artists. In turn, adherents of systems tend to regard such
critics, if at all, as nuisances. (I speak as one who has been swatted at
by academics.)

Intellectual systems stand in relation not to present ages but to
previous ones. Clement Greenberg consolidated his doctrine of mod-
ernism in the late nineteen-fifties, just in time for Pop and minimalist
artists to demolish it with up-to-date critical insight. The set of beliefs
called postmodernism arrived on a wave of nostalgia for the glory days
of that demolition and even earlier ones. Marcel Duchamp kept being
hauled from his grave and sent, zombielike, against some or another
imaginary oppression.

The key word in Wilde's phrase "intellectual relation" is "relation":
thought that pays its way by coaxing meaning from encounters with
reality. The effect is temporary. It involves ideas only as instruments.
No idea is true in itself. Truth happens to an idea when it clarifies an
experience. Then its work is done. It may prove useful again. I think of
Charles Baudelaire's definition of beauty, as a spark between something
fleeting and something timeless. That never wears out for me. But it
is true only intermittently, when beauty strikes. Then it goes back to
being words on a page.

I've touched on a natural antagonism between artists, who want
appreciation, and critics, who criticize. Gilbert dramatizes it in a fairly
jolting passage that ends with what, for critics, has to be the most com-
forting sentence in the essay:

> Bad artists always admire each other's work. They call it being
> large-minded and free from prejudice. But a truly great artist can-
> not conceive of life being shown, or beauty fashioned, under any
> conditions other than those that he has selected. Creation employs
> all its critical faculty within its own sphere. It may not use it in the

sphere that belongs to others. It is exactly because a man cannot do a thing that he is the proper judge of it.

That is, the inept man or woman is free to slip in and out of the minds of artists whose mastery is, besides a kind of palace, a kind of prison. The unskilled must bow to skill, of course. I hope always to keep in mind that I'm unqualified to understand the works of artists in the ways that they do. However, I can understand it in a way they don't: as myself, whoever that turns out to be on a given occasion.

Like the artist, the critic creates and affirms value to the degree of his or her individuality. This is a rule without exceptions. Gilbert says,

> ... there is no fine art without self-consciousness, and self-consciousness and the critical spirit are one. For there is no art where there is no style, and no style where there is no unity, and unity is of the individual. No doubt Homer had old ballads and stories to deal with, as Shakespeare had chronicles and plays from which to work, but they were merely his rough material. He took them, and shaped them into song.

That ought to be common sense. Both good art and good criticism employ self-consciousness as a workaday tool. We model our thoughts and feelings to ourselves, as if they were actors and we were directors auditioning them. Many we reject out of hand, some we schedule for callbacks, and a few we hire on the spot. If we are writers, we keep framing sentences in our minds, each with a tone of confidence and conviction even when a moment's reflection proves it weak or false. We grope for a sentence that advances the argument we're making, reads well, and, we hope, surprises us. We live to be surprised.

OK, it's a job. Critics toil within editorial constraints, which affect our styles. In an otherwise fantastically generous essay on me in the *New York Review of Books*, the critic-as-artist Sanford Schwartz decided that my writing was more fun before I joined the *New Yorker*. For all I

know, that's true. But I am not going to complain about working at the *New Yorker*.

Says Gilbert, pressing the point about individuality home:

> . . . it is only by intensifying his own personality that the critic can interpret the personality and work of others, and the more strongly this personality enters into the interpretation the more real the interpretation becomes, the more satisfying, the more convincing, and the more true.

That's tricky if you're not Oscar Wilde. Not many of us have personalities that are integral and robust enough to carry the full weight of an argument. So we must pretend that we do. A famous declaration of Rimbaud, "*Je est un autre*—I is somebody else," seems to me a normal condition for persuasive writing. We comb out our sorry selves to conjure better ones.

I'm always glad when someone praises my work, but at times I've been uneasy, as if I had gotten away with something. I almost want to say, "That wasn't me." A former actress, to whom I'm married, long ago taught me the right response. She said, "Smile and say thank you." And she added, "Keep moving."

Knowing a number of savvy performers—actors, musicians, comedians—has instructed me in this regard. By the way, I believe that frequent attendance at theater, cabaret, and music events, as well as dance and, if you can afford it, opera, and then comparing notes with knowledgeable friends, is the best nourishment for a critical sensibility, as reading other critics is the worst. Those are arts embodied by and for real people, in real time and space. They can form visceral memories, which set standards for private looking and reading. Let's remember that Wilde's most pronounced genius was for the stage.

Criticism is in large part a performing art. Compared to more directly performative artists, we may be role-bound functionaries. But the tighter the space in which you can swing your arms, the more precious is your liberty to do so.

Every good artist is an outsider artist, in a way that counts; and every good critic is an outsider critic, in a way that counts. Good art and good criticism are not "practices"—that horrible word, so prevalent in art babble lately. Practices are professional specialties. Associated with art, the word assumes settled social agreements on what artists do. This may comfort the moms and dads of art students, casting their children's choice of career as akin to medicine or the law. Like all jargon, it lets us rattle on about something without feeling, and thereby doubting, the relative truth and value in what we say.

The life of art is a renegade pursuit that scraps the menu of standard occupations in a society. I don't insist on myths of the bohemian rebel or the holy fool, though there is recurrent validity in them. Independence of spirit doesn't rule out a worldly-wise career, with dealers and assistants and a house in the country. But I insist that an original, burning dissatisfaction, likely ignited in childhood, distinguishes artists from their fellow citizens. The same goes for critics-as-artists.

Lastingly majestic about Oscar Wilde is his outsiderness at the center of creative culture in his time. His Irishness, gayness, dandyism, and erudition—laced with the feel for trends of a crack journalist—gave him an outsider's angles on the society that he inhabited and adorned. His wit startles by registering lightning dissents from conventional wisdom that didn't know it was conventional yet. He omits what he contradicts, leaving us to provide it. An unexamined assumption is attacked, throwing us off-balance. We must think a new thought to right ourselves.

Wilde's high-wire act couldn't succeed indefinitely, because reliant on a nimble perception of worldly change. He likely would have stumbled in the Age of Cubism. Like his rivalrous friend Whistler, he was fully modern, but on a British sidetrack of the Continental modernity express. The cause of his fall didn't have to be an untimely mishap of hubris, which gave people whom he had outraged the chance to destroy him. In brief: he sued a man for calling him homosexual, which lawyers proved in court that he was. He was jailed for three years and died in poverty, of cerebral meningitis, in 1900, forty-six years old. The tragedy

had one good effect. It afforded a naked view of the real Oscar Wilde, beneath the masquerade: a serious, decent, brave man. His aplomb survived it all. As he lay dying in an ugly hotel room, he was heard to say, "Either this wallpaper goes, or I do."

The critic-as-artist Dave Hickey has noted that when two curators agree, that's a trend, but when two critics agree, one of them is redundant. Bringing to bear and even exaggerating our peculiarities is both the pleasure and the duty of dedicated critics. Readers should not be able to predict, with precision, what we will say on a given subject, because we can't know, ourselves, until in the midst of saying it. We may be perverse when we can't think of a sensible alternative to a commonplace opinion. Wrongness worries us less than tedium. By sacrificing our dignity, we might at least counter the drag of banality on art talk.

One of my intellectual patron saints, William James, remarked that a thinker can avoid error or seek truth but cannot do both. Another, Baudelaire, wrote, "I cultivated my hysteria with terror and delight." If that doesn't sound insane to you, you may be a poet or the kind of critic I'm talking about, or, like Baudelaire, you may be both. In any case, your potential reflects the type and degree of outsiderness that your early life and character have stuck you with—along with an itch to crash the circles of insiders and teach them a little courtesy toward the likes of you. You will endure as much loneliness as you can, to the verge of panic. That verge is your limit. You have to feel liked by somebody.

Most of all, you require a loving relationship with an ideal reader whom you have never met and never will, in person, but who companions you constantly, in imagination. The relationship is conducted with a full view on the world but a step away from it, as an exclusive compact of mutual devotion. I'm reminded of a pretty good speech by Shakespeare, which gives symbolic voice to my own fondest wish, in this regard, and with which I'll conclude. Lear to Cordelia:

. . . Come, let's away to prison.
We two alone will sing like birds i' th' cage.
When thou dost ask me blessing, I'll kneel down

And ask of thee forgiveness. So we'll live,
And pray, and sing, and tell old tales, and laugh
At gilded butterflies, and hear poor rogues
Talk of court news, and we'll talk with them too—
Who loses and who wins, who's in, who's out—
And take upon 's the mystery of things
As if we were God's spies. And we'll wear out
In a walled prison packs and sects of great ones
That ebb and flow by the moon.

The play's chief villain speaks next. He says, "Take them away."
So away we go.

Lecture, 2009–2018

ACKNOWLEDGING

Brooke Alderson.

Ada Calhoun, Neal Medlin, and Oliver Medlin.

Jarrett Earnest.

Dave Hickey.

Jerry Saltz.

Virginia Cannon and Cressida Leyshon, my editors at the *New Yorker*.

Vince Aletti and Jeff Weinstein, my editors at the *Village Voice*.

Steve Greco, my editor at *7 Days*.

Geoffrey Young, who first reprinted twenty-one of the pieces in this book in two paperback originals from his fine small press, The Figures: *The 7 Days Art Columns* (1992) and *Columns & Catalogues* (1994).

Gary Morris, my agent.

Eric Himmel, my editor at Abrams.

NOTE: I have revised most of the pieces collected here, sometimes considerably, without changing the opinions expressed, which belong to their occasions.

Peter Schjeldahl, New York, 2018

INDEX